FORTY-FIVE TODAY

29 April 1998

In 1986 I recorded a long-playing record entitled 'The Man'. It was released by Creation Records. It was a very personal record. All the songs dealt with my life and my emotions at that point in time. It was done to mark the end of one period of my life. I was 33⅓ years old. Time for a revolution, I thought. I was leaving pop music behind to start writing books. I promised myself I would not have any further involvement with music until I reached the age of 45, when I would make one single 45 rpm seven-inch record.

My promise was never kept. Like that dog, I returned. As I entered my 45th year, I decided to write a book that contained snapshots of the world from where I was standing. The stories span a period from early in my 45th year to well into being 45. I will read them again if I get to the age of 78.

If this book gets written, this page may act as an introduction.

45

Bill Drummond

An *Abacus* Book

First published in Great Britain by Little, Brown in 2000

This edition published by Abacus in 2001

pb

Copyright © Penkiln Burn, 2000, 2001
www.penkiln-burn.com
Introduction copyright © Neal Brown, 2001

A CIP catalogue record for this book
is available from the British Library

ISBN 0 349 11289 4

Typeset by M Rules
Printed and bound in Great Britain
by Clays Ltd, St Ives plc

Abacus
A Division of
Little, Brown and Company (UK)
Brettenham House
Lancaster Place
London WC2E 7EN

THE WINNER TAKES IT ALL

2 September 1997

I'm pulling my horse face.

'Dad.'

'What?'

'I might have found it funny you doing that when I was seven, but now it just makes you look stupid.'

5.05 p.m. Kate (12), James (10) and Dad (me) are standing in line at the Finn Air check-in, Heathrow. We're off to Helsinki. It's a summer holiday of sorts. I'm weighed down with a couple of rucksacks stuffed with a few hundred seven-inch singles, a thousand sheets of freshly printed, letterheaded writing paper and a notebook filled with lies to tell. We are on our way. In front of me in the queue is a girl; shoulder-length, sleek brown hair, expensive shades, hip-hugging slacks with 1997 regulation flared bottoms, skimpy black top, her every movement giving off total sexual confidence. Classy. I can't help but stare. She has a man with her a good twenty-five years her senior; hair loss, tired and drawn looks. He is checking in at least half a dozen bulging cases. They're an odd couple, but very familiar and comfortable with each other. The only thing that gives her away is when she opens her mouth. Rough, tough Glaswegian.

Kate and James are sitting on their bags. Kate is drawing a picture of the cute, keyboard-playing singer with Hanson.

James is bored and pissed off. It's been a long day already. We were up at 6.15 a.m. to drive to Peterborough, to the passport office, to get their names on my passport. On the way back down we heard Noel Gallagher on the radio being interviewed. *Be Here Now* is released today. Noel was trying to tell us that Oasis are going to blow every other band off the face of the earth. What a quaint aspiration.

The girl in front calls out to three others lounging about with attitude on an airport couch. I hadn't seen them until now. One of them comes over. The first thing I notice is her massive platform trainers, white, a good six inches off the ground. The next thing I take in is her hair. Ginger with streaks, the cut identical to Geri's from The Spice Girls. She's in her early twenties, sucking on an alcopop, and I'm thinking, 'Why would anybody her age and at this time in the history of pop want to have a hairstyle so knowingly identical to Ginger Spice, seeing as The Spice Girls are into a phase of their career in which their appeal is strictly pre-teen?'

Their two tubby mates join them, and all is becoming clearer. One is an even plainer version of Sporty Spice. As she drags on her Marlboro Light, back flips look like the last thing she could ever manage. As for Baby, bleached-blonde bunches are about as close as the likeness gets.

My mind is off, racing down half a dozen back alleys at the same time. Posh Spice with a tenement-slum Glaswegian accent, Sporty Spice on forty a day, an alcoholic Ginger and a fat Baby. What seedy showbiz office was this whole exploit hatched from, where was the advert placed? How many wannabes responded, and why? Are these girls after fame and fortune? And once they passed the audition and got the job as would-be Sporty, Posh, Baby, Ginger and . . . Hang on a minute, where is Scary? I stop and look around. There is no lookalike Scary. Has she just not turned up yet or was she kicked out last night for getting pissed up once too often? Do they get the tabloids every morning to check on the latest Spice Girls news, clothes, points of view,

[2]

hairdos? Can they sing, or do they just mime to a backing track? Do they live in fear that their Spice Girl alter ego might take an overdose, get up the duff or be chucked out? What then for them? Back to the Situations Vacant pages in *The Stage*? Maybe none of it's that sad, maybe they are just a bunch of girls game for a laugh, taking a year out before they start their BA course in Medieval History at the University of East Anglia or something.

Not since Monkeemania hit our TV screens on that Saturday teatime in 1966 has a band appeared which required us all to have our favourite. Mine was Circus Boy and drummer Micky Dolenz. Then there was a thirty-year wait before I had to make a similar choice. This time it was Baby Spice; I've always been a sucker for a grown woman with bunches. But in the past couple of weeks my allegiances have shifted. It's that fishwife-done-up-like-a-pushy-transvestite-with-big-tits-look that has drawn me to her. That and her glorious lack of singing and dancing talent, only surpassed by her driven desperation to be famous at any cost. I also like the fact that she seems older than she says she is, that the other four probably hate her, that no bloke appears able to put up with her for more than four weeks and that she will almost certainly be the first to lose her looks. Geri, you are now Spice Girl Number One in my heart. There is room for no other.

But why, here and now, are these Spice Girl look-sort-of-alikes (minus Scary) queuing to go to Helsinki? Off my mind goes again into another internal pop debate. When it was just the Bootleg Beatles, the Australian Doors and Björn Again I could understand it. But now it seems that for every band in the history of rock 'n' roll that has ever had an album out, there is a corresponding tribute band. Do gangs of young blokes hang around cafés flicking through back numbers of the *NME*, trying to find groups that haven't been tributed yet? Last week in my village hall The Love Cats, a tribute to The Cure, played. With all due respect to his artistic talent, who in their right mind would want to look and sound like Robert Smith?

Stop! Stop! Stop, Bill! I'm thinking too much about this. It doesn't matter, none of this matters. Pop music has become like a cancer that has spread through my whole body and is now affecting my brain. But what if I were cured? What would be left of me? I'd be like a shrivelled-up party balloon seven days after the birthday party. I saw a sketch on *The Fast Show* where the character could not do or say or hear or see anything without relating it back to a line in a pop song. That was me. I never listen to anything but Radio Three or Four, don't look at a music magazine from one year to the next, do not play any sort of music at home. But still it goes on, this internal sound-track of riff, hook, chorus and backing vocals to every moment of my waking life. I can't pass a mirror without hitting a power chord. Can't pass a sweet shop without hearing the Shangri-Las. Can't put out the milk bottles without wondering what happened to the Hermits. It's got to stop. I've tried everything, and it's too late to hope I die before I get old.

'Dad.'

'What?'

'Why do you keep looking at those girls?'

3 September 1997

Breakfast time in the Seaside Hotel, Helsinki. This concrete block of a hotel is down by the docks, no sand castles or donkey rides in sight. Kate and James are bickering. Kate has recently fallen in love for the first time, with that lad out of Hanson that she was drawing at Heathrow. James has already got to the stage of thinking he can take the piss out of girls for having a crap taste in pop music. Between mouthfuls of pickled herring and rye bread, I try to defend Kate against his onslaught about Hanson being a joke, and how great Radiohead are, by telling him I think 'MMMBop' is the best single of the year so far, and probably the greatest teenage rock 'n' roll record since the Undertones' first single.

'Look James, they play their own instruments, write their

own songs. They are a proper band, not like the rest of those boy bands.'

'Yeah, but they look like girls.'

As much as Kate's bedroom walls declare her undying appreciation of all things Hanson, she is not stupid enough to get caught up in this conversation – or even attack James for his love of the allegedly dreary Ocean Colour Scene.

In late 1996, Penguin Books published *Bad Wisdom*, a novel by Z (Mark Manning) and me. *Bad Wisdom* is a novel which documents a journey that Z and I, and a character called Gimpo, made from Helsinki to as near the North Pole as we could get. We took with us an icon of Elvis Presley. We believed that if we placed our icon of Elvis at the very summit of the earth, it would radiate good vibes down the longitudes, bringing about world peace. We are still waiting and hoping, but in the meantime we had an idea: to compile an album of tracks we heard on our way to the North Pole and subsequently namechecked in the book. On our journey we had heard all these strangely great and moving records being played on a station called Radio Mafia: Finnish progressive, Lapp punk, ice biker metal, Arctic soul, etc. Z and I contacted the station, found out what the records were called, tracked them down and listened to them. They all sounded shite. None of them contained the ethereal or hard-rocking magic they had when we first heard them on our mission to save the world.

Instead of giving up, Z and I decided to go out to Helsinki ourselves, find a bunch of out-of-work musicians and singers and set to work writing and recording the songs we heard in our shared memories. It took a couple of trips, but by spring '97 *Bad Wisdom (The Original Soundtrack)* was recorded, and we were proud men. It featured such fantastic bands as The Daytonas, Gormenghast, The Blizzard King, Aurora Borealis, and The Fuckers. We knew everything possible about these bands: their dates of birth, favourite foods, where they met,

line-up changes, suicide attempts, drug habits, love lives, the lot. The fact was, none of these bands existed anywhere but in our imaginations. Mind you, that's where all great bands exist. Being in a band or into a band is all about building, living out and worshipping (or loathing) a myth. Doing it this way, Z and I were safe from confusing our various alter egos with our real selves.

Back in London we played the tracks to a number of record companies. All were keen to get involved. Z and I were flowing with enthusiasm about all these brilliant singers and bands we had discovered, telling the eager A&R men about the wonderful lives and disastrous careers of our protégés. The record companies wanted photos, wanted to see the bands play live, wanted to know how all these fantastic bands had somehow slipped through the international talent-scout network unnoticed. Most importantly, they wanted options on whole careers, tying Z and me up in contractual lies, deceit and misery, before they invested their time and money. We had overlooked telling them that these bands only existed in our imaginations, but I think they guessed. It must have been something in our eyes. They started not to return our phone calls. Sod that.

So no deal was done with a proper record company. Instead, Kalevala Records was invented, along with its history and Mr Virtanen, its boss, with his foibles, his lack of understanding, his no-nonsense approach to artistic whim, his naïve aspirations. The plan was to press up half a dozen of the tracks by the afore-mentioned bands as seven-inch singles – only 500 of each – and let the records drift out of Helsinki. No promotion, no marketing, just a vibe out there on the edges of the pop ether. So that's why Kate, James and I are here in Finland. In my bags are the first four releases on the Kalevala label.

9.37 a.m. The three of us are in an open-plan office. Anna, whose office it is, is cooing over James and making the coffee. Anna is in PR. She works on dodgy Finnish disco records. She

appeared in our *Bad Wisdom* book under another name; I described her thighs as 'chunky'. I'm hoping she never read the book. I'm exploiting my children as unpaid labour. Kate and James work hard, although I have to furnish James with a constant supply of Coca-Cola to keep him at it. Kate is a natural worker. There are four piles of records, a hundred in each pile. Each record has to be put into a mailer with a Kalevala flyer, closed, addressed, have a stamp stuck on and lastly have the date it is to be mailed written in the corner. Each of the four piles of records is to be mailed out at two-week intervals to independent and specialist record shops around the world. There is nothing about any of these four records that could ever evolve into commercial pop success. Maybe they only make any sense from the standpoint of a man in his forty-fifth year, looking back across a lifetime of loving records that come from the outer edges of pop. When people ask me, 'Don't you miss the music business, Bill?' I try to tell them that the music business is about making unsuccessful bands successful. Successful bands by their very definition are as interesting as packets of cornflakes. No, it's strange, weird, fucked-up, unsuccessful pop music that I dig. Deluded pop music that wants to be successful and can't understand why it isn't. I don't mean any of that avant-garde shit or stuff made for and by those who value musicianship, but the cheap and nasty and mistaken and cracked, sung by singers who will fuck up with the first hint of success and by bands who will only ever make two singles before they fall apart. Records from places far away, by people who have no understanding of how things work in the worlds of London or LA but think they do. Records with crap sleeves. Is Kalevala Records the ultimate knowing folly of a retired pop person with some money still to burn? Right now I don't give a shit, 'cause I adore these records, these bands, this vinyl, these sleeves. For me, The Fuckers are more real, relevant and now than any other band in the universe.

2.15 p.m. Kate, James and I have finished our work. They ask

questions; I try to answer them. James tells me his mates back in Aylesbury will take the piss out of him for not going on a proper holiday, to Centre Parcs or Spain. Kate wants to know if we can come back next year and 'do it again'. I can hear Brian Wilson sing. But things on the popometer are getting strange. We are in a small café next door to Anna's office, having a late lunch. The walls are covered in tacky Elvis memorabilia, all very 1970s, an airbrushed retro version of a 1950s that never was. That point in 1972 when Marilyn Monroe and James Dean were back in vogue, and young directors planned to make films about hotrods and drive-in movies, and every art student had cut his hair in favour of a quiff. We order our hot dogs and knickerbocker glories and Coca-Colas from Elvis Presley. Now this is the heart of the problem. This is why I know something is happening. The closest thing to Elvis that I've seen has just handed me a Coca-Cola. Do I phone the *Sunday Sport*, or tell Kirsty McColl he's left the chip shop?

'Could that man be Elvis Presley?' I ask Kate. 'I mean, not just like him, but really him.'

'Yes Dad, I think he could be.'

Then a memory surfaces. The night before Z and I started to record our *Bad Wisdom* LP, we were invited to the launch party of the Helsinki Film Festival. Unbeknown to the both of us, Gimpo was a guest director at the festival. Gimpo's career as an avant-garde film director was taking off in Europe. The three of us were together again in Helsinki. We had just bumped into Gimpo at the bar when over the PA came the announcement (in English): 'Ladies and gentlemen, please welcome live on stage, all the way from the mountains of Lebanon, the King of Rock 'n' Roll himself – Elvis Presley!' Before I had time to see who or what was on stage came that rip-roaring howl of male sexual frustration let loose from its cage: 'You ain't nothin' but a hound dog . . .' Then the racket of a local pick-up band destroyed the brief epiphany and reality hit in: a crap local Elvis impersonator was on stage in his rhinestone-encrusted Vegas-period white

jumpsuit. If you have read *Bad Wisdom*, you may recall the significance of Elvis Presley, and that song in particular, for me and my life. The Elvis impersonator on stage bore a stunning resemblance to the King himself. It had nothing to do with the suit, quiff or ludicrous shades. It was his face, his voice, his moves. (Well of course it wasn't, but me and Z wanted it to be and it was pretty good for the first ten minutes, until we got bored.)

But back to the present, and the fact that Elvis has just handed me a bottle of Coca-Cola. I realise he is the Elvis impersonator I witnessed with Z and Gimpo at the Helsinki Film Festival last year. Uncanny is too weak a word to describe this man's likeness to the King. A cassette is on the crappy hi-fi, playing the soundtrack to *Blue Hawaii*. I make conversation.

'How did you become an Elvis?'

'Well, I am from a village in Lebanon. I had never heard of Elvis Presley. Then I met a Finnish girl who was on holiday and she told me I looked like the King of Rock 'n' Roll. She became my girlfriend and I moved to Helsinki, and here everybody tells me I look like Elvis, so I become Elvis. It's easy for me. Sometimes I forget my real name is Omar. Do you like Elvis?'

I decide not to explain the lengths to which my relationship with Elvis has driven me; instead I just nod casually and say, 'Of course'. I tell him I saw him perform last year at the Helsinki Film Festival. My mind drifts back to The Spice Girls lookalike troupe and I wonder what they are up to. Did they have a show last night? What kind of audience turned up to see them? What did the audience want from them? And when the girls came off stage and felt empty and pathetic in the dressing room, as one always does after performing, were they still in character? Did they throw backstage tantrums, just like you can imagine Posh or Ginger doing?

Either because fate has decreed it or through choice, this former Lebanese peasant is an Elvis Presley impersonator every waking hour, 365 days a year. When he falls asleep, does

he dream of being back in Memphis smothered by a mother's love, or is he under the spreading cedars keeping an eye on his father's goats? Do I bother trying to explain that his tacky '70s shrine of a café to the Great God Elvis could be so much better if he . . .

'Dad.'

'What?'

'How many piercings has Leroy out of Prodigy got? Kate says it's four, but I know it's three. Can you tell her I'm right?' Time to go.

Anna shares her office with a bloke who is a radio plugger. He has offered to lend me his 1970s Thunderbird for three days. The plan is for Kate, James and me to head up country; lakes and forests, that sort of thing.

Sunday morning. A deserted lakeside picnic park. The squeaking of swings. Kate and James happily getting on. They are singing Coolio's 'Gangsta's Paradise'. The waters lap, the leaves on the silver birches are already turning gold, there is a late-summer chill in the air. And in my head, I'm trying to stop myself writing yet another song by The Fuckers. There are two songs by The Fuckers on the *Bad Wisdom* soundtrack: 'Sexy Roy Orbison' and 'Teenage Virgin Supermodels Eat Shit'. There is no need for any more, but not a week goes by without me finding I've written a couple more of their amphetamine-and-cider fuelled howls of despair and hatred. The trials and tribulations of Billy Fuck (vocals), Nasty Fuck (guitar), JJ Fuck (bass) and Sick Fuck (drums) are becoming an obsession. They are the only Lapp punk band in the world. They have been together for over ten years, no line-up changes, thousands of gigs, no success and no selling out. They always get drunk before they go on stage. Once on stage they fall over, break strings, get in fights with each other or members of the audience. The night always ends with them being ripped off by the promoter. They hate everybody and everything, but especially Helsinki. To them, Helsinki is full of soft, southern, disco-loving,

homosexual, rich, arty wankers, and full of girls they want to shag but never can, things they want to own but never will. The Fuckers are the eternal dispossessed outsiders, failures and fuck-ups. All of their own doing, though of course they'll never see it that way. As far as I'm concerned, The Fuckers are the greatest band in the world.

On this Sunday morning, while Kate and James swing happily away and the lake waters lap, I've composed the basic framework of the latest Fuck, Fuck, Fuck & Fuck two-minute anthem of punk brilliance. It's a song in celebration of the recent and untimely death of Princess Diana: 'One Less Slag'.

'Dad, I'm bored. Can we go back to Helsinki?'

2.15 p.m. Driving the Thunderbird down a twisting and turning forest road, hardly touching the accelerator.

'Dad.'

'What?'

'I've decided to stop learning the guitar and learn the bass instead.' This is loaded. James spent the first few months of this year pleading with me to get him an electric guitar. I finally caved in, telling him it was a combined early Christmas and birthday present, and made him start guitar lessons. He's been going for about six weeks and can already play 'Wild Thing' and the 'Smoke On The Water' riff. I was a proud father. But this afternoon, I snap.

'That's it, James. I'm not paying for your lessons any more. The only reason why you want to start playing the bass instead is because you think it is easier.' My voice is raised, I'm losing it, something I hardly ever do with my children. 'I've had enough of your complaining, your moaning, telling me things aren't good enough, you're bored. Well, I'm bored with you and all your spoilt ways.' A year ago he would be crying by this point; now he just sinks into sullen silence. Kate says nothing. I switch on the radio. Abba's 'The Winner Takes It All'. I slip from reality into pop Nirvana, where the pain of heartbreak

feels like the ecstasy of submission. The tears push themselves out the corners of my eyes, as Agnetha and Frieda's grating vocals sear through whatever defences I have left against the power of pop's emotional battalions, every line in the song cutting deeper into my already scarred heart. Is there no escape, no getting over …? I hope Kate and James can't spot the tears now rolling down my cheeks.

'Don't you understand, Dad? I have to work hard at school all day, and if I come home and just spend all my time practising guitar it makes me a boring person.'

'What, and lying around watching TV doesn't?'

'You're just getting like all the other dads, wanting me to do what you did.'

'No I'm not. I would far rather you didn't want to be in a band. Most people who dream or struggle their youth away wanting to be in a band end up unhappy, depressed, unfulfilled, 'cause it never happens.'

'It happened for you.'

'That was just luck; right place, right time. Look, even if it does happen, it always goes wrong. Do you think Keith from Prodigy goes home at night happy?'

'You talk rubbish, Dad. I want to be in a band because that's what I want to do; it's got nothing to do with you. And anyway, I don't want to be a bass player, I want to be a singer. I want the people to look at me.'

'James, all singers are thick. Think of the boy you like least in your class – he'll be the singer. Everybody hates singers.'

'Crap. Everybody loves the singer most.'

'I mean the other lads in the band. They always hate the singer. He's always the lazy, loudmouthed, show-off one. You don't want to be like Liam Gallagher, just standing around doing nothing but being thick.'

'Oasis are one of the best bands in the world; better than The Beatles ever were – it would be great to be the singer in Oasis.'

I do not rise to the bait. Silence descends. I can't believe I've

just had this conversation with my 10-year-old son. If he's like this now, what's he going to be like when he's 15 and growing dope plants in his bedroom? A couple of years ago, all I had to put up with was his non-stop questions about football: was Darren Anderton the best taker of corners? Is Chris Sutton better than Alan Shearer? Will Aylesbury United ever make the Vauxhall Conference? I was able to ignore all that, but now he is into pop I can't stop myself getting dragged into the mindless debates. Uncomfortable silence as we head south, back towards Helsinki.

'Kate, ask me a question,' demands James.

'What's the name of the girl who left Eternal?' replies Kate.

'Louise.'

'Louise what?'

'I dunno, ask me a proper question.'

'What sort of guitar has the guitarist in Dodgy got?'

'One of those Gibsons that's got two letters. Dad, what's the two letters?'

'SG.'

'Dad, why don't you go faster?'

'If we go any faster and I was to touch the brakes we would be straight in the ditch, miles from nowhere.'

'Then don't touch the brakes. Why are you the most boring dad in the world?'

We hit the highway 148 kilometres north of Helsinki. I finally get over my fear of the accelerator on the Thunderbird. I push it to the floor and the engine roars. The road is empty except for the odd sign warning us of wild elks straying on to the highway. The car is going faster than I have ever driven before. The bodywork is beginning to shake and shudder. 200 kph and climbing.

'Dad.'

'What?'

'You're just trying to show off to us.'

*

[13]

4.35 p.m. We enter the outskirts of Helsinki. On all the lamp-posts of the main boulevards are placards for a massive Andy Warhol retrospective: Chairman Mao, Micky Mouse, Marilyn Monroe, those dark-blue self-portraits and Elvis, Elvis, Elvis. The King of Rock meets the King of Pop. We check back into the Seaside Hotel. There is an envelope waiting for me. It contains three tickets for a show tonight. The tickets read:

THE HISTORY WORLD TOUR
MICHAEL JACKSON
THE KING OF POP

7.35 p.m. We have found our seats high up on the southern stand of the National Stadium. James may currently be into the Verve, Dodgy, Radiohead and The Prodigy, but as far as he is concerned, Michael Jackson is the greatest pop star ever. James has a cousin three years his senior. This cousin got James into Jackson when James was five. James has all the albums from *Off The Wall* onwards. James is beside himself with antici-pation. Even Kate is showing some visible signs of excitement. The stadium is packed with good, clean (if not fun-loving) Finns of all ages – Michael Jackson, it seems, is family enter-tainment. The two huge screens either side of the stage are showing instant video footage of the crowd: close-ups of chil-dren's faces, pretty teenage girls, placards and banners. 'Finland needs you.' 'Moscow loves you.' 'Germany has come 4 U.' But the best one is 'Wrap your wings around the world and heal it with your love.'

Every so often a booming announcement is made: 'Thirty minutes and counting to Jackson time', interspersed with Motown classics from yesteryear over the PA. 'Do You Love Me', 'Fingertips', 'Mister Postman', 'You Really Got a Hold On Me', 'My Guy'. My toes are tapping. I've never been to a stadium show in my life. I loathe the whole idea of them. But I want the show to be great, I want to be moved. I want religion. I want to

rise above all that cynical, Jackson as fucked-up paedophile, freak-show stuff and believe that he can wrap his wings around the world and heal it with his love.

'Dad.'

'What?'

'Is Elvis the King of Rock like Michael Jackson is the King of Pop?'

I don't go into what a ludicrous and cynically contrived notion this 'King of Pop' thing is. All I tell him is that Andy Warhol is the King of Pop, and that's that.

'Dad.'

'What?'

'You're not going to carry on writing in your notebook when the show starts?'

'Why?'

'You're so embarrassing.'

Suddenly, the two massive screens either side of the stage are filled with Omar from the mountains of Lebanon, in his full Elvis At Vegas regalia. A roar of recognition and approval goes up from the crowd. The camera pulls back, revealing that Omar is just another punter in the crowd. Does he turn up at all the shows that roll into town? Does he get free tickets to add colour? Has he forgotten how to milk goats?

Show time. The space man has landed. I try to put my notebook down but keep getting it out when I reckon Kate and James are too engrossed in what's happening on stage to notice me. It may be the King of Pop on stage, the biggest-selling pop act ever, but I have no inclination to document in my notebook his corny entrance, his stale moves, his lacklustre costume changes and bombastic, hollow funk workouts. I look around, hoping to see Glasgow Posh, Fat Sporty, Ugly Baby and OK Geri. My mind drifts back to the real Geri and how things are going with the much anticipated film *Spice World*. My guess is that whatever qualities the film is deemed to have when it comes out around Christmas, only in twenty to thirty years' time will it

be fully appreciated as a work that perfectly captures the aspirations of the late '90s. But in the meantime, which Spice Girl is going to have a breakdown first? Get into smack? Go into rehab? Run to the tabloids to tell her terrible tale of bullying, hatred, double-dealing, rip-offs and what talentless no-hopers the other four are?

But these petty thoughts of mine don't hold my imagination. My mind drifts again, back to 1972 when, as a 19-year-old art student, I was walking down Lime Street in Liverpool. A few hundred screaming, pubescent girls are holding up the traffic. The focus of their screams were five afro'd heads belonging to five boys who were leaning out of a window of the George Hotel and waving back at the girls. I recognised the cute one with the Bambi eyes; the other, older ones just merged together. While my mind was no doubt agonising over why I wanted painting to die and my disdain for Roxy Music's debut album, what was going on in Michael's little piccaninny head? Had he any idea that over the next twenty-five years he would be responsible for some of the greatest pop records ever made?

'Mad Jacko's face melts as he bursts the bottom of a 12-year-old boy at his secret wedding to sister Janet Jackson as Liz Taylor watches.'

Whatever version of him was being delivered to us via the tabloids or his publicity machine, he could still deliver the goods on record like no other. After he made 'Man In The Mirror', I thought he could never surpass it. Then when I saw and heard 'Earth Song' in late 1995, I knew there was only one pop genius alive and working in the 1990s. This was global, Benetton, Pepsi-Cola pop, transcending all criticism. Jarvis could keep his little stunts for the provincial British media. The morning after the 'Earth Song' video had been first shown on British TV I received a fax from Jimmy Cauty. All it said was, 'Because we will never be as talented as Michael Jackson'. It was the only answer worth giving to any question that anyone may care to ask the pair of us, ever. It still rings true as I sit here

with my wandering mind and this tawdry little stadium show trying to puff itself up into something important and spectacular. Kate and James are up on their feet, clapping along with 70,000 other happy customers. Back my slippery mind goes, way back.

1970. I was standing in a field with 300,000 other children of the '60s. Jimi Hendrix was up on stage. It was a pile of shit. The man who had made 'Foxy Lady', 'Purple Haze', 'Little Wing', 'All Along the Watchtower', was boring me. And while I was standing there disappointed and wanting to hitch for home, a little ditty was going round and round my head. I couldn't stop it. It had been there all summer long; whenever I was bored it would start up again. 'ABC . . . it's easy as 1-2-3 . . . ABC, that's how easy love can be . . .'

'Dad.'

'What?'

'This is the best thing that's happened in my life so far.'

I wonder what The Fuckers would have to say?

THE URGE TO PAINT
or Have I Got The Strength To 'Just Say No'?

12 November 1998

A bowl of porridge and a pot of tea on the table in front of me. In the background, Radio Three's *On Air*. Every morning it's the same. While the rest of the house sleeps I sit at this table and stare out of the window.

I have lived here for six years, longer than I have lived anywhere else throughout my adult life. I must have stared out of this window (in fact it's a patio door, but I can't bring myself to call it that) for more time than I've stared at any other one thing. The view is a broad sweep across the Vale of Aylesbury, south towards the Chiltern Hills. Field after field, hedgerow on hedgerow, stands and further stands of black poplars and, of course, my beloved pylons. When I first moved here in early '93 it was the nocturnal version of this view that held me entranced. That distant string of orange phosphorus lights that followed the course of the A41 from east to west at the far side of the vale. I had driven that stretch of the A41 a thousand times. Knew every cat's eye, every empty Silk Cut packet on its verge. It's as uninteresting as any other road in the south of England. But at night and viewed from where I'm sitting now,

that string of phosphorus lights would have the same effect on me as listening to Scott Walker singing 'The Lights of Cincinnati' or Glen Campbell's 'Wichita Lineman'. All those long-ago songs about a faraway Middle America. I would sit there singing lines like 'See the tree, how big it's grown', willing the tears to flow. Of course I was living alone then, which encouraged this melancholic wallowing. If there was any rational thought going on it was along the lines that I should try to write some classic heartbreaking ballads, songs that would make me proud to be a songwriter, a proper one like Burt Bacharach or Jimmy Webb, and of course one particular song that would never stop getting played, thus providing a nice little pension plan.

But now it's different. It's not the lonely nights and the phosphorus lights that comfort me. It's the early hours. As the first light streaks the sky above where the Chilton cement works must be, the dark grey-blues and almost purple blocks of clouds shift, unmasking pale pinks and ribbons of orange as minute by minute, field by field, the vale reveals itself to the coming day. A damp and low-lying country, it's prone to mists that cling to the ground, waiting for the rising sun to disperse them. It's these mists that do the trick for me most mornings, as they must have done for dawn watchers since man sat at the mouth of his cave. Sometimes it's like the fields of Avalon, sometimes it's a Japanese watercolour. And sometimes it's just me sipping my tea and thinking, 'that bit over there beyond where the canal must be would make a great painting.' Except that that 'sometimes' is happening more and more often. Each time it's a different bit of the sweep. I've begun unwittingly to fantasise about the blocks of colour on the canvas, the texture of the thickly applied paint. That hump of a hill over there, that black silhouette of a dead ash tree. That pylon rising up from the swirl of mist that covers its feet. An endless supply of beckoning prospects, each and every one worth a day at the easel. For twenty-six years I've been able to suppress this urge. To banish

it with reason, to ridicule it with cynicism, to let it wither through years of neglect. But still it must always have been there, biding its time, gnawing at my subconscious. Does there come a time in every artist's life when the urge to capture the emotion generated by an innocent prospect returns?

It began a few months ago. At first it was more that I imagined somebody else painting it, not that I was going to track down and persuade a local landscape painter to come round to my place at 6.45 a.m. with a paint box. After a while I realised that in my imagination I wasn't seeing somebody else's interpretation of this landscape. It was my own. I had to face the fact that I wanted to paint.

Some mornings I could indulge myself in the fantasy of spending the rest of my life painting different parts, moods, lights, moments of this same landscape. I would sit here, in the exact same spot, with my pot of tea and bowl of porridge by my side. Monet and his lily pond would be nothing compared to this. My soul would blossom across a thousand dark and brooding canvases. The trouble is, I know I'm drawn to a comforting unoriginality. Tens of thousands of paintings of similar scenes have already been painted by men in chunky jumpers.

My mother has a painting hanging on the wall of her hall. Lots of dark greens and thick browns. It's of the back of a run-down house and its overgrown garden in Northampton. It is the last painting I ever painted. I was nineteen. When I was painting it I felt a rush of energy and excitement go through me that I had never felt before. I thought it was brilliant. I thought I was going to have a glorious life painting canvas after canvas, riding the untamed creative force within me. The painting was rubbish. Every time I visit my mum's I'm shocked at how bad it is. Maybe it's time I gave my mum a visit.

Before it's too late.

MICK PHONED

29 April 1997

Mick phoned me.
Mick Houghton, friend and publicist since '79.
They wanted to know
if I'd do some sleeve notes
for an Echo and the Bunnymen Greatest Hits package
that Warners are putting out
coinciding
with the reformation
of the band.

This is what I wrote:

SLEEVE NOTE

We were in the back of a transit van, careering down a highway. Nobody was at the wheel and nobody knew where we were going. The journey started in '78; I fell out the back door somewhere in the mid '80s. I picked myself up, dusted myself down and walked away.

If I were to bring myself to listen to the tracks on this record, they would drag up too many memories I would rather remained buried. Memories of lies, deceit, hatred, hotel floors, cocaine dealers, transit vans, acid trips, broken amplifiers, American girls, service stations, loss of innocence, corrupt road crews, missed opportunities, vanity, broken promises, shit gigs, bad sex, crap mixes, late VAT returns, petulance, incompetence, petty rivalry and Pete de Freitas dying.

I make myself a pot of tea.

Read the above and remember.

I love Echo and the Bunnymen more than I have loved any band before or since.

And

Not because

Echo and the Bunnymen embodied all the great archetypes of the classic band: a drummer who knew how to have a good time; a bass player who knew how to keep everybody else in

time; a guitarist who was introverted, twisted, bitter and fuck-
ing brilliant and a singer who had the lips, hair, voice, words
and all that other stuff that you have to have from a Parthenon
Drive frontman.

But because

Within the soul of Echo and the Bunnymen there was a pure
aspiration that transcended all those would-be dragged up
memories. It's as if The Bunnymen were going for some ulti-
mate but indefinable glory. A glory beyond all glories, where
the gates are flung open and all you can see is this golden light
shining down on you, bathing you, cleaning all the grime and
shit from the dark corners of your soul. You know what I mean?

Good.

I drink my tea.

TAKE THREE BULLETS

What I didn't write was this:
All bands reform for the wrong reasons
You know the ones
Last year
Or was it the year before
I heard a rumour
'The Beatles' were to re-form
Julian, Paul, George and Ringo
Headlining Woodstock
The Silver Jubilee
The Beatles don't re-form
It's against the rules
Mark Chapman was still in jail
So the job had to be done by me
I would get my gun

Take Three Bullets

Take three bullets
Go to Woodstock
And do the job
The gig never happened
Just a crappy single
A good job
Or I'd have had to face my own futility
Will, Mac, Les,
You gotta
Prove me wrong
And
Do It Clean.

COCAINE DEALERS AND AMERICAN GIRLS

I phoned Mick to find out
If they liked what I wrote
Warners wanted to scrap
All text up until
'I love Echo and the Bunnymen more . . .'

The band wanted 'cocaine dealers'
Changed to 'drug dealers'
And 'American girls'
Got rid of
Altogether.

Like I say
Do It Clean.

ON PAPER

Now
After writing that
It churned things up in me.
Things that had been unchurned for a long time.
I needed to set down on paper
Other stuff.
Stuff to do with me and The Bunnymen.
It is not their story.
It is not the story of my relationship
With them as individuals.
It is not a critical assessment of their work
And its place in the Rock 'n' Roll Hall of Fame.
It's this:

FROM THE SHORES OF
LAKE PLACID

Julian Cope said, 'McCull's got a new group with Will. You know Will? He's that bloke who's into The Residents.' I didn't know Will but I did know McCull (Ian McCulloch); didn't like him. He was into Bowie; I didn't like Bowie. But for Julian to tell you that somebody was into The Residents was his highest form of recommendation. To be into The Residents requires dedication, hard work and a love of the perversely weird and weird is good and The Residents are from San Francisco; double good.

'Will is the lead guitarist and Les is to be the bass player.'

'Who's Les?'

'You know Les. Les Pattinson. Looks like he's a Gerry Anderson puppet. Wears a black polo neck and has that band The Love Pastels.'

'Oh, The Love Pastels.' The Love Pastels were one of the better imaginary bands around. It was Les and three imaginary girls. Farfisa organ, acid bubblegum, West Coast '66 vibe.

It was Liverpool, October 1978. Julian Cope and I were in a van driving over to Kirkby to pick up a mattress to take back to his new flat in Devonshire Road, Toxteth. I'd just been telling him about this record label called The Zoo that me and Dave Balfe were imagining, and Julian was going on about his new band. Julian had a new band every week, each with a

manifesto, a built-in history and a moral high ground. This week's band was called The Teardrop Explodes. I instantly knew this was the greatest name for a band I had ever heard. And we agreed we should put out a single by The Teardrop Explodes on The Zoo label.

'You should make a record with McCull's band.'

'What are they called?'

'Echo and the Bunnymen.' It didn't have the instant 'I'm already into this band and I haven't heard or read anything about them' feel that The Teardrop Explodes had, but it was in the right area. Better than those groups with shit names on the Fast label. It sounded strange, psychedelic, enticing.

A couple of weeks later, I was sitting in a kitchen with McCull. (It was only later that the McCull got shortened to Mac.) The kitchen was in a flat on Penny Lane that he shared with Gary Dwyer (The Teardrop Explodes's drummer) and Pete Wylie. I lived less than a hundred yards away, around the corner past the chippy.

'The thing is, we're doing these badges for The Teardrop Explodes and The Zoo and if you agree to do a record with Zoo we will do an Echo and the Bunnymen badge as well. I need to know by tomorrow.'

In '77 or '78, for a band to have one of those crappy little button badges was the ultimate statement that you were real, out there in the world, and you better watch it 'cause . . . Next day I got a call from Mac. Will and Les agreed; the badge would be made, a record recorded. This thing with the badge may not be remembered by Mac, but it is etched in my conscience as the first point when soul-corroding record-business sleaze entered my being. The kitchen table was Formica, the legs were painted yellow. As for Echo and the Bunnymen's music, I still hadn't heard it.

January 1979. Dave Balfe and I recorded a single with The Bunnymen in a proper studio called August, with eight tracks and everything. It was round the back of the Renshaw Street

dole office. The Bunnymen didn't have a drummer; they used a drum machine with four settings: bossa nova, foxtrot, rock beat 1 and rock beat 2. They recorded two songs, 'Pictures On My Wall' and 'Read It In Books'. 'Books' sounded great, 'Pictures' a dirge. They wanted 'Pictures On My Wall' to be the 'A' side. It was written by Will, Mac and Les. 'Read It In Books' was an older song, written by Julian Cope and Mac. Well, this is a problem which almost twenty years later has not been resolved. Mac insists he wrote the song. Julian Cope claims they wrote the song together. I registered it with the PRS and MCPS as a McCulloch/Cope composition. Mac and I may love each other deeply, but he will never forgive me for this. Following on from the badge incident, this was the first shifty music business compromise I had made.

So the dirge-like 'Pictures On My Wall' was to be the 'A' side. I was resigned to the fact that The Zoo was putting out another crap single, following up The Teardrop Explodes's crap 'Sleeping Gas'. Balfe and his friend Kevin Ward did the artwork for the sleeve. They delivered a silhouette illustration of a ghostly rabbit figure with devil's horns, rising arrogantly from the ashes. The record might be shit, but this devil rabbit took a grip like a vice on my imagination. Kevin Ward had also written the band's name in a paranoid scratch scrawl. This too resonated with something lurking in me.

The single came out and to my amazement was reviewed in the coveted position of 'Single of the Week' in the *NME*, *MM* and *Sounds*. Music journalists started tracking us down to get interviews with The Bunnymen. In these interviews The Bunnymen were understandably asked, 'Who's Echo?' And Will, Mac and Les answered, 'Our drum machine.' With the benefit of hindsight, I am sure that with their answer my relationship with Echo and the Bunnymen started to take a dark and possibly dangerous path. They were wrong. Echo was not the drum machine; that was just an answer they made up to satisfy the journalists. I knew, even if they didn't, that the real

Echo was something to do with the devil rabbit that Balfe had illustrated for the sleeve. A character named Smelly Elly had come up with a number of imaginary band names, including Echo and the Bunnymen. Will, Mac and Les chose one. I never got to ask Smelly Elly where he got the name or what it meant to him.

It was about this time that I started to slope off and disappear into the library, the big one by the Walker Gallery in the centre of Liverpool. I was on the hunt for real or even imagined information on who this weird Echo character was. I assumed the name The Bunnymen referred to his followers. So it was among those book shelves marked Weird amongst Religion/Myth/ Tribal that I was searching. The first thing anybody on this paper chase would come up with is Echo, Greek Mountain Nymph, and I quote: 'Vainly loved by Pan who in his wrath had her torn to pieces by a mad shepherd, only her voice remaining.' There was something else about this Echo falling in love with Narcissus but that sounded like bollocks to me. Didn't correspond with the illustration that Balfe had done.

The next thing I came across was a mythical hero of the Algonquin tribe of Red Indians of Northern Canada. His name was Kluskave. Kluskave is born of a virgin, fights his evil brother and after the great flood creates a new earth out of a piece of mud. He can take the form of a hare or rabbit to travel the world. His home is in the northlands where he remains to this day, struggling for the welfare of the world. This was more like it. Kluskave sounded like he'd got all his archetypes in order, and he'd got two Ks in his name. My search continued. There was a nomadic Siberian tribe with a rabbit spirit who, in some way, was involved with regeneration. There was more stuff from Viking culture and from a northern island of ancient Japan. Then I found this:

> The concept of the Trickster is related to that of the
> twin heroes, either or both of whom embody some of

his aspects. A protean figure, Trickster is a creator, but also cunningly devious and sometimes spiteful, sometimes 'too clever by half'. He appears in both myth and folk tale, forming the first world, recreating the earth after the flood, obtaining fire, creating man, causing his death and loss of immortality, defeating monsters. Where the creative role is assigned to some other figure, Trickster's role as an adventurer is predominant, but even where he is the creative demi-urge he is also a joker. He is usually conceived of in theriomorphic terms, on the North West Coast as Raven; on the Great Plains and in the South West as Coyote; in the Woodlands as the Great White Hare or Rabbit.

It was over a period of time that these various strands of myth and folklore started to merge and grow in my imagination to form one, still vague, entity that I knew to be Echo. I remember one Bunnymen interview in which Les Pattinson explained the name of the band. He imagined Bunnymen as in Bunny girls, as in *Playboy*, as in Hugh Hefner's idea of fantasy women. Up until then I had never made that obvious connection. I had to stop myself from butting in and saying, 'No, no Les, you've got it wrong, it's nothing to do with Bunny girls. Bunnymen are the scattered tribes that populate the northern rim of the world and are followers of a mythical being, divine spirit, prime mover who takes the earthly form of a rabbit.' But I didn't, and if I had, fuck knows what they'd have thought. It's strange and probably for our own good that we can all walk about with these weird interpretations of what is going on around us. If we were to share them openly with one another, we would right-fully be seen as nutters.

Echo and the Bunnymen and The Teardrop Explodes started to do one-off gigs around the country. Joint headline. Taking it in turns to go on last. The music papers began writing about a

Liverpool Scene, which we all denied existed. Pete Frame did one of his family trees, which we were all very proud of and which confirmed for all time that there was a well-post-Mersey Beat Liverpool Scene. But most importantly, the big record companies from London, New York and beyond started to sniff about. Ask questions. The Teardrops, The Bunnymen, Dave Balfe and I were all on the dole. Balfe was keen we should become the managers of The Teardrops and The Bunnymen, and if possible sign the two bands to big record companies down in London for loads of money. I reluctantly agreed. A dodgy management contract was drawn up by a Liverpool solicitor and all the relevant parties signed it.

Seymour Stein, who owned the New York-based Sire Records, contacted me. He was interested in The Bunnymen. He thought 'Pictures On My Wall' sounded like Del Shannon and Ian McCulloch looked like a star. At that point in time Sire Records was about as hip as you could get. A Liverpool band signing to Sire was unimaginable. Stein sent an offer, a five-album deal. I didn't show it to the band; instead I wrote Stein a long and detailed letter, explaining how the album was bringing about the destruction of great pop music. That the rot had started with *Sergeant Pepper* and snowballed with the progressive rock scene. When Punk arrived to save the day it was seen (by me) to be a false dawn as soon as the Pistols released an album. I quote from my memory of that letter: 'The Pistols were supposed only to release singles that blistered the charts and split the nation in two, not albums that students could sit down and listen to and contemplate.'

The letter was pages long, in my almost illegible scrawl. I launched into a personal attack on Seymour Stein himself, telling him he had released two of the greatest white pop records of the decade, 'Shake Some Action' by The Flaming Groovies and 'Love Goes To Building On Fire' by Talking Heads, and that creators of such pop perfection should have never been allowed into a studio again, leaving their respective

singles to resonate their wondrous glories for pop eternity, untarnished by the album-making tossers that created them. Both bands should have been forced to disband instantly. I told Seymour Stein that as far as I was concerned he could forget any idea of five-album deals, or any albums at all. That I would be more than willing to talk to him about The Bunnymen sign-ing to Sire to record a single although, I told him, I personally felt that they didn't have it in them to record a truly great single. As for Del Shannon, the creator of 'Runaway', one of pop music's finest two minutes thirty-seven seconds, how could Stein compare that to the dirge-like 'Pictures On My Wall'?

Seymour Stein wrote back, and I paraphrase his letter from a somewhat corroded memory of it: 'Although I like to think of myself as a rather important man within the international music business, I am not powerful enough to change the whole basis on which the industry functions, i.e. singles are there to promote album sales. Album sales generate the cash that is the justification for the whole industry.' He was also flattered that I thought 'Shake Some Action' and 'Love Goes To Building On Fire' were great records. He still wanted to sign Echo and the Bunnymen, and what did I think to the possibility of Del Shannon producing them?

Tony Wilson phoned me from Factory Records. They had started at about the same time as The Zoo. There was some sort of friendly rivalry between the two labels, which mirrored the less friendly rivalry that existed between the two cities of Liverpool and Manchester. There had even been a rather sad and pathetic attempt at a festival in the summer of '79 – 'Factory Meets Zoo Halfway' – on some derelict ground outside Warrington. The bands featured were A Certain Ratio, The Teardrop Explodes, Orchestral Manoeuvres in the Dark, Echo and the Bunnymen and Joy Division. Tony Wilson tried to dis-suade me from signing The Bunnymen to a major label. He told me that it didn't have to be this way, that Joy Division, as we spoke, were recording an album to be released on Factory.

We should do the same with The Bunnymen. Up until then none of the rash of indie record labels that had sprung up around the UK in the wake of the Punk DIY ethic had produced anything but seven-inch singles. As far as I was concerned, this was part and parcel of some vague ideology. I assumed that most other people out there running small independent labels must think the same way. That they too were going for the eternal glory of pop and the seven-inch single. The Alan Hornes, the Bob Lasts. So when Tony Wilson implied I was selling out and buckling in to the money and power of London, I didn't get what he meant. As far as I was concerned he was the one compromising, by giving in to the indulgent muso tendencies of Joy Division and letting them record an album for Factory. (There is another side to this. We were skint. Tony Wilson was on telly every night earning loads of money. We needed the cash the southern bastards could tempt us with.)

In November 1979, I made my compromise; deals were struck and the band was signed to a new label called Korova, initially financed by Warner Brothers Music Publishing and Sire. The records were to be released by Korova in the UK and by Sire for the rest of the world. We dealt exclusively with Rob Dickins, the boss of Warner Brothers Music and Korova front man. He was both inspiring and infuriating. For us Korova was him, a one-man show. We had no contact with WEA, the company that actually pressed, promoted and marketed the records. We didn't even know where the building was for the first couple of years, let alone get to shag the secretaries and nick records. As far as I was concerned all a big record company did was press records, print sleeves, put the records in shops. If people liked the records they would buy them. If people bought them they would be hits. Simple. The idea of going there, talking to the people who worked there, getting tough with them, vibing them up, didn't enter my head.

As far as being a manager of Echo and the Bunnymen was

concerned, my vision was almost as naïvely simple. My job was to trick Echo and the Bunnymen into being the greatest band in the world. I knew there was no chance that they could ever make the greatest single or even one great single (they later proved me wrong on that point), but they could be a band that people would die for. A band to follow to the ends of the earth. The trouble was, they still just had a drum box with four settings, a guitarist who thought changing chords was selling out, a bass player whose riffs were metronomically monotonous and a singer whose idea of melody was to jump the octave. Still, what they also had was self-belief, tons of it, far exceeding any objective judgment of their talent. What The Bunnymen didn't have was a drummer. All the great bands were four piece and they all had drummers. The Beatles, Doors, Monkees, Velvets (forget Nico), Zeppelin, Creedence, Sabbath, Television, Residents, Ramones. The Stones, as a five piece, were the exception that proved the rule. I knew only two drummers: Gary was already drumming with The Teardrops and Budgie was off down London joining The Banshees. However, Dave Balfe's brother Kieran had a mate who had a drum kit. Me and Balfe went to see him, didn't hear him play but saw his drum kit, and asked him to join The Bunnymen. He did. His name was Pete. Taffy to us.

We didn't know any proper producers, so we asked Ian Broudie to produce The Bunnymen. Broudie had been in a band called Big in Japan with me. He was a brilliant guitarist and arranger. He did two tracks with the band. Balfe and I did the rest of the first album. I don't know why we didn't get Broudie to do the lot, he might have done a half-decent job. As it was, the album was shit. It was tinny, reedy, thin; not an album by the future greatest band in the world. I had failed.

A bloke phoned me up. He mumbled into the phone. His name was Mick Houghton. I didn't know what he was on about. It turned out he had been working for WEA but had now set up by himself, and Rob Dickins was paying him to be the publicist

for The Bunnymen. Publicist? Was that something to do with
adverts? He tried to explain about journalists, lead reviews and
front covers. The album came out summer 1980. *Crocodiles*. It
got five-star lead reviews. The Bunnymen were on the front
cover of music papers. The album still sounded shit. And the
band knew it.

But a couple of months later, I was sitting on the battered
sofa in The Zoo office in Button Street, a copy of the *Crocodiles*
sleeve on the floor, front side up. The photograph, taken by
Brian Griffin, was of the band in a wood at night, the trees lit
up. From where I was sitting, the photograph was foreshort-
ened. I imagined I could see something in the picture that I
hadn't noticed before. The four members of the band were all
looking aimlessly in different directions. Les, the most central
figure, was leaning against the trunk of an ash tree. The tree
must have been coppiced at some time, because it had two
primary trunks that had grown to twist gently around each
other. I went out into the street with the sleeve of the record
and asked a passer-by, a middle-aged woman, if she would
look at this album sleeve from a certain angle. What did the
ash tree in the middle look like? 'The head of a spooky rabbit.
Why, what am I supposed to see?' She confirmed my suspi-
cions.

Alone in the office, ignoring the phone, I spent most of the
day looking at this weird apparition, kinda hoping it was a mis-
take but knowing this was the real Echo making his presence
known on the sleeve. Later I phoned Brian Griffin, the photog-
rapher. Without letting on about my secret world of Echo, the
trickster, the creator, the watcher, I was able to ascertain from
him that he had no notion of there being a tree on the cover
with any visually symbolic meaning. Anyway, he reminded me,
it was not the shot that he wanted used for the cover. None of us
wanted that shot. It had been a compromise.

Without anyone asking their permission, Echo and the
Bunnymen were shoved reluctantly on to the rock treadmill.

Club tours became college tours, college tours became concert hall tours. Trudging around Europe, breaking down in the States. I blundered on. MTV launched, so we needed videos. I asked a mate from art school days, Bill Butt, if he was into making films. He was. He made a short film with The Bunnymen, *Shine So Hard*. A Bunny army of followers grew. Gigs in strange places. The coolest band around. A look that defined early '80s hip. Sullen, detached, arrogant, raincoats.

Spring 1981. The second album, *Heaven Up Here*, is recorded. At the last minute I bottle out of co-producing it with the band and leave it to the engineer, Hugh Jones. The album is as dull as ditchwater. The songs are unformed, the sound uniformly grey. It gets rave reviews and enters the UK album charts at Number Two. Goes gold. Internal band factions threaten implosion. Brian Griffin had taken the cover shot again. He'd driven the band up to some mud flats on the Severn Estuary. It was a classic photo. Even I could see how it romanticised the essence of the band to great effect. The four of them, backs to the camera, standing in a line in the middle distance, raincoats on, staring into a bleak milky sky.

From nowhere, this loud-mouthed American punkette with bleached hair turned up in Liverpool. She seemed to love everybody, and she'd got LSD. Loads of it. I didn't know that LSD still existed – as far as I was concerned it was just something in the history books. 1967 and all that. Even heroin hadn't hit the council estates of Liverpool then. She turned a Liverpool generation on. Our generation. A generation that had never been into drugs; we were quite happy with our pints of mild and our rum and blacks. Never even smoked dope or took speed. All that stuff had been considered totally unhip. That was for smelly hippies. But acid turned a northern grey day into a northern grey day with paisley-patterned trimmings. I refused to take any. I hate all drugs. Courtney disappeared back to the States and her awaiting infamy. As for The Teardrop Explodes, Julian Cope had discovered drugs. His ego

was going nova. I should have shot him. Instead I was pretending to manage his band. They were having hit singles, one of which, 'Reward', was almost a truly great record; but it was all falling to bits. Julian was wanting me to sack band members every second week. He did a runner from his missus and took loads of acid and I had neither the strength of character nor the know-how to deal with any of it, let alone kill him. I didn't have a gun.

Factory Records released the album by Joy Division. It defined romance and misery for the young men of the age. Then Ian Curtis, the singer, topped himself just before their second album was released. The music press deified him. He was an instant rock legend. Their album *Closer* was a milestone in Rock's Rich Tapestry. And I thought, wow, if that's all it takes, let's kill Mac. Well, not actually kill him, just get him to stay at his gran's for a couple of months, with the curtains closed. See how the rock media deal with it. See what the obituaries have to say. See how soon the sainthood is given. See where the record sales go. Nothing as sexy as the death of a young man. Nothing proves he meant it as much as having to take his own life. Ask Vincent. And then go, 'Ha, tricked you.' (I'm still hoping that The Manic Street Preachers are going to pull that one.) I talked to Mick Houghton about it; he didn't think it was a good idea.

It was a while after *Heaven Up Here* had been out that the weird shit began to leak from the cover shot. On the cover of *Crocodiles*, Echo looked benignly on while Will, Mac, Les and Pete gazed aimlessly about themselves like innocent children, unaware of the Trickster's presence. On the sleeve of *Heaven Up Here*, Echo had taken to the skies. Off. Gone. In this photograph (remember – Severn Estuary, bleak sky, raincoats) Will, Mac, Les and Pete were seemingly still unaware of Echo, but were aware that something had departed, like when a shadow moves across your face and you look around to see what's there. It was as if they'd become aware of a presence only through its departure. They stared up into the skies,

wondering what it was. It was a big something. Not just a little bunny hopping down a hole. This departing presence filled a whole sky.

The tours get bigger. Singles are released. The fan base can shove them in the charts the week of release. Radio One are forced to play these unfriendly records – remember this is in the days when Dave Lee Travis was the Hairy Cornflake doing the *Breakfast Show*.

I'm on the train down to London from Liverpool with a journalist who's been doing an interview with the band. Chit chat chit chat. He asks me why I think so much talent has come out of Liverpool. Blah blah blah. Instead of giving him the usual social commentary about dole queues, seaport to the world and the Celtic soul of the city, I go straight into hyperdrive, letting whatever rubbish that wants to rush out of my mouth:

'It's the interstellar ley line. It comes careering in from outer space, hits the world in Iceland, bounces back up, writhing about like a conger eel, then down Mathew Street in Liverpool where the Cavern Club – and latterly Eric's – is. Back up, twisting, turning, wriggling across the face of the earth until it reaches the uncharted mountains of New Guinea, where it shoots back into space. Deep space. You know what ley lines are? Those things that hippies are into, imaginary power lines across ancient Britain, lines that can be traced by Saxon churches, stone circles, burial mounds, that sort of stuff. But just boringly straight and static. Well, this interstellar ley line is a mega-power one. Too much power coming down it for it not to writhe about. The only three fixed points on earth it travels through are Iceland, Mathew Street in Liverpool, and New Guinea. Whenever something creatively or spiritually mega happens anywhere else on earth, it is because this interstellar ley line is momentarily powering through the territory.

'Whenever The Bunnymen do a brilliant gig, we know it's because they were on the line. Sometimes it's only there for a

couple of songs. Sometimes it pumps down through one bit of the world for a few days, even a couple of years.'

I decide to shut up before I get too carried away, and get a couple of teas from the buffet. When I return, the journalist is making notes. He tries to draw me out on this interstellar ley line stuff. I'm thinking that he is thinking, 'I got a nutter here – I wonder what other crank theories I can get out of him?' I make light of what I have already said. But inside my head I'm going, 'Of course, it all makes sense: interstellar ley lines, why had I not realised before?' Another part of my brain is going, 'You fuckin' eejit Drummond, get a grip.' And yet another is going, 'Why did I pick Iceland, Mathew Street and New Guinea?'

These are the reasons why. When I was 17, my sister and I hitched a ride on an Icelandic trawler in Grimsby. The crew had sold their catch there and were heading back home. It took us five days. Jane and I spent the summer there, exploring the island. It blew my mind. The lunar landscape like Arctic deserts, the geysers, the bubbling sulphur pools, the rocks that could float in water, the whale fisheries, the volcano where Jules Verne started his *Journey to the Centre of the Earth*, the Icelandic sagas (I was reading the Penguin edition as we hitched our way around). But the place that affected me the most was this bit only sixty miles north-east of Reykjavik. I can't remember its name, it's a wide valley, an uninhabited wilderness with parallel cracks in the ground. Big cracks, giant cracks, some hundreds of feet deep, some filled with crystal-clear water. At certain points you could leap across a crack, at other points they might be twenty feet wide. But these cracks, and there were a lot of them, went on mile after mile, following the flow of the valley. As I said, it blew my mind. My sister told me that it was the beginning of the Atlantic rift, where the new world of the Americas and the old world of Europe and Africa had been ripped apart. Geographically speaking, Iceland is neither the Old World nor the New.

45

It was as if we were in a land that was still in the initial throes of creation, where molten rock flowed and the rocks moved and life just about clung to its edges. The landscape was unsoftened by time, vegetation or man's master plans. Hard, harsh, cold, violent and threatening. My kinda landscape. A landscape for Odin and Thor, a landscape for the Old Testament God without olives, sunshine and the tender thighs of Hagar. So. If an interstellar ley line is going to hit the world anywhere it is right there, splitting the New World from the Old World.

Next. Mathew Street, Liverpool. As I said, both the Cavern Club and Eric's Club were in Mathew Street. One of the things I liked about Liverpool at the time was that it had neither respect for its heritage nor any realisation that this heritage could be exploited. At some point in the mid '70s they flattened all the Victorian warehouses down one side of Mathew Street and filled in all the cellars to make a car park. That was the end of what had been the Cavern Club. Nobody cried. No petitions were signed. It wasn't until the mid to late '80s that a heritage trail of Japanese and Americans bursting with cash started turning up, demanding to see where those four lads that shook the world had started.

Throughout the '70s the creative youth of Liverpool hated The Beatles and all they represented. The shadow the Fab Ones cast over popular culture was too dark and big for any bunch of likely lads in Liverpool to find a patch of sunshine and set up their stall. The weird thing is, it was almost at the same time as the old Cavern Club was filled in that a local promoter called Roger Eagle got Eric's going in a cellar directly across the street. And it was from us lot who cadged our way into Eric's that the music press perceived a whole new Liverpool scene blossoming forth. Not that it ever came to that much. Frankie Goes To Hollywood were never going to revolutionise the minds of a generation, define an age and find a cure for boredom. But they were fab. Anyway. As I said, they flattened all the

[42]

warehouses down one side of Mathew Street. But there was one at the bottom they didn't. Back further in time, maybe late '75 or early '76, I wandered into this last standing warehouse. There was a bloke in it trying to hammer a nail into a piece of wood. He told me he was a poet. His name was Peter O'Hallaghan. He had short grey hair and a moustache and talked like a man who Knew.

'Karl Gustav Jung had a dream and the dream went like this: he found himself in a dirty, sooty city. It was night and winter and dark and raining. He was in Liverpool. He was with a bunch of mates, walking up through these dark streets. Up from the docks, heading for the town, the bars, the bright lights, Lime Street. Jung and his mates found themselves in this small, cobbled square. A number of dimly lit streets converged on this square, and in the centre of the square was a small pool, and at the centre of the pool an island. Like I said, it was a shit night, rain, fog, smoke and just the odd gas lamp. But that small island was bathed in pure sunlight. On the island, a lone tree was growing, one of those sort people have in their gardens with tulip-like flowers, but he knew his mates couldn't see the tree or even the pool. One of them remembered somebody who had moved to Liverpool from Switzerland, and now they'd seen the place he couldn't work out why anybody would want to move here. But Jung, in his dream, thought, "I know why", and then he woke.

'And Jung interpreted the dream, just like Joseph did for Pharaoh, 'cause that's what he did for a living. Jung reckoned the dream represented his life at the time. Drab and dreary, unclear, unpleasant. Everything in it was shit, going nowhere. But that tree in the sunlight was like a vision of almost unearthly beauty. It was that vision that kept him alive, well not literally, but you know what I mean. From that he reckoned Liverpool to be the Pool of Life. According to legend the "Liver" is the "Seat of Life". If he had ever visited Liverpool in reality he might have thought differently. The dream was a turning point

in Jung's life. A watershed. The goal had been revealed. Through this dream he understood that within yourself is all meaning – and something about an archetype being found there. That the journey was to the centre of your own whatever-it-is. The sunlit tree was his true centre, its roots drinking from the Pool of Life, the fountainhead. Whatever shit is going on, you can find your way there.'

Peter O'Hallaghan didn't look like a hippie, more a Scouse Beat. So he was OK with my prejudices of the time. I didn't really understand what he was on about but it resonated and I remembered it almost word for word, which is unusual for me. O'Hallaghan then told me he too had had a dream and in this dream he could see the spring bubbling forth from the cast-iron drain cover in the middle of the road where Button Street, Mathew Street and a couple of other roads met. The morning after his dream he came down to Mathew Street, and sure enough there was a manhole cover. He did some research at the library and discovered there was a spring there that had been covered in Victorian times and channelled into the city's sewerage system. On the corner of Mathew Street and Rainford Gardens was a warehouse with a 'To Let' sign. He went to the bank, got a loan, got the lease and was now setting up the Liverpool School of Language, Music, Dream and Pun. He had commissioned a bust of Jung which would be set in the outside wall of the building.

I jacked in my job building and painting stage sets at the Everyman Theatre and became a pupil of the school. Moved all my tools and my workbench into the basement of the warehouse. The ground floor was divided into market stalls under the name 'Aunt Twacky's', selling groovy tat, second-hand records and brown rice. On the first floor O'Hallaghan, his cousin Sean and a sculptor called Charles Alexander opened O'Hallaghan's Tea Room. It soon became the creative hub of the city. For the price of a mug of tea a generation of dole-queue dreamers spent their days discussing the poems they

had written, the books they were writing, the happenings they were staging, the bands they were forming.

The people of Liverpool were proudly insular; none of my fellow pupils at the school sipping their mugs of tea gave a shit whether anybody in London ever heard of their existence or if any quarter of the media ever documented their creativity. All that mattered was what other people thought within the city state of Liverpool. Every day people staged impromptu performances, happenings, readings, installations, exhibitions, while Peter O'Hallaghan communicated his wisdom from behind the tea bar. Ken Campbell, the iconoclast of British theatre, arrived and decided it was the place to set up his Science Fiction Theatre of Liverpool. I was enlisted to design and build the sets for the company's premier production, a twelve-hour adaptation of the *Illuminatus* trilogy of books.

The rains were heavy. Late one night while I was hard at work building sets in the cellar, water began to seep through the walls. The seep grew to a gurgle. The gurgle to a flow. I was ankle deep and my bench began to float. The spring under the manhole cover must have been flooding. 'The sewers can't take it, captain.' The Pool of Life was coming to get me.

Ken Campbell taught me to entertain the possibility of everything. I was 23 years old – a very good age for entertaining possibilities. O'Hallaghan dreamed new dreams and moved on. Aunt Twacky's closed down. The tea room moved downstairs and changed its name to The Armadillo. In the year of '78 it seemed like a million bands formed in Liverpool. Most of them never left the imaginations of their members. If they had nowhere to rehearse or even no instruments to play, they all could sip mugs of tea in The Armadillo. The movers and shakers of this scene were all to be found holding court at their separate tables. The idea of this being the Pool of Life was a very entertaining possibility.

So that's why Mathew Street, Liverpool.

New Guinea? I've never been there. But my great-great-uncle

on my mother's side, a certain Oliver Tomkins, was a missionary. He went out to New Guinea to spread the Word but got put in a pot and eaten by savages with bones through their noses. Then when I was a boy there were the pages of the *National Geographic*, with their colour photos of New Guinea tribesmen; the phantasmagorical figures with nightmare masks, dancing with demons and up to all sorts of pagan witchcraft. Bodies painted, skin pierced – and all this was real, not some Hollywood film. It was all going on now. It was there in the pages of the *National Geographic*. My grandad had given me a stack of back issues. I kept them under my bed. Who needs the *Dandy*, the *Beano*, *Hotspur* and *Victor* when you've got the *National Geographic*?

At 17 I saw a French film, *Obscured by Clouds*. Pink Floyd had done the music. It was about a bunch of French hippies who had got this map of New Guinea. In one bit of the map, the central highlands of the island, there was a white patch with no cartographic information, just the words 'obscured by clouds' (but in French). This was, I learned from the subtitles, the only bit of the world left unmapped. These hippies set off to get there. They climbed up through seething, writhing jungles, met up with the savages that I had met on the pages of the *National Geographic*, climbed further up into the mountains accompanied by Pink Floyd music. And, just like my missionary forefather, were never seen again. It was a shit film, but it left its mark. Seventeen's a great year for having marks left.

So in my subconscious, New Guinea must be the place where all taboos are broken, where all the demons run round free. Where the unknowable areas of the soul will forever be left unexplored, dark and dangerous, and if you attempt to get to know or tame them, you pay for it big time. So if that interstellar ley line was going to leave this earth somewhere it had to be from those unchartable jungle-covered highlands in New Guinea. Makes sense.

Iceland and New Guinea are both islands, mystical things in

themselves. On opposite sides of the world, the antithesis of each other in every possible sense: geographically, historically, mythically. All of this adds to the fact that these two islands have ended up symbolising to me the very yin and yang of the human soul. So far apart that, in some strange way, they almost meet.

So, back to Echo and the Bunnymen and The Teardrop Explodes. In my secret world I began to identify the souls of the two bands with the two islands: The Bunnymen, Iceland; The Teardrops, New Guinea. The Bunnymen: cold, grey, honest, northern, dour, unformed, harsh, hard-working, cloaked in a glacial splendour with a halo of northern lights, and with roots deep and mythical. The Teardrops' soul was less the band's than Julian Cope's alone, a soul with the uncontrollable creative energy of the jungle. A soul with a thousand masks, dark and devious, light and seductive. A soul charmed by birds of paradise and poisoned by belly-going serpents. A soul being born, fornicating, dying, all at the same time.

Even if I had the wherewithal, the idea that I was supposed to be trying to make chart-topping, stadium-filling, money-spinning careers out of these two bands was fast slipping. I could keep up the charade while I had meetings with the record companies or promoters. I didn't have the strength of character to confront the members of either of the two bands with any of this, or any of the other stuff managers should be confronting their clients with.

A secret plan started to evolve. I wanted to get The Teardrop Explodes to do some sort of performance in New Guinea, while simultaneously having Echo and The Bunnymen perform in Iceland. I would be at neither place; I would be standing on the manhole cover at the bottom of Mathew Street, the one that covered the Pool of Life. The reason? This was pretty unfocused, but had something to do with harnessing the powers of the interstellar ley line for my personal gratification.

But I had a major problem. My relationship with The

Teardrop Explodes was deteriorating so fast as to have become almost non-existent. Their second album was a commercial failure. Band members were being sacked as fast as new ones could be auditioned. Julian Cope was careering from being pop pin-up to great acid-casualty pop eccentric, somewhere between Sky Saxon and Syd Barrett but with an ego telling him he was Lord Byron, Jim Morrison and the son of a very unchristian god all at once. Great stuff and I loved it all, but how was I to persuade him he should do a concert in the highland jungles of New Guinea when I couldn't even tell him to take a bath?

Julian Cope had a parallel universe, in which he was called Kevin Stapleton. Dave Balfe was named Milk, and the band was called Whopper. Cope, Balfe and I went down to Rockfield Studios to try to capture an album by this parallel-universe version of The Teardrops. It was more unlistenable than The Residents and I think we only finished one track, a version of 'Sleeping Gas' called 'Kwalo Klobinsky's Lullaby'. This whole parallel-universe thing started getting out of control. It was expanding all the time. My recollections of its landscape are vague. It was peopled with characters who were strangely like those we already knew in the regular world, but different, sometimes more beautiful, sometimes more dangerous and sometimes their thumbs were missing. My idea was that this parallel-universe album should be completed and released as a limited edition, mail order only. I contacted the Head Post Office in Port Moresby, the capital of Papua New Guinea. A PO Box was set up there in the name of Whopper. I was then going to take a box ad in the *NME* giving details: cheques to be sent to PO Box . . ., made payable to . . ., in exchange for one copy . . . If this was done, I was sure that Julian Cope would be up for doing some sort of weird concert in New Guinea, and I hoped this could be achieved despite the fact that The Teardrop Explodes' career was spiralling out of control and Julian and I were unable to communicate. It didn't happen. I got the PO Box in Port Moresby and that was it.

A short while later I read a story in the *NME*. Jaz Coleman, the singer with Killing Joke, had left the band and done a runner, ending up in Iceland. The *NME* had tracked him down and he was quoted as saying he needed to be in Iceland so that he could re-energise himself from the interstellar ley line. This seriously frightened me. I knew I had just made all this shit up. It didn't exist in the out there, real world. However real it was in my head, I knew it wasn't supposed to be something other people shared in and tapped into. How could they? I had made it up. I tried to get rational. Maybe the journalist I was speaking to on the train that time had been talking to Jaz Coleman and Coleman had taken the whole thing on board. Got serious about it. It just seemed so completely unlikely that two people who did not know each other, had never met, could come up with the same ludicrous concept. Unless. Unless there was more to it than my own ego-driven myth-making? You can read stuff about the oceanic feeling, global unconsciousness, nod your head in vague agreement, but you don't expect to be confronted with it in reality.

The remaining members of Killing Joke were going to audition for a new singer and carry on. In the back of the following week's edition of the *NME* was a strange and cryptic classified ad. It was obviously theirs. Drastic action. I phoned the number. It rang and rang. It was finally answered by a very stoned-sounding Ladbroke Grove type.

'Yeh.'

'I'm phoning up about the job as singer with Killing Joke.'

'Yeh.'

'Can I have an audition?'

'Well, you in a band now?'

'No, but I used to be.'

'So what do you do now?'

'I manage a couple of bands.'

'What bands?'

'Echo and The Bunnymen and The Teardrop Explodes.'

'What? You manage Echo and The Bunnymen and Teardrop Explodes and you want to sing with Killing Joke? You must be mad. What do you want to sing with us for?'

'I can't really explain that, but obviously I'd stop doing the management and stuff.'

'Look, give us your number and we'll get back to you. We're doing auditions on Saturday.'

Now the thing is, I wasn't really bothered about being the singer with this band or any band – my ego is not made that way – but I was interpreting this Killing Joke thing as a message. Whether I wanted to or not, I had to become the singer in this band. There were no Killing Joke records in my collection. I'd never seen the band live. Up until then I had not been interested in them in the slightest. I spoke to Will and Les about the possibility of me becoming Killing Joke's singer, or at least I think I did. Told them I would have to take time out from the management, or even pack it in altogether. Saturday came and Saturday went. The audition never happened. I never got the phone call. And the next we knew, Jaz Coleman was back from Iceland, singing with the band, and no more was said by him about the interstellar ley line. I shoved the whole thing into the shit-locker at the back of the mind where we dump all that stuff we don't want to remember. Maybe I should go and track down back issues of the *NME* to make sure this is all true. But I can't be arsed.

My pop ideals were shifting. The long-playing record was no longer anathema. This internal world of mine, I decided, was an unfolding private drama, a trilogy of plays. We had reached the end of the first of these plays. With Mick Houghton I put together an album by the original cast to mark the event. It included early and unrelated recordings by both Echo and The Bunnymen and The Teardrops and all sorts of other weird stuff that had been infecting our lives. The album and play were called *To The Shores of Lake Placid*. It was ridiculously lavish in its packaging. So much so that for every

copy sold we lost more money. It was worth it. These were the liner notes:

> The Music On This Record Has Been Taken From
> The Play *To The Shores Of Lake Placid*, Which Ran
> From August 24, 1978 To February 21, 1981. The Play
> Is The First In A Trilogy, The Second Of Which, As
> Yet Untitled, Began On November 10, 1981 At 'Club
> Zoo', 'The Pyramid', Liverpool, And Will Close At
> 'Eric's', Liverpool, On November 15, 1983.

Reading them back fifteen years later, I realise I'm still not cured of wanting to make the grand – but at the same time private – gesture. All the dates were significant. First, 24 August 1978 was the last performance of Big in Japan, the band I had been in before Zoo started happening. The closing date, 15 November 1983, was the fifth anniversary of The Bunnymen's first performance. Both gigs had been at Eric's. At the time I wanted The Bunnymen to end on that date. It didn't happen like that.

For some time I had thought The Bunnymen should knock it on the head after five years. In my head, no band worth any sort of respect hung around for longer than that. Everybody knows bands do the only vital stuff they are going to do in their first flush; after that it's just careerism with bouts of trying either to get back to their roots or get hip to whatever the kids are into next. Or, even worse, they discover irony. As for this Club Zoo – an explanation. The Teardrop Explodes were a shit band. Julian Cope was a genius. The reason why they were shit was my fault. I had gone along with Mick Finkler, the original guitarist, being kicked out. Once he was gone they were never a band again, just an ever-shifting bunch of more than adequate musicians backing up Cope's majestic vision, with Dave Balfe as the occasional thorn in his side. The Bunnymen's records may have sounded crap, their songs unformed, but at least they

were the classic four lads out against the world. People were drawn to The Bunnymen; they recognised honesty, a consistency. They liked the noise, they dug the arrogance, the angst, they identified with the unspecified mission. The package was complete. The Teardrops were just an ego, fed on too much mother love, feeling sorry for itself.

'I thought you said Julian Cope was a genius.' You.

'Yes, but that's no excuse.' Me.

1981. The Teardrop Explodes had their one big crossover hit, 'Reward'. I knew if The Teardrops were to be able to capitalise on this one hit and grow from it, they needed to be forced into becoming a proper band, not just a bunch of tossers waiting for pay day. Rock 'n' roll myth number two goes, 'Great bands are melded by having to spend their early years playing a shit-load of gigs in the worst possible circumstances.' The Teardrops had a keyboard player, bass player, guitarist and two trumpeters, all brought in after the band were having both critical and commercial success. There was no shared history of struggles bonding them together, just shagging girls, taking drugs and complaining. Something had to be done. This is what I did.

The Teardrops had just finished a national tour, playing sell-out shows in all the big venues across the country. Screaming girls. The whole shit. The Pyramid Club was a crap dive just round the corner from Mathew Street in Liverpool. I did a deal with the owners of the club, paid off the protection. We had the place for three months and called it Club Zoo. The Teardrops were to play six nights a week, two shows a night, plus a matinee on Saturdays. I wanted the band to push themselves to the limit, take risks. No lights, no mega sound system, no promoter's hype to sell tickets, no safety nets for falling egos. Just grind. I wanted people to turn up and get bored and not turn up again, or think it was the best thing they'd ever heard and sign up for every show. I wanted the band to prove something, find something, grasp something. Explore.

From The Shores Of Lake Placid

Of course it didn't fucking work. Yes, people got bored, the novelty of seeing a chart band in a small club wore off, they didn't turn up again. But Julian was able to refine his acid-casualty cabaret artist act. As for the boys in the band, why should they give a shit? They were on full wages without any of the tour bus hassle of a proper tour. They spent their days hanging out in the hotel smoking dope and moaning.

I had a misguided theory at the time: while The Bunnymen were to split on 15 November 1983, their fifth anniversary, The Teardrop Explodes were to last forever. It was to be a life sentence for Julian Cope. No way out, just carry on making mistakes until – well, I can't remember what I thought the point or even the reward of this would have been. Maybe he had to continue until he did something that justified the talent he was born with. Hindsight has given me no easy perspective on this theory. The whole thing was fucked. My relationship with Julian Cope was now non-existent. I did a deal with the band's UK tour promoter, who gave me a sum of money for the tattered remnants of the band's management contract. Then, after one disastrous world tour and a pathetic jaunt of British universities, the band collapsed. A half-done third album was scrapped and, as far as I'm concerned, Julian Cope's vast talent has never been stretched before or since. Nobody who has worked with him has had the bollocks to tell him, 'Julian, it's a load of shite, go back and do it properly.' Not that I could tell him, but somebody should. To have that sort of talent and waste it is a crime against Creation.

Some years later, in 1986 when I tried to stop doing music, I sat down to write the book *To The Shores of Lake Placid*. I wrote and wrote. It was rubbish. What I'm writing here is a brief outline of the second half of the book, the salient points.

But this story is not about The Teardrops, their part in it is almost incidental. Back to Echo and the Bunnymen. In 1982 into '83 things were moving ahead. As a cult band they were reaching superstar status. I stood on the balcony at the Ritz

Ballroom in New York, watching the band perform. The place was packed. And, for the first time in about four years of the band's existence, I felt confident that the audience weren't going to demand their money back. The Bunnymen were recording their third album with Ian Broudie producing. It was time to think about the sleeve. In my head it had to be another full bleed shot of the band on location. But this time the four Bunnymen, the four followers of Echo, would be off on the journey to find Echo, to seek his wisdom. Somehow I was able to persuade the record company to come up with an album cover budget to include the cost of the band being flown to Iceland with photographer Brian Griffin and designer Martyn Atkins. I didn't go. But they came back with a shot of The Bunnymen wandering along the edges of a frozen canyon. A perfect cover. The album was shit. Not Ian Broudie's fault. The band just couldn't write what I thought were proper songs with chord changes and melodies. It wasn't their thing. Their thing at the time was chundering dirges with too many overdubs. The album went Gold on week of release.

Summer 1983. A tour was scheduled for The Bunnymen to play a string of dates starting in Reykjavik, capital of Iceland, then a couple of shows in the Western Isles of Scotland and one in Liverpool, finishing with a celebration show at the Albert Hall, London. I knew what I really wanted was to have The Teardrops playing New Guinea then a couple more dates across the globe as they snaked their way back to London, to arrive and play at the same time as The Bunnymen were performing at the Albert Hall. But this was not going to stop my interstellar ley line-harnessing plans. I just had to accept I wasn't going to get the full charge. The Bunnymen did play Reykjavik. I stood on the manhole cover at the bottom of Mathew Street and, of course, nothing happened. I joined the band for their dates in the Western Isles and had a weird night out with Will and Les at the Callanish Standing Stones after which, staying in the hotel in Stornoway, I had a dream.

From The Shores Of Lake Placid

I was walking down the side of a crater of a dead volcano. A mist hung in the air. There was a faint ringing sound. At the bottom of the crater was a lake. I walked on the black, shingle shore of the lake. Small bubbles were rising through the water. This was the source of the ringing sound. As I walked, I spied a small envelope on the black shingle. It had my name on it. I stooped to pick it up but when I straightened myself up again I found I was no longer on the shore of the strange lake at the bottom of a volcanic crater, but on the edge of a reservoir that for some reason I knew to be in Warrington. I still had the envelope. I opened it. There was a plain white card inside on which were written these words – 'You already know.'

Now, I had already half-digested enough Jungian theories under the guidance of Peter O'Hallaghan to know what this meant – 'the answer lies within . . .' and all that stuff – but somehow I needed this dream before I got it on a personal level.

At the Albert Hall shows (there were two on consecutive nights) I had a simple programme printed up. Just one-sided A4, grey (my favourite colour). These were put on each of the seats. As well as the relevant information, across the top was typed 'Lay Down Thy Raincoat and Groove'. The two shows were brilliant. The Bunnymen were now one of the greatest live bands ever. This fact is based totally on my own prejudices. Seeing as I hardly ever saw any other bands play live I had nothing to judge my prejudices by. I just compared them to the memory of the bands I saw as a teenager. Using that marker, The Bunnymen were now better than the Stones, the Doors, the Who, Jimi Hendrix and Led Zeppelin, but not quite as good as the Keef Hartley Band, the first rock band I ever saw.

Officially, this string of dates was to promote the band's 'Never Stop'. The record was rather dull. Bowie had just revitalised his career with a label change and a more upbeat

dancey direction, 'Boys Keep Swinging' nonsense, and Mac, being a Bowie fan, wanted to try out this groove dance stuff. I fucked up by trying to get Steve Lillywhite to produce the record without telling the band. Mac said the record was something to do with the Michael Foot-led Labour Party losing the '83 election so badly to the Falklands-conquering Maggie. But, more important than all this tawdry, dull, single-stiffs-at-No-14 stuff was the next album. Back in my secret world, The Bunnymen's fourth album was to be their last. I'd long given up on the idea of being involved with the creation of great pop, let alone The Bunnymen being able to make a single that could have any relevance outside the narrow demographics of their regular following.

I had a vague idea that evolved. The final record would be greater than any album ever recorded by any band anywhere. It would be perfection. It would contain proper songs with lyrics that weren't shrouded in bogus mystery. The meaning would be direct. The wisdom of Echo would have been received. The Bunnymen would be on the sleeve, head on, holding us firmly in their stare, confident and strong. The Bunnymen would never have to write another song again. Everything that needed to be said would have been said. Then they would start to tour the world, imparting their knowledge via their concerts. They would play everywhere, from lost villages in the upper Himalayas to the sprawling cities of South America. From the scattered Aboriginal places of the Australian outback to the crumbling industrial heartlands of Eastern Europe. They were already the greatest live band in the world. A fact I have proven above. They would become the biggest band in the world and exist completely outside the recognised music industry. Their status would become mythical. Their legend would spread by word of mouth across the continents.

Will Sergeant and I were sharing a couple of pints of mild one evening and, with a touch of Dutch courage, I broached the subject. I can't remember his exact words but it was something

like: 'Don't be daft, Bill; the best thing about being in a band is recording.'

Mac had this idea of recording the fourth album in Paris. Get that romantic vibe. Be as un-American as possible. More Jacques Brel than the Doors. I was up for this; in my head Jacques Brel equates with proper songs, not post-Punk dirge riffs. I also encouraged the band to get a more natural sound: Pete on brush sticks, Les on acoustic bass, Will on his twelve string, Mac on acoustic guitar, not his scratchy pink Telecaster. There was no proper producer. I hung around the studio in Paris trying to give encouragement. Working with middle-aged French engineers helped. I don't think they had ever mic'd up a rock band before. The album was finished in Liverpool with engineer Gil Norton at the controls.

Brian Griffin, the photographer, had a location idea for the sleeve. A huge, flooded cavern in a disused tin mine in Cornwall. Yet again, I didn't want to intervene too directly. I didn't want to force the natural flow of creative events. The first three sleeves had evolved perfectly without me having to impose my dictatorial visions on them. When Brian Griffin developed the shots, the obvious one to use was of the band in a small rowing boat floating aimlessly in the flooded cavern, bathed in a weird blue light. The shot was far from the direct, head-on confrontational image I had previously hoped for. But I knew it was right and whatever my previous notions had been, they were not applicable.

The album was finished, and titled *Ocean Rain*. It too was not the earth-stopping album I had wanted, with songs that said, 'now these ones have been written, there is no point in anybody else ever writing any more songs ever again.' Instead, the band had made a pretty good record, a fact that I made sure was stated on all the adverts and posters for the album. 'The Greatest LP Ever Made' ran the copy. I didn't tell the band. They understandably felt it was an arrogance too far, and one they might be called on to defend. Even though I believed the

45

copyline, I also knew this was not the album I had hoped for to complete the series, the one where Echo was found and his way, wisdom and truth were revealed. Even the interstellar ley line stuff had lost its grip on my imagination. The Bunnymen in Iceland and me on the manhole cover in Mathew Street had put an end to that. Something had been completed within me. A level reached. A cycle turned. The power of Echo lay not in his material revelation but in his eternal mystery. That in itself was a major revelation. That is why for me the *Ocean Rain* album is so perfect. It retained the mystery without relying on adolescent pretensions to wisdom. The sleeve portrayed the band once more adrift. But to be adrift is the only way to travel on the glorious journey. It was as if Echo were turning round and saying 'I'm not so easily nailed down, called to account.'

Simple Minds and U2 were considered by the pundits to be Echo and the Bunnymen's main rivals in whatever that early '80s scene was. As far as I was concerned, Simple Minds might as well have been Genesis and U2, with all their pseudo-spiritual bombast, were just the Billy Grahams of rock. U2 did a deal with *The Tube*, an exceedingly influential music programme. *The Tube* was almost able to break bands in the way that *Top of the Pops* had been able to break singles. *The Tube* filmed an open-air concert by U2 at a place in the vastness of the American West called Red Rocks, the perfect setting for their wide-screen music. This film helped, in a big way, to jettison U2 from being a student band with big guitars to crossover stadium rockers, took them on to the coffee tables of middle England and everywhere else. The first band of the post-Punk era to break out of the ideological constraints of '77 and declare they wanted it all, and get it. I fuckin' hated them. Aided by Bill Fowler, the fiftysomething head of radio and TV promotions at Warners, we convinced Malcolm Gerrie, the producer of *The Tube*, to film a special event staged by The Bunnymen. The programme would be aired to coincide roughly with the release of *Ocean Rain* and then be screened around the globe. *A Crystal Day* was the title.

[58]

From The Shores Of Lake Placid

This is what *The Tube* filmed. It was a day of happenings around Liverpool. It happened on 12 May 1984. A cryptic ad placed in the classified pages at the back of the *NME* alerted the hardcore Bunnymen fans. 1,500 tickets were made available, 1,500 were sold. They came from all over these islands. The day began with all 1,500 fans having to buy breakfast at Brian's Diner, a café we all frequented now that the Armadillo had gone upmarket. On purchasing their breakfast they handed in their ticket and in exchange, and only then, got a pass that was valid for the main concert that evening. The rest of the day, between this breakfast and the concert, was filled with apparently meaningless, if entertaining, events. Of course, to me they weren't meaningless; each event dripped heavily with ritualistic symbolism. With the passing of time I can't remember what these events were. I do recall something going on at the old cathedral and a vast amount of blue and yellow balloons being released, blue and yellow being the colours of the label on The Bunnymen's first single. But for me the pivot of the daytime events was a cycle ride around the city. I don't know how many people actually went on it. I didn't. A couple of blokes called Kevin and Boxhead were the leaders of the ride. I'd drawn an outline of Echo, the rabbit god character – as depicted on the 'Pictures on My Wall' single sleeve – on a map of the City of Liverpool, the manhole cover at the bottom of Mathew Street being Echo's navel. The bike ride followed this outline, including a regular ferry trip across the Mersey, on which thousands of bananas were given away. I had done some deal with Geest in exchange for five full bunches of bananas, each weighing a couple of hundredweight. The bike ride was to be twenty-three miles long. From what I understand, a few short cuts were taken. Tracing out vast images or words on the side of the globe has always been big with me and something to which I keep returning.

The concert that night took place in the King George Hall, a massive mock-Greek acropoliptic building that celebrated the

Victorian vanities of commerce and empire. It's one of the main landmarks in Liverpool, standing opposite Lime Street Station. It was never used as a concert hall in those days, only as a huge waiting room for the law courts, both county and magistrate, that surrounded the area. We had draped the outside of the building with Nuremberg-proportioned yellow and blue banners. The inside of the building was as impressive as the exterior. The main hall was marble floor, columns, lintels, the lot. The Bunnymen were to play on a stage at one end of the hall. At the other end was another stage; on this a troop of Chinese dancers and musicians were to perform an opera. The Bunnymen played three separate sets, each one defined by a mood and style. Between each set the Chinese dancers and musicians performed their opera.

The show was not that great. Many of the Crystal Day events went off half-cocked. *The Tube* special, which went out as part of their midsummer's night show, was pretty flippant. Jools Holland was the presenter, his humorous style totally debunking my desired epicness for the whole day. It wasn't *U2 Live at Red Rocks* and it didn't have the effect on The Bunnymen's career that the Red Rocks film had on U2. But the real reason for this whole Crystal Day thing, or at least my own private reason to get this Crystal Day thing to happen, was nothing to do with trying to break The Bunnymen on some world stage and go triple platinum. It was me trying to say 'thanks' to Echo for the journey and, more importantly maybe, for the revelatory dream.

That night, I was staying in the Adelphi Hotel in the centre of Liverpool. Lying on my bed going over the day's events in my head, I knew it was the end of my relationship with The Bunnymen. They had mortgages to pay, mouths to feed and a chosen career to follow. They didn't need me weighing them down with my hidden agendas based on my own highly personalised vision – a vision flawed by the secrets and lies that riddled my personal life. I left my room, went downstairs. It

must have been about 3 a.m. Some members of the entourage were still up and grooving. I got in the transit van and drove off, heading for Warrington, trying to find the reservoir that I had dreamt about, trying to find out what I already knew. I found neither. I played for time, not having the courage to admit to The Bunnymen that as far as I was concerned it was over, complete, finished, job done. I talked about them taking twelve months out. But in the end our relationship sort of fizzled out. The band staggered on for a couple more years, freed from my disregard for the realities of the music business, my incompetence and my complicated personal life, before crumbling into bitter acrimony and death as bands are wont to do.

May '97. Ironically, I'm back in the Adelphi, writing these notes. I'm up in Liverpool for some strange reason unrelated to all this Echo stuff. I've been for a walk down through the old city, down to where the four streets meet, to the drain lid, up Mathew Street. I'd not been there since that Crystal Day. Not dared go back. I'd heard about all the understandable commercialisation of the area, the Cavern walks, the restaurants, the bars and all the other shite. The original pink granite cobbles in Mathew Street have been ripped up and replaced by the modern pedestrianised-walkway type of brick. A fake Cavern Club is open for business. On the opposite side of the street there still hangs a sign for Eric's Club where The Bunnymen played their first date on 15 November 1978. The club closed in the early '80s.

While standing there, I know that the original and re-formed three Bunnymen, Will, Mac and Les, are on stage in the Mercury Lounge, New York, playing the opening date of their first American tour in ten years. I want to be there. For me, they will always be the greatest rock band in the world.

Nothing about Mathew Street gives you the feeling that the Pool of Life is only feet away and that the interstellar ley lines have ever powered down these cobble stones. Peter O'Hallaghan's Liverpool School of Language, Music, Dream

and Pun is now a bogus Irish pub. Strangely, there is still a bust of Jung in the wall, but it's different from the one that was placed there in 1977.

I nod my respects to the man and hope I'm not the only remaining pupil of the school who's still dreaming dreams.

21 May 1997

IT'S SHIT

Mick Houghton read what I wrote.
I value his opinion.
He reckoned
I should qualify my glib dismissals
Of various Bunnymen recordings.
I re-read
And thought, 'If you think a record is shit
It's shit.
And everybody knows what you mean.'
Then I thought,
'Maybe it's only shit compared to
What I wanted it to be like
In my head.'
Then I thought,
'No. It's shit full stop.'
Mick also said,
'You need to fill in some
Biographical details
About the numerous characters
You mention in passing.
Contextualise them.'
I sort of agreed
And wrote this:

CHUNKY THIGHS

Julian Cope (*circa* '78)	Headboy good looks. Middle class, confident, but dickhead factor still intact. Favourite word – 'seminal'.
Ian McCulloch (*circa* '78)	Unable to recognise his own mother without his blue-tinted aviator specs with one arm missing. Council-estate-bedroom boy dreamer with strong premonitional vibe about future star status. Favourite observation – 'chunky thighs'.
Will Sergeant (*circa* '78)	Short-order chef with black moods and beautiful eyes. Favourite Stone – Brian Jones.
Les Pattinson (*circa* '78)	Boat builder, van driver. Man of dreams. Specialist subject – weird '60s TV programmes.
Alan Gill (*circa* '79)	Only unpermed Scouser brave enough to sport a muzzi in 1978 and

still be hip. Later taught Julian Cope
to smoke dope. Favourite command –
'Skin up la.'

Gary Dwyer
(*circa* '81)

Evertonian. Six foot four. Ex-Big In
Japan roadie. Stage names: Rocky and
Buff Manila. Most likely to say – 'Fuck
off, Balfey.'

Charles Alexander
(*circa* '76)

Southern public-schoolboy-type but
good sort. Always pleased to see you.
Articulate. Hugh Grant good looks but
with fuller figure. Where are you now,
Charles?

Smelly Elly

No further information available.

Dave Balfe

David Ian William Miguel Balfe, but
Balfey to the world. First male in
Liverpool to wear leather trousers.
Created Blur then bought a big house,
a very big house in the country.
Damon doesn't like him. I do.
Favourite pastime – winning.

Pete Wylie

Spokesman, not for a generation but
for mankind. When the mood takes
him, the second-greatest songwriter
from Liverpool. Ever! Favourite
position – on the stairs.

Seymour Stein

Everything you want from a fat Jewish
New York record man. Wit, genius,
magnanimity and a close acquain-
tance with everybody who's ever made

a great record. Signed Madonna. Bad habits – signing pretty boys.

Tony Wilson

Mr Granada Land. The man on the telly. The most articulate man in the north. Without him things would be different. His favourite weakness – vanity.

Alan Horne

The boss of Postcard Records, Glasgow. 'The Sound of Young Scotland' *circa* 1981.

Peter De Freitas

From certain angles he could be mistaken for a duck. A perfect body and a perfect way to die.

Bob Last
(*circa* '78)

The man from Fast, Edinburgh. The sound of serious young men. The definer of Post Punk.

Rob Dickins

Became MD of Warner Brothers Music aged twenty-four. Twenty years later he was the boss of the British music industry. A man who has never felt the need for doubt. Born to charm. Born to win. He does both.

Budgie

Born to drum. The Spitfire Boys, Nova Mob, Big In Japan, The Slits, Siouxsie and the Banshees. Girls like him. So do boys.

Ian Broudie

Guitarist with Big In Japan '77–'78. 'A spotty, four-eyed yid with an

Chunky Thighs

attitude problem' and composer of England's National Anthem, 'Three Lions'. From King Bird to Lightning Seed.

Brian Griffin

A photographer and film-maker who understands power, speaks with Brum blur (sic) touched with a Welsh lilt. Makes very expensive TV commercials. Wins awards.

Mick Houghton

Cricket, Billy Fury, The Beach Boys, The Grateful Dead, Raymond Chandler and cricket. Favourite thought – 'The Ashes coming home'.

Bill Butt

Looks like a film-maker. Is a film-maker. Born to sell salads on Northampton market. Understands women.

Hugh Jones

Journeyman in the best sense. Produced the summer record of '96, Dodgy's 'Good Enough'.

Courtney

She will go to the ball. She will win an Oscar. She will not be Yoko Ono for Generation X. And Hole is an even better name for a band than The Slits.

Roger Eagle

Towering and glowering. The man who invented the concept of Northern Soul. The third-greatest visionary in Rock 'n' Roll. Anyone from my generation out of Liverpool who ever

made a record is eternally in his debt – or can blame him for the mess we have made of our lives.

Peter O'Hallaghan Mystic, Guru, Scouser, Poet. Still pushing.

Karl Gustav Jung As the Everlys said, 'Dream, Dream, Dream', and he did. And we are grateful, especially those young folk on their voyage of discovery. Dead.

A SMELL OF MONEY
UNDER GROUND

23 January 1998

My favourite drink? Tea.

My favourite colour? Grey.

My favourite contemporary artist? Richard Long.

Easy.

These are the answers I would have given to the above questions for the past fifteen years, and probably will be for the next fifteen years.

Late morning, late January 1998. I'm on the top deck of an almost-empty bus heading out of Aylesbury, cutting across country to Oxford. Heavy clouds, flooded fields, it's been that kind of winter. In my pocket is a small stone that I picked up in the garden early this morning.

Last December I was asked if I would be interested in interviewing Richard Long for the Bristol and Bath listings magazine, *Venue*. The Bristol City Museum and Art Gallery were displaying a new sculpture by Long entitled *Delabole Bristol Slate Circle*, and he had agreed to talk about it.

I'm not in the business of interviewing people. I wasn't interested in meeting Long. I have a rule: don't meet heroes. In reality he would just be another dickhead with an over-developed ego, and the meeting would forever get in the way of me loving what he does. But the invitation to interview him

set something in motion in my head. I wanted to explore that rushing feeling I get from his work. So I had an idea: I would start the piece by stating what my favourite drink, colour and contemporary artist are, then spend all of my journey to Bristol writing about rushing feelings and why I think Richard Long's work is great, and when I did get to meet him at the Bristol City Museum and Art Gallery I would ask him his favourite drink, colour and contemporary artist. End of interview. End of piece.

The people at *Venue* were more interested in a straight-forward head-to-head typescript of a recorded conversation between the two of us:

BD Blah blah blah.

RL Blah!

BD Blah blah?

RL Blah blah blah blah blah.

Sod that, I thought, I'll just do it my way. If *Venue* don't like it, I'll keep it for myself. Here goes.

I don't think Richard Long is the greatest artist that has ever been, or even the greatest artist alive today. I don't understand why he is so highly regarded on the international art circuit, is bought by those people who feel the need to own contemporary art.

It was a pissing-down October day in late '81 and I was bunking off from managing Echo and the Bunnymen. I was playing a private game with myself and my London *A to Z*. On page 139 I had printed my name – BILL – in block capitals, and I was walking the outline, or as near as the streets would allow. It was something I had done countless times before, both in London and in Liverpool (where I was living) – and in the countryside back in Scotland.

If I stopped to think about it, I suppose I could have given a number of reasons for this habit. On the most basic level, I was the same as those adolescent taggers who decorate our inner cities and market towns with barely legible spray-can tags. But

my work had the added bonus of being unseen. I was aloof. Arrogance one step beyond. Normal taggers were happy to play at being teenage tearaways, to hide behind their illegible tag names. The good citizen, passing by their sprawling graffiti, would shake his head and mutter 'Something should be done,' but he was never even aware that I had made my claim, left my invisible stain, cast my spell.

'Cast my spell' leads me on to another unfocused reason for doing it. It had something to do with magic. Not black or even white, just a personal magic. But the best thing about these walks was that they took you down streets, up alleys, across back gardens, over ditches that you would never normally have visited. You would discover things: shops, cafés, old saucepans, skips full of discarded treasure . . . and secret signs. The secret signs were always the best.

So on that October day in '81 I was completing the second L when I found myself on the steps of an art gallery. I walked up the stairs and had a look around. It wasn't one of the big public art galleries, but one of those small private ones where people sell stuff.

There was an Ordnance Survey map in a frame. Somebody had drawn a circle on the map and then with a black pen filled in all the footpaths contained within the pencil circumference. There was another map, another circle in pencil and more black pen markings, but this time roughly following the circumference. There must have been some text that made me aware that the artist had walked those black lines. And this was art, in a frame and for sale! There were also some big black-and-white photos of piles of stone in desolate places, and yet another frame with nothing more than a few printed phrases and lone words, one below the other, like some concrete poem. The words obviously described a walk, in a most minimal, Zen-like way. I can't remember the initial impact, but it did inspire me to splash out what cash I was carrying on two small publications by the artist in question: *A Walk Past*

[71]

Standing Stones and *Five, Six, Pick Up Sticks; Seven, Eight, Lay Them Straight*.

My maternal grandparents lived in Norwich. As children, we would make the journey down from Scotland once or twice a year to stay with them. My grandfather would take us to Norwich Castle, which housed the museum. What I loved most were the dioramas. These depicted scenes from the natural history of Norfolk: the Fens, the Broads, Breckland, the coast. There were also scenes of prehistoric Norfolk man hunting and fishing, drying skins, mining for flints. These inspired me to wander the countryside looking for the hidden traces of pre-historic man. I would eagerly dig the garden, searching for arrowheads.

The museum also had a collection of paintings by the Norwich School, a bunch of artists working around and about Norwich in the first few decades of the nineteenth century. They were the first generation of serious artists to work with watercolour. We now associate watercolours with evening classes for pensioners, or the pictures sold in tea rooms, but back then the use of watercolour was cutting edge. It was the first time an artist could get out there, into the outside world, and create a finished work, a work that captured his emotional response to nature as he experienced it. This was a massive break from art that was conceived, composed and executed in the confines of the studio. (Of course, the French Impressionists came along fifty years later and did the outdoor thing with much more vibrancy and success, abusing oil paint in the process – an added bonus.)

My favourite of the Norwich School was a little-known char-acter called John Middleton. He suffered from depression, and died of consumption at the age of 29. The fluidity and clarity of his watercolours had a transcendental effect on me. Over the years I keep going back to these paintings. They seem to cap-ture that moment when man and creation reach out to one

another, and something beyond our personal ego and our petty little lives is born, something of the universal and eternal. I know this is stretching it all somewhat. If you were to go and check out the Norwich School, all you would see is some faded, rather formal scenes from a bygone rural England, which would not blow your mind one little bit. But they were the first proper art that I ever experienced; they left their mark when my mind was still free of cynicism and postmodern dogma. They also left the immovable feeling that the purest (the greatest, the truest, the bestest) form of art is created far from the tawdry comings and goings of our man-made world.

My father's influence also had its part to play. No family holiday was complete without him poring over an Ordnance Survey map, trying to find the precise location of a little-known stone circle or lone standing stone, before he would lead the way across some Scottish bog to find it.

Maps. Ordnance Survey maps in all their shapes and sizes are the most beautiful manifestation of twentieth-century British functional design. Ever since I can remember, I have spent stolen moments, wasted evenings and secret hours studying the mystery and beauty of the Ordnance Survey maps of these islands. The concrete trig points that had originally been used in their creation became almost as powerful in mystical properties for me as standing stones.

It wasn't just me. My big sister must have fallen under the same influence: the pull of bleak landscapes, the mystery of prehistory man, the drudgery of walking. My younger brother was never seduced by this dour glamour. Moved to London as fast as he could and steadfastly refused to learn to read a map.

In the summer of 1970, my sister and I hitched a ride on a trawler from Grimsby to Iceland. She was 19 and already at university doing photogrammetry, the study of the earth's surface from satellites in order to make maps. I was 17 and about to start art school. Armed with our boots, maps and a tent, we attempted to cross Iceland from north to south. We trudged as

far as the remains of a massive volcano named Askja, about halfway, before accepting a lift back to civilisation. There was little snow or ice at that time of year, no vegetation, just the arctic desert, huge horizons, vast emptiness, littered with rocks the size of churches, flung from some volcanic eruption. Black lava floes, frozen in path. Losing one's virginity, going Number One, even hearing 'Neat Neat Neat' by the Damned for the very first time – none of these comes close in the major epiphany stakes to staring out across the emptiness of central Iceland, a landscape frozen forever at lunchtime on the second day of creation.

Not once over the next three years at art school did I think to mine or explore the emotional pull of the outside world, the world at a distance from man and his doings. At the outbreak of the First World War the modern artist retreated from the natural world into the safety of his/her studio, and since then it had been deemed eternally unhip to find the 'out there world' a source of creative inspiration. Even the land art that I came across was created with urban sensibilities, more Capability Brown than Offa's Dyke. American abstract minimalism, which seemed to be where it was at in the first half of the '70s, bored me shitless. As for photo realism, it had nothing more than its gimmick factor going for it. When I jacked in art school in '74, as far as I was concerned art was dead.

The bus pulls into Oxford bus station. I walk the few hundred yards down to the train station. No dreaming spires, no Inspector Morse. I drop my stone into a ditch and pick up another one from a municipal flower bed. The flower bed contains twelve severely pruned rose bushes and enough litter to fill a binliner. I buy a polystyrene cup of tea and catch a train to Didcot. It's raining.

The reason I went into all that childhood stuff was to emphasise the impact of discovering Richard Long's work. Walking into the art gallery in Mayfair on that October day in '81 was the

first time I had come across art that was being produced in the here and now, that spoke directly to me. I stood there thinking, 'This is it. This is it. This is what I should have been doing all those years back at art school, and carried on doing for the rest of my life.' Standing stones, Ordnance Survey maps, bleak landscapes. The power of minimal words, and walking. Walking: the only way to travel. Walking as an art form? I only understood walking as a means of escape. My life has been filled with thousands of journeys on foot, bike, bus, boat and train, some so short they were just round the block, others across oceans, all taken for no practical reason I could see. My innate guilt told me I was just attempting to leave behind my responsibilities and put off arriving at the ones that were waiting. I didn't know the journey itself could be a legitimate act of self-expression, one worthy of documentation and comment.

I wasn't in the least bit interested in Richard Long the man. I had no idea what he looked like, what age he was or where he came from. Even if these personal details of his were published in catalogues or his own artists' books, it passed me by. I didn't become an avid, trainspotting fan; I didn't try to keep up with his latest work or attend new shows, but occasionally I would come across his work almost accidentally as life went on about me. It fell into three rough categories. There were large photos (usually black and white) documenting sculptures that often took the form of a stone circle or line created out of whatever natural object was lying about: stones, sticks, seaweed, wind, snow, piss. These sculptures seemed to have been conceived and created in a very short space of time during his walks across empty landscapes. There were the aforementioned maps that documented the walks in a very literal way. And there were the text works.

To begin with, these seemed dull and boring, but the more I saw them, the more I fell in love with them. A few words printed on a large white sheet of paper. The typeface always the same, a mundane, no serifs, modernism-to-the-max typeface.

Always upper case, always a little bit too far apart, but not in a pseudo-Italian-constructivist way. Black letters, with maybe the title in a dull red. These text pieces recorded a walk in as few words as possible. Sometimes there would be no more than half a dozen words to document a thousand-mile walk.

The words were usually laid out in as basic a way as possible; no attempt to entertain the viewer with imaginative graphics. (In fact, that's not quite true. There would be the occasional work where words might follow an unmarked river course.) It was the utmost confidence of these very simple works, works that required no intricate craftsmanship, that gave them their strength. There seemed no room for doubt. Total consistency – no flimflam, no dabbling, no need to explore or experiment. Well, maybe there was a knowing British 1950s-austerity vibe about his graphics, but seeing as I warm to that look anyway, I excused his indulgence. Apart from this, the work made no obvious or even indirect connections to the rest of society. No political statements, no ironic asides, no humour, no sex.

In 1989 he won the Turner Prize. I wasn't even aware that there was such a thing, let alone that Richard Long was a winner. In July 1991 I went to his major retrospective at the Hayward Gallery. This was the first time I had seen more than a handful of his works at once. I was both enraptured and disgusted. The rapture was for what I've already described. The disgust was for his gallery-based sculptures and wall paintings. I hadn't seen these before, didn't know he did them. They left me cold. They left the same negative feeling as did all that '70s American abstract minimalism. They seemed banal. Soulless.

I couldn't figure this out to begin with. Surely a stone circle there in front of me on the gallery floor should be more alive than one in a black-and-white photo hung in a frame? But no, the one captured in a photo would fire my imagination and arouse my nerve ends. Staring at the photo I could taste the air, feel the tired thigh muscles, take in the sensation of viewing the landscape and making the decision that this was the place to

build that stone circle. To choose the rocks, to stand back and look at the completed work, take a photo then walk away, heading for the horizon that I can now see in the photo, knowing you could never see that stone circle again. Maybe some stranger would accidentally come across it; maybe the wind, the rain, the sun and stars would witness its simple beauty as it slowly evolved back into the landscape. Whereas the gallery-based sculptures and wall paintings seemed to smell of something rotten, something to do with art galleries in Chicago, of careers being plotted. They reminded me of people standing around sipping wine, being introduced to each other and talking about what other shows they had been to lately. But more important than this, they just looked shit on a gallery floor or wall, with the fire exit signs and the bored security guard providing the backdrop. They didn't take you anywhere. They reduced; I want art to expand.

I get off the train at Didcot. The wind blows straight through me. I buy a Cadbury's Cream Egg for comfort. Walk to the far end of the platform, find another pocket-sized stone and leave behind the one I've taken the ten miles down the line from Oxford.

The train arrives. The Great Western. I received a letter yesterday from *Venue*, telling me that the interview was off. I would not be able to ask my three questions. It seemed the Anthony d'Offay Gallery thought it would not be suitable for a man of my reputation to interview their client, Richard Long. Me, publicity-seeking ex-pop star; him, internationally respected, award-winning artist. Makes sense. Can't argue with that. If he were my client, I would say the same thing.

I was disappointed. I'd spent the last two weeks building myself up for today. For my little pocket-stone homage. For my outpouring on what the work of Richard Long means to me. Me alone. But – and this is the bit that I liked – back some time after Jimmy and I (as The K Foundation) had burned a million quid

in '94, I decided to celebrate by buying myself a present. A once-in-a-lifetime present. I went down to the Anthony d'Offay Gallery – it was now in Dering Street, off Oxford Street, not that place up some steps that I had wandered into thirteen years earlier. I had noticed in the *Time Out* listings that they were showing some new works by Richard Long. Being a sucker for synchronicity, I was hoping that one of the new works would be a piece he had done on the Isle of Jura the previous summer, the Isle of Jura being the place we had burned the cash. There seemed to me no reason why he shouldn't have. He had done numerous works in the Scottish highlands and islands in the past. Something done on top of one of the three paps would be a fine thing.

I entered the Anthony d'Offay Gallery as you always enter these places: as if you don't belong. The synchronicity wasn't working that day; there was no Jura 1994 work on display, nothing done in Scotland at all. I asked the young woman behind the desk if d'Offay had any other work by Richard Long for sale. 'Excuse me, sir, I will just check' – and she lifted a phone. She didn't tell them about the cow shit on my boots. A besuited man in his early thirties appeared; short, with gold-rimmed glasses and an educated east-coast accent. We introduced ourselves and he invited me up to the d'Offay offices. I followed. I was shown into some sort of upmarket waiting room. Over the next few minutes he brought in a number of large, framed Richard Long works. I seemed to be getting The Treatment. I don't know if it was the cow shit or the battered Barbour, those tell-tale signs of the moneyed landowner, but he seemed to smell a serious customer, and not an obvious time-waster. I asked about the Isle of Jura.

'No, I don't think that Richard has ever created any work there. Where did you say it was?'

'Off the west coast of Scotland.'

'No, but we may have some work from Ireland.'

A very mannered conversation ensued; he was obviously

trying to learn something about me, trying to gauge at which level he should be making his pitch. All he got to know was that I lived on a farm in the Home Counties, I was originally from Scotland and I liked to walk. And I had loved the work of Richard Long for a number of years. He tried to tell me what a wonderful artist Richard Long was. The bigot in my head was raging: 'What would some New York Jewish homosexual know about the glories of trudging across a Scottish bog, soaked through to the skin, when it's getting dark and yer lost?'

I was fast losing interest in this art-buying venture. I could feel the self-loathing creeping up on me. I could sense my Class War brothers and sisters about to firebomb the establishment, with me inside. I wanted to get out of there. He brought in about six framed works. I hardly noticed them. They were no longer these great, liberating works of art, just the tawdry tat of the marketplace, created to sate the vanities of people with too much money and wall space. He then brought in a seventh. I stared silently at it for what seemed like minutes before I realised my mind had been blown.

It was entitled *A Smell of Sulphur in the Wind*. A large black-and-white photo of a stone circle. The circle had been constructed on a low hill, beyond which stretched out a vast, flat plain, an empty wilderness. Above the plain hung a dark cloud. Technically, the photo was shit. The shitness added power. At one glance I knew exactly where that plain was. I'd walked across it myself twenty-odd years earlier. Central Iceland.

I didn't let on to the young man that my mind was blown. At least he wasn't the pushy type of salesman, the second-hand-car type. I suppose the art world requires something far more subtle than that. He was keen just to talk about 'Richard' – 'Have you ever met him? Would you like to meet him? Maybe you'd like to walk with him . . . He would really appreciate that a fellow walker is so keen on his work.' Up to this point I had not thought about the price tag on any of these works. You'd

[79]

hear of Van Gogh's *Sunflowers* going for millions, but this contemporary stuff? I had no idea.

'How much is that one?' – pointing my finger at the dark cloud.

'Twenty thousand dollars.'

I was not shocked at the price, just surprised I was being quoted it in dollars. Whatever this said about the art market, I didn't want to know. What happened to guineas?

'I will want to think about it.'

'Of course.'

Before I left I was given a handful of ten-by-eight transparencies of the work that I had been shown and of the stuff hanging downstairs. Back home, I stuck them up on the window of my work room. The morning sunlight shone through them as through some stained-glass window, except that the prominent colour was grey. A week or so went by. Life as normal. Struggle, strife. Frustration with work. But there all the time in my head was a vision of a stone circle, in an empty wilderness, with a dark cloud hanging above. I picked up the phone. A deal was done. It now hangs in my bedroom. I try not to show it to visitors, not even family. It's not that I want selfishly to hoard its secret powers for myself. But if I showed it, I'd feel compelled to explain all the stuff I've written here. I couldn't just go, 'Do you like it? He's my favourite artist, I think it's great, what do you think?' Of course, there's also all that other embarrassing baggage that goes with a pop star buying art, trying to prove to the world, his mates and himself that there's more to him than a couple of hits. I shudder to think of the number of Damien Hirsts that have been bought by pop stars and are now prominently displayed in their gaffs, awaiting the next dinner party.

Even if somebody does see it, asks about it, wants to know what it cost, I never let on – almost as if I'm ashamed. I'd never spent anywhere near that sort of money before or since on something for myself; can't imagine I will ever be in a position

to again. The thing is, though, when you live with a bit of art you hardly notice it. I get up each morning and look out the window and check what kind of day it is. I don't look at *A Smell of Sulphur in the Wind* to check my soul.

The train pulls into Temple Meads station, Bristol. The day is fine. I walk up through Bristol and find the City Museum and Art Gallery, a building built with Empire wealth and heavy with Victorian civic pride. Dark and quiet inside. I wander from room to room. Ancient stuffed animals, flint arrowheads, medieval pottery, Roman jewellery. All very educational, in a pre-1960s sort of way. They even have dioramas like those at the Norwich Castle museum. Upstairs is the art. Boring old paintings done for the landed gentry of bygone times. I have a leaflet with a plan of the building. I find the twentieth-century room, where the Richard Long stuff is being shown. Stanley Spencer seems to be as twentieth century as it gets. It's as if I've walked into a dream where everything has stopped at some point in my boyhood.

At the far end of the room, beyond a partition, are the Richard Long works. The usual stuff: a photo, a text thing, a map and the new one, *Delabole Slate Circle*, on the floor.

I'm unmoved.

I lift one of the smaller lumps of slate and replace it with the stone that has been in my pocket since Didcot station. The plan is to put the lump of Delabole Bristol slate in my haversack and be off with it. I chicken out, retrieve my small stone and return it to my pocket. Leave the museum. Walk up through the old town, heading for Clifton. Walk out on to the middle of the suspension bridge. There is a plaque with the Samaritans' phone number on it. Somebody once told me that on New Year's Eve they have an ambulance at each end of the bridge. Two hundred feet below, the tide is out. The steep, muddy banks to the Avon look scary, but the gorge looks fine in the winter sunlight.

[81]

I take the stone out of my pocket and fling it. It arcs its way down and disappears into the mud, to lie with the bones of forgotten suicides.

Walk back down through the town, heading for Temple Meads. Catch a train. Change at Didcot. It's dark. At Oxford I've missed the last bus back to Aylesbury. I wait for a cab and think and make notes. *A Smell of Sulphur in the Wind*. When Richard Long gave the work its title he was obviously referring to the stench of the natural hot springs that seep up through the ground all over Iceland, it being volcanic and that. But for me it had another meaning. As a teenager I lived in Corby. Whenever the wind blew from the north-east, the whole town stank of sulphur from the steelworks. At first you hated it, but you grew used to it. The smell of home. When the steelworks closed down, the smell of sulphur in the wind went away, along with the jobs. Now it triggers nostalgia for the days of full employment.

I know by the *Blimey! What a Sensation* standards of the past year (1997), Richard Long's work is as much an irrelevance as John Middleton's watercolours, saying nothing about the human condition at the arse-end of the twentieth century. For me, both are as alive as ever, celebrating that moment when something sparks between man and creation.

For some reason I didn't bother insuring the work. You could come round to my place and nick *A Smell of Sulphur in the Wind* and I wouldn't get my $20,000 back. I'm still not too sure what I bought and what it is I now own, thus what it is that I should be insuring. Is it the stone circle in Iceland? The concept of the stone circle? The idea of the walk across Iceland? That long-gone dark cloud? My memory of a time I spent trying to cross Iceland? That rushing feeling I was going on about? An investment? Art-owning kudos? Or that piece of card in a frame, that I don't show to people and hardly take notice of myself?

The taxi arrives. Javed is one of the boss's five sons. We talk,

and he tells me about his life. His father, Mr Akahta, is back in Pakistan sorting out the family estate. The five sons are squabbling. Yesterday was the end of Ramadan. Javed tells me it is the done thing, the manly thing, to read a passage from the Koran at the Aylesbury mosque, but his brothers kept him working all day.

'Why don't you close the business down for the day?'

'My father wouldn't allow it. He says we would lose our regular customers to our rivals.' He tells me he has just got back from spending four years wandering the world. Before that he had been living with an English girl in Aylesbury. He was ostracised by his family, disinherited by his father.

'They didn't understand I loved the girl. Then one morning I woke up and she told me it was over, she was seeing someone else. That was it; I just walked and didn't stop.' He didn't look the hippie drop-out sort.

'My brother tracked me down in Ceylon. My mother was sick. They begged me to come back. All was forgiven. But that girl, that English girl, she has begun to follow me. She waits in her car outside our place and watches. Two of my brothers have warned her, told her if she carries on they will go to the police. She has to understand, I can't go back to her. I can never trust her again. My family are important, the lifestyle and security I have are important.'

'Do you still feel something for her?'

'Of course. I still love her.' We drive on in heavy silence, both pondering the mess we make of our lives and how we never learn. My place is quite difficult to get to. A few miles out of Aylesbury, down country lanes. We pull up.

'Do you mind if I ask you a couple of questions?'

'Yeah, what?'

'It might sound stupid, but it's for some research I'm doing for my work. What is your favourite drink?'

'Ah . . . Coca-Cola.'

'What is your favourite colour?'

'What's this for? Sounds like a kids' game. Purple. I like purple – not for me to wear, but on girls. Purple looks pretty.'

'And lastly, and this might sound a bit strange, who is your favourite contemporary artist?'

'What kind of artist?'

'Contemporary. Like, modern. OK, living artist.'

'I don't know if I know any artists' names. In the Koran it tells us we must not make pictures of what we see. It would offend Allah if we copied what he's already created. Allah is the greatest artist, the only true artist. Modern, contemporary, whatever you want to call it.' And he's off.

The house is in darkness. The family have gone to bed. I put the kettle on, creep upstairs. I lift *A Smell of Sulphur in the Air* off the wall and carry it down into the kitchen.

It takes a couple of trips but I'm now sitting in the middle of my field. The work is propped up against the water trough. There is enough moonlight for me to see the photograph of the stone circle clearly. I wonder if the original is weathering. I suppose it will be deep under snow. Making its way through that long Arctic night. Maybe there's hardly any of it still standing.

And I think about Richard Long. Does he still wonder about the works he's done? Does he maintain a relationship with them, or just get on with the next one? And the next one, and the next one? Does he think about the people who buy his stuff, and why they buy it? Does that New Yorker at d'Offay's gallery still have his job, and did the d'Offay Gallery ever make a connection between the Bill Drummond who handed over $20,000 in secret celebration of a money-burning and Bill Drummond, the money-burning anarchist they decided was unsuitable to interview Richard Long? Why do I like this notion? And where do all these loose strands of thought meet?

An idea is beginning to surface from my murky imagination. Something is evolving, maybe my relationship to the original work, or the work itself, or something totally new. It's getting

clearer. I will sell the photo for $20,000. Make a stout wooden box with a strong padlock. Put the $20,000, in dollar bills, into the box. Return to Iceland, find the stone circle. Dig a hole in its centre and bury the box. Not only will I have gone to great(ish) lengths to track down the stone circle, experience blistered feet, aching muscles, loneliness, but if I awake at night filled with the terrors I can comfort myself with the thought of those twenty thousand greenbacks in their strongbox, rotting to a worthless mush. As for Richard Long, if he ever reads these notes, will his relationship with the work change? Is that good or bad? As he may be the only other person on earth who knows where the circle is, will he be tempted to return to the spot, retrieve the cash and put it to a worthwhile cause?

I will take a black-and-white photo of the enriched stone circle, blow it up big, frame it and hang it on a wall. The title? *A Smell of Money Under Ground.*

LET'S GRIND
or How K2 Plant Hire Went To Work

'31 December 1999'

'That is just plain evil. Why in God's name would you want to destroy Stonehenge?' – is an approximation of the standard answer either Jimmy or I get whenever we let it slip that the removal of the stones is the last great undone contract of K2 Plant Hire.

It's teatime, my place, and I'm waiting for Jimmy to turn up with the gear. The rest of the world may be partying like it's 1999, but we've got work to do.

We have had the notion for the best part of ten years that something had to be done about Stonehenge. Either somebody had to fix it up, or the whole thing should be scrapped as unworkable. I could easily launch into an attack on heritage culture, but that is best left to broadsheet journalists who know how to put a rational argument together. For me and Jimmy it was a case of: it looks like nobody else seems to be doing it, so it must be our responsibility.

I think we are drawn to the stones not because of some sort of New Age pagan yearning in our souls, but more because they seem to symbolise something for us that lives on in these

islands. A continuity that has a stronger and deeper pull than the Union flag, our royal family, our mother of parliaments, our victories in war, our language, our sterling currency or even our pop music. They haven't been rammed down our throats at school. They aren't on the coins in our pockets. They don't try to tell us what to do, or make us feel guilty. They are just there, from generation to generation.

Back when we did the Timelords thing in the late '80s and were flush with cash, we looked into hiring a massive helicopter and lifting the fallen stones – mending the Henge, getting it working again. We then learned that all the air space down there was military, and we couldn't get any civilian pilots to do the job with us. So we had our photograph taken with Gary Glitter in front of the fallen stones, then went off to the Sierra Nevada and blew all our cash on making a mystical road movie instead.

Next. After we knocked The KLF on the head, Jimmy spent about a year doing a series of large paintings depicting apocalyptic scenes involving ourselves, the destruction of Stonehenge, the unleashing of dark forces and the death of thousands. All a bit childish and comic horror, but incredibly well executed. I liked them. Then he destroyed the lot by sanding the paint off the canvases, carefully sweeping up the dust and keeping it in a series of jam jars. One jam jar for each painting. Why? Best not ask. We all deal with our moments of doubt in different ways.

Next. One night in February 1993, Jimmy and I were walking in an easterly direction along the A303, away from Stonehenge. We had been doing some nocturnal research at the stones and were now deep into a rambling conversation, out of which the idea of The K Foundation evolved.

Next. November 1995. Jimmy, Gimpo and I were in Glasgow with our film *Watch The K Foundation Burn a Million Quid*. We were supposed to be showing it to prisoners and Buddhist monks and Rangers supporters and all sorts of other people,

site-specific-style, but it was pointed out to us by a man that our efforts were a waste of time. Me and Jimmy agreed with him, and jacked in being trustees of our bogus art foundation. Instead, we decided to become K2 Plant Hire. (At that point in time, being the owner of a plant-hire company seemed to be the ultimate ambition of any proper man.) We set to work immediately and started to design our calendars. Decided that all our plant would be painted orange and black. And we imagined what the inside of our hut would look like. We then did some other stuff in Scotland and Gimpo got pissed off with us and left us stranded in a transport café. K2 Plant Hire has waited patiently over the passing years for its first major contract.

Next. Some time in early 1997, Sarah Champion, editor of the cash-in-on-Irvine-Welsh book *Disco Biscuits*, contacted me. Was I up for contributing to her next anthology of short stories, *Disco 2000*? She explained the theme of the book, a collection of stories all taking place on New Year's Eve 1999. I like Sarah. I was up for it. I had an idea that I would do a bogus 'Drummond's Log' about what me and Jimmy got up to on that date, thus realising our joint ambition of destroying Stonehenge through the safe medium of fiction. I was also into the idea that once it had been written as a partly fictitious story in 1997, it would give us the impetus to go and do the real thing on the given date. Somehow the story would be a contract. If we didn't do it, it would undermine the whole 'Drummond's Log' thing. I would never believe myself again. I don't care if you don't believe me, but . . .

Before I got the story written, though, I was committed to getting some things done. If this meant I didn't meet Sarah's print deadline, so be it. Then on Thursday 15 May 1997 Gimpo and I met up at the BRS truck-hire place at the back of King's Cross station. You know, the area where all the prostitutes used to hang out. We hired a seven-tonner. Big enough. The two of us drove through London, stopping off at a cash point to pick up

the grand in cash that we needed to do the job. On to the M4, then down it for a few miles before doubling back on ourselves. Parked up in the service station and waited for Jimmy in the café. He came. We ate breakfast before unloading the chains, the blocks and tackle and the rest of the gear from the back of Jimmy's van into the back of the truck. Loaded. The three of us climbed into the front of the truck and headed for the M25.

Jimmy and I had been working together for the last ten years, and seeing as we are in an age of anniversary fever, we thought we should celebrate our ten-year partnership of sorts. Some time in the early '90s our interest in sheep had waned, to be replaced by an infatuation with the cow. We had as yet done nothing to express this interest in the idea of a cow. The fact that Damien Hirst won tabloid fame with his mother and daughter divided thing had kind of put a stop to things. Added to that, when Jimmy accidentally caused a cow to miscarry while testing his advanced acoustic armament equipment and got splashed across the media and branded as a cow killer, it seemed to make our joint interest in exploring the meaning of the cow redundant. But the cow came back, and refused to go away. We had to do something.

So we got on to the M25 at the M4 intersection and headed south, anti-clockwise. We were looking for pylons, or if there weren't any good-looking pylons visible to the passing M25 motorist, we wanted a stout oak tree with a good strong horizontal branch fifteen feet clear of the ground. We wanted a good lynching tree. Like the ones you see in those old black-and-white photographs: Ku Klux Klan members in the foreground, the boughs behind them laden with their strange fruit.

We had seen the right tree in our imaginations and were positive it was going to be easy to find. It wasn't. There was none. As for the pylons . . . The whole pylon thing had started when we had been driving up the M6 through Birmingham. There were loads of these great squat pylons glowering over

the weary landscape, tempting young boys to come and climb, heavy with their thousands of volts of instant death, strung together with cables to snare and fry migrating swans. I suppose each of us had always been into pylons, what lad isn't? But it was there and then that we began to share our vision of what could be done with them.

Jimmy and I were being open-minded. Strong oaks or squat pylons – either would do, as long as they were clearly visible from the M25 and we could get the truck up to them. We drove the southern arc under the belly of London. Nothing. At some point it started pissing down, but that just added to the perfect gloom. We stopped at Clackett services and we all played on Road Rage, a brand new arcade game. Drank a bowl of soup. Gimpo told us what Blair would be putting in the Queen's speech.

We drove under the Dartford Tunnel and up into Essex. This felt more like it. West Thurrock marshes. Plenty of pylons, keeping guard over a crumbling industrial landscape. We came off the motorway and started to explore. Industrial estates, run-down chemical plants, disused oil refineries, feral buddleia breaking through everywhere, and us on our truck, looking for the right place. Then we came across a massive entertainment complex. Cinemas, shopping mall, discos. We drove slowly past and watched, like paedophiles outside a school gate. A police car pulled us over and asked what we were looking for. Gimpo answered: location hunting for a film about the end of civilisation, starring Sean Connery. They asked for tickets to the premiere and wished us well.

Then we caught sight of the perfect pylon. It was perched on top of a dirty chalk cliff. No bluebirds. The cliff ran alongside a busy dual carriageway, and the pylon gazed across the above-described landscape of multiplexes and industrial wasteland. Perfect. It took us some time to find an access path. To get the truck down it we would need to liberate the gate from the padlock with bolt cutters. We parked up the truck and walked

down to the pylon to join it in surveying the scene. Its high-voltage cables were buzzing in the late afternoon drizzle. We reckoned if we got the truck down under the pylon and climbed on the roof, we could get the chains over the lowest horizontal girders. The only problems seemed to be how long it would take us to do the job, and how visible we would be from the dual carriageway below. We had spotted the cop car that had pulled us up a number of times by now. It seemed to be on a constant patrol of the area, a perfect place for joyriders.

We left the pylon, satisfied we had found the ideal site. We would be back later that night with bolt cutters. And loaded with meat.

Heading north on the M25, still anti-clockwise, I used Gimpo's mobile to phone the brothers. The job's on, I told them, be there in an hour. They ran a small backstreet business, about sixty miles north of London. For their protection I can't be any more specific than that. Most of my dealings had been with the younger brother; he seemed the less paranoid of the two. He told me they would do the job about thirty minutes before we got there. He didn't want rigor mortis to set in before we got loaded up. But thirty minutes was time enough for him to get things cleaned up. He then took pride in telling me that he had brought his 2.2 rifle in and was going to use that. It would make a far smaller hole than the bolt gun they usually used. It would be a neater job; far less leakage.

We stopped off in the small market town of Tring to buy bolt cutters, a pair of brown card parcel labels and a ball of twine. The next thirty-odd miles were across country. We got to the brothers' place some time after seven. It was officially closed. The brothers were there, and the job had been done. The bodies were stacked in the back of their blood-proof truck. The first thing that drew my attention was their cunts; both of them were gaping open. Big enough to slide your arm into without touching the sides. There was this sort of semi-translucent jelly stuff that was seeping out. I was filled with the

same indefinable fear that I'd felt as a nineteen-year-old lad, when cleaning out similar parts of the dead women whose bodies I laid out on the hospital ward where I worked.

I pushed the terror out of my mind. Only then did I notice they were black-and-white Friesian, huge udders, perfect. A dead cow is so much bigger than you imagine. I know this will sound trite: there is something so undeniably final about a dead body, animal or human. Only that morning, these two cows had been chewing the cud in their field, enjoying the sun's warming rays and waiting to be relieved of their milk. Somewhere else a mobile phone had rung, deals had been done, sums agreed and their fate sealed.

The brothers were uneasy. Mad cow disease had swept the nation over the previous year. All cattle slaughtered had to be accounted for; spinal cords and brains were collected by the authorities on a daily basis, counted, ticked off and taken to be incinerated at designated sites. No beasts were allowed to stray out of the chain. BSE had become the Aids of the '90s; it was going to be the thing that killed us all.

We had tried to tell the brothers the truth. What we told them went something like this: we were going to take the two cows off to some private land in Essex, where we had permission from the landowner to string them up from the bough of a large oak tree. We were then going to have the scene photographed at dawn, after which we would have the carcasses cut down and brought back to their place to be dealt with in the proper way. Except our plans had changed, we were no longer going to bring them back for them to dispose of, but we had made arrangements with a local Essex knacker's yard to do the job. We had already dealt with the questions of who we were and why we were doing this by explaining we were a pair of those modern artist types that like to do stupid things in the hope it shocked somebody and got publicity. This they understood, had seen it on TV, knew that was what artists had to do these days to make a living. And anyway, they liked the colour of our money.

Let's Grind *or* How K2 Plant Hire Went To Work

They wanted to know the name of the knacker's yard in Essex. We couldn't remember. They wanted our assurance that whatever happened, Farmer Jones, who had owned the cows until that very day and was a long-standing and trusted customer, would not open up the *Daily Telegraph* tomorrow morning to see his Daisy and Buttercup strung up in some disgusting stunt. We gave them our assurance, knowing that if Daisy and Buttercup did make the front cover of the *Daily Telegraph*, it would not be until the morning after next.

One of the brothers took it upon himself to take a knife and cut an ear off each of our cows. Each of the severed ears had a tag that could identify the beasts as easily as a car number plate. Both brothers knew they were too far into this to get out now.

Jimmy got changed into his wellies, waterproof overalls and acid-resistant gloves. Gimpo was already clambering over the beasts, trying to work out the best way to get the chains around them before winching them across into the back of our truck. Buttercup's eyes were open. They were big, a dark and very deep blue – the eyelashes were as big as a cartoon cow's. She looked very friendly. She smelled of fresh hay and warm milk. Blood dribbled from her nostrils. Gimpo had the chains fixed and we started the long, slow process of winching her over. Milk squirted from her udders, slurry from her arse, and a fist-sized lump of congealed blood spurted from her mouth.

Jimmy and I tried to make ourselves useful, but Gimpo was in control (as ever). It took us the best part of an hour to get them in our truck. There was blood and shit everywhere. The brothers hosed everything down. It was only then that they told us that the beasts' guts would swell up to twice their normal size overnight, that the innards would probably be forced out of their arses. That the law of the land states that all carcasses must be dealt with and parts disposed of within twenty-four hours of slaughter. Things can quickly become dangerously toxic, and be a severe health hazard to anybody coming into contact with them.

We counted the crisp new fifty-quids out on the bonnet of their van and bunged in a few extra for the farmer. Blood money. No invoices were written, no surnames known. We bade our farewells, and the three of us drove off with our heavy load. Silence in the cab as awful repercussions slurried around our as yet CJD-free brains.

We stopped off at my place. A farmhouse. Gimpo played with my daughter, Bluebell. She is only just over two, already wants to marry Gimpo, and often asks for Gimpo to live with us, insisting he could sleep in the attic. I collected eggs from the chicken house and made us all scrambled eggs for supper. Jimmy and my girlfriend Sallie caught up with gossip and compared pharmaceutical notes. Gimpo had to read Bluebell a bedtime story before we left. It was dark.

We drove across country again. I felt the weight of our load as we took each bend on the lanes. We joined the M25 just north of Watford and headed south for Essex.

The bolt cutters went through the hardened steel like a Stanley through a cheek. The gate opened and we bumped the two hundred yards down the rough track to our chosen pylon. Below us were the lights of the dual carriageway. The Warner Brothers multiplex was entertaining the Essex men and Essex girls. The Deep Pan Pizza was packed. The police were busy with the joyriders and Gimpo was up on the roof of the truck pulling on chains.

Jimmy and I had our felt-tip pens in hand, each of us writing the same two words on our separate cardboard parcel labels. The labels were to be tied around our cargo's necks.

For the previous few years, I had relished the idea of stringing up a beast like this, with no further explanation than a plain cardboard label with the two words, 'FUCKING COW'. There were times when I was driving along in my truck, cocooned from the rest of the world, and I would laugh and laugh and laugh in an almost maniacal state, just thinking of it.

FUCKING COW.

FUCKING COW.

FUCKING COW.

Louder and louder.

(Of course, the reason for wanting to have just two cows and not the full twenty-three, or the more economical one, was not just to have one each but to proclaim, as loudly and as silently as we could, 'Mu Mu.')

I can't remember if either of us got the two words written before we not only confronted ourselves with the fact that we couldn't go through with it, but admitted it to each other. Who said what first I can't remember. But it was agreed that this was the end of the road; we had got to this brick wall. We had been able to burn a million quid of our own money, but we could not do this. Were we worried for the health and safety of the local government workers who would come out to clear the whole thing up? Or were we just too horrified about whatever this statement said about our own dismembered psyches?

Contrary to what we said to the brothers, there had been no plans to tell the media or even have the event officially witnessed or photographed, although one can never stop Gimpo bringing along his video camera, so he must have evidence of our sad failure somewhere. We had just wanted the two cows to be discovered, the way that a dog in a ditch or a body in a canal would be – anonymous, horrible, true – and for people to make of it what they would. We didn't want anybody tracing the act back to us.

We helped Gimpo to pack the chains. We drove off in silence.

The next morning I took the bloated and stiffened Daisy and Buttercup back to the brothers. Although they had hoped never to see my face again, they were mightily relieved to see the two now-worthless carcasses and hear that they had not taken part in any art prank, scam or pop publicity stunt. After a few more crisp notes changed hands, they were willing to dispose of the bodies in a clean and legal way.

Some weeks later Jimmy and I got talking about Stonehenge

and its clearance as a K2 Plant Hire millennial gift to the nation, and we admitted that it could no longer be part of the master plan. If we couldn't get it together to string up a couple of dead cows, there was no way we would ever do the stones. Something had ended.

Time shifted and we ended up celebrating our tenth anniversary in a different way. What started as Jeremy Deller's Acid Brass project evolved into our 2K 'Fuck the Millennium' project. It was some way through this mammoth recording that I got home one Sunday night to find an answerphone message from the skinhead, novelist and thinker Stewart Home, telling me the Rollright Stones were up for sale. Being a keen ley liner, he was afraid they might fall into the hands of the New Age fascists. He thought Jimmy and I should buy them and put them to good use. I forgot to tell Jimmy this for a couple of days. We were too consumed with the prospect of fucking the millennium and getting our electric wheelchairs. When I did, it was with no thought of us buying the things, more out of politeness to Stewart Home. Another couple of days passed, with us doing whatever it is that gets done in a recording studio. Then Jimmy said, 'We've got fifty thousand left in the K2 Plant Hire account. It seems fitting that we should buy the Rollright Stones and clear the account.' I liked his logic. He had already been working on some drawings of what we should do with them. It involved a huge drilling rig, like a traditional Texas oil one. We would use it to drill down into the crust of the earth and extract the mystical powers of Avalon and sell them, or something like that. Both the great and the stupid thing about Jimmy's ideas is that they are usually wildly impractical, thus protecting him from ever having to realise them and face the consequences.

I was quite happy for us to get a K2 Plant Hire JCB in, dig up the stones and cart them off to a lime works. There, they could grind them down to a fine powder and, using the powder and whatever other substance would do the job, remake all the stones in pristine rectangular shapes. Stewart Home had faxed

me a photo of the stones. I could see they were in a shocking state, all worn away by the weather, with bits of lichen and moss growing on them. They looked like they were trying to blend in with nature.

Obviously, nobody was looking after them.

It was partly the fault of the original contractors who constructed the site. They used limestone, which, as anybody who knows anything about the building trade or geology is aware, doesn't last more than half a dozen millennia if exposed to the elements. At least the blokes that built Stonehenge knew to get some imported hard rock, and not the local soft shit from Salisbury Plain.

But out of respect to the geezers who made them in the first place, and as a millennium gift to the nation, K2 Plant Hire would replace the stones in perfect working order. A precise circle, each stone of equal size and equidistant from each other. Then we could all relax, safe in the knowledge that they would last, if not an eternity, then at least as long as the monolith in *2001*. And we would provide good car parking facilities.

Upon getting the particulars we discovered that it wasn't the actual stones that were for sale, just the land they crumbled on. The stones were the property of English Heritage or something. On purchasing the land, we would have no right to improve the stones and make them our millennial gift to the nation.

Initially we just gave up on the idea, knowing that we hadn't got what it took for all that illegal cow lynching, Stonehenge clearance stuff. But after we did our 2K 'Fuck the Millennium' performance at the Barbican in September of that year (1997), Jimmy and I couldn't face going to the after-show 'do' and all those 'why?' questions, so we drove up the M40, turned off at Ardley and found the Rollright Stones.

We were horrified. They were in worse condition than we had ever imagined. Something had to be done. We knew that the responsibility once again fell on our shoulders. We also knew the perfect night to do it, a night when the rest of the

world would be otherwise occupied. As for the fucking cows, whatever problem that was in my psyche seemed to have been sorted out. Stonehenge would have to wait; one thing at a time.

There's a knock at the door; it must be Jimmy. It is. The week before Christmas he did one of those JCB crash courses. He has just driven up from Devon in the one he got in an auction down there. Gimpo has finally passed his HGV Grade A and will be driving the ten-tonner. Time for one more cup of tea, and then a night's work for K2 Plant Hire to be done.

ONE IDEA

11 November 1997

Last night there was a message on my answerphone from the northern edition of the *Big Issue*. They wanted eight hundred of my words on the upcoming Turner Prize. I'm not a journalist, I'm not a rent-a-quote; I have better things to do with my time than provide copy for even the worthiest of journals. But I'm sitting on a plane 37,000 feet above the Baltic and I'm bored and my book is open on my lap and ideas are popping and my pen is writing. When I've finished I'll fax the piece off to the *Big Issue* with a covering note: 'Use this in exchange for a year's supply of your magazine.' At this rate I will be producing words for products, the barter system providing all my worldly goods.

'What a load of bollocks,' comes the cry from the mob. It's that time of year again, now a permanent fixture on our cultural calendar: come October/November, the arts editors of our national broadsheets and most of all the hundreds of lifestyle and listings magazines know they can fill a couple of pages on the Turner Prize. The sponsor of the Turner Prize (the Tate) knows full well that the whole idea of judging artistic endeavour like it's some sort of beauty contest is blatantly banal; that's why it pushes the 'to promote the discussion of contemporary art' angle on things.

Because so much of what drives the artist to create exists in

a space, it is impossible to discuss or even defend it without tying yourself up in Artspeak knots that completely devalue the many languages of art. But that doesn't stop these features on the Turner getting commissioned, written and published. As most people don't want to read, let alone try to understand, Artspeak, these features end up being about peripheral subjects, such as the significance that all four of the shortlist are yet again women, the ethnic quota is up, none of the traditional mediums is represented, etc. If any of the four artists are either photogenic or have entertaining personalities then the features can concentrate on that.

Very little of this discussion promotes what is essentially important about contemporary art. What gets promoted is fame, names to know, behind-the-scenes movers and shakers and, of course, prices. But worse than all this is that contemporary art is made safe, unchallenging, boxed off, neutered and summarised. This prevents it from performing its most vital function: helping us to see, feel, understand, celebrate, challenge and wonder at the world we are living in right now, in ways never before known.

If the Tate Gallery is really interested in promoting the discussion (and discussion doesn't have to be just words) of contemporary art, then next year they should ditch the whole boring notion of a panel of judges, four shortlisted names, televised dinner do, and the 'now for this year's winner' crap. Some serious lateral thinking is needed. Why not try something like this – invite every artist in the country who considers him- or herself worthy, or under fifty, or handy with a paint brush, or left-handed, or even contemporary, to take part in or contribute to the creation of one massive piece of work. Something with no price tag on it or personality-cult-as-career attached to it. Something that can catch the general public's imagination. Then on the Turner Prize night the chosen arts celeb can draw one of the thousands of contributing artists' names out of a hat, and they can be the winner of the £20,000 cheque and attendant

One Idea

honour. Then let us celebrate the age of the lottery by allowing the winning artist to set light to the combined work of a nation of artists. Make a huge bonfire night of it so it doesn't hang about museums or public art spaces. Maybe public and private art bonfires could become an annual event, replacing the outdated concept of Guy Fawkes Night.

Well that's one idea. I'm sure there are plenty of better ones out there. I invite you to write yours down and send them to Nick Serota, c/o The Tate Gallery, Millbank, London.

THE NUMBER FOURTEEN

28 November 1997

Z is pissing me off. It's the same most mornings, as he dawdles along, checking out the shop windows he's checked at least a dozen times before. At the crossroads at the bottom of the hill the number fourteen bus has just turned into Fredrikinkatu. At the top of the hill is the bus stop. If I start running now I may be able to make it before the bus overtakes and leaves me to wait forty minutes minimum for the next. I shout, 'Z – the bus', and then run. I just make it to the stop as the bus pulls up. It's my turn to get the tickets. Do I bother to get his? He most probably hasn't got any change on him, knowing it's my turn. But I'm blowed if I'm going to hang around for forty minutes for the next one to come along. There is a queue in front of me; mothers with toddlers, old men with bags. It's a time-consuming business for the driver-conductor. The queue moves slowly. Just as I'm about to step on the bus and purchase my single ticket to Pajamaki I hear the familiar tones: 'Bill, have you seen those knives in that hunting shop back there? You should check them out.'

'Two tickets to Pajamaki, please.' Then we make our way down the length of the bus to the back seat. Z always has the right-hand window one, I the left, leaving the three empty ones between us to be occupied by the taciturn citizens of this fine

city, Helsinki. The same little drama with its internal tensions and satisfactory outcome was played out yesterday morning and will be again tomorrow morning. It's not always the hunting knife that catches his eye. It could be a children's clothes shop (his daughters in mind), a second-hand book store, some new and untested Euro porn, a martial arts aid, an exotic-looking toaster, an expensive fountain pen. But for now we are both safely in our seats, far enough apart so we don't have to talk. We can pull out our black notebooks and pens and enter our separate private worlds, the only worlds where we truly fit.

Alice had her looking glass, Kerouac his road and Moses his mountain; I've always had the bus. I'm not talking about Ken Kesey's bus or The Who's magic one or a mystery tour one, and certainly nothing as noble as a bus you can start a civil rights movement with. I just mean the bus to school, to college, to work. That bit in the day when you've got out the house, braved the elements and managed not to miss it. It's not misty-eyed nostalgia for a certain type of bus, such as an over-the-Andes exotic bus with goats and chickens on board. Any bus will do, ancient or modern, as long as it moves and can pick up passengers on their way to work and I can find a seat. When I've escaped the strains of family and relationship and have not yet got to the confrontations of the schoolyard or coal-face, the bus is a place where I don't need to talk to anybody or do anything. A place without telephone or fax machine, with no radio or kettle or any other distraction that I easily succumb to. There have been periods in my life where buses have not featured in my daily routine; I can't say I knowingly suffered withdrawal symptoms or even felt a vague yearning, but whenever the pattern of my life shifted once more and required a morning bus ride to get me where I needed to get, there was a sense of returning. This will sound patronising to my fellow man, but there is that feeling of returning to the fold, of being just another of the anonymous millions going about their daily struggle. It's the perfect place to be if you are not a very

sociable person but still have the animal instinct to flock, to be part of the unknown masses. Sitting on a bus doesn't bring out all those negative sides of your character that driving a car does. If there is a traffic hold-up while you're travelling on a bus, it is far easier to accept your lot. No horn to honk or lights to flash. No temptation to overtake, no urge to take the life of your fellow traveller. Those that make a daily journey by train or tube may feel the same, but for me the tube in London has always had a desperation about it, something vaguely threatening, something too urgent.

Frederikinkatu is a long straight road running north-west through the old city. It is mainly a mixture of upmarket shops and second-hand book stores. By the time we get to the top of it by the Kamppi metro station, the bus is usually full. However crowded and hot the bus gets, everybody keeps their hats and mittens on. Even Z and I have taken to this habit, but in our case there is nothing very Finnish about our headgear. Z has his balaclava and I've got my Aylesbury United green-and-white bobble hat.

Finland has the highest consumption of books per head of population in the world – thus all the second-hand book shops, I suppose – but nobody reads on the bus, not even newspapers. (I'm one of those people who have what I understand is an infuriating habit of reading my neighbours' newspapers over their shoulders. It has been explained to me on numerous occasions that this is the ultimate infringement of a fellow passenger's private space, and I fully accept that it is, but I still find it impossible to break the habit. An over-glimpsed newspaper article, however difficult to read, is always ten times more interesting. There have been times when I have had the very same newspaper as my fellow passenger, but still strained my neck to read his or her copy. It is usually only when I become aware of them bending the sheets to an angle so that I can no longer see the desired column that I realise I'm doing it and the displeasure I'm causing.) So no reading of other

The Number Fourteen

people's *Helsinki Bugle*, even if I could read Finnish. Which leaves me free to stare out the window and let my mind wander. The only problem with this is that you can suddenly be confronted, while off-guard, by the reflection of an unappealing stranger next to you – and then have to come to terms with the fact that the dreary, sullen and sagging face is your own. I have an almost primitive fear of my own reflection. It is only recently that I have given in to my girlfriend's demand for a mirror in our bathroom. I shave by touch, always have done, and never brush my hair. I have no practical need for a mirror. I remember at some pre-school age swirling and spinning, dancing and twisting naked around my bedroom. On the inside of the wardrobe door was a full-length mirror. On that far-off morning, I had the wardrobe jammed wide open so I could watch myself as I cavorted around the room in my own innocent and divine nakedness. My mother came in. Later that day, the mirror was removed. Luckily for me, the suppression of one vanity is like that bump in the linoleum; it just has to find expression elsewhere.

Like Vic and Bob, we wouldn't let it lie. Z and I are back in Helsinki, our favourite city, making a record. The number fourteen bus route takes us from near our cramped rented apartment down in the old part of town to our place of work, Finnvox Studios, which is on an industrial estate on the northern outskirts of Helsinki. We catch the number fourteen only two stops into its journey, when it is almost empty, and we stay on all the way to the end of the road, its final destination, Pajamaki. We are usually the only passengers left on board as it pulls into the terminal. In between it seems like hundreds of passengers clamber on board and struggle off. This time we are in Helsinki producing an album of songs written and sung by Kristina Bruuk. We first came across Kristina Bruuk when we were recording the *Bad Wisdom* soundtrack album earlier this year (1997). The story behind the recording of that album I have written about elsewhere.

Kristina Bruuk contributed one song to *Bad Wisdom* – 'Supermodel'. It was an incredibly delicate and fragile song. It ached of loss and longing. Via the song, Z and I fell in love with the woman. Well, the idea of her, if not the reality. She was one of those women with whom it would be impossible to have any sort of relationship. Even a one-night stand would generate too much mind-fuck. And anyway, she was a fellow artist. Rule one: never get involved with another artist. Two centres of the universe in one kitchen don't work.

Kristina Bruuk must have been in her early forties, although we would never have dared ask her age. She had dark hair and dark dark eyes and a pale, translucent skin. She hardly spoke, except to ask for a glass of water, or if a vocal take was to our satisfaction. It sounds like I'm describing a subordinate, malleable woman, but she had an aura of immense inner power. We would never dare to criticise her vocal performance.

'Kristina, it sounds brilliant to us. Maybe you should listen back to it yourself and see what you think.' She would listen to her performance, then:

'I think I have sung very badly. I will sing again. This time I will get closer.' She spoke English with a heavy accent, unlike the other natives of Helsinki who all speak English incredibly well. If there was a mean streak in you, you would assume there was something affected in her accent. It wasn't just the way she spoke: every move she made was mannered, as if she were being filmed at all times. Her performance never ended. You had a sense that she knew you knew it was all a performance, but somehow her almost-threatening aura would never let you dare challenge it. However, we also knew that all of this was somehow done to protect something very fragile at the core of her being. Whatever that was in reality, Z and I decided to recognise it as the tortured soul of a dark and dangerous artist, still retaining the innocent selfishness of childhood. She fascinated us. We tried to learn more about her, but she was deliberately unforthcoming. She would drop vague

hints to a mysterious past – a childhood in Estonia, time spent in London, Paris and New York – but we were never too sure how much was actual truth and how much artistic truth, as she embroidered her own greatest creation: her enigma. In reality, as is often the case with these types, it was all quite pathetic and mundane, but for Z and me she was up there with those heroic pop casualties Steve Strange and Martin Degville. She did let it drop that she had once known Andy Warhol, but when we picked her up on it later she didn't seem to know what we were talking about. She was also prone to talking to herself. She seemed like a woman who felt she had an awful lot to hide.

We had first got to know about her when Dracula's Daughter, a four-piece band, brought her in to be the guest vocalist on a track that they recorded for our *Bad Wisdom* album. Dracula's Daughter were all women in their early to mid twenties, part of the young Helsinki art crowd, all very post-Britpop/YBA. For these four, Kristina Bruuk was a heroine from another age. To hear them talk reminded me of how women used to talk of Virginia Woolf or Simone de Beauvoir. We learnt from Dracula's Daughter that she had recorded some albums in the '70s for various labels, even one rumoured to have been produced by Lou Reed, but none had sold and all were long since deleted. When we asked Kristina Bruuk directly about her past records, her answer was too knowingly vague.

'Oh, it was all so long ago, I don't remember. There was talk. Andy said I was a star. I don't know.' It was as if she were in her late nineties, talking about her time with the Bloomsbury set in the 1920s, not just a woman in her early forties. When we asked the engineers at the Finnvox studio about her, we got the usual Finnish grunt then grin then silence. When pushed further with the help of a little after-session Koskenkorva vodka, they would hint at her legendary loser status. According to them, there was a time she would be at every after-show lig in Helsinki, always with some new buck on one arm and a bottle of champagne in the other. Then she would disappear for months, years. The

young buck was no longer the singer of an up-and-coming band or a tousle-haired, finely chiselled painter, but more likely a skinny roadie or even worse, a drummer. The bottle of champagne had been exchanged for a bottle of cheap vodka. The mascara was thicker. Then another disappearance, and the next time she would be seen it would be eating by herself in Helsinki's most expensive restaurant, dressed in Moroccan robes or in Versace.

'Hey Bill, have you noticed the scars on her arms? Some look kind of fresh to me. What do you think, Z? I think I still see her at the station sometime; I don't think she is waiting for a train.' Finns love to talk in this mysterious way. Jana, the guitarist and band leader of our session, told us about a time in the late '80s when Kristina had persuaded a local businessman to promote a concert of hers at the Helsinki Philharmonic Hall. Jana had been given free tickets and went along. The cavernous hall was less than a quarter full of people and most of them, he guessed, had got their tickets free, like himself. She appeared on stage playing a little glockenspiel, accompanied by a drummer from a local heavy metal band playing a pair of bongos. She left the stage in tears after only half a dozen songs. Stories like this only added to her mythical status in Z's and my head. The trouble is, we also have to deal with the reality of her. We would prefer she only turned up at the studio to do her vocals, but she insists on coming in every day and getting involved in the production side of things.

'I think of my songs as children. They are all I have, they are very precious to me. I have so many ideas for them. In my head I can hear how they should sound.' In reality, all her ideas are the same one: a four-note descending scale played on her broken glockenspiel over and over again throughout the song. To be fair she does have another one, but that just consists of a meandering glockenspiel solo. If we dare to mention, however politely, the odd bum note, she gives us her special withering but pitying look as if we don't appreciate the purity of atonal

and experimental music. 'My music is not your silly English pop songs.' We have never challenged her with the fact that she always chooses to write her lyrics in English, which we reckon must be at least her third language.

It sounds like I'm being flippant, but it's getting to the point where her mere presence in the studio puts us all – Z, me, the musicians, the engineers, all of us – on edge. She may be just sitting in the corner of the control room, saying nothing and drawing her dreams in her sketch book, but she is somehow able to emanate a vibe that is a mixture of paranoia and threat. She never says it, but what I imagine her thinking is, 'You don't understand, you stupid men, how could you? My precious songs, my art, my life, if you dare destroy them with your cheap gimmicks, your little tricks for the marketplace, I will . . .' What I long to tell her, but never do, is, 'Look Kristina, you know nobody else would touch your songs. The world is no longer interested in an old bag, ex-junkie like you, if it ever was. It is only because Z and I have a perverse love of pop's backwater that we are here at all. Nobody is going to get rich from this, nobody is ripping you off.'

A couple of months after Z and I had recorded the song 'Supermodel' with Kristina Bruuk, we received an old cassette in a scruffy envelope. There was no letter or covering note, just a Finnish stamp and Helsinki postmark. The cassette contained eight very badly recorded songs, each accompanied by a Spanish guitar and glockenspiel. We knew it had to be from the Kristina Bruuk whom we had worked with on the *Bad Wisdom* album. Z was instantly taken with the songs and was up for us catching the first flight out to Helsinki and recording an album with her. I questioned Z's enthusiasm. As nobody was interested in releasing our *Bad Wisdom* album why on earth would anybody think it worth releasing a whole album of these derivative dirges? Z has a persistent streak; he wore me down, and the songs grew on me. In time I thought, sod it, let's just go and make an album with Kristina Bruuk. From a commercial

standpoint, I justified the (relatively) minimal expense of recording it by convincing myself there must be a couple of thousand 'beautiful losers' around the world who could dig her thing. And I can't deny the part of me that identifies with those girls who live alone with their cats, who light candles around their beds, for whom suicide is the great seducer. Those dark dreamers and lonely watchers.

Today is our last day in the studio. We have to mix all thirteen songs in one session. It will be a long day. The bus pulls up at a stop near the Olympiastadion. The young boy next to me gets up with his mother to go. He gives me a glance as if to say, 'Who is this dishevelled, muttering man next to me, who keeps scribbling in his notebook?' I remember that I have not had a bath or a shower since we got here over ten days ago. The boy's face is lost in the surge of fellow passengers, all shoving their way to the exit. I want to tell him I'm not usually like this, at home I have a bath every night, fresh underpants and socks every morning. We have been working very long hours; we leave our apartment before 8 a.m. and don't get back until after midnight. No time to eat proper meals, scrub our backs or wash our socks. The bus fills with students from the university. A gaggle of nineteen-year-old girls chatter and giggle around us. They are dressed in brightly coloured ski-style fashions. I glance over at Z. He is lost in his notebook, too far gone even to notice these fresh young heirs to the future. They are naturally blonde, blue-eyed, innocent, freckled, all scrubbed clean and eager for life. I feel like a dirty old man, but no lust stirs in me; it's as if I'm watching some young rabbits playing in a field, not creatures I'm programmed to want to breed with. Maybe it's the ageing process, or maybe I just don't go for those radiantly healthy-looking types.

The bus is now out of the older part of Helsinki. Modern apartment blocks, open spaces. This is always my favourite part of the journey. A long, low bridge traverses a lake. On one side the lake is fringed with quivering reeds and tall, slim silver

birches. On the other side there is a building development: blocks of flats, drive-in fast-food outlets, a concrete-and-glass church. Finnish architecture always seems perfectly balanced with the country's natural landscape, whether it's the grand national romantic style of the late nineteenth century or the post-war modernism they have allowed to evolve without a backlash. The extremes of both these styles also sit comfortably with the more humble and ubiquitous painted clapperboard house and farm buildings. Somehow the silver birches in all their symbolic purity, the clear and clean lake and the building development providing homes for the inner city overspill always look like they are in perfect harmony. This may just be novelty value – if I lived here, the development might look the same to me as the new estates going up on the outskirts of Aylesbury. If you are the editor of the *National Geographic* and you are planning a feature on Helsinki, the lake is called Pikku Huopalaht.

After we have crossed the water, the bus turns right into Huopalahdentie. The passengers are thinning out. The students leave. Everything about them tells of lives happy and fulfilled. They will have no need for a Kristina Bruuk album. Rowans heavy with their red berries, silver birches and granite boulders as big as black cabs surround the clapperboard houses. The first house on the right is the one that has begun to haunt my imagination. In the garden under the empty trees is a solid work bench. On the bench is a large lump of granite – not the size of a black cab, more a big pumpkin. The rough, unfinished face of a demon is emerging from one side of it. I've been passing this house, on and off, for over a year. I've seen the garden blanketed in snow. I've seen the leaves in all their April green freshness on the branches above. I've imagined the feel of the dappled sunlight of summer dancing over the rock face sitting on its stout bench. I've watched the golden leaves of the silver birch tipple down over the still-cool head of rock as autumn cast its shadows. And as that half-emerged face waits for the

first snows of winter to come and cover it, I realise that the large round stonemason's mallet and the rusting chisels lie in exactly the same place as they did when I first saw them a year ago. Not once have they been lifted; not one blow has been struck, not one chip has flown from the block.

Why all this flowery prose? Because every time I pass this house, I wonder what has happened. Why has that demon been left unformed, held back from taking life? Are the sculptor's aged arms too withered to pick up his tools and strike the final blow? Has he upped and left with his wife's best friend? Is he on a year's teaching secondment at an American university? Has his wife threatened, 'You find a proper job or you're out'? In a moment of sublime creative ecstasy, did he run out into the road and get run over by the number fourteen? Or did he just get bored with sculpting and take up fishing instead? Every morning as we pass this house, my imagination delivers up another interpretation of the mystery of the unfinished demon. If this journey were carried out on a car or bike, I could pull up, knock on the door and be given some banal explanation to account for the lack of creative industry going on under the silver birches. But since I am on a bus, with no bus stop in sight, the mystery is left intact and the imagination is free.

For a kilometre or so we speed along the dual carriageway of Pitajanmaentie, the bus empty but for Z, myself and an old lady with a wicker basket on wheels. The thirty-five minutes have passed, the journey has nearly ended and the bus turns left into Pajamaki Estate. Had you guessed? Maybe it was obvious from the start? Kristina Bruuk does not exist. We have both fallen in love with an illusory muse. Our ultimate femme fatale is no more real than Venus on her half shell, or any of the other hundreds of figments of the imagination that artists have invented over the centuries to hang all their dreams on, when they can no longer hang them on the reality of the good woman back home.

We have been recording an album of fourteen songs, all

originals, to be released by 'Kristina Bruuk' at some point in the future. It all started when we were recording the *Bad Wisdom* soundtrack album. There was a girl sitting in the TV lounge; she had dark hair and dark dark eyes, but she was only thirty at the most. We then saw a picture of the same girl in a local music paper. We asked Jana, our musical director, if she was a singer. She was. Her name was Aija Puurtinen and she sang in a band called Honey B and the T-Bones. Z and I had already written a very simple song called 'Supermodel', which we wanted to be sung by a woman. We phoned Aija Puurtinen and asked her if she would like to sing our song. She heard the song and said yes.

Z and I have a friend in England who is a writer and performance artist called Chris Brook. He has a performance piece in which he tells the audience about how, as a teenager, he fell in love with Candy Darling, the beautiful Warhol superstar who was also a transsexual. Z would take the piss out of him mercilessly, all very good humoured but tiring just the same. Z and I wrote 'Supermodel' and invented the character of Kristina Bruuk as a gift for Chris Brook. Chris was rather disturbed, but I think flattered all the same.

But Kristina Bruuk wouldn't let go of Z and me. Every time the two of us got together we would tell each other stories about the life and times, the loves and tragedies, the fuck-ups and failures of Kristina Bruuk. It has to be said that Z was the leader in all of this. His flights of fancy would leave me gasping at the debauched depths to which our poor Kristina had sunk and the private creative ecstasies she had scaled. Then the songs started to pour: 'Do I Collapse', 'Muse And Comfort', 'Che Guevara's Eyes', 'Lost In Soho', 'Helsinki Angels'. We had her whole deleted back catalogue mapped out, the diabolical live album, the over-produced comeback failure and her disastrous affair with Peter Darkland (the leader of Gormenghast) in the early '70s, from which she has never recovered. The poor men in all her subsequent relationships have had to bear the brunt

of all her inner anger. We fell head over heels in love with her failings, her vanities, her pride, her lost looks, her childlike belief that one day justice will prevail and the world will recognise her genius. Of course, it took Z to recognise that what we had done was fall in love with the female anima inside ourselves. I didn't know I had one until he explained. Luckily enough for ourselves and Aija Puurtinen, none of these fucked-up passions was in any way projected on to her. We liked the way she looked, respected her professional attitude to the job in hand. We thought she had a brilliant voice, without which none of this ludicrous fancy could have taken flight. She even understood where we were coming from. Z and I demoed most of the songs in a small studio in Leicester called Memphis, then sent Aija a cassette. By the time we got out to Helsinki ten days later, she had more idea of what Kristina Bruuk should sound like than we did.

The history of pop is littered with male backroom dictators trying to turn the raw talents and unfocused good looks of innocent, eager young women into their very own femme fatale divas, at whose feet the world will fall and worship, making their creators very rich in the process. The bit that Z and I seem to have got wrong is that we want our female creation to be an eternally bitter and fucked-up outsider, to be adored by only the most discerning.

The number fourteen pulls up at the terminal. Z and I and the old lady with the basket on wheels climb off. This is the last time I will make this journey to work on the number fourteen. Today we have to mix all those songs we have spent the last few months dreaming about; then they will start their journey out there into the real world, where people decide to part with real cash (or not) for this CD or that.

Just remember, Kristina – whatever happens out there, we will always love you.

A CURE FOR NATIONALISM

10th June 1998

> For as long as one hundred of us shall remain alive,
> we shall never in any wise consent to submit to rule
> of the English, for it is not for glory we fight, for
> riches, or for honours, but for freedom alone, which
> no good man loses but with his life.

I don't hate the Germans, I don't hate the French, I don't hate the Argentinians. I don't hate the Irish or the Australians. I don't even hate the Americans and I certainly don't hate the Brazilians. All my hatred is stored and nurtured and kept in readiness for one people alone.

A couple of years ago I was at a party. Dave Balfe, long-time associate and friend, and I were having an alcohol-fuelled debate: why are men willing to go to war?

'I mean, is there any country that you'd be willing to go to war against, Bill?'

'England,' came the instant reply. A flippant answer maybe, but it was connected to something far deeper, some immovable, illogical, unknowable lump at the heart of my being. I have lived in England all my adult life. My mother is English. The mothers of my children are English. Most of my friends are English. So is my tough talk just the phony patriotism of the

expat? Nostalgia for a long-lost childhood, a time of innocence, a never never land? This feeling is not toward any one English person in particular, or even a whole load of English, but that indefinable thing that the word England has come to symbolise for me.

The English have never hated the Scots, never felt their culture threatened by the Scots. They may have thought us ludicrous, pathetic, drunk, dour, tight, funny, romantic, but not worthy of their hatred. They have allowed their hatred to wander across the majority of the above-noted nations, taking in wogs, yids and Pakis on the way. The Scots may have had their own internal religious differences, clan rucks, Highland versus Lowland, Edinburgh versus Glasgow, but we have for hundreds of years, generation to generation, been able to unite and focus all our hatred on one nation, one people, one enemy alone. (Of course, the better-balanced, less insecure and more mature Scots have risen above such backward-looking childish bigotry.) So where did this begin? How did it start? I look into my personal history.

If blame is to be laid, it should be at the feet of a handful of aged and godly spinsters and widows who taught me through my primary education. From them, my classmates and I learnt one history: William Wallace, Robert the Bruce, the glory of Bannockburn, the tragedy of Flodden, the Union of the Crowns, John Knox, the Covenanters, 1707, the foolishness of the '45, the cruelty of the clearances and the Scottish renaissance of the nineteenth century that provided the world with all the great inventions for the twentieth century. In music lessons we learnt to weep as we sang 'The Flowers of the Forest' and feel pride while singing 'Scotland the Brave'. For us lads Robert the Bruce was the ultimate hero of these impassioned history lessons, Bruce the king in Wallace's wake, who crowned himself, watched the spider try and try and try again, united the nation and took on the vastly superior might of the English army at Bannockburn on that June day in 1314 and thrashed them. In

A Cure For Nationalism

the playground we re-enacted every moment of that battle over and over again. There was a local beauty spot near to where we lived in Galloway called Glen Trool. There Bruce had a minor skirmish with the English, a couple of years before the decisive Bannockburn. He and his men rolled boulders down the mountainside on to the unsuspecting Englishmen below. My mates and I would cycle up to Glen Trool to practise our boulder rolling. We learnt by rote the Declaration of Arbroath, which I used as an opening to this piece. We learnt that the world recognised Robert Burns as the greatest poet ever. Yes, we learnt Wordsworth and Coleridge, but the poem that resonated the longest and deepest went like this:

Scots wha hae wi' Wallace bled
Scots, wham Bruce has aften led
Welcome to your gory bed
Or to victorie.

Now's the day, and now's the hour;
See the front o'battle lour;
See approach proud Edward's power –
Chains and slaverie.

Wha will be a traitor-knave?
Wha can fill a coward's grave?
Wha sae base as be a slave?
Let him turn and flee!

Wha for Scotland's king and law
Freedom's sword will strongly draw,
Free-man stand, or free-man fa',
Let him follow me!

By oppression's woes and pains!
By your sons in service chains!

We will drain our dearest veins,
But they shall be free!

Lay the proud usurpers low!
Tyrants fall in every foe!
Liberty's in every blow!
Let us do, or die!

We wee lads didn't stand a chance. The power of poetry should never be underestimated. In this one poem, Robert the Bruce's imaginary address to his troops on the eve of Bannockburn, Burns ensured that for ever more young lads coming through a Scottish education would know who the enemy was. We only needed to go into the toy shop, the treasure trove of desires: everything we wanted, from Corgi cars to Airfix models, from Hornby trains to Raleigh bikes, would have somewhere on them 'Made In England'. Why oh why did it never say 'Made In Scotland'? And after my family moved south and I grew through my teenage years, the bands I was into, the girls I fancied – somewhere on all of them was written, even if the ink was invisible, Made In England. A resentment festered. At least nowadays with the rise of Made In Taiwan, Made In China and the might of the Sony Playstation, the insult of Made In England has begun to lose its oppressive power to younger generations of Scots. It's almost quaint.

When I was a boy we had no national anthem. When we went to the pictures we were supposed to stand as 'God Save the Queen' was played. It is only in the past few years that 'Flower of Scotland' has been adopted by the people as our national anthem. It was a song written in the 1960s by Roy Williamson, one half of popular folk duo The Corries. Unlike most national anthems, it has no official status. It was never commissioned by a government. We were never told, 'You must sing this song'; we chose to. What Englishman has ever sung 'God Save the Queen' except when duty called? Like the Burns

poem above, 'Flower of Scotland' takes 1314, Bannockburn, the overthrow of oppression, as its central theme. What other country would have as its national anthem a lyric that celebrates a battle with its neighbour that took place almost 700 years ago?

We learnt we had a better education system, a fairer judicial set-up. We learnt we were a small nation of five million for ever more physically joined to a far larger nation of fifty million, a neighbour grown fat and wealthy on suppressing less warlike or weaker people, on slavery, gunboat diplomacy and empire building. The very word England has somehow come, subconsciously or not, to symbolise everything from the playground bully to the overbearing wife, from the lack of career opportunities to the oppressive political and religious power from above, as opposed to the power of the common people. The date 1314 rings down the centuries as a symbol of the eternal hope of rising above the forces of oppression, of self-determination and yes, of that ridiculous (and I'm afraid almost meaningless) word, freedom. But a word to 'let us do or die' for all the same.

I'm focusing these thoughts and writing these notes as I'm sitting on the shuttle, heading for Paris. Outside, the hop fields of Kent flash by. I'm with my son James. Tonight Scotland face Brazil in the opening game of the 1998 World Cup. James and I are on our way. It's his birthday present from me. I didn't even bother trying to get tickets. I've no interest in sitting in a gigantic, antiseptic stadium stuffed with 40,000 journalists, 30,000 Frenchmen and only 10,000 with any real interest in the game either way. I would just be filled with too much loathing for the whole hype and over-commercialisation of the World Cup to enjoy any of it. On my reckoning, the best place to watch the match is in some Parisian bar crammed with fellow ticketless Scots screaming at a TV in the corner.

James is English in every sense other than his surname. James has never had the patriotic education that has set my prejudices in granite, never been humiliated with the insult

Made In England on all that he desires. Football is important to James, it's what binds him and his mates. He plays well in a schoolboy sort of a way. At the age of eleven he has far more understanding of the game than I will ever have. For some reason he threw his lot in behind the Scottish team during the qualifying games for Euro '96. I've never tried to indoctrinate him in any of the above – 1314 and all that. For his sake I hope supporting the Scottish national football team is no more than wanting to be a bit exotic, has nothing to do with celebrating chips on shoulders, backward-looking visions of the future and all that blinkered patriotism can lead to. There are a number of other Scots on the train, paid-up members of the Tartan Army. James is wearing his Euro '96 replica top. I'm dressed in civvies. My 1990 World Cup replica shirt is safely at the bottom of a drawer and my kilt hangs silently in the wardrobe. I've not even a tartan scarf around my neck, but in my work room back home I hung up my eight feet by six feet saltire before leaving this morning.

James and I head down to the bar for refreshments. On the way back we bump into Tony Crean and Andy McDonald. Tony Crean I have written about in 'Robbie Joins the Jams'; he was the man behind the *Help* LP, raising money for the War Child charity. Andy McDonald created the label Go!Discs, home of Billy Bragg, the Beautiful South and the reinvented Paul Weller, amongst others. He sold the label a couple of years ago and has now got a set-up called Independiente. Tony Crean works with him on the marketing side of things. Although Andy McDonald has an English accent, there is no doubt about his roots or why he is on the train. But Tony Crean is an Evertonian scouser of Irish extraction. He is wearing a long-sleeved yellow T-shirt with four numbers in red emblazoned across it. One, three, one, four. 1314, the only date in history that counts. I introduce James; they seem to be impressed and flattered that he bought the first Travis single (the first record released on the Independiente label).

'Why the T-shirt, Tony?' I ask. He explains it is a Primal Scream one, and that he has never supported the English national team. One of the things I always loved about living in Liverpool was that it never felt like you were living in England. The locals always considered themselves Liverpudlians above and beyond any nationality. Maybe this is because of the massive majority of its population being of Irish extraction and because, as a great seaport, the city had its sights set on the rest of the world and not on London, let alone such cultural backwaters as Manchester.

Crean and McDonald have been promised tickets for the match, although some shady deals have yet to be done before they have them in their hands. They are supposed to meet a go-between in a blue suit and a yellow shirt at the station. Conversation drifts towards the current rash of World Cup records. This is done in all innocence as far as Tony Crean is concerned, but I am desperately trying to ignore the fact that such things exist. Not because of a mere dislike of the genre – the reason is far more complex and petty than that . . .

Late last year I was contacted by a character named Rick Blasky. Blasky is a man who puts promotional music projects together for big business. 'Free Britpop CD with each pair of Doc Martens you buy', that sort of thing. He had also overseen the 'Three Lions' project for the FA for Euro '96. From a commercial and every other possible aspect, 'Three Lions' was considered the greatest football record ever made, a record that actually tapped into the emotional heart of the English game without patronising the fans or the footballers. Rick Blasky is an ambitious man. His current ambition was to co-ordinate the exploitation of all music connected with the '98 World Cup. He wanted to bring together on one album all the music used in TV adverts by the official sponsors, music used as the soundtrack to the slow-mo rerun shots that TV loves to show us and all the official national team singles from around the globe. It would be an album that could be simultaneously

released and promoted worldwide and sell millions of copies, thus making a lot of money for all concerned. He also told me he was a keen football fan, a lifetime follower of Leeds United or Sheffield Wednesday – one of those Yorkshire-type teams. He told me he understood the psyche of the modern football consumer. He ate football, slept football and drank whatever the sponsor was drinking. I believed everything he told me.

Blasky wanted me to write and record the Scottish track. He had already struck a deal with the Scottish Football Association. They were happy with the idea of me doing it. I told him I needed a couple of days to think about it. After the 2K 'Fuck the Millennium' record, I had vowed one more time to myself never ever again to attempt the hit-making process. But here I was being offered the chance to write and record the official song for Scotland. A chance to tap into all the things that I've already described above, but in the context of modern culture. Something that could stand the test of time and work for the moment. Something that all Scots everywhere around the world could feel proud of. Something that wasn't like those past embarrassing official Scotland football records. Something that could be as good as sodding 'Three Lions'. To steady my emotional state, I went for a drink with my friends Ian Richardson and Nick Coller, engineer and programmer/keyboard player respectively, with whom I've worked over the years. If I did the project, I wanted them involved.They convinced me I had to do it. They were both very excited at the idea of the project. 'You'll regret it for the rest of your life if you don't, Bill,' was the general vibe. The only problem was they were very much English through and through, Richardson a regular at English international matches.

On the train home I had the whole thing worked out in my head – the tune, the words, the video storyboard, even the *Top of the Pops* performance choreographed. I ran from the station back to my house, laughing, shouting and singing all the way. My heart was fit for bursting. All of my experience in pop

music had a reason after all. Everything I had gone through and learnt was leading to this point, to write this song, to make this record.

The opening shot of the video clip would be a blue sky, diagonally crossed by the white vapour trails of long-gone jets. The only sound that of the curlew and skylark. The camera angle would lower to reveal the grandeur of a wide and lonely glen, maybe a stag, maybe some Highland cattle. The only building in the vast emptiness a one-room, nineteenth-century Clachan-style school. We begin to hear the strains of a melody played on an old upright piano. The tune is in three/four time, not dissimilar to 'Flower of Scotland'. (In fact almost exactly the same, but we will sort that out later so that no copyrights get infringed.) We hear the opening line of the song, sung by children's voices – 'From Stranraer to Lerwick/From Stornaway to Dunbar' – before the film footage cuts to inside the classroom. A middle-aged teacher behind the piano, twenty-three children of mixed age up to about twelve years old. At the front of the class stands a small lad with a side drum and a lass with a full-size set of bagpipes. The lad brings in the second couplet with a roll on his side drum: 'From Oban to Wishaw/From Elgin to Dalkeith.' By now the lass with the pipes has joined in and so has a small, ragged but proud platoon of the famous Tartan Army, marching through a small Scots town led by three or four scruffy pipers, on their way to the green fields of France.

In comes the first sustained power chord, from a lone guitarist standing atop one of Glasgow's tallest high-rise blocks. The whole of the industrial heartland of the central lowlands is stretched out below him. 'From Govan to Pollock/From Bearsden to Largs' . . . With each line the sound is growing, getting bigger as more and more people are joining in. Mothers standing at an inner-city school gate, men in a shipyard (if there is one still working), a street full of shoppers all singing as one, like an advert for a building society. 'From Ardrossan to

Airdrie/From Carnoustie to Banff.' So here we go and it's into the first chorus, backed up with the full Bob Clearmountain production values of a rock epic.

> So come on Scotland
> We can hold our heads high
> So come on Scotland
> It's time to do or die.

As well as the chorus featuring film footage of packed singing and swaying bars in Govan and Leith there will be slow motion clips: Sean Connery in *Highlander*, Mel Gibson in *Braveheart* and Ewan McGregor running down the streets in *Trainspotting*. We are talking about milking everything but the White Heather Club. By the end of the first chorus, every ounce of national pride will have been harnessed. Every Scot around the world will be greetin, either with emotion or at the cynical crassness of it all. And then. And then. A sixteen-bar instrumental refrain featuring at least a hundred guitarists, all playing the same melody in unison! Every Scottish guitarist that ever made it into the UK Top 40 would be invited, from the lads out of The Bay City Rollers to Primal Scream; from Nazareth, Big Country, The Bluebells, Orange Juice, The Alex Harvey Band, Josef K to The Humblebums, the lot – and all the other ones I never knew about. All playing the same melody but in a hundred different styles, from the controlled slide guitar of that bloke in Texas to the howling feedback of The Jesus and Mary Chain; maybe even some of that stinging pseudo-Ernie Isley whine that Edwyn Collins likes to have an ironic go at.

The second verse. Time to feature all those embarrassing singers that Scotland has produced, from Kenneth McKellar to Marti Pellow; from Lulu to Moira Anderson, from Frankie Miller to Craig and Charlie Reid. Each taking a line, like in that Lou Reed song advertising the BBC that was a hit in '97. Instead of leisure activities, the first verse would list people:

A Cure For Nationalism

For William Wallace
And Robert the Bruce
For Archie Gemmell
And Denis Law
For Billy Bremner
And Big Jim Baxter
For Jock Stein
And . . .

For the video clip each of the singers would be filmed separately while doing their shopping, making a cup of tea, walking the dog, sitting in a bar. Kicking a ball with their son. Cut into this would be black-and-white footage of the 4–3 defeat of the English '66 World Cup Squad and other epic matches over the decades, including the goal that David Narey put past the Brazilians in 1982.

Second chorus bigger than the first. Then the whole track breaks down to a lone piper on the other side of the glen playing the melody. But he is joined by the full pipe band, marching around the headland like in 'Mull of Kintyre', then it's back to building up the sound with all the guitarists again. This instrumental section would grow over thirty-two bars, by which time there would be *1812 Overture*-style orchestration going on, before the whole lot crashed into a double-length chorus bigger than Ben Nevis and Loch Lomond put together, the Tartan Army ten thousand strong marching on Paris, up the Champs-Elysées, under the Arc de Triomphe, saltires flying, kilts a-swirling, drummers drumming and pipers piping and grown men crying with pride. By the end, the Scottish lion would be truly rampant and those three other skinny lions wouldn't stand a chance. We can do it this time. We can get to the second round.

I phoned my dad, who was in his eighty-fifth year. He wrote a song in his pre-war youth about his home town, Melrose in the Scottish borders. Over the years this song of his has been taken up by the citizens of Melrose as their town anthem, a

fact of which he is rightfully very proud. I wanted to tell him about the offer that had been made to me. This maybe was going to be the first thing that I had ever done that he would be able to see the point in. The next morning the vision wasn't so clear. I started remembering about the reality of the long drawn-out process it would be. The compromises I would have to make along the way. Fear and loathing started to flood my soul at the very idea of entering a recording studio to make any sort of record. Either that or I was just shit scared of not being able to deliver the goods. A couple of days later I got a letter from my dad. For some reason he was staying in the Holiday Inn, Aberdeen.

Dear Bill,
In an odd moment I dashed down the first verse.
It's to the tune of 'The Lights of Aberdeen'.

SCOTLAND V THE WORLD. 1998.
We've followed fitba'a oor life,
And many a match we've seen,
Sae here's tae Scotland's Chosen lads,
They are the best that's been.
They've skelpit aa and every team,
That dares tae come their way,
They'll win the cup and lift it up,
The Champions of the day.
Sae here's tae Scotland's fitba team,
We cheer them on their way,
Sae on ye go ye chosen lads,
And see ye win the day.
Use aa yer skill
And beat Brazil,
When they begin tae play
Ye'll win the Cup and lift it up,
The Champions of the day.

Greetings to all the family,
Dad.
PS Tear the thing up if you want to.

Somehow, the innocence of it got to me. I don't think I could explain to him that even if you got all the skill in Scotland packed into one man, it wouldn't come close to what Ronaldo has reportedly got in one leg. I decided not to make any firm decision either way for a fortnight. In the meantime I made a trip to Edinburgh to visit a couple of friends to talk to them about my ideas, both to use them as a sounding board and find out if they wanted to be involved in some way. One was Kenny McDonald, who has a music management company. He looks after the affairs of The Proclaimers, amongst others. He is a long-term Hibs supporter and a travelling member of the Tartan Army. He also makes records and was already working on his own idea for a Scottish World Cup record. He was going to go for the complete antithesis of what I had thought about. He had been listening to a lot of Astrud Gilberto lately and was aiming for that light and airy samba feel, with a breathy girl singer. The song title to be 'Je t'aime, l'Ecosse'. It made sense. I also met up with the actor Tam Dean Burns, who had just started rehearsing for a new Irvine Welsh play. We sat in a bar just off the Royal Mile and sorted Scotland out. In the morning, it was still raining. On my return I phoned Rick Blasky and told him I would be unable to make the record, but Kenny McDonald had a good song. He said he was going to approach Del Amitri.

A couple of months after that, some time in March, I heard a programme on Radio Four late one night. They were talking about the up-and-coming football records for the World Cup. They played a snippet from the Echo and the Bunnymen/Spice Girls one, a bit from 'Three Lions', then a chunk from what the host of the show predicted would be the anthem of the whole event: 'Vindaloo' by Fat Les. This 'Vindaloo' record sounded

[127]

brilliant, captured everything a British novelty record should. Went straight to the heart of the English beast and dragged it back, screaming, shouting and stomping its way from Blackpool Pier to the top of the charts. The presenter then explained that Fat Les was, amongst others, the comedian Keith Allen and 'Vindaloo' the first release on the artist Damien Hirst's record label. My emotions were thrown into confusion.

Back in 1976 when I was designing and building the stage sets for Ken Campbell's adaptation of *The Illuminatus* at the Liverpool School of Language, Music, Dream and Pun, there was this bloke called Keith who I used to get on with. Keith wasn't working on the show, he was just the boyfriend of one of the girls who was. Keith was loud, opinionated and a laugh. Keith and I would drink mugs of tea together in O'Hallaghan's. The first day that I met Keith was also the first day I met this other youth, who was going to be playing guitar in the show's band. He was only 17, a spotty little Jewish kid, but he already had a white Telecaster and everybody said he was a brilliant guitarist. He was. A few months later, this lad joined a band I was in called Big In Japan as our lead guitarist. Much later, he had a band of his own called The Lightning Seeds and wrote a song called 'Three Lions'. He was called Ian Broudie. It was at the same table in the tea shop where I first got talking to Ian Broudie and this Keith bloke that I met a Bowie clone called Ian McCulloch, who was later in a band called Echo and The Bunnymen. My life became intertwined with Broudie's and McCulloch's, me managing The Bunnymen and Broudie producing some of their better records. There were feuds, fall outs, make ups and fall outs again. Too many medium-sized fish in one little pool.

In 1986 I went to the Glastonbury festival with friend and future creative partner Jimmy Cauty. He had some acid with him, and I took half a tab, the first since the early '70s. It was dark and pissing down with rain. The Bunnymen were on stage doing a set of cover versions. I had not seen any of them for

over a year. Things had got complicated. My mind was in a strange place. The Bunnymen had a laser light as part of their show. I had never seen one before. The acid was telling me that if I jumped high enough I would be able to catch the beams of laser light in the rain and put them in my pocket. Save them for a rainy day. I couldn't jump high enough, so I took refuge in a marquee, lying on my back on a wooden bench. My eyes were tightly closed. On stage, The Bunnymen were playing a version of the Doors classic 'People Are Strange'. Then I started to hear this voice.

'Bill Drummond, I know who you are. Bill Drummond, I know who you are. Bill Drummond, I know who you are.' The voice was getting louder and louder. It was obviously one of my demons coming to get me, or maybe a messenger from God, or even God himself. Maybe I was dead, and this was it. I couldn't move. Maybe I was in my coffin already. 'Open your eyes, Bill Drummond. I know who you are. Open your eyes.' This sounded like an order from some almighty being that must be obeyed. I opened my eyes. Six inches away from them was another pair of eyes, a wild, staring, demonic pair of eyes. I recognised the face but I didn't know where from. It wasn't the face of God, though.

'Who are you?'

'Ha ha ha haa! Don't you know? I know who you are, Bill Drummond. I know all about you.' I shut my eyes and went back to thinking I was dead. Being dead felt better than staring into those eyes. After a while, the voice went away. But over the weeks, months, even years that followed, the memory of that voice and those mad staring eyes haunted me. I felt sure I had known that face from somewhere else. A past life? A childhood nightmare?

In 1990 New Order made a football record for Italia '90. It was considered, by those who consider these things, to be the first good football record ever made. I had lived through the 1980s without a TV set in my house; I'm not superstitious in any

traditional sense, but in the past when watching TV I always got the sensation that there was a force inside the TV set that was sucking something out of me. I didn't like that sucking sensation. A side effect of this lack of TV was that a whole section of modern culture had evolved that I had no idea about. 'World In Motion' went to Number One and Gazza cried and the English nation fell in love with him and somewhere I did see the video for the New Order record. Along with the lads and lass in the band and the friendly face of John Barnes, there was this other face. The face with the eyes and the 'Bill Drummond, I know who you are' voice. I had a breakthrough, I suddenly knew it was not the features of a character in a past life or childhood nightmare – it was that Keith bloke I had met fourteen years earlier in the Liverpool School of Language, Music, Dream and Pun, on the same day that I met Ian Broudie.

'Is that bloke called Keith?' I asked whoever was watching the video with me.

'Yeah, Keith Allen. You know, *the* Keith Allen.'

'What does he do?'

'He's a comedian. You must have seen him on TV. Those Comic Strip spin-off things.'

'Oh, I didn't know.' And that was that; it was only a comedian. It was not some demon coming to take my soul after all. Those eyes and that voice stopped haunting me. Then some time in late 1995, I got a letter from a theatrical agency telling me that one of their clients (unnamed) was interested in buying the ashes of The K Foundation's million quid. The ashes weren't for sale, but I wanted to know who the interested party was. The agency wanted their client's privacy respected, so wouldn't tell me the name . . . I made some enquiries elsewhere and found out that it was Keith Allen. It began again. In moments when I was caught off guard I would find myself again being haunted by those eyes and that 'Bill Drummond, I know who you are' voice. My rational self can put it down to the acid flashback side effects searching out cracks in the

mask. I'm sure if Keith Allen himself were to know about this he could take it as a compliment to his acting abilities. Keith Allen has now made quite a name for himself in films playing psychopathic, possessed hard men. We have almost forgotten he was once just a comedian.

That night after I heard the three English World Cup football records I fell asleep with the 'Vindaloo' tune going around and around my head. I had a dream. Ian Broudie, Ian McCulloch, Keith Allen and myself were sitting around that table in the Liverpool School of Language, Music, Dream and Pun.

'Why didn't you make your record, Bill? You know you were supposed to make it. It was agreed a long time ago. We made our records, why didn't you make yours?' Broudie and McCulloch can be argumentative, difficult sods at the best of times, and I'm sure those that know Keith Allen would say the same of him. In my memory of the dream I can't remember trying to put my case to them. But I do know that since that dream I have found myself sitting on the bus, staring out the window, my mind going over and over that dream. Trying to put my side of the story. When that fails, attempting to put each of the three of them into the dock. Broudie first.

'Look Ian, you're a Liverpudlian Israelite with a Scottish name. How could you write the anthem for a xenophobic nation that's still suffering from empire-loss syndrome? Your middle name is Zachariah, not George.'

McCulloch next. 'Mac, why England? Ian McCulloch is a name straight out of the Highland clearances. It was never heard once in the mists of Avalon. A song for Liverpool, but not this.'

Lastly, the comedian. 'I was told you were Welsh. So what happened to the Land of Your Fathers?'

Pathetic of me, I know. It's only pop music. Football records at that. There have been at least a couple of occasions over the last month or so where I have found myself in conversation with people and they start giving it, 'How could Echo and The

Bunnymen stoop so low as to record a football record? And even worse, a football record with The Spice Girls?' I don't know if I'm supposed to defend The Bunnymen or agree with whoever it is, but in those situations I never come clean about all my twisted nationalism, bad dreams and guilt-seeking acid flashbacks.

Back in the here and now. The shuttle is already into the outskirts of Paris. My son James is explaining to Tony Crean why Ocean Colour Scene are his second-favourite band and how he hates The Spice Girls, and Tony Crean is telling us about his exploits on the Italian Riviera during Italia '90. We pull into the Gare du Nord. We say our farewells and James and I set out to walk to our hotel to check in before finding somewhere to watch the match.

Now's the day, and now's the hour.

11 June 1998

Less than twenty-four hours later, James and I are back on the shuttle. The Paris suburbs are flying by and we are heading for Waterloo (not ours). The match is history. We had a great time. We watched the game on a big screen set up in a square by the Hotel de Ville. The square was packed with about two thousand of the Tartan Army and a sprinkling of Brazilians – total carnival atmosphere. When Collins hit his penalty home it was like Scotland had won the World Cup. But that's enough about the football. As much as Alan Hansen might go on about the mistakes in defence, this isn't about football. It isn't about beating Brazil or Norway or Morocco. It's about the celebration of a thousand years of shared history. There had been a huge pile of *Daily Record*s (the Scottish tabloid) at the Gare du Nord newsagents, shuttled in for the tartan hordes. I got my copy. It was front-to-back coverage of the match from every possible angle. Stories about the empty Glasgow streets, about the bloke who, while buying an ice cream, was left stranded by the coach that was heading for Paris with his mates, his money and his

ticket. The best piece was written by Joan Burnie, the paper's regular agony aunt. She had made an appointment at the hairdresser's to coincide with the match. She wanted to have nothing to do with it. I found myself agreeing with all her criticisms. They were all the usual ones.

> This so-called beautiful game which is a substitute
> for life for too many . . . the world racing towards
> oblivion and destruction with flood, famine and war
> while 22 sweaty men run up and down a few yards of
> grass trying to kick a piece of leather into a net . . .
> Men unable to shed a tear or show a decent emotion
> throughout the birth of their children and the death
> of a relationship but who so easily weep when their
> side loses or even when they win. The same men
> who can happily divorce their wives, dump their
> girlfriends, neglect their children – but ah the team,
> especially the national team, the country, bonnie
> Scotland, our flower, that is supported for ever more.

Joan tells it like it is, in her best tabloid prose.

> The average Scottish follower of the team is a
> lovesick masochist. He wants his team to do him
> wrong. He wants to lose. He expects it. Comfortable
> with failure. Chips on both his Caledonian shoulders
> keeps him a perfectly balanced individual.

Of course, she is right. Every word of it. I'm the classic case. I was present at the births of all five of my children; not once did I well up with the mystery and wonder of it all, but just the notion of Scotland is enough to make me weep. This morning I sit silent on the train. I feel totally empty. Not because Scotland lost. Even if they had won I'd feel the same. It's investing all that emotional energy into something you have no control over.

At least Bruce's men were willing to give their lives to defend Scotland's sovereign statehood. What do I or any of the Tartan Army ever actually do for Scotland? For the good of its appalling nutritional standards, its chronic abuse of alcohol, its stagnant economy, its highest rates of cancer in Europe? 'Let us do or die' – what a lie. We do nothing but die. Forget fantasy football, this is fantasy nationalism. None of us really gives a shit about Scotland, even those that vote SNP. We are all just running away from our pathetic little lives. Running away from our wives, children and meaningless jobs. Wrapping ourselves in a flag, wallowing in 1314 and all that, bonding in our hatred of the common enemy, England. The only real history is what we create in our own lives; the only date is now; the only real enemy is ourselves. Nothing revelatory there, but I need reminding. The only saving grace of all this bonnie flower of . . ., lion rampant, tartan-bonnet-with-ginger-nylon-hair-attached nationalism is, we all know it's silly. It is a send up – nationalism as a postmodern jape. Thank God we are not about to do or die like some tragic former Yugoslavian state. We have never had an empire, never wanted one. Thank God we do not suffer from a crippled national psyche that makes us go around kicking Johnny Foreigner and smashing up continental bars and thinking we are doing it because we and our pompous has-been country deserve respect.

Right, I feel cured of the phony nationalism and am ready to get on with the duties of being a modern father and citizen of the world. Well, that's until next I hear the pipes calling across the glen.

A CHRISTMAS CAROL

24 December 1997

'Bill, are you going to come to midnight mass with us?' asks the maternal grandmother of my two youngest children.

'No, I'll stay here. I've still got some presents to wrap. You go.' I don't mention that such Episcopalian habits as midnight mass are hardly to my Presbyterian taste. The merrymakers leave with their goodwill to all mankind. The house falls silent and I pull out my black notebook. I've got about an hour to set down this story. It's a story about the events that happened two Christmases ago. If I wait any longer before I write it down, I will begin to forget all but the mere facts.

In October '95, Jimmy and I had been talked into signing a contract by Marc J. Hawker, a Glaswegian artist, in which we agreed to a twenty-three-year moratorium on all K Foundation activities. It would be a relief to get out of all that 'justification of past deeds' stuff. But first, we felt duty bound to fulfil our obligations, which meant screening the film *Watch The K Foundation Burn a Million Quid* at various odd places up and down the country. The last screening was to be in the NCP car park in Brick Lane at the heart of London's East End.

It often happens with Jimmy and me that we try to cram too many things into one event, one record, one lifetime . . . we can't stop ourselves, and we usually end up confusing,

complicating and finally undermining whatever power the original work had. As well as screening the money-burning film on the outside wall of a huge white-washed warehouse for whoever turned up, we decided to get a round of drinks in for everybody as a final gesture of thanks, using the loose few thousands we still had rattling around the bank account. It was the least we could do. The round of drinks was going to comprise 6,250 cans of Tennent's Super. The reason for this exact number had nothing to do with the amount of people we thought might turn up to watch the film, our generosity or even numerology. We had gone out and bought one can. Measured its size: six and five-eighths inches high by two and nine-sixteenths inches in diameter. Then we worked out the smallest solid cube that could be made from a load of these cans. 6,250 was about the size of it. It would stand five feet six and a quarter inches high. It was also going to weigh three tons, six hundredweight, two stones, one pound, six ounces.

A cube, the perfect symbol of modernism. If Western art of the twentieth century is remembered for anything in a thousand years' time it will be for Marcel Duchamp's one joke being repeated endlessly by a million other artists, and the cube. Why the cube works far better than the sphere I don't know. Each shape is as pure as the other, but the sphere is never as satisfactory. You always get the vibe it's going to roll away from you. Maybe the cube is male and the sphere is female and it's just down to the fact I can identify with it.

Why Tennent's Super? That's obvious, but seeing as I'm writing for posterity and when posterity gets round to reading this, the symbolic position in '90s British culture of Tennent's Super may have long since been forgotten . . . The contemporary British street drinker makes a decision early on in his street-drinking career. He commits himself to drinking either the continental and upwardly mobile Carlsberg Special Brew – remember those 'Probably the best lager in the world' ads – or he goes for the patriotic Tennent's Super, in its red, white and

blue (and gold) cans. Of course, the most important information any serious street drinker needs when deciding what tipple to go with is the ratio of percentage proof to cost to cubic capacity, i.e. what is the cheapest way to get the desired effect. Carlsberg Special Brew and Tennent's Super are neck and neck, so it's all down to patriotism versus the lure of the cosmopolitan.

You are probably thinking, 'This is a load of bollocks, Drummond's just making it up because he thinks it's funny.' I challenge you to go and ask a sporran of street drinkers, the next time you are trying to ignore them, why they prefer one of these strong lagers to the other.

Of course, all this could change overnight if one of the other big breweries brings out another strong lager at a more competitive price. In the '60s, street drinkers favoured VP sherry, which was then superseded by strong cider, then at some point in the '80s these two lagers cornered the market.

First we went to the offie for our rather large carry-out. They didn't have enough on the shelves or even out the back so we contacted Tennent's head office to see if we could buy the 6,250 cans direct from them. No, they could only sell to licensed premises. I knew the landlord in a pub in the next village along from where I live, so I went and asked him. He contacted his dealer and a bargain was struck.

The dealer lived on a farm. His barns were filled with cases of alcohol hidden by bales of hay. Hundreds of thousands of pounds' worth of booze with no security, just the straw, like something from a prohibition gangster movie, only set in the Home Counties and not Chicago. The dealer was a good bloke, he liked what we were doing. Thought it rather sporting of us to be so generous with getting our round in. Did I hear him whistling an old Badfinger hit? He took it upon himself to see if Tennent's would be interested in getting involved in some way. Maybe they would like to offer some sponsorship in exchange for upping the media profile of their superior strong lager, the

way Beck's and Absolut have used the sponsorship of art in an attempt to up their hipness. Tennent's declined. They stated that Tennent's Super is primarily drunk by street drinkers and Afro-Caribbeans, and that neither of these niche markets could be successfully reached through advertising and sponsorship. In fact, my continual use of the term 'street drinkers' comes from their response. I'd never before heard this way of describing the homeless alkie dregs of our society, who litter our street corners and frighten our children. How cynically do these marketing ploys get discussed in the boardrooms of the big breweries? How important is the continued support of the street drinker to the market share of Tennent's? If I was to dwell on this for too long my conscience might get pricked, and I'd feel I should go out with a placard proclaiming that something is rotten in this society of ours – or is it Denmark? (Don't you just hate those subtle literary references that writers shove in, hoping to impress the reader while at the same time pandering to the writer's own literary vanities? You know the ones: 'April may be the . . . but this December was fuckin' worse.')

We got our 6,250 cans of Tennent's. They were delivered to my garage. In fact we got 7,000; we got a better deal that way.

Next we tracked down a flag maker in the *Yellow Pages*, George Tutill Ltd of Chesham. They proudly proclaimed they had been making flags since 1837. Their product had flown over every battlefield upon which our Tommies had claimed a victory and even over some of our more memorable defeats, including the charge of the Light Brigade. We wanted to have a large square Union Jack made up for us to drape over our cube of 9% proof strong lager. I think I've written elsewhere about Jimmy's and my love of the Union flag. From the cuddly comfort of Mark Wallinger through to the threat of the UVF, it's got to be the grooviest flag in the world. I enjoy being one of those belligerent buffers who get all worked up when I see a Union Jack flying upside down. As well as the large square one, we ordered up a dozen or so banner-shaped ones that we could

hang around the warehouse walls of the Brick Lane car park, Nazi rally-style. We had planned to leaflet all the haunts of London street drinkers about the 6,250 cans of free lager available in a Brick Lane car park on 8 December. We believed that even Carlsberg Special Brew drinkers would turn up for the party.

Some time in early December we started to get cold feet. We began to have a vision of a Stewart Home novel coming to life, with us justifiably caught in the middle of it. It's one thing to expect sad old KLF fans to turn up and watch an hour-long silent film of their former idols burning a million quid of what was originally their hard-earned grant, dole or pocket money. But then to add thousands of desperate, bitter and angry homeless alkies and the even-angrier Bangladeshi residents of Brick Lane, who'd got wind of a mass fascist-style rally going on in their back yard . . . It was obvious what was going to happen. Or so Disobey, the promoters of the event, explained. Really, though, what swung Jimmy's and my change of heart was our friend Gimpo's version of what he thought would happen: '*Nothing.*' He told us street drinkers keep to their own small patch. When they are heading for blackout, they always make sure they are at a close staggering distance to wherever they are going to crash out for the night. There is no way, according to Gimpo, that they would hike halfway over London on the ludicrous promise of 6,250 free cans of Tennent's Super. What were they going to do, catch a cab back to their shop front or dossers' hostel? We could only really expect those within a half-mile radius of the event to turn up. There are not many down and outs in that part of the East End. Inner-city Muslim enclaves and street drinkers never mix their patch. Fact.

So we cancelled our whole nightmare scenario idea, much to the relief of the Disobey gang. As it was supposed to be the last screening of *Watch The K Foundation Burn a Million Quid*, the Disobey idea was to cut up the celluloid itself into twenty-five-

frame lengths and sell them for a quid each, thus paying for the event and making a tidy profit. I never got round to working out if it would recoup all the original cost of making the film. In the event, the screening never even happened in the car park. Come the night of 8 December it was bitterly cold. We took pity on the would-be punters and changed the venue to the Seven Stars pub, by Aldgate East tube station. None of the film was sold. The evening passed without any serious mishaps. It was a bore.

But Jimmy and I had a plan. The best plan we ever had, and this is the reason why I want to sit down and write this story tonight, while the shepherds are watching their flocks and Mary is on her donkey and Herod feels threatened and there is no room at the inn, and the stockings are stuffed and the turkey is lying in wait and the midnight mass is being given. We took an ad – one of our usual full-page black-and-white ones – in a national broadsheet. Only text, no giveaway logos, all it said was *6,250 CANS OF TENNENT'S SUPER*. It was The K Foundation's farewell ad. It would make sense to no one. A few K watchers would recognise the typeface, but even they would be left unable to give any explanation of what it meant. Jimmy and I believed, though, that in the fullness of time all would become obvious and people would go, 'Oh yes, I see, it all makes sense. How clever.'

On 23 December 1995 we were in a West London photography studio, a huge white space where they do photo shoots of cars for ads. With the help of friends, we built our cube. First we made a perfectly proportioned wooden pallet on which to place our cans. Then came the actual building of the cube, which took longer than we'd planned. We were on the last layer of strong lager, Gimpo on top to place the last few cans, when the whole lot started to go. Crumble, tumble, a landslide of booze. Hundreds of cans burst their ring pulls as the sticky, disgusting brew fizzed and frothed. Lucky we had those extra 750 cans. It took all night to rebuild the cube. This time we

used Gaffa tape to hold all the cans together. From the outside, none of the tape could be seen.

When it was finished it was the most beautiful object I had ever seen. It gleamed against the pure white of the studio interior. Other than our 'Nailed to the Wall', this was the only three-dimensional reality thing that had ever been produced under the name of The K Foundation. We stood back and were proud of our work. Next, we built a wooden packing case that fitted perfectly over the cube. Gimpo had hired a flat-bed truck. He drove it into the studio. Our encased cube was hoisted gently up on to the truck. By then it was 7.30 a.m. on Christmas Eve. I drove the fifty miles home. Spent the day preparing the festive feast for the following day, as I have done today and will do every Christmas Eve for the rest of my able life.

Jimmy and I had talked through the plan with our long-standing and long-suffering publicist, Mick Houghton. We thought from a media point of view this would be the biggest thing we had ever done. The K Foundation Award/Turner Prize thing in 1993 had only broadsheet appeal. The million-quid burning was done in dubious secrecy and only came to the wider public awareness in dribs and drabs long after its news-worthiness had slipped away. This was different. We wanted the events of that Christmas Eve to be seen in a full blaze of tabloid glory. We wanted *News At Ten*, and not just the 'And finally . . .' slot. We wanted our wheeze to be a proper, grown-up news story that everyone across the land would be discussing and debating over their Christmas Dinner as crackers were pulled, as merriment was made.

Mick Houghton, the publicist, didn't see it that way. He reminded us wearily that there was no printed media over the Christmas holiday period, no *Newsnight* for in-depth debate. As for regular broadcast-news coverage, that is always kept to children's hospital stories, what a good job Crisis At Christmas are doing and other feelgood items. A couple of has-been pop

stars with a load of cans of beer, whatever they do with them, a Christmas Day news story does not make.

'But Mick, you don't understand. It's like the evil underside to "Do They Know It's Christmas?" This is an important statement we are making, even if we don't know what it is ourselves.'

'Well, I can set up an interview with one of the broadsheets or Sundays. You can try and explore your motivations with them.'

'We don't want to explore our motivations, we just want to go and do it.'

'OK, I understand. But there is no way I can get a bunch of tabloid journalists and photographers down unless we tell them what is going to happen. It will be on Christmas Eve, for God's sake, even journalists have got better things to do with their time than hang around with you pair in case you do something outrageous. I'll contact one of the news agencies, they might send somebody down with a photographer. If they do, they'll be able to put the story out on the wire and any newspaper that wants to can run with it, can pay them for the story. And anyway, you don't want a whole pack of tabloid journalists following you around all night. It will make the whole thing look too contrived.' We had to accept Houghton's wisdom.

The rendezvous time was 8.00 p.m. The place was the main gate to Lambeth Palace, on the south bank of the Thames. Gimpo was there first with the truck and its load. Jimmy next. Me last. A middle-aged man in a raincoat and trilby, looking every bit the 1950s celluloid epitome of a cynical news hound, turned up from the news agency, with a teenage photographer in tow. Before leaving my house that night, I had cut down a couple of young sycamore trees and trimmed all the branches off them. They were about fifteen to twenty feet long. To these I had tied two of our smaller Union Jacks. Jimmy and I lashed the pair of these rustic flag poles to the front of the truck's cab.

We set off. Our first destination was Parliament Square. The plan was to undo the packing which encased our glorious cube.

We wanted it photographed with Big Ben in the background. The Houses of Parliament, a symbol of all that is great and good about our democratic and welfare-stated nation.

It became obvious even before we had got two sides of the packing off that the Gaffa tape was not going to hold. Quick-thinking Gimpo had an idea. The flat-bed had drop-down sides. They were only eighteen inches high at most, but if we got them up at least it would save some of our load. We took the remaining two sides of the packing case off, and watched as gravity did its work and our beautiful icon of modern Britain twisted and slid in slow motion before collapsing across the back of the truck, hundreds of cans spilling over on to Parliament Square. Churchill glowered from his plinth, Big Ben struck nine blows for whom . . . And dozens of Japanese, German and American tourists started to grab armfuls of Tennent's strongest, oblivious to the social stigma of being seen with a can of Tennent's Super in one's possession. A passing bunch of Australian lads thought we were their best friends. Gimpo started to organise the willing tourists into work gangs, collecting up our rogue cans. Scores were being squashed by the passing traffic. I had completely forgotten about the bloke from the news agency and his photographer sidekick.

'Mr Drummond, it's a disaster. How do you feel?' I tried to ignore him, manfully getting on with the job in hand.

'Mr Drummond, it's a disaster. How do you feel?' I could not carry on ignoring him. I can't hide behind deafness like Gimpo can.

'This is not a disaster, this is just the beginning. We believe in letting things take their natural course, allow for the organic, go with the flow and build on it.'

'But Mr Drummond, you told me the plan was to drive up Whitechapel and down the Mall to Buckingham Palace with your glorious monument before distributing it to the needy. What does failure feel like?'

Jimmy was keeping his head down and mucking in with the

Japanese tourists, who were thoroughly enjoying taking their orders from Gimpo. There was some sort of *Bridge On the River Kwai* karma going on here in a strange, twisted but friendly way.

'Mr Drummond, I have my story. Is there anything else you want to add before I file it?'

'What are you talking about? We've only just begun.'

'No time, it has to be in by 9.30. But tell me, Mr Drummond, will you be spending Christmas with your family on your estate?'

'What estate?'

'I was told you lived on a large farm in the Home Counties. But if you have nothing to add, I'll be off. Thank you, Mr Drummond, I wish you better luck in your future ventures. And of course, a merry Christmas.' And he was gone.

'Bill, give us a hand with this lot over here.' Gimpo was trying to rescue every last can. I was more concerned about forth-coming headlines pricking the vanities of old pop stars now retired to their rural estates. Somewhere down the line, Jimmy and I have picked up a reputation as being willing and suc-cessful media manipulators. I can't think of one occasion when we have successfully manipulated the media to our own ends. We have never properly appreciated that what people really want is to see the supposedly successful fuck up, the more spec-tacularly and painfully the better. The media know this. The only time that an individual from the 'entertainment world' genuinely makes the news headlines is when they get caught out or die. You know that, we know that, you don't have to be a media-manipulating genius to work it out. If Jimmy and I seri-ously wanted to make the front pages, we would have to ceremoniously chop up our children at Stonehenge, then carry out a suicide pact where we strung ourselves up from a high bridge straddling the M62, leaving a suicide note hinting at weird witchcraft and sex with animals. Now that would get us all the front page headlines we could desire, and a whole

[144]

chapter in the Faber & Faber book of the greatest rock legends ever.

But I digress. A police car could now be seen at the far side of Parliament Square. Even if we had blown our chances of having our cube photographed with the mother of all parliaments, we didn't want the main thrust of the evening's purpose curtailed by all-night questioning down the cop shop. We got off, waving goodbye to the friendly Japanese tourists and our Australian chums. Round the square and back over Westminster Bridge, briefly stopping, like Wordsworth, to check the view.

We headed for the roundabout south of Waterloo Bridge. Gimpo had told us that was where London's largest shanty village of alkie down-and-outs, street scum and loser degenerates was located. It's where the denizens of cardboard city on the Embankment had moved after their homes had been razed to the ground in the early '90s. It took Gimpo a while to find his way down the one-ways and dead ends under the concrete overpasses. Jimmy and I had to untie our makeshift flagpoles.

When we finally got to where we wanted to be, it was as if we were in the belly of the beast. Shelters built from all the discarded rubbish of our capital city. Plastic sheeting and pallets nicked from building sites, frayed car tyres, empty milk crates. Cardboard boxes seemed to be a thing of the past. It all looked pretty much like the set from a near-future, post-apocalypse '80s film, or one of those adult comix that like to glamorise the squalor of inner city breakdown. Except this was real, and smelled, so wasn't quite as sexy. But it seemed even this lot were getting postmodern about their situation; they had seen the movies, knew what a sexy Mexican barrio should look like and were going to have a go at building one here on the south bank. Gimpo was up on the roof of the truck cab.

'Merry Christmas everybody, come and get your Tennent's Super, as much as you want, as much as you can drink, as much as you can carry away.'

[145]

'What the fuck is this?'

'Who the fuck are you?'

'Is this some sort of a fuckin' practical joke?'

But it didn't take long for them to find out that it wasn't a joke. Some were climbing up on to the truck, giving us a hand distributing our load to the needy.

'Hey mate, what's this all about? Is it like a promotional thing from Tennent's or what?' I didn't bother explaining that Tennent's feel there is no point wasting money promoting to their particular social stratum.

'Is Tennent's Super all you've got? Haven't you got any Special Brew?' Talk about ingratitude. You come out on a freezing Christmas Eve when you could be at home with your family and friends. At great financial expense to yourself, most probably putting yourself in physical danger, you try to spread a little goodwill. You bring this repellent underclass what their bodies crave. And all they can do is complain it's not Special Brew.

Gimpo bantered away with these rejects from our society, as I stood by and wondered: did they jump or were they pushed? Should we applaud their rejection of the safety net our nanny state provides? Are the holes in the net just too big? Is it something to do with the closing down of the Victorian mental institution? Care in the community? The breakdown of family values? The licensing laws? Education? Drugs? Lack of respect? The media? The Tories? The royal family?

There were only about fifty citizens of the urban underclass in evidence.

'You should have been here last night, mate, most of them have gone to that Crisis At Christmas place over in the Borough.'

We decided to move on. The plan was to visit all the centres where these unwashed, undesirable rejects huddle for shelter across the nation's capital. Lincoln's Inn Fields was to be our next destination. Gimpo knew that a soup kitchen turned up

there every evening; it always attracted a few hundred of our brothers and sisters.

Up over Waterloo Bridge. The Thames looked great. All the trees along the Embankment festooned with strings of lights. Retired battle ships were now finding worthwhile employment as novelty restaurants. On the central concrete block of our National Theatre you could still make out the scrubbed shadow of Jimmy's and my first joint-venture into public art, a vast graffito fifteen foot high: '1987' and underneath, the question 'What the fuck is going on?' Jimmy and I have always been eager to pose questions, never very good with coming up with answers.

Gimpo was driving. Jimmy and I were standing knee deep in cans in the back of the truck, our Union Jacks flying aloft. We felt that rush of energy you get as a teenager just after you've nicked a car. We felt like glorious revolutionaries as the citadel was about to fall, but before the counter-revolution kicked in. We struck heroic poses and waved at the bewildered Christmas Eve-ing passers-by.

'This is rock 'n' roll, this is what we dreamed it all should be like, this is playing Shea Stadium, this is truly the stuff of legend. Fuck that little snivelling reporter with his "What does it feel like to be a failure, Mr Drummond?" questions. This is power chord heaven! Bob Geldof can keep his starving Ethiopians, Sting his rain forest Indians, Elton John his Aids victims. We've got our unwashed, undesirable underclass, useless, sponging, street-drinking vermin. Giving up our precious time and money to help the drinkers. Crisis At Christmas, what crisis?'

Round the Aldwych and up Kingsway. We turned into Lincoln's Inn Fields. To our disappointment there was only a small posse of street drinkers, no more than half a dozen.

'Fancy a drink, mate?' asked Gimpo. 'Where's everybody else? Where's the soup kitchen?'

'The soup van won't be down for some time. Nearly everybody has gone down to the Borough, there's one of those Crisis At Christmas places open down there.'

[147]

'Do you know where? What street?'

'Don't know, mate. You should be able to find it easily enough. You'll be able to spot some of us on the way. Just ask them.' We stood around and chatted for a while, made sure all their pockets were crammed with cans. We all wished each other a merry Christmas and happy New Year, and we were on our way. Jimmy drove the next bit; Gimpo had his video camera with him and wanted to film whatever he could for whatever he films this stuff for. It took some time to find the mission hall that Crisis At Christmas were using as their base in the Borough. This was all proving harder than I had envisaged. I think we still had about 5,000 cans at this time, and I had promised my family I'd be back home by twelve. Bit of a Cinderella type thing. If I didn't get back by midnight, I would be kicked out. Putting work before family at Christmas is an art-terrorist bridge too far, a chuckable offence. If I got thrown out it would be the slippery slope for me, down to the brothers we had been handing out alms to that evening. Instant karma, just deserts, etc.

We found the mission and set up our stall on the street outside.

'Get your free cans of Tennent's Super here. Roll up, roll up, this ain't a con, this is the real thing. 9% proof, all yours for nothing. Drink as much as you can, no questions asked.' Even Jimmy and I were joining in with Gimpo like seasoned fairground barkers. We soon had a small crowd gathering round.

'Go tell your mates inside the mission. We have enough for everybody, we don't turn anybody away. All are welcome.' From loud-mouthed junkie punks with spider-web neck tattoos to sad, lonely old men shuffling in threadbare overcoats and heartbreaking life stories if anybody was ever arsed to listen, from Glaswegian hard men on the run to pretty little rent boys who had lost their looks down some toilet, from '88 ravers whose E-popping days were long since past to ex-squaddies who found civvy street a lonely place to be, we turned none away. Some stank of piss, others looked like they would

A Christmas Carol

kill you for 10p. Some climbed on board to help us in the distri-
bution. Some believed we must have robbed a brewery. Some
thought there must be a catch. Some thought we were Santa's
little helpers.

'For God's sake, what are you doing?' came the voice of
authority from amongst the grateful crowd. By the time the
question was repeated, a spokesman for the caring professions
was standing in front of me.

'Handing out free Tennent's Super.'

'Free Tennent's Super? This is totally and utterly irresponsi-
ble of you – to the Nth degree – who the hell are you?' There
was no Christmas cheer in his voice.

'Well, we were the trustees of The K Foundation and we
burned a million quid, but because we couldn't explain why, we
were advised to stop trying, so we thought we'd do something
different instead. But before we did that different thing we
decided to get a round of drinks in for all the street drinkers of
London.'

'Look mate, I don't care what you've done in the past. We are
trying to do a job of work inside there. These are desperate
people. We are giving up our Christmas to try and help them.
For a couple of nights over Christmas, we can give them some
proper food, give them a medical, a wash, some clean clothes,
let them sober up.' I can feel a wave of guilt coming on, but
before it does, Gimpo steps in.

'Don't "Look mate" us, mate – you're not the only fucker
doing a job of work here. For the next two days all the off
licences in the country will be closed. These blokes won't be
able to get hold of the one thing they need most: alcohol. Are
you providing any for them? No!'

'This is ludicrous . . .'

'Ludicrous my arse. Every other fucker in the country is
going to be spending the next two days drinking more than
they have drunk in the past year, while this lot, who like I said,
need it more than any of us, don't get any.'

'Don't you understand? For some, these are the only two sober days in the year. We allow them the space to maybe start their life again, not just blot it out. We give them the chance to contact their family or whoever. You are taking that away from them.'

'We're just buying them a drink. They're above the age of consent. It's a free country.'

'I don't want to hear any more of your rubbish. Just go away! Go, don't come back.'

'Where?'

'Home.'

So we drove away. It was getting late. The midnight hour was getting near. Mary was in labour. The shepherds were shivering. Gimpo dropped me off where I had parked my car, near the Archbishop of Canterbury's gaff, Lambeth Palace. He and Jimmy had a plan to drop a load of cans off somewhere in Camden.

In the end we didn't get rid of much more than half the stuff. The remains of it are still stacked up in a container that Jimmy and I have, where we keep all our old costumes. The plan is that if there is ever a retrospective show of what The K Foundation did, we can empty these leftover cans down the drain and then use them to build a hollow, life-size replica of our original cube and this piece can exist as the all-important documentation of the event.

As for the media coverage: nothing. That was until a friend who was travelling to Australia spent Christmas Day in Jakarta, capital of Indonesia, and saw the front cover of a local paper. It seems that in Indonesia they publish newspapers on Christmas Day. The headline story was about a pair of English pop stars who had planned on giving every one of London's two million homeless a drink for Christmas. But everything had gone wrong because all the drink had fallen off the back of a lorry in front of the famous English Houses of Parliament. The only people to get drunk were some Members of Parliament. Media manipulation, don't you just love it?

I drove home. Stockings to fill, turkey to stuff, even presents still to be wrapped. It was a good old-fashioned family Christmas.

As for a moral to this tale, I gave up looking for it a long time ago. Maybe you can spot one in there. The only thing I can offer is don't drink Tennent's Super; it is disgusting. I tried.

BOXING DAY

26 December 1997

I get books for Christmas.
It's the way I like it.
One of them was a book of medieval Japanese Verse.
Translated for the likes of me.
One of the verses I thought would be good at the beginning of
this book.

> If pressed to compare
> This brief life, I might declare
> It's like the boat
> That crossed this morning's harbour
> Leaving no mark on the world.

It was written by somebody called Mansei. In or around AD 730.
After reading it
I wrote:

> That's as maybe Mansei
> But that won't stop us
> Wasting our lives
> Trying.

Boxing Day

Then I read
the next poem in the book.

> How does it happen?
> I take this dried fish, your gift,
> And go to the shore
> And throw it into the Ocean
> It rises and swims away

It was written by somebody called Tsukan.
I liked it.
I liked it a lot.
And I thought
It would make a good poem to
have at the back of this book.

WILLIAM BUTTERWORTH REVEALED

18 December 1998

A week to go before Christmas and I'm sitting in the library, correcting the story 'Art Terrorist Incident at Luton Airport'. A young person has sat down at the table next to me. He lets thump a heavy pile of books and makes to get on with his studies, but my concentration has been broken. I look over to see what his weighty tomes are. From the look of the young man I expect them to be on architecture or petrochemicals or at least something equally worth spending time reading in a library. But no. It's the *Rare Record Price Guide 97/8, All You Need to Know About the Music Business* by Donald S. Passman and *Q's Encyclopaedia of Rock Stars*. I ought to tap him on the shoulder immediately and whisper in his ear, 'Son, don't even think about it. Go and do something useful with your life. This stuff will only make you unhappy. Learn how to mend roads, build bridges or save lives.' But I don't. What I want to tell him is that the entry for The KLF in *Q*'s encyclopaedia is a pack of lies. But I don't do that either. What I *do* do is stop correcting my Bewley's/Luton Airport story and start writing this one.

Some time last year I received a letter from an acquaintance I've known for four or five years, but the envelope was addressed to William Butterworth. In the letter itself there was

no reference made as to why the sender had chosen the unfamiliar yet strangely familiar name on the envelope. I thought no more about it. A couple of months later, the Butterworth incident forgotten, I was into a lengthy pub debate on the significance of the Pink Fairies and their influence on the roots of London punk rock with friend and writer Chris Brook, when he brought up the name Butterworth. He had been told by a reliable source that my surname was not Drummond at all but Butterworth, and that I had changed it because Butterworth wasn't the sort of name upon which you could build a legend. Rather strange.

Then last Christmas I was given a copy of *Q's Encyclopaedia of Rock Stars*. On unwrapping the present and duly thanking the giver, my vanity prompted me to flick the pages looking for the Ks and hoping for a generous KLF entry. To my satisfaction, there it was. 'KLF – Bill Drummond; Jimmy Cauty. 1986. Nov, Drummond (b. William Butterworth, April 29, 1953, South Africa), who had already worked in Scotland as a set designer, carpenter and deep-sea trawlerman, joined Liverpool power pop combo Big In Japan blah blah blah . . .'

'Butterworth? Where's this sodding Butterworth stuff coming from?' I slammed the book shut, suppressed my anger and got on with the season of goodwill. I'm no stranger to the world of the pseudonym and have enjoyed using a couple myself: King Boy D and, very briefly, Timeboy. Both done in a very obvious and knowing way, aping the black-American-artist tradition of creating pseudonyms that tuff up or weird out their image. The world is a better place with names the like of Timbaland, Howlin Wolf, Ice T and Muddy Waters in it. I thought it an act of high-camp creative genius when my friend Z named the three individuals in The Love Reaction, his mid-80s band, Cobalt Stargazer, Kid Chaos and Slam Thunderhide, and named himself Zodiac Mindwarp. But changing one's name from Butterworth to Drummond – what was that about? To do such a thing wouldn't be about creative genius of either a homeboy or

high-camp variety. It smelt of real deception, something to be hidden, to be ashamed of, weakness.

In many circles it's bad enough to have been born in South Africa, the white South African being one of the most loathed subspecies of mankind known to the Western liberal. If I'm in company and for some reason my origins are revealed, I proudly recount that my father was a Church of Scotland missionary in the Transkei bush; that I was breast-fed in a mud hut; that my first words were in Xhosa, a language of the Bantu people, in fact Nelson Mandela's native tongue. As an extra badge of honour I can also lay claim to the fact that my parents beliefs ('All men are born equal in the eyes of the Lord') were not shared by the then incoming apartheid government, thus making their position untenable and forcing their return to God's own country before I was 18 months old. So you see, I have no shame or guilt about my place of birth and even if I did have, I'm bigger than you.

But the Butterworth thing, that's different. A couple of months will go by and it won't enter my head. I answer phones confidently, 'Bill Drummond speaking.' Sign the dotted line W. E. Drummond, without further thought. Then there in my head is a voice saying, 'Drummond (b. William Butterworth, Apr 29, 1953, South Africa). If he has already lied to you about such a fundamental thing as his name, he has probably lied to you about everything else in his life and career. This man is not to be trusted. He is a conman, shyster, scam-merchant and trickster and I could see through him all along.'

I drown out the voice. 'No, no, my name is Drummond. The clan motto is "Gang Warily" and we have at least three tartans: Hunting, Royal and Ancient. A forebear of mine, Margaret Drummond, married Malcolm Canmore, King of the Scots. Our chief supported the Jacobite cause. As long as there has been a unified Scotland there have been Drummonds. It's not a joke name like McTavish or Naughtie, it's a proud and a strong name, and it's my name and it always has been and always will

be. The name of my father, and my father's father, and my father's father's father.'

'Methinks the laddy doth protest too much', you may mutter.

I grew up hoping to hear about other Drummonds, ones that had made their way in the world, but no Drummonds played in our national football team, or even for the then Division One teams. There was Pete Drummond, the part-time Radio One disc jockey and Don Drummond the Jamaican trombone player and that was about it. Nobody worth making a playground claim for as a distant relative of mine.

Two weeks ago I was in Waterstones looking for Christmas presents. On one of the display tables heaving with the newly published was a stack of the weighty *Virgin Encyclopaedia Of Rock*. I looked furtively for references to my own contribution to popular culture. An unfocused rage headbutted its way into my skull. *Who is this William Butterworth?* Where has he come from? Am I really him? Have I been all along? Am I not being told something? Is my whole life a lie, not just the bits I choose? Maybe I should write to the editors of these so-called rock encyclopaedias, explaining that my name is not Butterworth and never has been. Then I imagined receiving letters back from these editors. 'Dear Mr Butterworth, Thank you for your letter dated 4 December 1998. We have it from reliable sources that your name has never been and never will be Drummond. It is just a fantasy that you may want to believe but nonetheless have created to further your career in show business. We are not fooled. Yours sincerely, the Chairman of the Board of Rock Facts, Pop Ephemera and Dance Music Statistics.'

That night I got home and started rummaging through my collection of second-hand filing cabinets stuffed with all sorts of facts, ephemera and statistics gathered up and hoarded over a lifetime. Somewhere in that lot I knew I had a birth certificate. Surely that would confirm who I am. Some hours later I found what I was looking for, dog-eared and a dirty olive green. The first word that confronted my eyes upon this scrap of worthless

litter was 'BUTTERWORTH', written in a large upper-case hand. The printed matter was in Afrikaans. I read:

Geboorteplek	BUTTERWORTH, C P
Geboortedatum	29TH APRIL 1953
Ras van ouers	EUROPEAN
Geslag	MALE
Vournaam	WILLIAM ERNEST
Familienaam	DRUMMOND

No mention of the Rosalind Mary Drummond and Jack Scott Drummond who I always assumed to be my mum and dad, just somebody called C P Butterworth. I phoned my mother, expecting the worst. Expecting to have to come to terms with the fact that I was the progeny of some poor teenage Afrikaans girl, who got in the family way and had her baby adopted by those good missionaries Jack and Rosalind Drummond.

'Mum, who is C P Butterworth?'

'C P Butterworth?'

'Yes, Butterworth. The name on my birth certificate.'

'Butterworth is the name of the town in South Africa where you were born. C P stands for Cape Province. Surely I told you how I had to drive fifty miles over dirt track to get to the nearest hospital, and me a month overdue? And when you came out you weighed ten pounds and ten ounces; the Bantu nurses had never seen such a big baby. And when they left it was just you, me and the full moon.'

Yet none of the above explains how the editors of the world's most comprehensive rock encyclopaedias have been able to gain precise knowledge of my place of birth and then confuse it with my ancient and proud family name . . .

DEATH BY DEED POLL

19 December 1998

I very rarely attempt to write anything after three in the afternoon. My mind moves into a different gear, where even the idea of trying to put words on paper is totally irrelevant. But tonight is different. Tonight I have been lying in bed unable to sleep; words, phrases, whole sentences have been going around and around in the darkness behind my closed eyelids, looking for a way out, looking for my notebook so they may be set down in it. Only then will they allow me to have my rest. So pyjama'd, slippered and dressing-gowned I have tiptoed down the stairs of this silent and December-cold house, crept into my work room and switched on the light.

What I want to write about is the 'William Butterworth Revealed' story. I've begun to see it, along with some of the other more recent stories I've written, in the context of art works, displayed in a White Wall Situation. I can't stop these thoughts. They keep recurring. I am powerless to resist them. Yesterday I imagined 'WB Revealed' on a wall as a text piece, and next to it the relevant pages ripped out of *Q's Encyclopaedia of Rock Stars* and the *Virgin Encyclopaedia of Rock*, a page torn from a tourist book on clan history and my birth certificate.

The trouble is, if I were to do that it might reveal some

inaccuracies in 'WB Revealed'. In fact, more lies than mere inaccuracies. Basically, the telephone conversation with my mother never happened. I've known ever since I can remember that I was born in a place called Butterworth, that my mother had to drive fifty miles over unmade roads to get there, that I was a month overdue, weighed ten pounds and ten ounces, and that the moon shone on me and her through the wee small hours. It is obvious from my birth certificate that there could be no confusion over my name; the fact that it is all written in English as well as Afrikaans leaves nothing to conjecture. So although I thought 'strange' when I first got the letter addressed to William Butterworth, by the time I had the Pink Fairies debate with Chris Brook things were becoming clearer. It was obvious that somewhere along the line my place of birth got confused with my family name. My guess is that at some time during my rock 'n' roll years a sharp-eyed and eager music journalist must have perused my passport as we travelled together across the continents. It was a regular thing for me to accompany a young pop reporter on a journey to some far country to interview Echo and The Bunnymen. Page one of my old-style large-format navy-blue passport reveals my name to be William Ernest Drummond. On page three there is a photo of me. But on page two, under the word Bearer, is written the 'name' Butterworth. Underneath that is the date 29 April 1953. To the left of the 'name' Butterworth is printed Place of Birth, and to the left of 29 April 1953 is printed Date of Birth. I remember thinking it strange when I first received the passport that the authorities didn't see fit to state that Butterworth was in South Africa, rather than some corner of these islands.

What is certainly true is my unfocused and somewhat stupid anger at seeing myself portrayed as a man likely to present himself as someone different from whom he is. There is also the small matter of my father; I don't think he would take too kindly to the knowledge that we were, in reality, Butterworths. It may be in a different way, but he also suffers from the sin of

being proud of his good name. He can trace our ancestry back to an apprentice stonemason working on Melrose Abbey in the 1300s (Melrose, in the Scottish borders, being his home town). So what is to be done?

The idea I have, and it seems like a good one, is that at the earliest opportunity I should change my name by deed poll to William Butterworth, and be done with it. Eric Morecambe and Vito Corleone made a similar move, and it didn't do them any harm.

BA BA GAA

7 March 1998

'Hey mista, you wan' Ba Ba Gaa? You wan' Ba Ba Gaa. I know you wan' Ba Ba Gaa. You see Ba Ba Gaa, you think Ba Ba Gaa bag of shit, OK, OK, we go.'

I try to ignore the persistent communicator of the above statement. I don't even try to make sense of what he is trying to tell me. It's seventeen minutes to midnight and I'm standing on the T-junction of Sudder Street and Mirza Ghalib Street, in what is obviously the most dangerous part of Calcutta. I've left the keys to my hotel room in a restaurant about a mile from where I'm standing. The boss of the hotel sleeps with his master key. The night porter didn't dare wake him. The city is silent. There is very little light. Street lamps don't exist around here. The pavements are littered with the sleeping homeless. There are no taxis. In daylight hours Calcutta has more buses, taxis, rickshaws per square foot of tarmacadam than any other city I've ever visited. After dark the city falls silent. Nothing moves except the rats.

'We go Ba Ba Gaa now.' These Calcuttans don't give up. If they think you should want something they are trying to sell, they just keep banging at it right in your face. Hasn't anybody told them that the art of being a salesman is to get the punter to enjoy parting with his cash? To make him feel relaxed, that

parting with the cash is a mere detail on the road to making life more complete?

'Ba Ba Gaa she real young. She little girl. She good.' The thing to do is completely ignore them, look the other way, pretend they don't exist. 'Hey mista, you look, she bag a shit you go.' Or that's what I try to convince myself. He's not giving up, and there is still no taxi. I've been unreliably told that Calcutta is the only place left in the world that still has hand-pulled rickshaws, the kind you see in films like *Empire of the Sun*. My liberal sentiments have been shocked at the sight of them. The idea that you pay some underfed, barefoot, low-life-expectancy fellow human to use his own knotted muscle to drag you along while you just sit up there admiring the view seems to be on a par with condoning galley slaves. But then earlier today I heard an argument by a fellow whitey that if all the taxis in Calcutta were got rid of and replaced by rickshaw, the city's pollution would be cut by 80 per cent. Kids would stop dying of lead poisoning; life expectancy would rise; there would be more jobs, as rickshaws only hold two passengers, compared to four in a taxi. And the taxi drivers forced to become rickshaw pullers would get fit and stop dying of heart disease. The fossil fuels would be saved. So slavery equals green, yes? No? I'm confused. The madman who is trying to fix me with his demonic stare and going on about Ba Ba Gaa is a rickshaw puller and, whatever else he is going on about, wants to get me into his rickshaw. My support of the green movement wins out over my anti-slavery sympathies.

'How many rupees to take me up to the Moulin Rouge restaurant on Park Street and back?'

'You ask me how many rupees? You very rich man, me very poor man and you ask me how many rupees? You get in rickshaw, I take you. You see Ba Ba Gaa.'

'No, I don't want to see Ba Ba Gaa. I want to get to the restaurant before it closes.'

'OK, OK. I take you.' I decide not to even attempt to negotiate

the fare. He's hit my guilt spot. Of course, by the standards of 99.9 per cent of the world me very rich man, he very poor man. It's disgusting that I even contemplate trying to haggle with him about the price of a short ride that will only amount to a few pence, whatever it is. Anyway, I've got to get there before it closes.

Karma is a big thing for me, ever since John Lennon sang about the instant variety and Kerouac explained what it meant. It sits very comfortably with my 'Mrs Do As You Would Be Done By' upbringing. I had tried to impress the performance artist Marc J. Hawker with the claim that when I got to Calcutta I would sleep on the streets with the untouchables. In his performing art, Hawker pushes himself to his physical limits, naked, freezing and bleeding, just to prove he means it. But the thing is, I knew that Hawker wouldn't dare sleep on the streets of Calcutta. He needs an Arts Council grant and hip-and-highbrow spectators before he shows off. But me, I would do it just for hardman kicks. I don't think I ever believed my boast and since arriving in Calcutta I've known there is no way that I'm going to try the pavement out for comfort. So leaving my key in the restaurant and being forced to climb up on this rickshaw is all part of the karma thing. 'Instant Karma's gonna get you.' And I'm getting mine.

So I climb up, and my man with the mad, staring eyes is off. Now in all those films I've seen with rickshaws, the pullers are always running as fast as they can trot, every muscle in their body straining to get to their passenger's/master's destination, but my man is walking at a lazy pace. It's not just that he's slow, but he is doing it with attitude. As if he doesn't give a shit that I need to get to the restaurant before it closes, to get my keys so I don't have to sleep on the street. He is pulling the thing with a nonchalant swagger, as if he thinks that although he may be a very poor man and me a very rich man, he's better than me. I look around. Is there an equivalent to a horsewhip handy, or am I just supposed to shout out 'Faster!

Faster!'? He is walking at about half my natural walking speed.
I have an urge to climb down, get him to sit up in the rickshaw
and run to the restaurant and back, pulling the rickshaw and
him behind me. Why did I ever get in the rickshaw in the first
place? I'm quite happy to run most places, when needs be.
The answer is probably that I'm shit-scared of these Calcutta
streets, as the witching hour approaches and the Thugees are
tying their Kali coins in the corner of their hankies before they
go out to do a bit of strangling. I suppose I thought a rickshaw
and its puller would provide me with protection. Sitting up
here I feel more unprotected than I have felt since kissing a
gay mate who was dying of Aids, only this time I have ration-
ality on my side. I feel my white, peely-wally face is beaming
out into the evil darkness, saying 'Come and get me, I deserve
it, me very rich you very poor, come on, hanky at the ready for
a nice clean strangle. I won't struggle much, and I must be
carrying plenty of rupees. If you don't get me, someone else
will.'

But I just freeze. I don't shout 'Faster! Faster!' or get down
and run; I just sit bolt upright and wait for Fate to do her thing.
I will take it like a man. Tell Penelope I have always loved her.
We've only gone about 300 yards when he pulls the rickshaw
into a side street. My initial thought is that he knows a shortcut,
like London cabbies do. But no, the street we are on is as direct
as you can go. Then he drops his handles and I nearly capsize
out of the thing. He turns to me, points a finger from each hand
at me and locks me in his madman stare.

'Now! You have Ba Ba Gaa. She here.' Points to dark door.
'She li'l Gaa, she Ba Ba Gaa, she what you wan'. You look, if you
think bag a shit we go. OK.'

It is only now that I make any sense of what he had been
going on about before this karma-driven ride had begun. I
begin to sense the approach of others, coming at me from
behind. I look around. There are three other men closing in on
me. One of them smiles a tombstone smile.

'You want a nice, clean young lady? We have just the one for you.'

Behind that dark door a young girl is sleeping, dreaming sweet dreams of an innocent life. No nightmare could be worse than her reality. Or is she lying awake, waiting in terror at the thought of what monster her master will bring back to her? I have prepared myself for all the poverty and leprosy-deformed human life that India can offer me, but what is going on here truly disgusts me. I'm being offered a young, enslaved girl to do whatever I want with – that's if she's not a bag of shit, of course. Is this the reputation my white face brings before me? White man comes to Calcutta, he wants one thing: Baby Girl? How young is Baby Girl? Do her parents know? Is one of these men her father? Was she sold by her brother? Is this the fate that lies in wait for all the street kids that flock around your legs wherever you go through the day? I think back to my three daughters. Everybody that I have ever met who has travelled in India tells me what a wonderfully rich, culturally diverse, spiritually uplifting, life-enhancing place it is. I'm not thinking I'd better phone the police and social services, I'm just thinking, I want to get out of here. Anywhere. Give me the Congo any day, compared to Calcutta at seventeen minutes to midnight.

Then my mind flicks to a different page. Maybe there is no Ba Ba Gaa. She is just a tempting idea, to ready my arousal. To ensnare me behind a dark door with my mind engorged with lust for some prepubescent rape. Then they'll get me on the floor and have every rupee off me, and in their rage at my inadequate lack of funds chop me to bits and feed me to the stray dogs. (Being Hindu, thus vegetarians, they won't indulge in cannibalism.) Quick thinking is needed. But I've always been crap at that. I climb down out of the rickshaw. No point in trying to run for it; they'd easily outrun me, or I'd fall over a dead dog or sleeping child. I'll have to front them out.

'Look, all I want is to get to the restaurant on Park Street. If you won't take me, fine. I'll walk.' I make to walk away.

'OK, OK. I take you. You get back on rickshaw.'

My decision to climb back on is not based on any sound rationale, just that he has agreed to take me away from confronting this particular here and now. The other three men fade back into the darkness. The rickshaw is yanked around and pulled back out into Mirza Ghalib Street. Ba Ba Gaa will have to wait. I can pretend she doesn't exist. I can pull up my drawbridge and make believe that I'm the island that Donne said didn't exist. The 500 yards or so to Park Street drag by. I've numbed my mind down so as to freeze out the fear, the same way you do to stop yourself from coming when you're shagging. I focus my mind on the memory of the wall paintings in the Moulin Rouge restaurant less than forty-five minutes ago. Toulouse Lautrec-style cancan girls kicking their legs high, revealing gusset and garter. The last thing you expect to see in Calcutta. A whole subcontinent where the sight of any female leg above the ankle is unseen, and here for all its paying customers to view is full frontal gusset. It's a wonder the diners can keep themselves under control.

Park Street. Street lights, even the odd taxi passes by. Safety. I feel like singing 'Downtown' by Petula Clark in celebration. It's only a couple of hundred yards to the Moulin Rouge. He drops his handles. I tumble out.

'You pay me one hundred rupees now, then you go.'

'But you said you'd take me there and back.'

'You give me one hundred rupees now.'

'One hundred rupees is too much. I'm not giving you that.' Which it is. Double what a taxi would cost for the same journey. But while I'm thinking these thoughts, my right hand is fumbling in my back pocket, trying to peel off a note from the wad so he can't see what I've got on me.

'Here's one hundred rupees.'

'No, no. You give me baksheesh. Two hundred rupees.'

'You're not getting any more.'

'Baksheesh, or get police.'

'Police? What for?'

'Baksheesh now.' I pull another hundred note out my back pocket and hand it to him and walk away.

'Hey mista – baksheesh, baksheesh – this is not enough.'

I keep walking, looking straight ahead but careful to step over the sleeping bodies. I daren't look around, although I can still hear him threatening me with the police. My racist tendencies take full rein as I imagine what the police working the night shift in downtown Calcutta are like. As for Ba Ba Gaa, she's long forgotten. My conscience may have been pricked for a few moments, but it has now healed over. Just as yours will.

GIMPO'S 25

21 March 1998

'Fuckin' brilliant idea, Gimpo. Can I come with you?'

That was about three months ago. Today is 21 March. I've just arrived at the agreed rendezvous point, South Mims Service Station, have parked up my truck and am looking for Gimpo's white transit van. I'm late, but Gimpo is later. A van pulls up beside me. On the side is daubed 'Gimpo's Non Stop, 25 hour, M25 Spin'.

'You're late. Get in,' shouts Gimpo.

This is Gimpo's plan. For the next 25 hours Gimpo, a certain Mr Green and I are going to drive around the M25. For those that don't know, the M25 is an orbital motorway that circumnavigates the nation's capital. You have to drive 124.5 miles to get all the way round. Gimpo has a notion that if we keep driving for the allotted time, he will find out where the M25 leads. It is best not to rationalise Gimpo's notions. Gimpo loves the M25. Gimpo loves to drive. He loves to view the rest of the world through a truck cab windscreen. Gimpo loves to film what he sees through the windscreen and, when he is too far gone to drive, to take the film back home and watch it again and again and again.

We make it to the Queen Elizabeth Suspension Bridge by twelve noon, the official starting point and time. When you

[169]

experience things like the Queen Elizabeth Suspension Bridge,
you fall in love with the modern world all over again. All that
engineering. All that wonder. All that height and breadth, and
'aren't we just like ants'. There's a high blue sky. The Thames
shines, snakes up to London in the west and slides down into its
estuary in the east. Below us are the pylons and power stations,
industrial estates and entertainment complexes of the Essex
wastelands. And I love that too. On a sunny spring day, you can
love almost anything. Gimpo is already raging and we have
only just begun. We are heading clockwise. Gimpo tells me to
drive the first two laps, then we will fill the tank, have a slash
and change drivers. Gimpo is in the back, checking his boxes of
films, cleaning his lenses, packing and repacking his kit bag.
It's Gimpo's army training. He was a gunner in the Falklands
War. They taught him how to concentrate his mind on the
details of packing and cleaning, repacking and polishing, taking
to bits and putting back together, again and again and again.
Now, more of Gimpo's orders are being barked down his
mobile. His mobile is held together with Gaffa tape. Gimpo
loves Gaffa. But not white Gaffa. He hates white Gaffa. It has to
be black or silver. His mobile is almost permanently shoved up
against his right ear, the less deaf of the two. Gimpo is a pit bull
of energy, unfocused rage and terminal paranoia. The only
thing that Gimpo can do to soothe his seething is unpack and
pack, check and re-check, spit and polish. Gimpo is both a man
of our time and a man of any time. The history of England has
been built on men like Gimpo. He is the bulldog spirit, the
'never say die', the original Tommy. The only reason why
Harold lost the Battle of Hastings was 'cause Gimpo was not
there (he was fighting the rearguard action against the
Vikings). But Gimpo was at Agincourt. He was with Oliver in his
New Model Army. He was Napoleon's Waterloo. He survived
the Somme. Was the toughest desert rat Monty never knew. He
is the true embodiment of the nation. I'm just glad I'm not
English.

Gimpo starts to reveal his vision. He wants this thing, this Gimpo M25 spin, to become an annual event. The closest Saturday night/Sunday morning to 21 March each year, to mark the opening of the rave/festival/drug-taking/banging/techno/hippie thing that Gimpo and his weird mates know all about. He wants loads of other people to join in, come out in their cars, vans, trucks, loaded up. A non-stop 25 hour party, road to nowhere sort of thing; car stereos cranked up, people screaming, pumping horns, blowing whistles. Hundreds, thousands, pouring out at Clacky services. Not a race, but a celebration of this broken down modern world, where the M25 would get clogged up, grind to a standstill, the authorities could do nothing – and Gimpo would be king.

Mr Green is an artist from Warrington. He keeps his counsel. This is not the place to tell you about his twisted, ego-driven visions. I'm sure in time he will let you know all about them himself.

I'm driving as fast as I can, hogging the outside lane when the inner would do. Headlights flash me as I am forced to move over. One circumference is 125 miles. The second is only 124.5. Everything looks normal. I've seen it all before. The North Downs, the Surrey Woods, the Plains of Heathrow, up round the top M1 junctions, St Albans Cathedral in the distance, back down through Essex. All boringly familiar. But we know the further we go, the less familiar it will all become. We will begin to see things not seen before, discover new meanings in the sign posts. The lie of the land. Lost tribes. The tank is almost empty. We pull in at Clacky Service Station, fill the tank, buy trash food, have a slash. Gimpo has a stop watch. The pit stop has taken us nine minutes and thirty-seven seconds. He is not happy with this. Mr Green takes the wheel. We move back out into the flow. The eternal. The around and around. The headlights are coming on. The light is failing. The football results are coming through. End of the season is in sight and things are hotting up. And Mr Green is a dangerous driver. The weirdness

is kicking in. It's a drug-free zone; even though Gimpo has invested heavily in all-night chemicals, Mr Green and I just say No. Mr Green cuts another artic. up, slams the brakes, ploughs through a dozen cones in the contraflow. Oncoming headlights blind, jumbo jets climb into the shepherd's delight sky. It's getting good. Gimpo is swinging in his hammock, mobile pressed to his ear, laughing and screaming at some London low-life friend.

'Yeah, it's me, Bill and Mr Green, 25-hour spin around the M25. Do you want to come and give us a wave? Bring us a cake? Toss us off?' It must be a woman. I hear, 'Look, wear that black leather miniskirt with no knickers. Stand on the bridge so we can look up as we go under.'

Mr Green and I get talking about the Union Jack. How brilliant, the Labour Party move to use a Union Jack logo in their election campaign. Real carpet-pulling from under the Tories' feet. Such a loaded icon. It gives out so many weird signals. Jimmy and I saw Damon Hill do his lap of honour at Silverstone, flying the flag and we thought, 'Far fuckin' out Damon. Let's liberate the flag for the common man.' You can't help but be jealous of the Yanks, who rally around the Stars and Stripes, from ghetto nigger to southern white trash from New York yid to mid-west WASP. To burn the Stars and Stripes is one powerful political statement, saved only for moments of national self-doubt. To burn the Union Jack is just a waste of a good tea towel. You don't agree with me? I don't know if I agree with myself.

Once, Jimmy and I had this idea we should re-form The KLF. Massive campaign for the comeback single. Billboard posters, full-page ads, prime-time TV commercials, all with the Union Jack and the words 'God Save the Queen – The KLF'. Nobody would hear it until the moment of release. Everybody else would be thinking that the track would be some postmodern update on the Pistols' classic, mashed with our national anthem, the Queen's Christmas speech, some monster beats

and a pumping, subsonic bass riff. Wrong. It would be just a straight rendition of our national anthem, the one they used to play at the end of the main feature, and which when I was a kid you still stood up for. And the video would be the royal standard fluttering in the wind. For three and a half minutes, no edits. Thankfully, the idea remains unrealised. But as for Union Jacks, Jimmy and me, there is a job there yet to be done. And Marc Wallenger hasn't done it.

Of course, we try to keep to toll gate twenty-three on each lap. Some habits you can't break, like wanking and picking your nose. Gimpo hits me with a concept that he tries to convince me my mate and fellow literary arsehole Z has already agreed to. A 25-day non-stop M25 journey. Just me, Gimpo and Z, the idea being that Z and I could finish our journey-up-the-Congo book while we spin round the 25. I'm filled with dread at the idea and hope it doesn't become a reality.

Darkness. Gimpo lights candles in the back of the van. Lap five, and a buzz is tingling my body like some strange and untried chemical. Talking of which, Mr Green has put on a Chemical Brothers cassette. A live performance, where they bang into 'Sergeant Pepper's Lonely Hearts Club Band', The Beatles' version with some added beats and noise. I'm out there. I'm hanging in the hammock. The candles flicker, the night shimmers ahead, my mind slips its moorings. For some reason, the three of us and this van are an old-fashioned tin-opener going around the equator, opening the world up, and the worms are getting out. The fact that Tony Blair is younger than me is somehow connected. No drink, no drugs, just the hypnotic effect of sodium lights. I love it.

My shift. Midnight to 4 a.m. Me and Gimpo up front. 'Sailing By' brings the closedown of Radio Four. Somewhere up near the St Albans turn-off, we can see a huge bonfire and a daisy chain of people silhouetted against the flames, dancing around and around. The rain is falling but they keep going. I explain to Gimpo that like us they are celebrating the equinox, but with a

Beltane fire. A bunch of hippies in a dark, wet field and us on a miserable motorway, each going round and round. The rites of spring. Pagan roots. Nailed to the cross and risen on the third day. My biblical leanings grasp at a walls-of-Jericho analogy. Round and round we go, and the walls will crumble. On Monday morning, 2,300 points will have been wiped from the Footsie 100, and nobody will know why except for us. The mother of parliament's bastard son will have burned down the palace, raped Harry in the tower and taken a shit in your girl-friend's handbag.

Stop stop stop.

Calm down, Bill.

Hale Bopp streaks the northern sky. The World Service informs us that Buddhist monks are rampaging on the road to Mandalay. Kinshasa is falling and Mobutu is on the run. Channels are changed. Melody FM. Abba's 'Fernando' – mari-achi trumpets, a tale of war, death, love and loss. Sodium lights like a ten-mile serpent, heading for the estuary. Downriver like Iain Sinclair. What would Sinclair make of the psychogeo-graphical possibilities of this, our mindless journey? I am hoping to uncover some psychogeographical facts about both the ancient and modern roads and routes that radiate out of the unseen metropolis, around which we are winding and tighten-ing our strange spell. I may be sliding in and out of reality, but Gimpo's intensity is scaling new heights. He is still raging into his mobile. It seems the support team have not once been at the right place at the right time to capture on video this transit van hurtling by. I'm thinking, how long is this new girlfriend going to take Gimpo on full throttle? The novelty value of the man soon wears thin. Added to this is the fact that the two cameras in the van keep jamming. As far as Gimpo is concerned, the whole thing is a disaster. He was planning on having a com-plete 25 hour film, every cat's eye of the way. Not a moment missed. Real time to the max. But it is not to be. He bangs out some more numbers on his mobile and takes it out on whoever

answers. The film of this journey (I think) is to be the follow-up to his first major movie, *Watch The K Foundation Burn a Million Quid*. I can't stress strongly enough how important this 25 hours is for the man. He has talked of nothing else since first revealing his plan to me back in Cardiff three months ago. Mr Green is saying very little as the hours skid by. He observes. I try to ask him, why Mr Green and not just Dave? People will think it's some sort of corny reference to *Reservoir Dogs*. Then he tells me that if I write up anything about this journey, he just wants to be known as Dave. But the contrary side to my nature gets the better of me, and Mr Green it is, Tarantino or not.

Gimpo is at the wheel. Light is streaking the eastern sky . . . and all that descriptive stuff about breaking dawns. Lap eight. Through toll gate twenty-three and back up into ancient Kent. The waking Weald. The garden of England. Cockney hop-pickers. The turning for Canterbury. Gimpo's Tale – now that would be good. The Carpenters' 'For All We Know' is cranking through the three-inch speakers, compressed to fuck and sounding like one of the best records ever made. A green hill covered by a sprawling car boot sale. Above, the clouds break and massive sunbeams shaft down, illuminating the hill, already crawling with Sunday morning seekers one bargain away from happiness. It's like a neo-classical canvas depicting the smallness of man in all his little ways, and the power and glory of the Almighty as he looks down on his wayward creation.

The turning for Brands Hatch, and my mind turns from the biblical to Damon's bad career move in signing to Arrows. For me and Gimpo, Johnny Herbert is our man. No glamour, no chance, born loser, but at times, for some unknown reason, gets to the chequered flag before the others. A small clump of primroses brings morning gold. Will they spread like they do down the Devon stretch of the M5? Or like the wild lupins on the M6 as it cuts through Birmingham? Gimpo's rage at the universe has found a new avenue as he hurls his beloved

mobile phone out the window. I momentarily hear a female voice plead 'but Gimpo' before it smashes into the side of a passing artic. Gimpo then turns the video camera on himself. It's set up on the dashboard. I'm in the hammock. Mr Green's asleep on the passenger seat. Gimpo's voice is shot through, but he starts to bark, scream, glare at the unblinking lens. His madness, his psychosis, his vanity, his vulgarity pour from his scarred soul as he tries to explain this journey of his. His inarticulate genius. His excuse for living. His sordid reality. (For those interested in such facts, I've heard from various reliable sources that Gimpo can fuck harder, faster and for longer than any other man in London.) He starts to get maudlin, he starts to apologise to the camera for being a cunt to his girlfriend. It's like I'm eavesdropping on some last confession before Mme Guillotine drops. He must assume I'm asleep. Some of the stuff he is coming out with is pretty embarrassing, and I won't embarrass my mate any further by documenting it here. He falls silent, and my paranoia tells me that this whole M25 thing is some sort of elaborate suicide plot.

I drift into sleep for a while. I dream a dream where Gimpo tells me that in the future the crusties, the ravers without hope, the feral underclasses, will live on the M25 in broken-down buses, discarded containers, packing cases and anything else that can be procured for nowt and provide shelter against the rains. The M25 will be taken over, clogged up, no longer used as a thoroughfare to nowhere. It will be like one of those forgotten canals behind backstreets in Brum, stagnant and dank, fit only for dead cats and stolen shopping trolleys, until it is ripe for future heritage culturalists to proclaim its worth as a site of special historic interest. It will be a place where Gimpo will be king. The dream shifts, and I see Gimpo robed in purple trimmed with ermine, held shoulder-high by a pack of Swampy's wayward grandchildren. They are carrying him to a throne built from a discarded forklift truck and broken pallets, decorated with hub caps and liberated crown jewels.

'Last lap,' Gimpo shouts, and I awake from my dreams of his coronation. I clamber into the front. The three of us peer out the truck screen at our fellow Sunday travellers. Mr Green seems disappointed; he was hoping for something to happen, something to be revealed, for some sort of breakthrough. Gimpo says, 'It might yet happen.' I say, 'Maybe it already has. We just don't know it yet. These things take some time.' We are passing by Heathrow pylons, J.G. Ballard crashlands. M40 west-bound. Blackthorn blossom, catkins and gorse gold. Wild cherry, hovering kestrel. Not one dead fox, dead badger, dead rabbit, even dead hedgehog, but lots of dead pheasants. I notice these things. So does Gimpo, and he notices so much more, but I'll wait till the Congo book is written before revealing the true essence of Gimpo and the awfulness of his vision of our land.

Back into Herts, St Albans Cathedral on the horizon. Two minutes to one. The pips. Gimpo goes berserk. The job has been done. We pull up on the hard shoulder. Trucks plough by. Gimpo is out. Down the embankment. Hammering in a wooden stake with a huge wooden mallet that I gave him as a wedding present. Mr Green has prepared a Wedgewood-blue plaque. These are the words printed on it:

> On March 22nd/23rd 1997 Dave Green, Bill
> Drummond and Gimpo drove around the M25 for 25
> hours non-stop. This plaque marks the point where
> the journey was finished.

This is nailed to the stake. Mr Green has also got a camera. He takes our pictures. We smile. A job well done.

Postscript: The Truth Will Out

If you are the type to remember such things as when Halley's Comet last visited our corner of the Solar System, you may have reckoned that my 'Gimpo's 25' story to be mis-dated by at least

365 days. Well, if you did, your reckoning would have been right. The story was written a month or so before I made it to my forty-fifth year, but because I wanted it included I lied about the date and added a year on to it.

THEY CALLED ME UP IN TENNESSEE

7 April 1998

A phone is ringing somewhere. Let the answerphone take it. I roll over, switch on the radio to the 6.00 a.m. news headlines on the rescheduled *Today* programme. Something about the peace process, something about a wonder drug for breast cancer, then:

> Legendary country and western singer Tammy
> Wynette has died, aged 55. She had sold more
> records than any other female country and western
> star, and was known as the First Lady of Country.
> She was less successful in her personal life: married
> five times, she . . .

I switch it off, get dressed, go out to feed the animals and open the chicken run. The damson trees are now in full blossom, but the weather forecast for this Easter weekend is wintry conditions. A late frost could wipe the whole crop out.

People can never get enough of dead rock 'n' roll stars. Writers want to write about them, movie-makers make movies about them and record companies want to repackage them. I'm sick of the whole thing; all those dead rock 'n' roll stars should be taken out and shot. Except for the ones who died

young and pretty – they should be forced to live until they lose their looks, talent, cool and credibility.

I collect the eggs. A blackcap is singing in the hedge. It's the first I've heard this year. They have a song that confirms all your innocent notions that there is a plan, and the plan is good. Back in the kitchen, I put the porridge on and sit down at the table and write.

Early summer, 1991. Jimmy and I were about to dump the track. We were working in a south London studio, trying to breathe life into a song that had originally been the opening track on our first album, '1987 (What the Fuck's Going On?)'. The singer we had been using sounded uninspired, doing a job, watching the clock. Jimmy turned to me.

'What this song needs, Bill, is Tammy Wynette.' Jimmy is always right. I sang along with the track, mimicking her southern twang. It was going to be the best record we had ever made.

I disappeared into the TV room to make phone calls. Somewhere in the world was Tammy Wynette, doing whatever the greatest female country singer the world has ever known does, and somewhere near her would be a telephone. I just had to find the number of that phone.

Twenty minutes later I was talking to her backstage in a Tennessee concert hall. She sounded exactly like Tammy Wynette should sound; a classic warm and friendly southern drawl. We played her the track down the phone. She laughed and told us she loved it. When could we get over to record together?

In the twenty minutes between Jimmy Cauty suggesting the idea and me speaking to her down the line backstage in Pennsylvania, I had been talking to Clive Davis, boss of Arista Records, the company that put out The KLF's records in the States, and Davis had been speaking to George Ritchie, Tammy Wynette's latest husband and manager. Davis had convinced Ritchie that although he had never heard of The KLF, we were in fact currently the biggest-selling British act in the world. A

deal was struck. Jimmy and I went to a café and rewrote the lyrics to our song, 'Justified and Ancient'. We were proud of them, but doubtful that Tammy Wynette would ever agree to sing them. 'They called me up in Tennessee/They said "Tammy, stand by the Jams" . . .' 'They're justified and they're ancient, and they drive an ice cream van . . .'

A week later I was touching down at Nashville, Tennessee, with a DAT of the backing track of 'Justified and Ancient' in my pocket. It was mid-afternoon. George Ritchie met me at the airport. He was driving a powder-blue Jag. The cassette case to our *White Room* album was on the rosewood dashboard, and he wanted me to know how excited he and Tammy were about the project. I didn't tell him the project stank. The whole British tradition of 'young' white artists dragging up some has-been legend to perform with is an evil and corrupt exchange; the young artist wanting to tap into the mythical status and credibility of the has-been, the has-been wanting some of that 'I'm still contemporary, relevant (and will do anything to get back in the charts)' stuff.

George Ritchie was a time-served Nashville songwriter: snakeskin boots, fresh-pressed jeans, a wet-look perm and just recovering from major heart surgery. I liked him. We pulled up at a pair of huge iron gates. Across them was spelt out, in two-foot-high metalwork, 'First Lady Acres'. The gates opened automatically and we drove up the drive to a low, southern, '60s mansion.

'Bill, is that you, honey? Bill, you come on up here.' Deep white carpets, huge bad taste art and from somewhere upstairs, that voice, calling out directly to me. I was 39, been there done that seen it all, but I was starstruck like I'd never been before in my life, and I'd not even met her yet.

As much as I have loved all sorts of music, from unlistenable avant-garde classical shit through to 'Barbie Girl' by Aqua, country music is the only music I've been totally able to identify with, especially now that I've gone through divorce, heartache,

kids, revenge and Jesus in my own life. Many of my contemporaries may dig the kitsch value of country. For me, that's just something I try to ignore. There are more country records in my collection than any other kind; it's what I listen to when I'm alone in the house. The day Jim Reeves died was my first great rock 'n' roll death moment. The weep of a pedal steel guitar is the sound of heartstrings being torn. We all need one outlet for the Sad Bastard in us; country music is my avenue.

Tammy Wynette was talking to me, calling me honey, telling me to come on up. I would have declared my undying love for her, agreed to run away together, live a life in cheap motels and all-night bars and . . . Ritchie turned to me.

'Bill, you better go on up and meet her – she's in her boudoir.' I followed the voice up the wide staircase. Tammy had her own beauty parlour. Her fingernails were being manicured by a young man, as a woman teased her hair into some feathered concoction. Her free hand was flicking through the pages of *Vogue*. Tammy never had the movie star looks of some of her lesser rivals, but she had a tough beauty, a no-messin' allure. No amount of airbrush on record sleeves could conceal it: this face was the epitome of that over-used phrase, Southern White Trash. Married at fourteen, divorced at seventeen, three kids by the time she was twenty. (I embroider the myth.) Every fuck-up, heartbreak and overdose chiselled lines of real beauty into her face, which the soft focus tried desperately to hide.

'I'm yours, Tammy. Take me,' was not my opening line, but it would have been if I were honest. Instead, I suffered a blackout. 'I'm not worthy', etc., had the better of me. The next thing I remember is sitting at a white grand piano in a huge front room, big enough for a hoedown; crystal chandeliers, the lot. I tried to steady my hands as I played the chords to 'Justified and Ancient', while Tammy sang along. It wasn't working out – she couldn't find the key, let alone get it in pitch. Ritchie kept us going, encouraging the both of us, telling us it sounded great.

Ritchie had booked a studio for that evening, between seven

and ten. Tammy had cancelled my hotel reservation, telling me I was to stay with them and that she was going to cook me grits for breakfast. The two of them gave me a grand tour of the house. It was a museum to her legend: walls covered in gold discs, awards, framed letters from heads of state, massive oil portraits of her children and a Warhol of herself. The place was everything that anybody could want from a Tammy Wynette mansion; from backwoods shack poverty to what most of us over here would see as endearing tack on a massive scale. Not quite Imelda Marcos, but you get the picture.

Then Tammy took me out to her back lot, where her tour bus was parked up. This, she told me, was her real home. She only ever had a good night's sleep when she could feel the highway speed by four feet below. She spent as much of the year on the road as possible. The idea that Jimmy and I had a commercially successful band and had never played live was beyond her comprehension. The only reason she could think of for making records was to get out there and perform for people, to give love and get it back. The concept that Jimmy and I made records that were not intended to be performed live – worse, would be impossible to perform live – was as ludicrous as playing concert halls but not letting anybody in (Tammy's analogy).

'Bill, you're from Scotland? Can you tell me why I have such a large lesbian following there?' I had no answer, but promised to look into it for her.

An off-duty policeman, armed and fully uniformed, had been hired to provide security for our half-mile drive to the studio. Tammy didn't go anywhere without security: it came with the star status. Her legend required it. It also demanded the full make-up and hairdo for a mere recording session. A star must look like a star all the time, even if it was just the recording engineers and me that got to see her. Being the First Lady of Country isn't a part-time job, nor was she in the White House for a mere couple of terms. It was a lifetime commitment.

All studios around the world have basically the same gear. I

had been kind of hoping it would be all down-home 1950s Americana, but no. Even the studio engineers looked the same. Apart from the waist-length hair and the cowboy boots. As soon as Tammy tried to sing to the backing track I had brought with me, I knew the whole project was a complete disaster. She could not keep in time with the track for more than four bars before speeding up or slowing down. I began to fill my face from a bowl of boiled sweets that sat on the mixing desk. Being a non-smoker, I resort to stuffing myself at the approach of any emotional crisis.

'How's it sound, Bill?' came the voice from the other side of the glass. How do you tell the voice you have worshipped for the past twenty years, one of the greatest singing voices of the twentieth century, a voice that defines a whole epoch of American culture, that it sounds shit?

'It sounds great, Tammy. We just want to try it a few more times, so your voice can feel the track.' More complete bollocks. Ritchie knew the score, he knew it wasn't happening. He explained to me that when Tammy was recording her own stuff, the band always laid down the backing track with her singing along; they took their timing from her. Speeding up and slowing down is part of any proper singer's arsenal of emotional fireworks. She had never sung to a bunch of machines playing dance music. The whole idea was turning sour. What sort of egocentric, vanity-drenched trip were Jimmy and I on, appropriating one of the world's greatest and purest musical treasures just to reduce it to an ironic aside?

Ritchie had an idea.

'Hey, hon, I'll come in there with you. We'll sing it together.' So Ritchie went into the booth and attempted to conduct her through each line, mouthing the words for her to follow. We did take after take, but things didn't get much better. I felt truly ashamed hearing her voice, the voice of poor white American womanhood, struggling to find some emotional content in our banal, self-referential lyrics. I shoved more boiled sweets into

my face and prayed it was just a bad acid flashback, and nothing to do with reality.

Thirty-six hours later I was back in that south London studio with Jimmy, piling up more and more excuses as to why I had failed to get any sort of usable performance out of the First Lady of Country. This was before I played him the tape. When I did, he said:

'We just got this new machine. We can sample up every word she sang separately – stretch them, squeeze them, get them all in time. As for her pitching, the listener will hear that as emotional integrity.' As I said earlier, Jimmy is always right.

'It's a Christmas Number One,' he added.

Jimmy was wrong. Freddie Mercury died, 'Bohemian Rhapsody' was re-released and we had to settle for the Number Two slot. A singer dying always messes up the agenda.

I eat my porridge and check the answerphone to hear who rang at the ungodly hour of 6.00 a.m. It was a researcher from the *Today* programme, who had wanted to know if I'd go on air with a quote. I don't want to speak to anybody, but if I did, this is what I'd say:

'Tammy Wynette may have been the greatest female country and western singer of all time, but she is also the only woman who has ever cooked me grits for breakfast.'

There will be one less Christmas card on my mantelpiece this year. Tonight, I will go to bed and cry.

IN PRAISE OF COUNCIL HOMES

4 May 1998

Destination Dagenham Heathway, on the District Line. The green one, heading east, Essex bound. I've got a back-end-of-winter cold coming down and the weather is miserable; that's the way (uh huh, uh huh) I like it (uh huh, uh huh). Ten years ago to the very moment, I was sitting on this tube train heading for the Village Recorders studio to meet up with Jimmy and get to work on our new track; a track that grew into 'Doctorin' the Tardis' by an imaginary band called The Timelords. The record was released on our label, KLF Communications. It went to Number One in the UK. We never attempted a follow-up by The Timelords, but we did sit down and write a book: *The Manual (How To Have A Number One The Easy Way)*. We published the book ourselves. Printed 7,000 copies, sold the lot, then got on with inventing The KLF.

Over the years the book became collectable, a cult item, sought-after, bought and sold for vastly inflated prices. Now it had been proposed that a new edition of the book should be published. Would I be interested in writing a new postscript? My original copy had been lent and unreturned some time past, so I phoned Helter Skelter, the rock/pop bookshop. I felt like J. R. Hartley in that *Yellow Pages* ad, phoning up for his fly-fishing book.

In Praise Of Council Homes

'Have you got any copies of that book *The Manual*, about making a hit record?'

'You mean *The Manual (How To Have A Number One The Easy Way)*? Like gold dust, mate. We've got a waiting list for people who want that.'

'Can I go on the waiting list?'

'Not worth it, mate, it's that long.'

'OK. Thanks anyway.'

So I wasn't going to get a copy that way. But it didn't half make me feel good to be told a book I had had a hand in writing was like gold dust. Better than having the *Bad Wisdom* books in the remaindered bins. My ex-wife lent me her copy and I photocopied it. I know that's a bit dodgy from a copyright point of view, but what could I do?

I've decided to re-read this photocopy of *The Manual* while making my pilgrimage back to Village Recorders. I got on at Aldgate East and we are now overground, out of the tunnel. Bromley-by-Bow, Iain Sinclair territory. Over the muddy waters of the river Lea. The rising Dome glimpsed between the graffiti-emblazoned walls of a crumbling civilisation.

In 1987, Essex was the perfect place to create a Number One. The man on the Clapham omnibus was out of a job; if the media wanted to know what the common man thought, they headed for Essex to do their vox pops. Essex Man was in his prime. Mike Gatting was captain of Essex and England. Maybe making the record in Essex was the real reason it topped the charts, not all the stuff we wrote in *The Manual*. Pick the right county and you're away. Which reminds me, when are the Ordnance Survey going to publish their psychogeographical survey of these islands?

I open *The Manual* and start to read. 'Text by . . . The Forever Ancients Liberation Loophole.' Now that's a name that Jimmy and I never got to use. It still feels like we are holding back on it, keeping it in reserve for when things get totally out of control and we need to make a quick escape. As for the guarantee on

the next page, not one person wrote in for it. Maybe people thought it was just a lie. The thing is, we went to the expense of printing up a load of these guarantees, expecting to be flooded with requests.

'Be ready to ride the Big Dipper of the mixed metaphor. Be ready to dip your hands in the Lucky Bag of life, gather the storm clouds of fantasy and anoint your own genius . . .' What an opening couple of lines. Every book I'm ever involved with in the future should kick off with these lines. It sets you, the reader and the writer, up. It promises so much and it forces you, the writer, to at least try to deliver the goods. Plaistow, Upton Park, East Ham, Barking. I read on, all 78 pages in less than 45 minutes.

'We've had enough. Just show us where the door is. The White Room is waiting.' That's the closing line, not as good as the opening one. As for what lay in between, of course it wouldn't work, in one sense – totally arrogant to think that chart success was just down to some rigid, objective rules laid down by us, that anybody should be able to follow. When I was sixteen and read *Playpower* by Richard Neville, it made me feel that everything and anything could be achieved, that life was an adventure begging to be begun. I wanted *The Manual* to be the same. To be able to say to people, 'Don't be afraid. If you want to do something, just go ahead and do it, but be prepared to take the blame, to feel the fall. Don't sit around waiting to be asked, to be given permission. Just get out there and do it.' Yes, I know it sounds like the blurb on the back of one of those American self-help-bollocks books. But it is a simple fact that every generation of artists needs to rediscover this; to smash the yoke of pop, art, literary history and have their very own Year Zero, their own small-press revolution, their punk revolt and their Marcel Duchamp.

As well as genuinely wanting to demystify the pop process, we wanted, in our arrogance, to elevate the one-hit-wonder novelty record to Art with a capital A, and to do this without

anyone knowing but ourselves. We wanted to celebrate the most reviled member of the UK Top Twenty as it happened, and not wait twenty years for its kitsch value to be given credibility status.

Ever since that urinal got signed, generations of artists have wanted to appropriate and/or mimic the trashy and mass-produced. The patronising stance adopted by these artists towards the mass-produced has nearly always stopped them from being more than voyeurs and/or critics of the process, unable to produce work that is genuinely consumed by the mass market. Throughout the twentieth century some of us artists have been on the run, threatened and made to feel redundant by the mass-produced. As much as an artist might long to produce a work that is bought en masse by the proletariat, they are nearly always thwarted by their lack of craft or understanding of the market place. More debilitating than this is the artist's insecure need to be applauded by their own peer-group elite. A well-documented fact, this need for peer-group applause being our driving force and our undoing.

I don't think we believed that anybody would take the book literally, but a couple of blokes from Austria had a damn good try. Although they never had that UK Number One, they did sell a couple of million records worldwide. Nobody has heard of them since. Jimmy and I had just finished writing *The Manual* when we were contacted by these two lads from Vienna who wanted to come over and have a chat with us. We said, 'Fine.' They had an idea for a record using Austrian yodelling, break beats, Abba samples, lederhosen and loads of cleavage heaving out of Alpine period costumes. They wanted Jimmy and me to produce their concept for them. We said, 'We don't need to, you can do it yourself,' handed them a copy of *The Manual* and sent them packing back to Austria. A few months later, 'Bring me Edelweiss' by Edelweiss climbed into the UK Top Ten, was Number One in six European countries and even went Top Five in the States. It was as bad a record as (or an even greater

record than) our Timelords one, with the added bonus of a truly international appeal – and loads of that cleavage in the promotional video clip. (In my latest – but out-of-date – edition of the *Guinness Book of Hit Singles*, Edelweiss are wrongly attributed as coming from Switzerland. An easy mistake, with all that yodelling.)

Maybe the book's only current worth is as a period piece. So many of the supposed practical tips were of the moment, not eternal rules as we stated. The reference points have passed into pop history. I mean, where is Bruno Brooks (and who would want to know), and whatever happened to Steve Wright's genius? Like all pop genius, by its very definition it never stays faithful to one individual for longer than Warhol's fifteen minutes. Then it finds another host brain to reward and torment, like a flea gaily hopping its way from head to head.

The tube pulls up to Dagenham Heathway. I take a deep pull on the damp Essex marsh air. It feels good. It's about a mile and a half walk from here to the Village Recorders studio. This is the bit that I always liked best. Down past the Heathway parade of shops. Turn right by Mo's Fish Bar and Restaurant, into Reede Road. Post-war council housing. Forget timber-framed thatched cottages – this is England. Council estates on drizzly March days. It makes me feel safe and secure. This is where I belong, though fate intervened and took me away from the council estates of home. Tom Jones can keep his green green grass, I want that post-war grey Labour government pebble-dash, where everybody has their own front and back garden to fill with stained mattresses, retired washing machines or pretty maids all in a row.

Of course, the great owner-occupier push of the '80s changed the way these houses look. All over the country, proud new owner-occupiers invested their castles with stone cladding, mock-Georgian front doors, leaded diamond windows, brass number plates and satellite dishes.

I'm not trying to indulge in some mock Hoggart Uses of

Literacy observations about our isles. No. This is all building up to a fact that somehow got missed out from the original edition of *The Manual*: 97.5 per cent of all great British pop records have been created by individuals dreaming their teenage years away in fuggy box bedrooms on council estates. Ask Julie Burchill; this is the sort of thing she knows about. From Billy Fury all the way through to Sporty Spice – council house box bedrooms. Being stuck in a public-school dormitory waiting for your weekly fix of the *NME* somehow doesn't quite do the trick. I almost believe this myself. I want to go and prove my randomly invented percentage through exhaustive research. Phone Pete Frame – he's the sort of bloke who would know.

Turn left at Pondfield Road. Seagulls attack last night's fish supper, scattered across the road. A G reg. Ford Escort, fog lamps, sun screen, is up on bricks, its bachelor days over. Dagenham and Redbridge FC's ground. Dreaming of glory days in the Vauxhall Conference. Minor-league football grounds are always far more romantic than their big brothers; so much more to play for on grey, lonely away days. There is something that links all this with our nation's consumption of hit single records, something about this has to be understood even if it can never be articulated.

So, like we said in *The Manual*, we tried to pretend to ourselves that it was our early '70s Ford Galaxy American cop car that masterminded the record. We gave him the name Ford Timelord. The only thing is, nobody believed us, even though with the help of some primitive technology we got him to do all the interviews. *Top of the Pops* wouldn't even let us bring him into the TV studio for our chart-topping performance.

When the record slipped from the Number One slot, we had a plan. We approached an off-Cork Street art gallery. The plan was for us to paint two huge, life-sized portraits of Ford Timelord, one from each profile. The canvases would be about fifteen feet by seven feet. These two paintings would be hung

on opposite sides of the gallery. In between them we would exhibit Ford Timelord himself. Then at the opening of the show, Jimmy, dressed in his black top hat, tails and cape, and I, in my corresponding white ones, would take our axle grinders, cut Ford Timelord up and sell the bits to the art-buying guests.

Ever since Jim Reeves died I've had a fixation with the death of pop stars. I've always hated, resented and revelled in their instant deification and subsequent exploitation. This fascination has led to an unfocused fantasy that immediately after the death of Elvis, Colonel Tom Parker (the King's legendary manager) had him cut up into a thousand pieces, each piece frozen then sold off secretly in million-dollar bite-sized chunks. There was/is something so much purer in this than all the crap repackaging of back catalogues, endless calendars and tacky merchandise. It seemed to reach deeper into the human psyche, like the medieval market for the relics of saints.

The gallery owner seemed to be quite keen on our idea. He mentioned in passing that Bob Geldof had come into his gallery lately and bought a painting. He reckoned that pop stars were about ripe for getting into buying contemporary art. He wanted to know how many pop stars we knew that we could invite along, and were they likely to buy? Something about the idea began to smell. We had thought he was into it because it was great art. Maybe all he was interested in was tapping into the market of gullible pop stars wanting to buy their way up a cultural ladder.

He had another idea. He would stage the exhibition in an East End warehouse, and not in his off-Cork Street gallery. He told us about this scene that was beginning to happen around Whitechapel. A bunch of young British artists just out of college doing things like this. If our show was staged there it would give it the right context. We thought he just didn't rate our idea as good enough for his gallery, didn't want to tarnish his Mayfair reputation. We didn't want to be lumped in with a

bunch of no-hoper ex-art students in the East End. We had just had a Number One. We knew about corporate identity, commodification, logo is all, death sells, the common touch, ambivalent irony, contextualisation, appropriation. We knew about art. Wallowing in our naïveté, we knew we were clever. (Obviously, not clever enough.) So we said Fuck Off. Or rather, we didn't say Fuck Off. Nothing as up-front and tough-lad as that. We just didn't do the show.

Instead, we decided to use all the money that was pouring in from our Timelords record to make a movie. It was to be a road movie with no dialogue. Just a soundtrack. We would screen the film in acid-house clubs (it was 1988, remember). We would set up our machines at the other end of the room by the projector and play the soundtrack. We asked a friend, Bill Butt, to direct it. A crew who had just finished working on a Spielberg movie at Pinewood were drafted in, and we were off.

The film started at Trancentral, our South London HQ. Most of the rest was shot in the Sierra Nevada region of southern Spain, where all the spaghetti westerns were filmed. There were deserts, castles, dirt tracks, mountains, big big landscapes and even bigger skies. Jimmy, me and Ford Timelord on the road to oblivion. No script, no preconceived ideas, nobody to say No. Just a title. *The White Room.* When we got back to London and spent a day watching the rushes, we decided it was all a load of bollocks. The trouble was, by then we had written and were committed to recording the soundtrack to *The White Room.* In the fullness of time, the album came out and spawned a bagful of multi-million-selling singles.

So why am I telling you all this, other than to brag about what a wonderful, rich and varied life we lead? Because I want to emphasise how, when you push your boat . . . take that step into the . . . and just say Yes, things happen. You may have no control over them. Let them be, let them spiral out there.

Ten years after we turned up our noses at putting our car-cutting show on in an East End warehouse so we could be seen

as part of a sad scene of ex-art students, those same sad fuckers are the sexiest international art stars in the firmament.

Pondfield Road turns into Wantz Road and there is the Tip Top nightclub, though now it has changed its name to the Wantz Social Club. I remember reading an article about the so-called Essex Girl phenomenon. The journalist wanted to find out what the young women of Essex thought of this much-discussed creature. He trekked out to the eastern wastelands for research. The female natives of Chelmsford, Southend, Billericay and Canvey Island said, 'It's not us, it's those tarts in Dagenham that give us a bad name.' The research continued to Dagenham, where the journalist found the local stonewash-denimed, bleached-blonde-grown-out, white-stilettoed women, who said, 'No, it's not us. It's that lot that go to the Tip Top night club down Wantz Road.' That is where the true Essex Girl is to be found.

Village Recorders studio is on a small industrial estate, the Midas Business Centre. It is only now that I remember its name. Maybe you should forget all the revealing insights, handy hints and golden rules documented in *The Manual*. Maybe the fact that everything turned to gold was all down to working at the Midas Business Centre.

Village Recorders. Just another prefabricated unit on a light industrial estate. Tony the studio owner's Jag is parked up outside, as it always was. He now has a newish-looking XJ Sport, still with the same personalised number plate. I go up to the door and peer through the rather odd stained-glass window they always had. There is a light on. I can hear people's voices. I can feel the thud of a bass drum. I don't knock. I could never stand all that, 'So what have you been up to' stuff – I mean, where do you start? Do they want to hear the truth? Do *I* want to hear the truth? I turn around and walk away, whistling a tune that's been on my brain all day. The drizzle still tastes good at the back of my throat.

And you can forget all my self-effacing ramblings, because

In Praise Of Council Homes

The Manual still stands as the only book that delivers the truth about having a UK Number One the easy way. There is still time for you to go out there and dip your hands in the Lucky Bag of life, to gather the storm clouds of fantasy and anoint your own genius.

FOR

This book
Is
For
Alasdair
Bluebell
James
Kate
Tiger
and
Me.

MAKING SOUP

6 May 1998

Tonight I'm in the City of Dreams, Belfast, making soup for thirty or so young artists in a kitchen in College Green House. You can lose yourself in making soup. The imagination can start to spiral into uncharted regions, reality can become bearable, even enjoyable. You can also find yourself in making soup, though what you find may bore you. It always starts with chopping onions. You have to master holding back the tears, but once that's done, onions are the most rewarding vegetable in the world to chop. Everybody loves the aroma of frying onions. It's what unites all meals in every kitchen around the globe.

A couple of weeks ago I received an invitation to participate in an exhibition in Belfast. The exhibition was being presented by Grassy Knoll Productions and was entitled 'Reverend Todd's Full House'. Grassy Knoll Productions is basically the creative cover for Glasgow-born, Belfast-based artist Susan Philipsz. Philipsz's idea was to invite every artist that had ever lived, stayed or crashed at College Green House to contribute work that could be exhibited in a site-specific way in a domestic, inhabited setting, e.g. a sculpture built to make sense only under a bed, or in a fridge.

College Green House is on the Botanic Road, which runs from the Belfast city centre up to the blooming Botanic

Gardens. The road cuts through the student and Bohemian quarter of the city. I stayed in the House for a night in late 1996, thus the invite. My friends, Z and Gimpo, and I had been telling our *Bad Wisdom* story at the Catalyst Centre in the heart of Belfast. Until I arrived about an hour ago, I had no recollection of what College Green House looked like. It turns out to be a crumbling, three-storey, red-brick Victorian town house. No central heating, nothing that could be described as a mod con. Sacks of coal split and spilling outside the doors of the six flats into which the place has been divided. It was first owned by a Reverend Todd Martin, hence the show's title, and at some point in the 1930s, to quote the flyer that came with the invite, 'it fell from grace, its reputation became tarnished and it was known as a house of ill repute, wild parties and clandestine couplings.' It is now and has been for many years occupied by artists. Susan Philipsz and fellow artist Eoghan McTigue occupy a flat on the top floor of the house.

I had responded to Susan Philipsz's/Grassy Knoll's invitation by telling her that although I was not currently in the business of making art, I was having to visit Belfast in early May, and could call round at the house and make soup for whoever was there. A kind of Soup Kitchen Concept Thing. The real reason for my journey to the city was to sort out some roof repairs on a building in Northern Ireland in which I have an interest.

There was a time in the Church of Scotland, a couple of hundred years ago, when they would only celebrate Communion once a year. Instead of having a sip of soured wine and a nibble of stale bread, the whole parish would turn up at the church and have a meal together. The churches in those days didn't have fitted pews, so they were able to clear the chairs and construct a trestle table the length of the church. It always seemed to me the perfect way of bringing a community together, far more in keeping with the spirit of the first Last Supper. This trestle-tabled coming-together to break bread was somewhere

in my soup kitchen concept, and I must have told this to Philipsz on the phone, because when I turned up here late this afternoon there was already a huge, ramshackle and improvised table covered in best Irish white linen in the largest room in the house. She also said that a Berlin performance artist, Kieke Twisselman, was going to wash all the guests' feet while they supped their soup and broke their bread.

The kitchen is pretty cramped and it struggles against being squalid, but they have provided me with a sharp knife and a chopping board and have also rustled up four large cooking pots. My plan is to make a thick and lumpy (not chunky) vegetable broth. Nothing exotic, plenty of potatoes and turnip, but still rich and tasty. I was relying on picking up all the ingredients I needed locally, so on arriving here an hour or so ago, Philipsz whizzed me off to the local supermarket, to find its riot-proof shutters coming down for the night. The only other suggestion she had was the Asian cash and carry: 'They always stay open late.' I didn't like the sound of this. I didn't want to be tempted by decadent spices, weird vegetables and even stranger fruit. But Susan Philipsz reassured me that they did sell regular vegetables as well, and anyway I had no choice. On arriving at the Asian cash and carry I was relieved to be able to fill my trolley with potatoes, carrots, leeks, turnips, parsnips and, of course, onions. They only had those massive ones the size of grapefruit.

I had not travelled to Belfast alone. Accompanying me was a friend, Paul Graham. Paul Graham is a photographic artist. He has been coming over here at least once a year for the last fourteen, observing the land and its people and taking pictures. At home I have two of Paul Graham's pictures in my work room. Although they are framed, I've never got round to hanging them. I leave them stacked facing the wall along with a load of sheets of ply. One picture is entitled *Unionist-coloured kerbstones at dusk, New Omagh* (1985), the other *Republican coloured kerbstones, Curmin Road, Belfast* (1984). Every so

often I get them out to look at. It is as if I'm checking them to see if anything has changed. I keep getting the feeling that the paint on the kerbstones is fading. Mind you, it might just be something lacking in the solution when they were printed. I had better have a word with Paul about it.

Graham was a nuisance in the cash and carry. He kept trying to make suggestions and slip items into my trolley while my attention was being diverted. By the time I got to the check-out, as well as my basic veg, the trolley was heaped with those deca-dent spices, weird vegetables and strange fruit. Philipsz looked pleased with the haul. She is in her mid twenties and has long, naturally red hair, that sort of intense red that seems totally unreal. Added to the hair, her pale and freckly face give her that exaggerated Scottish look only ever seen in patronising tartan movies or insulting animated cartoons. To me, she looks the ideal of womanhood. She now wears her hair with pride, but recounts a miserable childhood cursing her fate and counting the days to when she could leave home and dye it black. And why the name, with that uncomfortable Z? She tells me of a Dutch ancestor and Flemish spelling.

Back at the house I learn that the kitchen, where I'm now chopping up the last of the ten onions and streaming with tears, currently belongs to a couple of first-year art students, Ellena Medley and Karen Mitchell. These two have the ground-floor flat. They are both English, and when I ask why they have chosen Belfast they say it's a great place to be. It is.

When I was a child living in Galloway, Scotland, in the late '50s, early '60s, Belfast was the nearest big city. It was both closer and easier to get to than Glasgow or Edinburgh. We would take the bus into Stranraer, catch the ferry across to Larne and from there the local train down into Belfast city centre. It is where we did our Christmas shopping. It is where I first met Santa in his grotto and experienced neon lights, department stores, escalators, buildings with more than two

Making Soup

storeys. It was the metropolis, the modern world. What attracts me to Belfast now is obviously not the glamour, the big city lights of my childhood, and it's not seeing the sites of tribal wars, being a tourist in somebody else's battlefield. These days, when I walk about Belfast one of the things I love is that you can never go a dozen or so steps without spying the gorse- and heather-covered hills that surround this modest city, peeking out from behind a passing building. (Not like Dublin with its Georgian crescents and literary vanities, Dublin with its rock 'n' roll and fake bodhran-bashing heritage, with its Liffy and Guinness and American tourists. In fact everything about the way it sells its cosy little self-satisfied tourist self to the world makes me sick.) Belfast is a city where artists are forced to take risks. There is no zero-tax support system, no booming business looking to up its cool by sponsoring some cutting-edge art. There are no galleries, no tiger economy. Just the crumbling remains of an industrial revolution, presided over by the towering gantries and cranes of the Harland and Woolf ship yards. Belfast is my kinda town.

It's eight o'clock and guests are beginning to arrive. I promised Susan Philipsz that I would be ready to serve by nine. I'm still at the vegetable-chopping stage and I'm beginning to panic. Paul Graham is giving me a hand. He has opened a bottle of Cape red and is stirring all four of the pots to prevent burning. For this he is using what amounts to a wooden shovel, a four-foot-long stirring implement made from tight-grained beech. There was a whole binful of them for sale in the cash and carry.

As each guest arrives they are ushered into the kitchen, where they introduce themselves, justify why they have been invited. Being Irish, each has his or her tale to tell. One informs us that Garrett Fitzgerald spent his boyhood here, another that Errol Flynn lost his virginity here. We are told that Oscar Wilde spoke the name of a love that dared not upstairs, and that the

first case of Aids in Europe was contracted in College Green
House, by a local lad sharing a bed with an African seaman. You
can't trust the Irish, but they tell good stories. We then ask each
person to stir ceremonially with the shovel the four bubbling
pots of soup. I do not ask them to make a wish, as one would do
with a Christmas pudding. Instead I secretly hoard all the
wishes for myself.

As I stir my desperate brew, I think about the fish soup, pre-
pared and presented with a quiet confidence, that I'd enjoyed
earlier in the day. Paul Graham and I had lunched with Marcus
Patton, the director of an organisation known as the Hearth
Revolving Fund. Hearth's main purpose is to oversee the
restoration and preservation of interesting buildings, however
modest, in Northern Ireland – not the stately homes or castles
that might interest the National Trust, more the toll-gate booths
or keeper's cottages. It was due to the broken slates and gen-
eral disrepair of the building over here in which I have an
interest that I was having to get together with Patton, although
I was also intrigued by things that he had done in the past.
Patton is a man in his middle years who affects a pre-war dress
sense, a man with an OBE after his name, a man who has done
things for the greater good, but also a man who in the late '60s
was one of the founding members of Belfast's Non Objectivist
Society. The Non Objectivist Society's manifesto was published
in 1968 and I'm going to use this story as an excuse to quote
from it.

> Art can no longer shock or disturb – its identity has
> changed. It is now a fallacy to say that art is art,
> therefore we have changed its name and will now
> call it 'ART', having no better name to hand. Should
> you be indecisive, act in the following manner: dig a
> hole about four feet deep (depending on your
> height). This hole may be dug anywhere. Now stand
> perfectly upright in your hole, and consider why you

> have dug it. Fill it in. If you have not reasoned why
> you dug this hole, dig another.

Art history will tell you that the above statement could have been written in any year and in any western city of the twentieth century. And probably was. That knowledge doesn't take away the power and the poetry from this telling. I like to think that if I were an art teacher I would hand this statement out to each of my pupils and force them to comply with its instructions. I'm also drawn to the cruel irony that a year after its publication, the world learned new ways to be unshocked and undisturbed by what Belfast had to offer. While his fellow countrymen were not surrendering, and learning new ways to use garden fertiliser, the young Marcus Patton was looking under the rubble and finding it difficult to uncover anything left to rebel against. Struggling young artists had a hard time of it if they weren't into painting gable ends or kerbstones. So Patton published *Crab Grass*, a magazine dedicated to concrete poetry, and promoted concerts of unlistenable music (John Cage and the like). It's one thing to do this in New York, Chicago or San Francisco. But in Belfast, it requires steel or stupidity.

We all know and understand the young artist's need to rip and tear, stamp and shout, and we all know that once he has shot his load there isn't much left, so he jacks it in or gets thrown out, hiding his bitterness under a bushel. With a young family to feed and a roof to keep, art is no longer what it was and the ideals of youth seem foolish and vain. But there are those who soldier on, the not-so-young artists, no longer satisfied with the thrill of the ride now that the rush of youth is over and the all-night party is a bore. So they dig deeper, explore their real and more complex selves. But we, the consumers, find all this self-discovery to be somewhat trite. Even worse, a bit of a bore. Marcus Patton is one of the lucky few. As he has matured he has been able to channel his creative energies into the care of old buildings and this is, to quote him, 'more

difficult – and in its way, just as experimental.' His creative energies have not been wasted.

Marcus Patton's 17-year-old son had lunch with us. He had been in the sixth form, but he jacked it in. He is considering becoming a gamekeeper or joining the army. Now that is rebellion, considering that he is the son of professional, liberal Bohemians, and where he has grown up. I doffed my cap to his sullen countenance and hoped he would find a path through, as his father did.

Marcus Patton wanted to know what else we were up to over in Belfast so I told him about 'Reverend Todd's Full House', the soup kitchen, and how we were just about to drive up the coast to see Charles McAuley.

'Charles McAuley the artist?'

'Why, do you know him?' I asked eagerly.

'No. I know of him, who doesn't? But the only thing you ever hear about him these days is when another one of his paintings goes for more than £10,000. Surely he represents everything you loathe? I know he did for us.'

As the young artists come into the kitchen to stir my pots of soup, I want to ask each of them the same question – why are you in Belfast? – but haven't the presence of mind to do so. Instead I decide to write all of this down as a memento of the evening and to pose my questions: Do you have a secret desire to run away to London? To have a go? To make a bigger splash? Cut a swathe through a media infatuated with latest openings? Or are you too scared to compete in the fast lane of international art marketeers? Or: are you here for the long haul? Driven to make a difference in a place where there are no Saatchis or Absolut vodkas, and d'Offay or Jopling is not about to make you an offer? Where stardom isn't an option? Write your answers on a card and mail them to me at PO Box 91, HP22 4RS, UK.

Things are getting pretty hot. Kieke Twisselman, the Berlin

performance artist, has turned up. To my surprise, she has a Belfast accent, a real tough one. She is getting her kit off and putting on a costume which involves a lot of latex body make-up, an amphibian-style mask and webbed feet. She ends up looking like one of the less-threatening aliens from which Doctor Who had to save the universe. She needs the washing-up bowl to wash the guests' feet in. I need it to scrub the parsnips in.

The walls are dripping with condensation. Paul Graham reminds me I haven't put the bag of okra or the lotus root into the soup yet. In it goes, reluctantly. A woman who I'm trying to decide if I fancy or not keeps coming to offer help. After I notice her snogging a loud-mouthed drunk outside the lavatory, I decide I don't fancy her. Paul is getting friendly with one of the young art students whose kitchen this is. I feel a twinge of jealousy. I wonder what line he is spinning her. What with his tousled black locks and his romantic Russian poet looks, she's bound to be impressed.

Every morning as I leave my house I cast a glance at one of Paul's pictures that I have hanging in a spare room that has been taken over by my two youngest girls and their toys. It is one of a series of pictures he took during the IRA's 'temporary cessation of hostilities' in spring 1994. All the pictures were of the grey cloudy skies above the towns, estates and roads whose names have all become famous to us on the mainland for one reason only. Mine was taken of the clouds above the Shankill Road. It's big, about four feet six inches by three feet six. It's not a dramatic sky, no great shafts of sunlight breaking through. Just a large grey rectangle hanging on the wall of an empty room. The glass in the frame reflects the plum tree outside the window. Every day I see the season slowly turn in that reflection. This morning, as I was leaving for Luton airport, I noticed that the last of the blossom had fallen as the grey clouds stayed held for ever in that one-sixtieth of a second above west Belfast. My three-and-a-half-year-old daughter had stuck up a

Teletubbies poster, one with lyrics to their song 'Teletubbies Say E-Oh', next to the clouds. Teletubbies love each other. And where do they live? 'Over the hills and far away.' In some of his shows Paul Graham hangs his photographs together in diptychs or triptychs. It is the way that the two or three pictures resonate together that gives the complete work its power.

I continue to stir the soup. The young art babe is responding positively to Paul's chat. I hope he doesn't try to get off with her. You come to Northern Ireland with one of your mates and just because he has recently split up with his girlfriend he thinks he can chat up an art student many years his junior.

Susan Philipsz is panicking about bowls. She has already scoured the six flats in the building for anything that looks like it could hold a ladleful of soup. The doorbell keeps ringing and more and more surprise guests keep turning up. Flower vases and bed pans, teapots and coffee jugs, salad bowls and shaving mugs are pressganged into working the soup kitchen for the night. Paul Graham and I haven't had a chance to see round the building; no idea what sort of work is on show. It could be any old crap, or just the sort of stuff that makes the feature editors of art magazines decide that Belfast is now where the cutting edge of art is at. Like they did for Glasgow once upon a time and are probably doing for Cardiff as I make this soup. But that kind of 'where it's at' is never for real. Lasts as long as a hula-hoop craze, as far as these islands are concerned. London is where it's at and where it's going to stay. Art is always where the power is. Talking of cutting-edge art, yet another kitchen cruiser has just told me that someone cut the privet hedge outside at the opening on Sunday. The piece was called 'Cutting Hedge Art'. As Gimpo once asked, 'Why do all these modern artists think they're fucking comedians?'

Back to the kitchen. I heard Will Self on the radio last week, mocking Nick Hornby for being the sort of bloke who was always in the kitchen at parties. I want to take this opportunity

to mock Will Self for being the sort of bloke who needs to go to parties in the first place.

It has just been pointed out to me by a drunken Swede that above the kitchen door is a fine piece of art. And so there is. A five feet by four feet sheet of steely grey paper with these words on it: *Mayflys dance across the floor, ascend abruptly like departing souls*.

'Is that part of the "Reverend Todd's Full House" show?'

'It certainly is, and a very good thing for sure.' It's strange to hear a drunken Swede affecting an Irish way with words.

The swingbin is overflowing with potato peelings and the linoleum is slippery with spilt wine. I've just remembered the sack of frozen plums in my bag. Paul keeps filling my glass. The bottle of Cape red is almost empty, and normally I'm a teetotaller, or as close as you can be without signing the pledge. The basic vegetables have now sweated it out for long enough; it's time to start piling in the taste. Here goes. A dozen red peppers get chopped on the board and slide in, along with half a bottle of claret. A garlic bulb is broken up, the cloves crushed. A catering-size tin of tomato puree is opened and scraped out. Two family-size packs of cashew nuts are emptied. A bottle of soy is shaken to the last drops. And a whole jar of crunchy peanut butter is scooped out. Now that feels better, looks better and smells better. But it still doesn't taste the way it should. Making soup is all about trusting your instinct, and right now my instinct is telling me I have forgotten the spice and herbs. So two of those skinny long red-hot chillis get chopped up and shoved in. A tip: always remember to rub your eyes before chopping – saves on rubbing them afterwards. Two dessertspoons of cayenne pepper. Four bay leaves from the stash I keep in my hip pocket. Tip two: never pass a bay tree without picking a couple of leaves; you never know when you might need them. Take a sip. Still lacking in the herb department. Raid the kitchen larder. Find a domestic-sized jar of mixed herbs, two weeks to go on the 'best by' date. Empty the

contents, take a sip. Now we are getting somewhere. Give these four pots half an hour on a low heat. That should mix and match the flavours. The only problem now is, will any of the pots burn? This is always a probability when working with pots and a cooker that you have not got to know. The fact that I'm having to work with four pots at the same time, all of which will react to the same heat in different ways, is a pain in the arse.

Eoghan (pronounced 'Owen') McTigue squeezes into the now-crowded kitchen, wanting to know how things are going. He has a lovely southern-Irish accent. Tall, lithe of limb, firm of jaw, and with clear blue eyes that you know every red-blooded female would want to go for a swoon in. He's also a good bloke with boundless enthusiasm for his chosen city, not just some blarney charmer.

'How come you came up here to live? I thought the last thing that anybody down in the Republic wants to do is come up to the north, even to visit.'

'Well, originally it was to come to college. Down south you had to pay for higher education; up here it was free. But once I got here I just stayed. It's more vital, exciting, strange things happen. Down in Dublin you feel you're always working under a heavy blanket of state-hyped cultural heritage. I went over to London for a while, but that seemed to be driven by a desperate need to be noticed. But maybe I just didn't fit in.' Eoghan McTigue then turns the questions back on me. 'Other than the soup, why else are you over in Belfast?'

I explain about the broken tiles and my meeting with Marcus Patton and how I hope Patton will get down to look over the house, because I think he would find the whole 'Reverend Todd's Full House' an inspirational experience, or at least an enchanting idea. But yes, I do have another agenda, and it's not just using this soup-writing as a vehicle to explore some of my feelings for Belfast.

'Do you know who Charles McAuley is?' I ask.

'No.'

Making Soup

'He is the greatest living regional artist in these islands.'

'Never heard of him.'

I suppose I'm disappointed at his ignorance; at least Marcus Patton's generation knew him as something to despise.

The other agenda, which I still can't quite bring into focus (and I'm not about to make a fool of myself by trying to explain it to Eoghan McTigue) has something to do with the three ages of the artist. The first being Eoghan McTigue and all the gang living in this house, 'kicking against the pricks' and celebrating life. And if they survive and have got something to give then they are lucky, like Marcus Patton whose creative juices are still flowing.

Then there is Charles McAuley, 88, gets about with the aid of a zimmer frame but is still painting. I explain to McTigue how Paul Graham and I had driven up the coast this afternoon, to the ancient village of Cushendall, deep in the glens of Antrim and home of Charles McAuley. I had been winging it: I had neither an appointment nor even his address. I phoned a friend in Ballycastle who knew the area and he recommended, 'Just go down Dalirada Avenue in Cushendall, ask for old Charlie McAuley, everybody knows Charlie the painter.'

Paul Graham had wanted to know what it was that I liked about McAuley's painting. I have to be honest, it is only the stuff he did as a young man that I like, the paintings before the war. Paintings depicting his local landscape and people at work in the fields. In his later years he kept harking back to those earlier times; whether this was his own nostalgia or pandering to the tastes of the local art market I don't know. But it wasn't so much his shortcomings that I was interested in, it was more how a peasant boy of the bog came to get started with painting in the first place. And how come he never wanted to run away to the big city and taste the wicked delights of the Bohemian life – beret, smock and willing models? How come he stayed all his life in the one glen, painting the same fields, streams and mountains again and again and again? And what keeps him

painting today, when he doesn't need the money and his fame has spread all its going to? Of course, McAuley's paintings are a million light years away from what gets written about in the pages of *Frieze* or *Siski* but there is something that connects them: the drive to make sense of the chaos that's in our head and fills our universe. The drive to hold it down so we can proclaim, 'Look, this is it, this is what I see, I hear, I feel. Don't you feel it too?'

Paul Graham and I found Dalirada Avenue easily enough, and asked a man washing his car if he knew which house was Charlie McAuley's.

'It's the last bungalow down there. His son, Henry McAuley, lives just across the road – maybe you should speak to him first.' This sounded like an instruction. We rang the doorbell of the large modern bungalow. It was answered by Henry. Six foot two, early 50s, full head of dark hair, a bristling moustache and a large cigar. He had that instant warm, easy and open charm that seems to come so naturally to the people of Northern Ireland. Don't let the hectoring tone of one of Ulster's more famous sons persuade you otherwise.

We made our introductions and were ushered into the spacious drawing room. Marble floor, lots of polished brass and dark wood. The walls were crammed with the work of his father. I explained that I was a writer and how in my opinion Charles McAuley was the greatest living regional artist in the British Isles, and that I was planning to write an article on him for one of the English magazines. I didn't mention the soup or Reverend Todd or how I thought all his father's work for the last thirty years was pot-boiling rubbish.

'I'm afraid my father has had it up to here with being interviewed. TV crews just turning up at his house, journalists knocking on his door, art students coming up from Belfast wanting to ask him how he does it. The trouble is he doesn't know how to turn people away, but all he wants to do is return to his easel and paint. What people don't realise, he is a very

shy man, finds it very difficult to talk about what he does. The way he paints.' All this was said while maintaining his warm smile. I was not upset or even surprised at the situation. Pleased in a way that Charles McAuley in the twilight of his years was still secure enough in his work not to need the praise of some far-off chattering classes. Either that or his son didn't want the outside world seeing the toll the passing years had taken on his father.

'Are there any books or writings that you think give a fair portrait of your father's work and life? Something I could refer to while writing my piece?'

'Well so much has been written over the years, it's hard to pick any one thing out.'

In fact I was just making polite conversation. I knew that nothing that could ever be set down in words would answer the questions I wanted answering. Maybe I just wanted to come and pay homage to a creative life spent at a distance from any metropolitan dash and as far from the shock of the new as you can get, yet still struggling with internal chaos and a market place that both contextualises and determines the work. Out here in the glens of Antrim the market place may not be governed by a Saatchi-style collector, City bank art speculators or even Arts Council grant application assessors. Out here it's the wealthy local farmers and successful Belfast businessmen with second homes wanting to hang their walls with reminders of their rural roots.

Henry McAuley found a small A5-size sheet of text, no more than 400 words on it.

'Basically, that is my father – artistwise – in a nutshell.' Firm handshakes and grateful thanks and we got off. Back in the hire car Paul Graham and I decided to use the spare hour we had before having to return to Belfast and the soup-making duties by driving further up the coast to Murlough Bay. Murlough Bay is one of the most beautiful unspoilt corners of these islands. Or that's what it felt like this afternoon. Skipping

lambs, hooded crows, grassy banks studded with primroses, nodding bluebells, sunlight dancing on the clear blue and green sea. And Paul Graham and me, arguing the toss as we skimmed stones across the water.

'Bill, how can an artist carry on oblivious to any developments and changes over the past sixty years in painting?' My insecurities tell me that Paul is really thinking, 'Bill, it was rubbish, just chocolate-box rubbish, and you must be stupid to think otherwise.'

'Why, do you think if we went back and I told him about Pollock and Rothko it would make his paintings any better? His paintings are about what he sees, or at worst what he wants to see. You come over here and take pictures of what you choose to see: the insignificant Union Jack stuck at the top of a tree, an inconsequential splatter of paint on a country lane.'

The truth is, that isn't the answer I gave Paul. I am only able to condense my vague thoughts now as I give the pots another stir. I also didn't tell him I was drawn to the idea of bringing two artists together, two artists from totally different worlds, at totally different stages in their lives, who work in completely different media but have chosen to explore the same small corner of our world. One because he has learned about Northern Ireland from TV coverage and newspaper columns, the other because he has never known anything else. Two artists whose work I have loved, and still love. One artist has a constituency who will have probably never been to Northern Ireland in their lives. They would find his landscapes totally meaningless if it were not for the minutiae that informs them that this is the troubled land they have seen so often on their TV screens. The other has a constituency who will have probably never lived anywhere *but* Northern Ireland. They would find his landscapes completely insulting and spiritually worthless if they contained even the smallest acknowledgement of 'the troubles'.

Back in the soup kitchen, the hour is getting late. The girl

Making Soup

that I thought I fancied is back with a different lad in tow. I wait until I judge no one is looking before adding my secret ingredient: a family-size can of Heinz Baked Beans. Instant comfort factor. A small posse of petite lesbians crowd into the kitchen and tease us males with their familiarity and wicked Sapphic ways. Susan Philipsz cuts up thirteen Italian loaves that she rescued from a late-closing baker's. A bloke has just come in with a camera, wants to take our picture.

'What for?'

'It's my job to document all the events surrounding "Reverend Todd's Full House". Susan Philipsz told me to do it.'

'Oh, OK.' I hate having my picture taken, but I oblige and pose while stirring one of the pots with the wooden shovel. Should I take my specs off for the photo? Inverted vanity has the better of me; I leave them on. Tip three: never pose to have your photo taken while making soup. I've been caught off guard. I can smell that one of the pots has burned. If you've never had soup burn on you, I should explain that it only takes a second for a very thin layer of the simmering soup at the bottom of your pot to turn from a tasty mush to black cinders. This instantly infuses the other 99 per cent of the contents with a disgusting flavour of burnt carbon and makes your whole culinary pride and joy a disgusting and inedible scalding slop with an acrid smell, which even the chickens (if you have any) will reject.

This is a disaster. One of the four pots, and it is the biggest one, is totally unusable, and at the last count there were now forty-two guests waiting to be served. I take a sip from each of the other three pots. It tastes exactly as this soup should, nothing like the simple vegetable broth I had originally planned, but that's the way things should be with soups. You should let them take on a life of their own, and this one did as soon as those shutters came down and we had to shop at the Asian cash and carry. My only problem now is, will these three pots be enough to go round the forty-two guests?

A volunteer guest, Paul Graham and myself carry the three pots down the corridor to the improvised banqueting hall. It is only now that I get a vague idea of what I was hoping for. Charles McAuley should have been here carrying one of the pots. Yeah, I know he's 88 and uses a zimmer frame and his soup-pot carrying days are over. It's not that I have been subconsciously trying to engineer the bringing together of Paul Graham and Charles McAuley for some artistic discussion. It's just that I wanted to hang a memory in my mind of the two of them doing something together. I had thought it might be McAuley passing Graham a cup of tea in his front room in Cushendall. No wonder I wasn't able to give Paul a satisfactory answer this afternoon when he wanted to know what I wanted to ask Charles McAuley, when in fact I think all I wanted was to see McAuley pass him a cup of tea. We carry the pots of soup down the dimly lit corridor, past the lavatory with the door that doesn't lock and its eternal queue.

The guests are in high spirits, the sprawling table already littered with empty bottles of wine and cans of beer. Susan Philipsz bangs the table with the ladle and calls for silence. She thanks everybody for coming and introduces Paul Graham and me. I step forward, thank Susan Philipsz for making the whole Reverend Todd house fill up and hope the house will continue to be full of all sorts of goings on for many years to come. I then thank them all for allowing themselves to be implicated in what they are about to eat by having them stir the pots. In fact I take the implication further by asking them all to sign the wooden shovel, so it can be donated to Grassy Knoll Productions as the first work to form part of its permanent collection. Next, I tell them that I brought a sack of frozen plums over with me from England this morning. It took some explaining at airport security. The plums were the last of my autumn crop that I had stashed away in the deep freeze. After serving the soup Paul Graham and I will disappear back into the kitchen to get on with making the plum crumble for pudding.

Making Soup

'But before we go, I would like to propose a toast: to Belfast, City of Dreams.'

Postscript: On reading the above, Paul Graham would like it stated that his photographs do not fade, and that he is not the dirty old man that his characterisation here implies. He rightly points out that it was I who made the crass and untrue observation, 'There are no shaggable girls here.'

THE AUTOGRAPH HUNTED

2 November 1998

I've got the window seat. The plane is banking. Below I see the drab and dreary streets of Dusseldorf. It's a grey dawn over Deutschland's industrial heartland. We climb into the clouds, and the fatherland is gone. I'm feeling good in a self-satisfied, smug sort of way. In my hands is *Das Handbuch (Der schnelle weg zum nr 1 hit)*. It's the German translation of *The Manual (How To Have A Number One The Easy Way)*. It looks great. The German publishers have done a good job. Really cute, pocket size. I flick through, staring at all the German words that I can't read, and bathe in the warm glow. These are words I've written, and somebody thought they were so great they had to be translated into another language. You will see from the way I'm describing the situation that I am aware how facile my self-satisfaction is, but I can't stop it. I mean, we all deserve to feel good about ourselves some time. A little bit of harmless vanity never did anybody any harm. I was in Germany for less than twenty-four hours. The publishers paid for me to come over, wined and dined me, the hotel was fine and the people friendly and interested. My ego was well stroked.

I lift the book up and inhale a deep draught from its virgin pages. It smells strong, as new books fresh from the printers can do. The ink is hardly dry. I also have a copy of the original

1988 English edition. I read the opening paragraphs – they still ring as true to me now as the day we first wrote them, over ten years ago.

In the seat next to me is a man in his early forties. A mane of thick greying hair, skintight jeans, shirt buttons undone enough to reveal a manly chest. Mobile phone in a belt holster, heavy bunch of keys hanging next to the phone. The timeless image of the classic English roadie. There was a time when I would have despised him for being such a rock 'n' roll cliché. Now I feel a nostalgic warmth for this subspecies' continuing existence, not as a museum exhibit or an actor playing the part in *Wayne's World II*, but walking, talking, real and with no aspic in sight. He flirts with the air hostess. He flicks through his copy of the in-flight magazine. The breakfast trolley approaches.

'Hey Pete, do you want any breakfast?' If in fact he is a roadie, he's talking to who I presume is his charge. I glance over to see if I recognise whichever young gun may be sitting in the seat across the aisle. But there is nothing rock 'n' roll about his companion. He's an overweight, late-middle-aged man, bald on top with straggles of unkempt hair around the sides. His thick lower lip and rounded fleshy nose are the sort that a cartoonist from less PC times would have used to depict an aging East End Jew. His clothes, although clean and pressed, are in no way out of place for a man of his years and physical stature.

It's when this Pete turns his head to answer the 'roadie' that all smug little thoughts of *Das Handbuch* drain from my body, thirty years of life evaporate, and I'm in the presence of God. No, not Eric Clapton: this is the real thing, this is Peter Green. Forget Clapton, Jeff Beck and any of the hundreds of other white twelve-bar twiddlers and fumblers. This is the only British guitarist (and singer) that could ever lay any sort of claim to white men playing the blues without being a joke by the Bonzo Dog Doo Dah Band. There is no point in trying to lay out some rational argument. This is about being 15 in October '68 and hearing 'Albatross' for the first time late at night on

Radio Luxembourg while lying in bed unable to get the idea of Linda Ballantyne's legs out of my head. This is about the fact that an underground blues band went all the way to Number One with the greatest instrumental single since 'Telstar', without having to 'sell out' any of their purist principles by doing some cheesy, good-time, radio-friendly tune. Hang on a minute: it was not only the greatest instrumental since 'Telstar', it was the most moving, distinct, evocative, strange . . . in fact, the greatest UK Number One ever.

Like a good left-of-centre citizen, I detest the whole notion of people being impressed by fame, the cult of personality, A-list and B-list and C-list celebrities. I read the *Guardian*, for goodness' sake. I'm as PC as a fucked-up modern man can be. But I can't stop myself. I could attempt irony and give it a bit of the 'I am not worthy, I am not worthy,' but that would be cheap and disrespectful. Peter Green declines his minder's offer of breakfast and falls asleep instead. His head slumps forward on to his chest. It's the sleep of an old and weary man. I pluck up courage and turn to my immediate neighbour.

'Excuse me, do you work with Mr Green?'

'Yeah, I'm his sound engineer.'

'Has he been performing a concert in Germany?'

'Yeah. We did a live TV show last night. How did you know who he was?'

'The eyes.' I didn't want to say that I had seen the occasional picture of him over the decades, pictures that documented the ravages as life took its toll.

'It was because of him that I bought my first guitar.'

'Yeah, you and thousands of others.'

My pride is a bit pricked by this. I want to tell him, 'But I went on and achieved international pop success.' But then in my head I can hear the stomping chorus of 'Doctorin' The Tardis', and I furtively push the copy of *Das Handbuch* under my jacket like it's a smutty magazine. I strangle my internal stomping soundtrack and replace it with the sweeping melancholia of

'Albatross'; the call and distant response of the two slide guitars, the one-note triple-time bass throb, the rising and falling muf-fled rolls on the ride cymbal. There was nothing else on the record, except mankind's longing for something beyond a tran-sit van ride home from another gig in the Midlands and another 3 a.m. fry-up at the Watford Gap services.

'Albatross' segues into the opening guitar runs of 'Man Of The World'. It was the follow up single, came out the same month I turned 16, and peaked at Number Two.

> Shall I tell you about my life
> They say I'm a man of the world
> I've flown across every time
> I've seen lots of pretty girls
>
> I guess I've got everything I need
> I wouldn't ask for more
> And there's no-one I'd rather be
> I just wish I'd never been born

Then there was something about a woman making him feel like a man should.

> I could tell you about my life
> And keep you amused I'm sure.
> About all the times I've lied
> And how I don't want to be sad any more
> And how I wish I was in love

Now those were lyrics to which a boy just turned 16, and a virgin in every sense of the word, could relate. The closing Minor harmonic chord on the octave is my favourite recorded chord on any record ever. All the other British blues bands of the era were inventing heavy metal or falling apart. I liked to believe it was only Peter Green who felt the underlying pain of

the black man's blues, and was able to transcend the patronising shit of the whole white boy singing the black man's thing, to ditch mimicking the black man's holler and groan and twelve-bar framework and evolve it into something that was real for a young white bloke from London.

I attempt to eat my airline breakfast. The captain announces we are currently 32,000 feet above Rotterdam. Peter Green has woken up. He has a magazine on his lap and is giggling to himself. I strain my neck to see what he is reading. *Loaded*. Peter Green is reading *Loaded*, the most despicable magazine currently being published in Britain, and enjoying it. The intro guitar riff from 'Oh Well' comes banging into my head. A guitar riff that I spent the winter months of '69 into '70 trying to master when I should have been writing my essays for Medieval History 'A' Level. 'When I talk' to God, he said "I understand"/ He said "stick by me, I'll be your guiding hand".' Those were almost the only lyrics in an otherwise instrumental seven-minute workout. How on earth was he ever able to persuade the record company that this strange non-radio-friendly track should be the first for his band on a new label? It got to Number Two in the charts, the same week as 'Bad Moon Rising' by Creedence Clearwater Revival was Number One. That very un-pop rhyming couplet has stayed with me over the years, coming back time and time again when I least expect it, when I'm waiting for a bus or watching a film. The in-flight breakfast is obviously inedible; I look up to see what Peter Green is doing. He's folding out the pin-up poster of Emma B (a young, up-and-coming supermodel, not a Spice Girl) from the centre pages of *Loaded*. Her ample and handsome cleavage can be seen heaving out of her tight black cocktail dress. A perfect *Loaded* babe. They know what we want. Peter Green giggles to himself again.

I pluck up courage and ask the sound engineer (note, not a mere roadie) beside me, 'Would Mr Green consider signing his autograph for me?'

'Hey, Pete, this bloke wants you to sign an autograph for him.'

'Not if he's going to screw it up and throw it away.'

'No! I would never do that.' I hand him my notebook and pen.

'What do you want me to say?' Peter Green is speaking directly to me, me who never was able to learn how to play 'Man of the World' all the way through or even work out all the lyrics.

'For Bill – that's all.' I watch as his uncomfortable hand scribbles something on the inside cover of my black notebook. Then he passes it back to me. 'To Bill from Peter . . .' and I can't make out what he's written as his family name.

'What's that say?' I ask the sound engineer.

'Greenbaum. It's his proper name.'

There is no artistic flourish to his autograph. Nothing affected or practised. When I used occasionally to get asked for my autograph, I hated it. It was loathsome, embarrassing and shite. Jimmy and I would try to explain to whoever the autograph hunter was that the whole concept of the autograph was a despicable, elitism-promoting thing, then try to persuade the hunter that we would be happy to shake his or her hand, it being a more equitable thing to do. Although we usually managed to bully them into accepting our worthless handshake, they always seemed disappointed. One time on leaving the gates of TV Centre after recording a slot for *Top of the Pops* a fan approached, her autograph book open and ready. I was about to launch into my shaking hands bit, when she said, 'Are you anybody famous?'

The index finger on my right hand traces out the letters of Peter Greenbaum. The hand that wrote and played those howling chords to 'Green Manalishi' touched this paper. 'Green Manalishi' was the fourth in the most perfect quartet of hit singles ever recorded and released by one band. It was something that even The Beatles never achieved. Certainly none of those make-up-wearing jokers that the next decade was packed with managed to come close. (Me being too Old and Wise by then to dig anything as facile as glam rock.)

[221]

'Green Manalishi' came out in May 1970, the same month my headmaster caught me reading a copy of *Oz* in the school library and recommended I should leave and look for a job in the steelworks. My concerned mother paid for me to go to an expensive private careers advice company in London. I spent a whole day doing ludicrous tests and answering questions. They discovered I was good at making things and liked music. After taking my mother's money and studying my tests they recommended I should become a violin maker. 'And how do you do that?' I suppose I asked. 'By going to a furniture-making and design college.' I phoned the furniture-making and design college in High Wycombe. They told me they would love to have me, but first I must do a two-year foundation course at art school. What I didn't tell anybody was that a record called 'Green Manalishi' had just come out, and all I really wanted to do was make a record that attempted in some way to be as strange, frightening and seductive as that.

I never did get to find out what a Green Manalishi was. It wasn't in the Oxford English Dictionary. A demon of sorts, I guessed. 'Green Manalishi' only got to Number Ten on the charts. It wasn't long after the record was released that I read in the *Melody Maker* that Peter Green had left the band, given all his money away and become a gravedigger. As far as I was concerned this was the coolest thing to do in the world. Far better than the pathetic mess that The Beatles had got themselves into. A million light years better than his aforementioned peer group of British blues guitarists, who went on to produce the biggest catalogue of overblown shite ever to fill the racks of my local HMV and stadiums around the world. As any aging rock 'n' roll trainspotter could tell you, after quitting his band Peter Green sank into years of mental illness, near destitution and pop oblivion. At the same time, his backing group sought new recruits, moved to California and became the biggest-selling band of the '70s. In the twenty-eight years since Peter Green picked up the gravedigger's shovel, there has been the

odd occasion when he has been tracked down, put in a studio, a guitar shoved in his hand and the green light switched on. The output, I understand, has always been a distant echo of what he once achieved. Although I do possess a copy of the first of these records, *The End of the Game,* and it does have a strange, affectionate place in my heart, there is no way I want to hear even a note of any of the others.

'Can I ask Mr Green a question?'

'Hey Pete. He wants to ask you a question.'

'I only ever get asked the same questions,' I hear him mumble. I desperately try to think of something that he will never have been asked before in his life, something profound. Something that will make him think I'm somebody worth answering, that I have an insight into his tortured soul. That I understand. Again, as you can tell by the way I'm letting this whole story shape up, I want you the reader to realise that I can stand outside myself and think, 'What an arsehole you are, Drummond.' I am that fawning fan, still wanting to elevate the focus of my fandom into a hero from some rock 'n' roll Mount Olympus. There have been times in the past when the roles have been completely reversed, when I'm pushing a super-market trolley or loading young children into the back of a Volvo and some unprepared individual whose day-to-day life has momentarily stumbled/collided into mine, asks:

'Excuse me, aren't you Bill Drummond?'

'Yeah.'

'I just want to say . . .' or 'Do you mind if I ask . . .', and what-ever it is they say or ask isn't what they meant and whatever I answer isn't what they want to hear. There is usually a look in their eyes that tells me that what I've been involved in in the past made an impression on their adolescent evolution, an evo-lution that they now may be embarrassed by, or at best feel a certain amount of nostalgia for. But they can't stop themselves, and now, even though I know all this, I can't stop myself either. I'm desperately trying to think of a question that Peter Green

has never been asked, yet one that won't in some way be misinterpreted as a slight on his wounded reputation. But no great question arrives before I blurt out: 'I bet you've never been asked, how many spots does the leopard have on the cover of *End of the Game*?' He doesn't say, 'What an interesting question! You are right, I have never been asked that before.' What he says is, 'The cover had nothing to do with me.' I feel one inch tall.

I pull out the copy of *Das Handbuch* and start to go through it page by page, comparing the original chapter headings with what they are in translation and wondering how my description of the genius that was Steve Wright comes over in Deutsch. Page fifty-eight, chapter heading, 'Groove'. It seems there is no German translation for this word. I turn over page sixty-three, expecting to see the translation for 'Chorus and Title' on page sixty-four. What I'm met with is *'Tonarten, noten und akkorde'*. Even with my rudimentary understanding of German I know this is more likely to be a translation of the chapter heading 'Keys, Notes and Chords'. Something is amiss. I compare the German edition with the original English. Eleven pages of translation are missing. Eleven pages that in the most precise and cynical of fashions, deal with the writing of a Number One song, breaking each component into its integral parts; the aforementioned chorus and title, the verses (or bass riff factor), the intro, bridges, breakdown sections, outros and hanging bits. All explained, all debunked, all laid bare, for any reader with a bit of derring-do to have a go at and achieve success. Without these pages, the book is meaningless, even as a period piece ten years after its original sell-by date. Without them, any German critic willing to review it would undoubtedly perceive *Das Handbuch* as the unworkable ramblings of another footnote in pop history, attempting to grab a bigger chunk of pop's infamous Rich Tapestry than he deserves.

Sitting here as the captain announces our imminent descent into Heathrow and the awaiting bad weather, I can feel the

hand of divine retribution taking its toll for my little vanities. The book's already out there in those German shops. It's too late to do anything about it, however much I might complain, stamp my feet and point my finger to wherever I may feel the blame lies. 'Serves me fucking right anyway,' is the only conclusion worth coming to. As the plane taxis to the terminal zone, I notice that the 'Singing and Singers' chapter is also missing.

As my fellow passengers and I make our way to baggage reclaim, I notice the hunched and shuffling figure of Peter Green up ahead of me. I have a habit of looking for meaning in the random incidents that present themselves to us as we stumble through life, hoping to discover some poignant wisdom that will be of use in the remaining days. But not today. Today I feel nothing.

ROBBIE JOINS THE JAMS

21 May 1998

We used to feel sorry for Gary Barlow for being the fat, ugly, boss-eyed, talented one. But now we don't.

Many is the night I fall asleep listening to the midnight news on Radio Four long wave, then the next day remember some archaeological discovery or a story about an Arsenal-supporting Jew talking to a Palestinian in a Liverpool shirt in the Gaza Strip. These vague memories invariably come from a night spent drifting in and out of sleep with the BBC World Service burbling on through the listless night. This morning I recalled hearing crowds chanting, insurrection, the mob. It could have been a documentary about Paris '68, or Tianenmen Square, or black people on a civil rights march. But through the noise of the people rising up as one to challenge the jackboot of authority, I heard the strains of a melody. It wasn't 'Street Fighting Man' by the Stones. It was the theme tune to *The Magnificent Seven*, followed by a mention of a radio station called B92, the only one left on the air that wasn't a puppet station of Slobodan Milosevic's regime. This morning, when the half-formed memory started to surface, I made a couple of phone calls to contacts I had in Beograd (aka Belgrade), capital of Serbia and the former Yugoslavia. This afternoon I decided to sit down

and write up what's left of my memories of seven days in September 1995.

The big pop story of summer '95 had been Robbie Williams joining Oasis on stage at the Glastonbury Festival for a couple of numbers. At the time, Robbie Williams was still a member of the fab five – Take That, the greatest boy band since the Bay City Rollers twenty-three years earlier. The biggest pop band since The Beatles. If you didn't love Take That you hated them and hated everything they represented. Take That symbolised everything that the average Glastonbury Festival mud wrestler loathes about pre-packaged pop music. Take That's cheesy grins, choreographed hoofing and saccharine tunes were everything that a successful Glastonbury band wasn't. Williams fulfilled the role of cheeky chappie in the troupe, Mark Owen being the cute one, Gary Barlow the talented one and the other two the fillers. But over the summer of '95 Robbie had been taking his cheeky-chappie duties too far. He had been turning up on the front cover of the tabloids after nights on the tiles. Cameramen were catching his numerous compromised moments; the paparazzi knew there was money to be made from Robbie's dilated pupils. The public are tired of old soaks like George Best; they are baying for new young pissed-up fuck-ups. We know that boy bands have to officially sanction all photographs, authorise all interviews, or the whole edifice crumbles, implodes. The sham is revealed and the pre-pubescent consumers shift their 'I will love you till I die' allegiances to the Backstreet Boys or Boyzone. Loose cannons are not allowed. Robbie Williams had become a loose cannon, worrying those up on the poop deck. Robbie got the sack from Take That some time in late August. Of course we all loved Robbie for being such a bad boy, such a renegade.

Over that summer of '95, as well as the ructions in Take That, the war in the Balkans had been getting nastier. Back in the Cold War days, we in the West had always regarded Yugoslavia as the friendliest and the most liberal of the Eastern-Bloc

commie countries. We enjoyed their wines, went there on holiday, applauded their football teams. Tito had been one of the great Second World War heroes and postwar political leaders. Yugoslavia had never been synonymous with secret police, torture or the threat of a third world war. Yes, they were commies, but friendly ones. Whatever had led to the assassination of the Archduke Ferdinand was ancient history. Names like Montenegro, Croatia, Slovenia, even Serbia, belonged only on Victorian maps of Europe. Names with as much currency as Ruritania. But with the collapse of communism, the commentators on the overseas pages of our papers told us that trouble in the Balkans has been, is, always will be, inevitable. One great leader can come along and hold it all together with his vision of a peaceful and united future for his lifetime, but the memories of the people remain stained with blood. From generation to generation, 'it was only a matter of time before the whole thing blew'. 'The unresolved conflicts between Catholics, Muslims and Eastern Orthodox, fighting over the same side of a mountain for almost a thousand years . . .' 'Systematic rape as a weapon of war . . .' 'Why don't they just stop killing each other? . . .' As much as I'd like to come up with some dodgy analogy between the hidden internal politics and power struggles in a boy band and the five main historical states within the former Yugoslavia, I won't. An analogy too far, perhaps.

So, back to that summer of '95. Our heart strings were being pulled by photographs of the starving inmates of Serbian prisoner of war camps. Photographs that reminded us of those we see in history books, taken of Jews in the newly liberated Nazi concentration camps fifty years earlier, except now the subjects were wearing track-suit bottoms and trainers. Stories filtered through of recently discovered mass graves containing the entire population of rural villages: babies, children, mothers and old folk. The ground so freshly turned that the nettles and poppies had not had time to grow. They were doing things to each other in this day and age that we thought only warring

African tribes did. For God's sake, these were white people with teams that played in the UEFA Cup, whose children listened to Take That records. Come to that, we (The KLF) used to get fan mail from Sarajevo.

We are born with an instinct to take sides. What we want to know first from the news coverage of horrible little wars in far-flung corners of the globe is: who are the baddies and who are the goodies? The reasons why they are fighting, the history, the reality, the 'what can be done', all come second to who we are supporting. It reminded me of the first, second and third division play-off finals at Wembley the previous week. I didn't give a shit in reality for any of the six teams playing, but in each of the three matches I was firmly decided before kick-off who I wanted to go up. Come the beginning of next season, I will have forgotten all about who was playing who. So as far as we TV news consumers in the West were concerned in 1995, the Serbians were the big baddies and the Bosnians were the underdog goodies. It was obvious, we were all in agreement. The fact that the Bosnians were being supported by some extreme fundamentalist Muslim states (our enemies) we chose to ignore.

Marc J. Hawker, the Glaswegian artist, had sent me a film proposal he had put together and was hoping to entice one of the TV channels to finance. He wanted to make a film documenting the current artistic life in Beograd. The proposal was headed *The Culture of War* and kicked off with three quotes: 'Should we create in such circumstances?' (from the *Manifesto For Ice Art*), 'There is no underground, all is overground and the name of the game is survival' (Sren Mile Markovic), and 'Welcome to Shit Town' (Fleka).

On Friday 8 September that year I got a phone call from an Evertonian called Tony Crean. He worked for a record company called Go!Discs. I'd never met him, didn't know him or of him, but within thirty seconds of him speaking to me on the phone I was willing to agree with whatever he was going to

suggest. Tony Crean was involved with a charity called War Child. His idea was to ask a bunch of current British pop stars, the 'credible' ones, each to record a track in a day, and for the resulting album to be out in the shops, selling to punters, within seven days. All pop stars to give their time free, all proceeds of the album (entitled *Help*) to go in aid of children caught up in the war in Bosnia. Tony Crean's dream was to raise a million pounds in one week. We had all seen the news footage of orphaned Bosnian children whose limbs had been blown away with land mines. Children whose mothers had been raped before their very eyes. Children who if their pocket money had stretched far enough would have bought Take That records. Even though Jimmy and I were no longer in the business of making pop records and despised the whole idea of people in the entertainment world getting publicly involved with charity, how could we turn these children down?

This is how. On Monday 11 September '95, three days after getting the call from Tony Crean and on the day all the pop stars were supposed to be recording their tracks for the *Help* LP, Jimmy, Gimpo and myself would be flying into Beograd, capital of the big bad Serbians, to premiere our film, *Watch The K Foundation Burn a Million Quid*. The film was to be screened in Republic Square, symbolically the very heart of the Serbian nation. We wanted to ask everyone that turned up in Republic Square if our money-burning act was a Crime Against Humanity. After Jimmy and I had let Tony Crean know we were unable to take him up on his invitation because of previous commitments, we got to thinking there was something interesting about the fact that the *Help* album was aiming to raise one million pounds from its sales for the children caught up on one side of a conflict, while we were over in the capital of the other side showing a film of us burning one million pounds. The fact that our one million pounds had been accrued by 'children' spending their excess pocket money on the records we made in our previous career added to the twisted equation.

For some time, Jimmy had had a yearning that wouldn't go away. A yearning to record a version of the epic western movie theme tune *The Magnificent Seven*. I had a fleeting idea: to ask the now out-of-work Robbie Williams to join the Justified Ancients of Mu Mu (The Jams, for short). The Jams are an age-old organisation whose whole reason for existing is to oppose the Illuminati, an age-old organisation who represent the forces of order. Both secret societies have had a long history in fact and fiction and in the minds of conspiracy theorists everywhere. For Jimmy and me, the Justified Ancients of Mu Mu is a handy joint alias that we have used occasionally over the years. In the past we had successfully invited Gary Glitter and Tammy Wynette to join The Jams. Over a mug of tea Jimmy and I got it all worked out. We would record our version of 'The Magnificent Seven', renamed 'The Magnificent One', through Sunday night. Over the track I would beseech Robbie Williams to join The Jams, and then Robbie would in fact turn up at the studio in the early hours of Monday morning and make his creative contribution to the record. We would have the track mixed by midday Monday and be on a flight out of Heathrow airport heading for Beograd that afternoon. I got back on the phone to Tony Crean, told him our idea. He was up for it. The only thing was, could he get hold of Robbie Williams for us? As it turned out, Noel Gallagher was doing a song with Paul McCartney for the *Help* album. Gallagher knew Williams, there was a connection. Within a few minutes Crean got me the number of Williams' new manager. It was a Manchester number. I gave it a call. I can't remember the bloke's name now, but he didn't know who the fuck I was and had never heard of The KLF ('But we were huge . . .'). He sounded well dodgy, more like a northern club owner or boxing promoter than the manager for a renegade boy band member embarking on a solo career.

'So you want my boy to front your record and you don't want to pay him?'

'Yes, but that's not the point.'

'And you've had lots of big hits in the past. So if my boy does this, for no money, you will agree to produce a couple of tracks on his first solo album for nothing . . .?'

'No. We don't make records any more.'

'Where did you say you got my number?'

'Well, look, I understand this is all a bit strange and you are obviously doing a great job looking out for Robbie's interests in these difficult times. But please just let him know what it is we want to do, or get him to call me, my number is . . .' Or something like that. Jimmy and I contacted Nick, Ian and Spike, the studio team we had always worked with in the past, to see if they were up for it and available, then booked a west London studio for Sunday night. Robbie was bound to call.

2 a.m., Monday 11 September 1995. Townhouse Studios, Goldhawk Road, west London. Synthetic strings that the Pet Shop Boys would kill for, a sweeping melody the size of Texas, a jungle break beat careering out of control way above 160 beats per minute. The track was sounding brilliant. Why did we ever want to give up making pop music? But still not a word from Robbie Williams. That was not going to stop us now. It was sounding so good that Jimmy and I were inspired to come up with an artist name for the track more epic than any of our previous aliases: 'The One World Orchestra Featuring The Massed Pipes And Drums Of The Children's Free Revolutionary Volunteer Guard'. However great the track was, though, it still needed a focal point, something to nail it down in the imagination of the listener. If Robbie was not going to show up, we needed something else fast.

In the previous week we had been sent a tape of a show from a Serbian radio station, B92. The presenter of the show was called Fleka. He had this wildly charismatic, Beefheartian rumble of a voice that tore through you like some Slavic Howlin' Wolf. Radio B92 was the voice of the underground-art grouping who were to be our hosts in Beograd. We had a

phone number. We got through to Fleka direct. He was on air. His show went from midnight to 3 a.m. We played the track down the phone to him, told him what we were up to and asked him if he could contribute a couple of statements in the style we had already heard. We could record it down the phone line, sample it up and use it in the track. We couldn't pay him anything, but he could use the track as a jingle for his show for nothing. Minutes later, we had his vocal contribution recorded.

'Serbia calling, Serbia calling. This is Radio B92 – Humans Against Killing – that sounds like Junkies Against Dope.' Some voices, as soon as you hear them, whatever words they are saying, have that instant sound of authority, of being the real thing. Fleka had it.

We didn't get 'The Magnificent' (we dropped the 'One' as sadly we didn't get to hear from Robbie in time) by the One World Orchestra Featuring The Massed Pipes And Drums Of The Children's Free Revolutionary Volunteer Guard finished until 10 a.m. 10.30 a.m.: Jimmy, Gimpo and I were in the Yugoslavian Embassy waiting for a telex to come through from Beograd stating that we were important international artists and we must be given visas immediately; it would be an insult to the Serbian nation if we weren't. On the way to Heathrow we delivered the track to Tony Crean's office. 3.12 p.m., Terminal Two, Heathrow Airport: the three of us boarded a flight to Serbia.

7.30 p.m.: we were met at Beograd airport by a young artist called Ninja. Ninja was the cousin of Gimpo's wife Ana. Ana was a Serbian girl now living in exile studying architecture at a London university. Ninja drove us to Nana Brancha's apartment, where we were to be billeted for our stay in Beograd. Nana Brancha was Ninja's great aunt and Gimpo's grandmother-in-law. Ninja's mum was also living with Nana Brancha; she had had to vacate her two-room apartment the previous week, to make way for Ana's country cousins. The

country cousins were refugees from Kraijna; eighteen children and six adults had arrived on tractors. Nana Brancha's apartment was in an old building down a side street near the city centre. A spartan affair. Nana Brancha was 87 and a widow. She made us thick, black, sweet coffee. She was blind. She had cataracts in both eyes. Gimpo had a brand new Samsonite suitcase; in it he had a specialist eye surgeon's book, bought in London for £100. One of Ana's cousins was a doctor. With the information in the book, he was going to operate on his grandmother's eyes and restore her eyesight. Somehow, the work of the Massed Pipes And Drums Of The Children's Free Revolutionary Guard seemed a bit distant.

Nana Brancha and Ninja's mum put on raincoats and left to stay with the eighteen children and six adults. We were to have the luxury of this apartment to ourselves. We had no say in the matter. The fridge was empty, the cupboard bare, the toilet shared and an Eastern Orthodox religious reproduction hung on the wall. What does Nana Brancha think? How many wars has Nana Brancha lived through? Does Nana Brancha rate the chances of Take That surviving the kicking-out of errant bad boy Robbie Williams? – were questions that may have arisen in my mind but which I forgot to ask. I savoured the contradictions that life has on offer.

Ninja was in his mid-twenties and looked like an early '90s raver who had just got out before the police raid. He had curly locks and a little-boy-lost look. He didn't speak any English but via Gimpo, who had a basic grasp of Serbian, informed us he was a DJ as well as an artist and that he was to be our chaperone for the duration of our stay. We divided up the floor space, dumped our sleeping bags and followed Ninja out into the night air. The streets were cobbled, ripe for revolution, the street lighting dim. First stop was Republic Square, where we were going to screen our film the following evening. Our art-underground hosts still had not been able to get a screen or any power source, but they had tracked down a projector. The

square was large and open; it had that warm, casual, continental feel. Trundling trams and open air cafés filled with 'shiny happy people'. We had time for a drink before our next appointment. The lager was disgusting. I pulled my copy of Marc J. Hawker's documentary proposal from my back pocket and reread the opening paragraph:

> Beograd is a black hole, a vacuum, a void which can
> hold everything and nothing. A country used to war
> and devastation and a state of nations settling old
> scores. With the demise of the left from European
> politics, the (ex) Yugoslavia has become extreme of
> nationalism and intolerance, choking on its own
> vomit. It is a bloody civil war of ethnic and religious
> hatred on all sides, a total economic and
> psychological collapse. Europe watches a once
> cosmopolitan city slowly die.

I looked up, took a sip from the revolting brew, ignored the gypsy waif trying to beg and wondered. I had been truly seduced by the above opening paragraph. Reading that a month earlier, Beograd sounded like the sexiest place on earth to be. The perfect place to premiere *Watch The K Foundation Burn a Million Quid*. Right at the epicentre of the *fin de siècle* madness that Europe was allowing itself to be sucked towards; a dark plughole that we were all going to sloosh down into, while our flames flickered and danced above. And yet, and yet – the reality confronting us was of cosmopolitan people enjoying a comfortable, balmy evening, as they would be doing in countless other cities across Europe at the same hour. We were joined by a fat teenager who was handing out flyers for our film. He spoke English well.

'Have you brought any records with you?'

'No, sorry.'

'Have you read *Trainspotting* yet?'

'No, but I was given a copy for my birthday.'

'Have you been to any good raves lately?'

'I don't think I've been to a rave since 1989.'

He took a break from his interrogation duties, surveyed the scene, then made the following observation: 'You would never guess my fellow countrymen are slaughtering babies, burning down villages and raping grannies less than forty miles from here.'

I was confused, so I bought him a drink, then reread the second paragraph in the proposal.

Serbia is a brutal military regime playing games of democracy, an aggressor with blood on its hands. Neatly sanctioned off from the rest of Europe the politics are the politics of intolerance and nationalism. Creating of a new Serbia – a celestial race – its cosmopolitan past is slowly being erased through state propaganda. Milosevic is the master of manipulation and his regime has no visible signs of political, military or economic power, all is invisible, all are shifting targets. There are no declared agendas, nothing to fight against. 200,000 people, including most of the artists, intellectuals and writers, have left with the black market and war profiteers filling their place. Shit Town is totally corrupt, 1000% inflation per month, food and medicines running out, economic collapse. All systems have broken down, there is nothing but the numbing psychological violence of control. If you exist you are part of the state, it cannot be escaped. This is a travesty, an insanity and hyper reality, nothing is absurd because all is absurd. Cut off from Europe there are no reference points, just the echo of isolation. In Beograd there are no snipers, artillery bombardments, slaughtering, Serbia is a place of

psychological shock, numbed in its isolation it is
slowly eating itself.

I asked the boy if he knew that Robbie had been kicked out of
Take That. He told me he hated Take That, they were com-
mercial rubbish and as far as he was concerned they could all
die. It was time to move on. Ninja led the way. We got on a
tram. We didn't have to pay; nobody had paid since 1991, since
the freedom riots in Republic Square when the water cannons
were turned on the people. (Don't you just love water cannons?
They make such exciting news footage.) Free public transport?
It sounded like something that Red Ken could only dream of.
We were to meet up with Fleka at his flat to present him with
our version of 'The Magnificent', featuring himself. It was only
when we got there that we discovered that Fleka was com-
pletely blind. Three years earlier he had had 20-20 vision. He
had been a painter. He showed us his paintings hanging on the
walls of his cramped apartment. He described all the paintings
in detail, which colours he had used and what the objects in the
composition symbolised. It was as if he was the one that could
see and he was having to describe them to Jimmy, Gimpo and
me because we had long lost the power of sight.

Next stop, Radio B92. It was a rundown, ramshackle affair,
housed in an otherwise derelict office block. Jimmy and I, as
The K Foundation trustees, were to be Fleka's on-air guests for
the whole show from midnight to 3 a.m. Ninja and Fleka were
a double act: Ninja spun the discs while Fleka rode the mike.
Fleka free-formed oral inner worldscapes, guttural incanta-
tions to 'Zombie Town' (his on-air name for Beograd). He
referred to his audience as 'the ugliest' and B92 as 'the worst
radio station in Zombie Town'. The studio was small, battered
and unbearably hot. Gimpo, video camera in hand, filmed the
proceedings. 'Close your eyes and you can see me better,' Fleka
intoned as he rode the rumbling rhythms of Can, Captain
Beefheart and The Fall, free-associating in broken English and

Serbian. A bottle of plum brandy was passed around the studio, which was littered with broken mikes and packs of Lucky Strike. Fleka had opened the show by holding up a 50-million sloto note close to the mike and tearing it in half, then asking 'Zombie Town' what they thought of that. Four years earlier, 50 million slotos would have bought half a house; in September 1995 it would have bought a coffee. Whatever our money-burning act meant to Jimmy and me, it took a marked twist as we were confronted with the reality of a people living in a state of hyper inflation. Those black-and-white photographs of German citizens burning mounds of almost-worthless Weimar Republic banknotes to keep warm had always been a boyhood inspiration, up there with that shot of Jack Ruby pulling his gun. Whenever asked why we burned a million quid, 'to keep warm' was the answer we wanted to give.

Fleka told his insomniac audience what The K Foundation was, why its trustees had come to the beleaguered and sanctioned Serbia and that they would be premiering the film *Watch The K Foundation Burn A Million Quid* in the Square of the Republic at 8 p.m. later that day. Fleka announced that the phone lines were open and invited his listeners to call and question. His gnarled and deformed hands (a bone crumbling disease, no cure) grappled with the controls, his rock 'n' roll shades hiding his ruined eyes. Hair greased straight back. He rocked in his chair, gold teeth gleaming, charisma radiating. Cigarette smoke curled up from his nostrils. The callers were mainly drowsy-voiced females, who were obviously willing victims of Fleka's on-air seduction techniques. He was a radiowave sex god of the wee small hours. Fumbling for a pack of Lucky Strikes, Fleka incited his audience to phone and challenge the men from The K Foundation. The phone lines buzzed and crackled with terse, pointed questions for Jimmy and me. We searched for answers to questions we had not been asked before. Somebody thanked us for coming, believed our souls must have been cleansed from the burning. We felt foolish, and

tried to explain about a stain so deep that a pumice stone the size of Vesuvius could not rub it out. The question we had come to Serbia to ask, 'Is it a crime against humanity?', was posed. Fleka rolled into rhyme.

'A rich man against money – how do you like that? Is it like a crime against reality?'

The artist Sasha Markovic was also a guest on the programme. He presented Jimmy and me with a pair of face masks he had made especially for us. He requested that we wear them for the rest of the show, and invited us to a performance he was giving the following afternoon in our honour. Breaking our own rules, we allowed Fleka to play 'K Cera Cera (War Is Over If You Want It)' performed by the Red Army Choir. Fleka explained to Zombie Town that it was the anthem of The K Foundation and that it would never be commercially released until world peace broke out. The track sounded big and strong. In Serbia there were no longer any official commercially released records, all releases were pirated copies. If there was any demand for our 'K Cera Cera' it would be pirated. We had no control over such things. The pirate market would be the judge of our masterpiece's true value, the absence of world peace notwithstanding. He also played 'The Magnificent' by The One World Orchestra Featuring The Massed Pipes And Drums Of The Children's Free Revolutionary Volunteer Guard. It sounded pathetic. We had let the children down.

'No, this is not Marxism, this is K-ism,' Fleka tells a caller. The studio clock wound its way round to 3 a.m. Fleka closed the show by playing 'America No More', the last track that Jimmy and I ever recorded as The KLF. We walked back to Nana Brancha's apartment, through the silent and dark streets. A movie script with Fleka as the hero is begging to be written.

The next morning we explored the sprawling markets. Fruit, vegetables, live fish, cheese, eggs, all brought in fresh by the peasants from the rural hinterland. Strong black coffee and dead-horse burgers for breakfast.

Midday. Back to Republic Square, café society still in business. The black market was lightening the corners the bankrupt economy couldn't reach. Elegant ladies sipped espressos, BMWs sped by. Gypsy children dressed in rags laughed and begged, tugged sleeves and pleaded before scampering away. The fat teenager was still leafletting the city centre. Ninja told us that permission had just been given by the authorities for the screening in the Square. Power was to be provided by a hot dog kiosk. Thirty-five metres of cable had been found and a projector loaned by the British Consul. All film screens were still unavailable, but a pair of double-sized white bed sheets and half a dozen safety pins had been purchased.

Two young women accosted us; we were to follow them. They led us to a purple photo booth, the only one in working order in the whole of Beograd. Our photographs were taken. We were then made to wear the masks that had been donated to us the previous evening. Next we were led through the streets. People turned and stared. We arrived in a quaint and crumbling yard; a spreading fig tree, heavy with fruit, gave the air of a set for an Italian opera. Whatever was happening, Ninja was in on it and Gimpo was filming it. We were met and welcomed by the proud, full figure of Sasha Markovic. He was beaming, his Brezhnev eyebrows bristling. Sasha had told us the night before that his life's work as an artist was to make masks. It was easy and cheap, he added. In the centre of the courtyard stood a tripod construction covered by Sasha's highly coloured and ornate masks. In his hands, a can. He doused the masks in black-market petrol and struck a light. Sasha spoke hardly any English, but the waving of arms was enough for us to know what was required of us: we were to help him throw the contents of a large box of masks on to the flames, one by one. There must have been hundreds. His life's work. Whether this was done in our honour or was just a bit of spring cleaning was never explained.

Robbie Joins The Jams

I tried to stop and think: if all state and private sector subsidy of the arts back in the UK were stopped overnight, what would rush in to fill the supposed cultural vacuum left behind? And in two years' time, what strange weeds would have grown? And in twenty years' time? And in fifty years' time? And in one hundred years' time, would . . . The thought fizzled out. A small crowd had gathered; they clapped as Sasha threw the last mask on the flames. Beers were ordered and views exchanged. We were told that this was the headquarters of the CPTP; the acronym was never explained, but we understood them to be an underground art group. Jimmy and I were jealous of an underground that was real, had a purpose, had no career structure or eager media support system. We tried to discuss with Sasha the idea of him making a brick with the ashes from his masks. We could then use his brick along with the one we proposed to make from our money ashes to build a wall. The Great Wall of Art. In the summer of '93, Jimmy and I had placed a full-page advert in the *Sun* and the *Guardian*, proclaiming 'Abandon All Art'. At the time it seemed like the only thing left to be said. Jimmy had then done a series of cartoons of artists travelling to designated sites to burn their art. We felt it was our duty to organise these designated sites. We were never very good at duty. But maybe this act of Sasha's proved that the idea was leaking out of its own accord. There again, it might only have been the age-old habit of the artist, turning moments of self-doubt into monuments of gross vanity.

Back to Republic Square. We climbed ladders, pinning up bed linen to billboards advertising a new Hollywood block-buster entitled, ironically, *Underground*. A small table and a brace of chairs had been commandeered from a café for Jimmy and me to sit at, below the screen. A press conference was cancelled; journalists were asked to stand in line with the public to ask their questions. Darkness, and a crowd of over a thousand people gathered. 8 p.m. was show time. A cheer went up from the crowd as the on-screen fire was lit. A translator was found.

She was a very pretty girl, mid-twenties, a Bosnian Serb from Sarajevo, a refugee; brother killed in the war, home bombed, but enjoying a happy life in Beograd. The crowd stood and stared. The first to step up with an answer to our crime against humanity/reality question was a middle-aged woman, smartly dressed, who had listened to Fleka's show the night before. She was clutching a couple of leather-bound art catalogues that featured her artist son's work. We got the life story. Her brother had been killed in the Second World War. Her uncle had been Tito's prime minister, or something. She wanted to know if we could help her son's career and if we had ever been to Barcelona. Next, a serious middle-aged artist stepped forward to ask us about our work.

'If you only had two dollars in the world and no food, would you buy a hamburger with the two dollars or burn it?' Serious artist.

'We would buy the hamburger.'

'So that two dollars is worth more than the million pounds that you burned?'

'Yes, but burning the million pounds was not about self-sacrifice, it was more about turning what a million pounds has symbolised throughout our life on its head.'

'Why didn't you burn five million pounds?'

'Because a million pounds is symbolically a bigger number than five million pounds.'

'Why have you come here to show your film?'

'Because we were asked.'

'But why is a million pounds so important to you? It is a meaningless figure to us.'

'Because we grew up in a country where in every playground the question was asked, "What would you do if you had a million pounds?" A million pounds was the figure that represented freedom from work, drudgery, responsibilities. It meant Permanent Vacation, admiration and all the fairground rides you needed.'

'I thought it was only in America that people thought like that. In Yugoslavia, even if you lived ten lifetimes, you could not earn that sort of money. In Yugoslavia nobody ever dreamed of wealth, because it was never an option. Young boys may have dreamt of being footballers and girls Olympic gymnasts, but never of being rich. In Yugoslavia there were no football pools, no national lottery, no rags-to-riches tales fuelling dreams of endless wealth. There was no need to dream of wealth when everybody had the same and the state took care of your needs.'

A teenage lad stepped forward proffering a rolled note, indicating to us that we should light it. Jimmy took his lighter and did the honours. The lad smiled, his mates clapped. The gypsy street urchins laughed to see such fun. The flames of the fire danced in their eyes as they gazed up at the screen. A man held up his empty wallet and burned it. More questions, more answers. The film finished. The crowd clapped. One more time for the money burners. The projector was packed. The tables returned. The screen was unpinned and went back to being a pair of bed sheets. The crowd thinned. Meal and talk with the underground art scene in a Serb restaurant. A gypsy band sang songs of love and loss. Then back through the night streets to Nana Brancha's.

Up early the next morning. Clear and clean Nana Brancha's apartment. A quick dash to market, buying fresh vegetables, weird wild mushrooms and strange cheese to take back as gifts for the family. Ninja got us to the airport. We learnt he got his nickname for being a former Yugoslavian judo champion. The city of Beograd looked splendid in the morning light, a vitality surging from its trade-sanctioned streets, ostracised from the international community, hardening its resolve to live a richer and fuller life. The Danube was huge and blue, teeming with Popeye tugs, barges and home-made houseboats. Desperate men sold canisters of black-market petrol along the roadside.

Back in Britain, there was only one message on my answer-phone. It was from Robbie Williams. He had left me his number and asked me to call.

'Robbie, it's for you.' It was his mother. 'He's in the bathroom, he'll be down in a moment.'

'Hi, Bill, thanks for calling back.' Robbie, it turned out, had been on holiday with his mum in Turkey, and had now returned to his home town of Stoke on Trent, where his mum was nursing him back to normality. We spoke long and hard about life in the pop lane. He said he was disappointed about not making the *Help* track, but maybe something else in the future? He asked what Jimmy and I were up to. I explained about the money-burning film. How we were about to tour it around Britain, screening it in a prison, a mental hospital, an art school, a Buddhist monastery. I had an idea: could we screen it in his mum's front room, just for the two of them?

'What? Yeah, fine. I'll send you instructions how to get here.' We then talked about the chances of Port Vale, and their eternal life in the shadow of their great home-town rivals Stoke City.

Later Jimmy and I had a change of heart, deciding that the continued screening of *Watch The K Foundation Burn a Million Quid* was counter-productive. So, sadly, we never did get to Robbie's mum's house.

This morning I made a call to Beograd to find out about hearing 'The Magnificent' on the BBC World Service last night. I learnt that B92 had become the rallying cry of last year's day-after-day, week-after-week, month-after-month peaceful demonstration for democracy in Republic Square, a demonstration that even those water cannons could not flush away, as hundreds of thousands of people demanded the same thing: for Milosevic to stand down. Our recording of 'The Magnificent' had not only become the theme tune of the station, but the anthem of the democracy movement. You spend your pop life longing for one of your three and a half minute slices of radio fodder to rise above being mere pop music, to enter the social

fabric of the nation and times we live through, like 'Give Peace a Chance' or 'Anarchy In The UK' or 'Three Lions'. And this morning I learn that a track that we recorded in a day, never released as a single, thought was crap and had forgotten about has taken on a meaning, an importance in a 'far off land' for a struggle I hardly understood. Strange.

And as for Robbie Williams, I see he's on the cover of this week's issue of *Time Out*, walking on water; a triple-platinum album under his belt, a headlining slot at Glastonbury to look forward to, Port Vale finishing the season four positions above Stoke. In fact Stoke City are for the drop. He obviously took us up on our offer to join the Justified Ancients of Mu Mu.

I also learned this morning that Nana Brancha's eyesight has been restored.

BILL DRUMMOND IS DEAD

29 May 1998

In the post was a postcard from Cally. At some point in the 1980s, Cally had been the manager of the singer Julian Cope, the former front man of the pop group The Teardrop Explodes. Mercury Records had asked Cally to 'design, compile, re-master and co-ordinate the proper reissue on CD of *Kilimanjaro* and *Wilder*, these being the only two long-players recorded by The Teardrop Explodes. Cally liked what I had written about Echo and The Bunnymen, and wanted to know if I could write something similar, but much shorter, on The Teardrop Explodes. I caught the bus to the library and wrote, knowing exactly what story I wanted to tell.

The Teardrop Explodes
A novel by Bill Drummond

Ever since the band of the same name crumbled into a sorry heap of forgotten ideals, unpaid bills, drug habits, foolish vanities, bitter recriminations, evaporated visions and regular stupidity, I have suffered a recurring fantasy of writing a novel about the subsequent (fictitious) career of The Teardrop Explodes. The story would start at the moment in 1983 when

the band split up, and end with the lead singer, Julian Cope, being shot in the head in mid-1986.

In Liverpool in the late '70s, there was a nucleus of about twenty-three individuals who were each fired by a dream of creating the ultimate mythical band. This dream had been inspired by a number of other bands from distant lands and other times. The list of bands may have included at various times Pere Ubu, Love, The Residents, The Velvet Underground, Kraftwerk, The Monkees, Can, Television and The 13th Floor Elevators. The greatness of these bands was obviously not measured by their commercial success, or even the guaranteed quality of their creative output, but by an aura that emanated from the mere possibility of their existence. We knew few objective facts about these bands. We gained glimpses of their greatness from the dog-eared sleeves of long-deleted LPs in the second-hand racks of the Probe Record Shop, or the minimal label information on rarer seven-inch singles. Singles like '30 Seconds Over Tokyo' or 'Little Jimmy Jewel'. There were no repackaged videos, no *South Bank Show* documentaries, no reveal-all biographies; just rumours, spread by word of mouth from Button Street to Devonshire Road.

We sat around our very unround tables in the Armadillo Tea Room in Mathew Street, refining our visions and working out routes to ride in search of the tea cup of true myth from which we could sup. My vision got waylaid and I somehow ended up managing The Teardrop Explodes. Once a contract with a major record company had been insecured, I had neither the experience of human nature nor the strength of character to hold the reins, drive the car or sail by the stars. The fact that my own private life was totally out of control didn't help.

With the luxury of hindsight, it is easy to pinpoint the moment when the vision of what The Teardrop Explodes could be was forsaken for something tatty and cheap. It was the morning that Paul Simpson, the original keyboard player, alone perceived that the way to greatness did not lie in accepting an

offer to be the support on a Patrik Fitzgerald tour, and quit the band. For the rest of us, this tour appeared to give the band its first opportunity towards nationwide exposure and just deserts. In reality, this was the first slip on a downward spiral that helter-skeltered through a world of Spandau Ballets, Howard Joneses and Duran Durans, and ended up in the summer of '83 with The Teardrop Explodes as the opening act on a stadium tour headlined by Queen. (I have wiped from my memory a subsequent tour, as a three-piece, of university freshers' balls.)

Although I would feature as a character in the last few pages, the novel would be written in the third person. It would begin with Julian Cope waking up in a bed, in a room, in a hotel in a South American city. Not knowing how he got there, but glad he had. He would feel inspired to phone Paul Simpson, to whom he had not spoken for three years, back in England and ask him to get over on the first available flight.

'Oh, and Paul – get Finkler, Dwyer and Balfe to come with you. We've got a gig in the hotel restaurant tomorrow night. I'll sort the gear out this end.'

Over the following three years, the original line-up of The Teardrop Explodes would tour, adventure and angst their way through South America as a bar band, playing their psycho-industrial pop classics and English pastoral ballads, Dave Balfe driving the bus, shagging the girls and counting the money. Mick Finkler discovering new hallucinogenic mushrooms, listening to modern jazz, Gary Dwyer humping the gear, thumping the drums and worrying about Everton and Julian Cope living out his fantasy of being a troubled poet and writing home daily to Dorian, his new wife. And Paul Simpson keeping the vision intact.

During their self-imposed exile, they would scrape together enough cash to record three LPs in rundown eight-track studios. The master tapes would be sent back to Bill Drummond in Liverpool, to be released on Zoo Records. The first two albums would be considered, over a period of time, to be two of the

greatest LPs ever recorded, even better than *Marquee Moon*, but neither would sell more than 20,000 copies worldwide. After listening to the tape of the proposed third album, Bill Drummond would decide it was marginally less good than the previous one. He would know at once that the time had come to get on the first flight to Bogota, buy a gun and shoot Julian Cope in the head. Drummond would lie to the rest of the band, telling them that Cope had done a runner to Manizales and that they should give chase before he attempted to get back to England and cash in on his now legendary status by launching a solo career. Later that day, the band's bus would leave the narrow mountain road on a high Andean pass, bursting into a ball of flame as it hit the bottom of an inaccessible ravine. The bodies of Drummond and the band would never be recovered.

In the postscript to the book it would be explained how The Teardrop Explodes became the ultimate mythical rock 'n' roll cult band, pissing all over The Velvet Underground, even eclipsing The 13th Floor Elevators. There would be whispers of a never-released third album. Tribute bands would tour the world playing to thousands, and Oliver Stone would be rumoured to be working on a biopic of their career. The book would be magical, serious and frightening. What moments of humour it might contain would go unnoticed by the casual reader. It would say more about young men driven by a vision than any other book written in the English language.

But if I were to start writing it, I would be too shit-scared of what it might reveal ever to finish it.

TOWERS, TUNNELS AND ELDERFLOWER WINE

9 September 1998

The stench of paranoia is about my person and they've got a sniffer dog. I'm sitting behind the wheel of a transit van, waiting my turn at the security check. I've just driven off the early ferry from Larne, Northern Ireland, to Stranraer, Scotland. It is the traditional port of entry for IRA members with a mind to plant bombs on the mainland. I'm trying desperately to come up with a plausible explanation for the load I'm carrying in the back of the van. 'I agree with you it's absolutely disgusting. They told me it's art. I'm just the van driver. Nothing to do with me personally. I've just got the job of picking it up and delivering it to an address in southern England.' Of course I know they won't go for it, why should they?

I am carrying a montage made from the pages of hardcore European porn – erect cocks buggering female arses. The photos have been tidily arranged together in the shape of a large swastika. There is also a picture of Dumbo the elephant flying through the night air looking wearily down at the plight of mankind. The montage has been mounted on a six foot by four foot solid backing and framed by a tube of neon lighting. When it is plugged in and switched on, the anal sex is bathed in a soft pink glow. The piece, for in fact it is an art work, is entitled *Nazi Assholes* and is the work of my friend and colleague Z.

The reason why it is in the back of this van while I do my best impression of an IRA bomber is slightly more complicated. Five years ago Z and I purchased a tower in the wilds of Northern Ireland. It had battlements, it had a dungeon and was relatively cheap as far as ex-rock stars' follies go. It seemed like the perfect place for the both of us to keep all our unwashed secrets under heavy lock and key, and escape to when reality was getting too real. In the months and years after we gained the title deeds, people who knew about that sort of thing started to point out to us all the symbolic nonsense that is associated with towers in myth, legend, religion and the tarot. All rather obvious stuff, but I didn't see it at the time; a tad embarrassing now. We just thought, 'Yeah, a tower five floors high, hundreds of years old, with its own well – that sounds great! We'll have it.'

Our domestic situations have changed somewhat of late and neither of us is as much in need of a tower. It has also been brought to my attention that rumours are rife across the province that we are keeping guns and hardcore pornography in the tower. As much as I laugh off these rumours I know that in parts of the world like Northern Ireland (especially in the constituency of the Rev. Ian Paisley) rumours like these can have dangerous consequences, especially when they are founded in fact. (The 'fact' being the above-described work of art and the two flintlock muskets that we have at the ready. Mind you, the flintlocks would not have been much good at the Easter Uprising, let alone in the hatching of a massed breakout from the H Block.)

It is my turn next in the security-check queue. The sniffer dog is not some fierce Alsatian or Doberman, just a friendly looking spaniel. Spaniels must be the best when it comes to sniffing out Semtex. The spaniel and his handler approach me. I wind down the window. 'Morning, sir. Carrying any dangerous explosives or firearms?' he asks in a jauntily ironic sort of way. 'Hope not,' comes my breezy reply, and I'm waved on. I want to tell them that for all they knew I could be packed with

two tons of Semtex, off to blow up the Houses of Parliament, and they shouldn't be so free and easy with who they let in. Then there is about a thirty-second delay before I relax into the knowledge I'm not going to have to come up with some far-fetched excuse for *Nazi Assholes* and two rusting muskets.

I drive out of Stranraer on the A75 into the bleak landscape of the Wigtownshire half of Galloway. This is boyhood territory. I've just passed a signpost – Newton Stewart seventeen miles. Newton Stewart was my home town from the age of eighteen months to eleven years old, those special years when minds are still open and monsters still roam. A time and place when a boy could wander free, when legends lived and ghosts haunted and the imagination had complete control. At least the weather hasn't changed in the thirty-four years since our family flit south. It's a grey, miserable day. The rain comes down in sheets and the crosswinds are buffeting the sides of the van. I min-imise the nostalgia attack by trying to remember a pop song title. I was in a bar last night in Ballymena, and there had been a TV set in the corner tuned to a cable pop channel. The show was co-hosted by Toyah Wilcox. Toyah had a moderately suc-cessful pop/punk career in the late '70s, early '80s. She also had a small part in the Seminal Youth Cult Movie, *Quadrophenia*. I thought she was great in the film. I also thought she was great as Jack in the *Jack and the Beanstalk* pantomime I saw with some of my children this past Christmas time in Norwich. She could fair belt out the show's songs and her principal boy's legs did the trick for me. I felt like a proper father at the pantomime. As a presenter of pop videos last night on cable TV, however, she looked wooden, old, embarrassed, more suited to be standing in the cold and wet waiting at the school gate to pick up her kids. I felt a mixture of pity and revulsion at the idea of her doing whatever this desperate career thing is. So as I am driving through the bleak and deso-late landscape I'm trying to remember the title of Toyah's big hit. I can hear the sound of the drums, the keyboards, the tune,

even her lispy voice. But not the title. I keep singing 'It's a miracle', but I know that's not quite right. So instead I congratulate myself for remembering the title of her album, *Sheep Farming In Barnet*. What on earth was she trying to tell us about herself by choosing that as a title?

Vague memories are battering down my defences. Memories of returning from summer holidays in Donegal along this same stretch of road on a summer evening, and my father pointing out the far hump of Cairnsmore to us children on the back seat. Cairnsmore was a big rounded mountain that loomed over Newton Stewart. Wherever you were, whatever you were doing, there was always Cairnsmore looking over your misdemeanours like something out the Old Testament, ancient and ever present. But this miserable morning, however much my eyes strain to see even a vague outline of Cairnsmore, I can hardly see further than the windscreen wipers that are battling with the rain. A signpost: Newton Stewart five miles. I pass the turning for Kirkcowan and recall a summer Sunday afternoon spent with my father picking elderflower blossom to make elderflower wine. Being a Presbyterian minister, my father took a dim view of the effects that alcohol had on the Scottish nation. No bottles of Johnnie Walker or 100 Pipers ever crossed our doorstep. But every year my father would set out in search of elderflowers to brew his own elderflower wine. My father's recipe (the one he still uses at the age of 85) required us to fill five soup bowls with blossom. The trouble was, he wouldn't get round to setting out in search of the elderflower until its season was almost over. In May and June elderflowers are ubiquitous, found growing in every hedgerow. The elder tree is a nasty, low-down sort of a tree; in fact it's hardly a tree at all, more an overgrown weed. When climbed, its branches splinter and break easily, revealing their no-good pithy core. Even if you do clamber (it being more of a clamber than a climb) to the top, it provides none of the satisfaction of conquering a sturdy oak. What timber there is has never provided man with any

practical help in his onward march; as kindling it burns badly and even if you can get it to catch, it spits mean sparks from the grate and burns holes in your hearth rug. When farmers go bankrupt and their buildings are left to crumble and fall, it's the first tree to sneak in, taking root on the ruins of others' misfortunes. It's the weasel or rat of the tree kingdom. But strangely, for all its no-goodness and low-downness, the elder tree produces a pale-cream blossom with the most delicate of fragrances, which has found culinary favour. Elderberry and gooseberry crumble is about as good as puddings get. The elderflower, when carefully fermented, is considered by those that know to be the first among hedgerow wines.

In the past few years, for some unfathomable reason, the elderflower has taken on a more and more strange and somewhat desperate significance in my internal life. The situation has begun to get out of hand. I seem to have no control over the panic attacks that flare up with no warning. Throughout May and the first half of June, all the hedgerows around where I live in the Vale of Aylesbury are heavy with large fronds of elderflower blossom. Come late June, the crop is almost gone. That's when the panic attacks begin. What if there are none left? Have I left it too late to find any? Not that I have ever been in the habit of making elderflower wine like my father before me, or am likely to do so in the future. I don't even like elderflower wine. It's just that I . . . and then I can't define the root and cause of this panic. I just need to know that there is still some blossom out there in case I need it.

In late June 1996 when Z, Gimpo and I got back from our journey up the Congo, one of the first things I had to do was drive over towards Leighton Buzzard. In years past I had noted a late-flowering elder tree down one of the country lanes that way. I was panicking that, while attempting to wrestle my soul back from the devil up the Congo, I had missed a whole crop of elderflowers. I found the tree, and there were three fronds of the blossom left. Massive relief flooded through me. I didn't

even bother getting out of my truck. It was enough to know that there was still time to pick, still time to make the wine.

The panic attacks reach their height some time in early July, but come August I'm able to resign myself to the inevitability of it all. It is too late. There is nothing that can be done. No amount of searching hedgerows, river banks or the buildings of ruined farmers will reveal the desired blossom. I can put it all behind me and look forward to the descent into autumn, and all that mellow fruitfulness stuff.

On this wet, windy, miserable morning in early September the elderflowers are long gone. The hedgerows have other offerings: haws, sloes, rose hips, blackberries and even elder-berries, none of which holds my interest. These days the A75 bypasses Newton Stewart, but I can't stop myself. The indicator is down and I'm turning off the main road, past the spot where as a small boy I stood and waved paper Union Jacks at a big black car that contained, so I was told, a princess who was the Queen's sister. Why she was driving through an unimportant little Scottish market town I have no idea. I just saw her driver with his hat. Along the back road. Past Penningham Primary School where I learnt all the things they teach you in a Scottish education. Ahead are the gates to our garden, with the same trees still waiting to be climbed, and the solid stone manse standing staunch in the rain, its grey slate roof shiny and wet. I try to banish the nostalgia, pull hard on a three-point turn and head out of town. But it's no good. As the van crosses the old Cree Bridge into the village of Minnigaff it's upon me, and I'm not going to get away this time.

It was about this time in 1963 that Alistair and Angus McKey and I set out on our bicycles over this bridge. It was a rare golden day and sunlight danced on the river below. We had a plan, or, to be more precise, Angus had a plan. Angus was two years older than his brother Alistair and me. Angus was always in control of the plans. This particular plan was to cycle to the foot of Cairnsmore, then climb the mountain. Not because it

was there, or because we needed the exercise, but because in the last war a German bomber had got lost on its way back to the safety of the Fatherland after doing its business on the Clydeside shipyards and in losing itself crashed into the top of Cairnsmore. In the early '60s there was still Third Reich wreckage up there, to be had by small boys who valued such things. We had been numerous times in the past; all we had ever returned with was a few bits of twisted metal. But the dream still burned; an unexploded bomb must surely be somewhere up there waiting to be found.

So the three of us boys cycled over the bridge, not stopping to look for the dark shadows of salmon making their way upstream to complete their mysterious lifecycle. We didn't stop for provisions at the toll-gate sweet shop, or to dig for Pictish treasure at the ancient burial mound. It never even crossed our minds to head up to the Kirroughtree Hotel, where on such a day we could scale the battlements of the walled garden to get to the tree that grew the sweetest apples in all of Galloway. We cycled right past the lane that led up to the disused Blackcraig lead mines, where we once found the rotting remains of a fully grown red stag, which Angus tried to cut the head off with his pen knife. Past Palnure Post Office, which Tommy McBride's father attempted to hold up with a plastic gun before doing a runner and getting caught by the police out over on the Black Strand. Then we turned right off the A75 at Muirfad. The memory gets hazy then. I think we left our bikes at a cottage owned by an uncle of Angus and Alistair. There's something about him giving us an apple each from his tree in his garden, and although they looked the same as the ones at the back of the Kirroughtree, these were bruised and bitter. The three of us set out on foot to complete our journey, throwing the apples away as soon as we were through the gate of their uncle's garden, following a rough track which would take us to the foot of the mountain. It led through a wood, with high trees and an undergrowth of rhododendron. To one side of the track was

a burn; a big-rocks-and-clear-pools sort of burn. The sort of burn that would detain three boys, however pressing their mission. We stared into a dark deep pool and watched five brown trout. The dappled sunlight glinted down into the depths and caught the red, yellow and blue speckles on their backs. Angus had a plan that we should return after the closing of the fishing season with our rods, pull these gifts from God out and cook them on a camp fire. I never questioned his wisdom. We moved on up the track until we came to a small wooden footbridge. The bridge was arched, like the one Monet had over his lily pond. Like the one with the lovers and the doves on my granny's tea pot. Like the one that Tiger Lily, the love of Rupert Bear's life, has in her garden. Although it meant leaving the track that led to the mountain, the bridge *had* to be crossed. On the other side, we left the small footpath and started to clamber through the rhododendron bushes, following the course of the burn as best we could.

I have no recollection of how far we had gone before we discovered it, but on climbing around a large rock that hung over the edge of the burn we came across the entrance to a cave. It was just tall enough for us to stand in, and probably wide enough for us to touch both sides simultaneously with our outstretched hands. The three of us edged our way in, relishing the fear. My heart was pounding. Fear, dread and excitement. All that stuff the makers of horror and suspense pictures want us to feel. Well fuck the lot of them and their tawdry fake art form. This was reality. Fear, dread and excitement. Although we had no knowledge of this sort of thing, we knew it wasn't a naturally formed cave, but a man-made tunnel. The walls of it were rough and timeworn, dripping and slimy, but the height and width were constant. We followed the tunnel for twenty-five or thirty feet before it turned a corner. We had no torch, and none of us dared go any further.

My memory after that is unclear. I don't know if we climbed Cairnsmore in search of the spoils of war, or headed back

home, overcome by the discovery of this dark, dangerous, but alluring tunnel. I can't even remember if the three of us ever talked about it again. I do know we never did go back to catch those trout, and within nine months my family moved away from the area for good. But that tunnel has never left my dreams. Time and time again I find myself in there, at the point where it bends into the pitch blackness, and I'm still without a torch. Nothing terrible happens in these dreams, there are no dragons or witches, just an eternally ten-year-old boy standing and wondering where it leads, what lies beyond, and planning to come back again with a big torch.

It doesn't take much to interpret the symbolism of these vague memories, or to wonder how much my subconscious has tampered with the factual information in my memory banks. Over the years I've almost assumed that the tunnel was unreal, that there never was a Chinese bridge, that it had always been just a dream, and now it was a dream of a dream of a dream . . . And yet, and yet, there is still that fragment of a memory that seems too real to have been a dream, of standing there that first time, straining my eyes to see deeper into the darkness.

In the intervening three and a half decades there has been a number of times when I've driven along the A75 and wondered whether I should try to find the tunnel, or determine that it never existed, so the dreams can be left to fade away. But there is never time. I'm either tearing along one way trying to make the last ferry from Stranraer to Belfast, or I'm heading back to home and family, trying to keep a promise that I'll be back before midnight. Today, as I cross the Palnure Burn and the Galloway rain keeps pouring down, I have plenty of time. Midnight seems weeks away. I turn off the A75 at Muirfad, but then my memory begins to fail me. I take a few wrong turns that lead to dung-splattered farmyards with a welcome of barking collies. Finally, through a process of elimination, I'm on the right track. Angus and Alistair's uncle's cottage looks different, no longer a dark rusty red but friendly and whitewashed. And I

can't see any apple trees in the back garden. A large buzzard swoops low over the van and disappears the other side of a 'dry stane' dyke, heading for where Cairnsmore must lie hidden in the rain and clouds. I drive the van up the track through the wood. Three hundred, four hundred yards on, then there to my right is the bridge. There is no doubt that it is the bridge, but it's not like in my dreams, or dreams of dreams of a 10-year-old-boy's memory. It isn't arched or Chinese-looking in any way, but it is wooden and it does lead to a small path on the far side of the burn. I've got no waterproof protection, no wellington boots and no big torch. But if I don't try to find the tunnel now, I never will. I switch off the engine and climb out.

The first thing to confront my senses is the roar, no dancing burbling brook with clear pools, but a torrent of rushing and tearing white water, hurling its way down from the sodden sides of Cairnsmore heading for the Wigtown Bay. I walk towards the wooden footbridge. A large grey heron is standing erect on one of its rails. Her gimlet fish-seeking eye catches mine and for an instant we are locked together. She turns her head from me, spreads her massive grey wings and lifts her ungainly but elegant body into the air. The first time I ever saw a heron I thought it was a pterodactyl. She flaps her wings slowly and glides off between the trees, vaguely following a curve downstream. She turns her head to take a last glance at me before disappearing into the thickening forest.

The rain is already finding its way down the back of my neck. I cross the footbridge, the torrent roaring below. On reaching the other side, I turn off the path and start clambering through the twisted rhododendron branches. Instinct has taken over. My jeans are soaked through. There is a large overhanging rock; I try to climb around it, but my hands keep losing their grip on the greasy moss. My foot slips into the waters; I regain my balance, but there is no way that I can get around the rock without falling into the torrent and being swept away. I strain my neck and can just see the entrance, a dark hole. There is no

room for doubt. No longer is it a dream of a dream based on a boyhood memory where fact and fiction, fantasy and reality, myth, magic and the seven-times table are all woven into one glorious plaid. The tunnel exists. My heart is pumping louder than the violent and furious waters that roar past my feet. A sense of elation sweeps over me, though I'm also clear-minded enough to know that if there hadn't been rain for seven days straight and the burn had not been in high flood, I would have been able to explore the tunnel, its secrets revealed to be mundane and rational. Something to do with land drainage, perhaps.

I retrace my footsteps through the undergrowth and cross the bridge. Back on the main track I walk up to where I can see the large overhanging rock on the opposite bank of the burn. Standing here on the opposite bank, where many thousands of hill-walkers must have passed by over the years on their way to climb Cairnsmore, I cannot see the entrance to the tunnel. The twisted and crooked branches of a rhododendron hang down over the rock face, its evergreen leaves camouflaging the dark hole. I imagine how in late spring the large exotic dark-pink blossom of the rhododendron must dance in the evening breeze, attracting bumble bees and dragonflies to drink its nectar. Growing on top of the overhanging rock, directly above the hidden entrance, is an oak tree in its prime. Stout, straight and towering, perfect for shipbuilding in case of approaching armadas. Even with the cold rain soaking me to the skin, I have a feeling of warm well-being flowing through my body, a sense that my dreams will no longer be haunted by this hidden dark hole, yet its mystery has been left intact.

I climb back into the van and start bumping back down the track, away from the unseen mountain and whatever may still be left of that German bomber. Just before I pull back out on to the A75 and the long road back home, I notice three large fronds of elderflowers in the hedge. Elder in blossom in September? It's not only unlikely, it's against all the laws of

nature. Instead of the rush of relief that I would have got, say, five weeks earlier at the discovery of a late-flowering elder, I'm filled with a panic, a dread. At my stage in life the last thing I need is tempting opportunities to disrupt the order of my days. Especially those tempting opportunities I would have relished in my younger years. I had already arrived at a comforting acceptance that it was all too late, and nothing could be done. But no, even at this late stage there is still time to make elderflower wine. I push my foot down on the accelerator and pull out into the speeding traffic.

GIMPO AND ME AND THE FABIAN SOCIETY

30 September 1997

I can feel the anger banging about in my head, trying to smash its way out. An unfocused rage. I don't do much kicking at the pricks, but something has to be done, even if the only outcome of it is that the rage subsides and I get some sort of a night's sleep. All I can do is get my notebook and pencil stub out, attempt to document the past few hours and hope to make some sense of my anger.

Gimpo and I are on the last train back from Brighton. Gimpo is ripping up a cold cooked-chicken he bought on the platform and we are shoving handfuls of the meat into our faces. We've got nothing with which to wipe the grease off our hands and cheeks.

Early this afternoon, Gimpo and I jumped a train for Brighton. *The Face* had got us a couple of forms that would supposedly get us into the Labour Party Conference, their first held in power in the last one hundred and eighteen years and all that, and certainly the first party conference of any persuasion that Gimpo or I had ever attended. The two of us have a date – Tony Blair's big speech – and we are running well late.

We need passport photos to get our passes. The photo booth at Brighton station is out of order, and kicking it only hurts my ingrowing-turned-septic big toe toenail. We belt down the hill

looking for Boots. The booth delivers its goods, and vanity prevents me from looking for more than the fraction of a second it takes to check that the ageing face is mine. Not only is the Prime Minister of our country younger than I, so is the leader of the Conservative Party. These are strange times and uncharted territories for me.

Next, to the accreditation office to get our papers stamped, our photos laughed at and, we hope, our passes handed over. We find the place up Dyke Road. But such things aren't instant, it's going to take at least half an hour to have our papers processed. Our money-burning, car-nicking, cop-killing backgrounds checked. Time for a pint.

We are cleared. Passes dangling around our necks, we bomb down to the conference centre on the seafront. Security is heavy. Cops at every turning, ring-of-steel style. Even a temporary crash barrier around the place to stop any would-be kamikaze-type car bombers. The entrance is via an underground car park. We follow a long line of posters, posted alternately: New Labour, New Britain, New Labour, New Britain, New Labour, New Britain, New Labour, New Britain, New Labour, New Britain. The mantra goes on and on, and I've got a feeling that, like all good mantras, it works.

But as we reach the entrance, happy, smiling, glowing people are pouring out. We've obviously missed Tony's Big Talk to the new rank and file, the new world and the new millennium. 'Fuck it! Fuck it! Fuck it!' is my reaction, but Gimpo is unfazed. He's already getting acquainted with the crusty beggars outside, plying their trade by working on the guilt of the New Labour faithful.

The Grand Hotel seems to be the place where everybody is heading, so we go with the flow. Not too late for afternoon tea. Gimpo and I are obviously the scruffiest blokes in the place. New Labour, New Suits. My jeans and boots are still splattered with the paint job that me and Jimmy did on the National Theatre a couple of weeks ago. '1997 – What The Fuck's Going

On?' I can't see a Dennis Skinner or a Tony Benn anywhere. I know champagne socialism has been an easy target for right-wing journalists for the past twenty years, but all this is taking a bit of getting used to. 'The times they are a-changin''; for example a couple of the striking dockers who took part in our Fuck The Millennium thing are filling their workless days by attending Media Studies courses at Liverpool University. Now that's what I call New Labour, New Britain. We spot the odd front-bencher, but I'm hoping to see Clare Short, get her autograph for the family. Now there's a real woman, still shaggable after all these years, and not because she's had a tit job or a face lift but because she is made of the Right Stuff.

Cream tea done. Gimpo is collecting the flyers advertising fringe meetings. He suggests we should check out the Fabian Society, and reads from the leaflet: '5.45 p.m. – Lights! Camera! Action! The New Creative Economy. Old Ship Hotel, Paganini Ballroom. Sponsored by Polygram Films.' Note the capital N for New – those things get slipped in under the guise of irony and before you know it, it's for real.

5.35 at the Old Ship Hotel, and I'm in a state of shock. The last face I was expecting to see in a place like this was that of Rob Dickins, one of the most charming men on the planet. Somebody whom I have both loved and loathed. I was his protégé and I let him down. But I let myself up. A great part of the drive behind The KLF's international pop success was my desire to prove him wrong. The trouble is, it only proved him right. Next to Rob is Alan McGee. Fellow Scot, fellow ex-Hun (can one be an ex-Hun?) and fellow man with a mission to do the wrong thing. The conversation is stilted, as I'm pouring with sweat and ringing with fear. I can hear words come out of my mouth, but they are nothing to do with what's going on in my brain.

Of course, Dickins wants to know why I am here. As I don't know myself, I am unable to give him any sort of satisfactory answer. He tells me he came down with Mick Hucknall, how they watched Big Tone do his thing together. How Big Tone had

total class, like a great pop performer who knew how to communicate to a mob-filled arena but still make it all ring true. Rob throws in a revelatory anecdote; the last time he saw Tony Blair was when he took him to a Simply Red concert. They sat together admiring Mick Hucknall's voice, stage presence and professionalism, and chatted about all-time great singers and the great prospects for New Britain. I ask Rob if he came to last year's Labour Party Conference. He gives me a look as if to say, 'Don't be stupid'.

In an attempt to steady my nerves I grab a glass of red from the white-linened table laid out with mineral water, orange juice and wine. The Paganini Ballroom is upstairs and at the back of the hotel. It's not that grand, in fact it's long and narrow and a bit grubby, with a small proscenium-arched stage at one end and a few dozen chairs in rows. Gimpo and I take to ours. Less than half the others are sat upon. Rob sits directly behind me. The sweat pours down my back.

Five speakers sit behind the table on the stage, carafes of water in front of them. The chairperson gets up and proceedings proceed, but my attention is elsewhere. Gimpo nudges me, and I'm thinking what he's thinking. She's sitting alone a couple of rows in front of us like a teenage Brigitte Bardot: long blonde hair, a black fitted cocktail dress, body to match. Her face angelic, sensual; naturally pouting lips, her eyes large and innocent as if her cocksucking days are yet to come. I know that Gimpo and I are both thinking, 'What the fuck is this girl doing here alone?'

I attempt to drag my mind back from this dark alleyway to the words of the woman chairing the meeting; she is now doing her introduction bit. I check my Fabian Society flyer and see that she is Carmen Callil, co-founder of Virago Publishing. Gimpo and I turn our attention from BB to one of the most influential figures of the women's movement over the last thirty years, as she welcomes us all. There's an irony here, but I attempt not to wallow in it.

Callil is introducing us to the man at the far left of the top table. He turns out to be Chris Smith, our Secretary of State for Culture, Media and Sport. All I know about him is that he is the first totally out-of-the-closet-and-into-the-cabinet gay that the country has ever had. No mean feat. I like him. Warm and friendly. His words are agreeable, silky but not oily – the general drift being that as we slip into the twenty-first century, it is our creativity as a nation, our culture (both contemporary and historical) that will be the big wealth creators for our economy. He bandies some facts about: how already the music business generates more cash than British Steel.

A pang of anger surges through me.

I spent my teenage years growing up in the steel town of Corby. A '60s Mecca for Scots to find work and a bright future, all new and prosperous and filled with hope, away from the desolation and poverty of central Scotland's crumbling tenement slums. Come the '70s, successive governments decided that it made more sense to buy our steel from overseas – and closed the whole place down. 12,000 workers were put on the scrap heap. Yeah, I know I sound like some blinkered old sod from the SWP. But don't start giving me the 'music biz creates more wealth than the steel industry' bit when it was a Labour government that had a big hand in shutting ('scaling') the latter down.

Chris gets his applause and sods off. A busy man, I presume. A woman called Jude Kelly, the artistic director of the West Yorkshire Playhouse, stands up and bores us about something or other. Next up to speak is Stewart Till, President of International Polygram Filmed Entertainment. Polygram International are the sponsors of this meeting. I wonder what that means. Did Polygram pay for the wine, water and orange juice? Hire the hall? What do Polygram get from this?

I hate Stewart Till. My hatred is not rational. It is based on one meeting I had with him sixteen years ago. He was Head of Marketing at Warner Music – WEA in those days – and I was

the manager of Echo and The Bunnymen. He laughed at my ideas and proceeded to blow his marketing budget on something trivial. Madonna, probably. Now he is spouting New Labour-friendly platitudes, quoting 'British film industry – bigger than British Steel' facts. Polygram is a Dutch-owned multinational corporation; most of the steel used in the UK now has been made in Germany. I am a very pro-European person, but . . .

The mike is passed to Alan McGee, who is introduced by Carmen Callil with a line about 'a minute's silence in honour of Oasis'. McGee fumbles with his papers. He's not sure whether to sit or stand. In the end, he goes for some position in between. He's not wearing one of his now customary suits, and seems to lack any sort of public-speaking confidence. He reads from the page, monotone style. I warm to him instantly, which isn't surprising as I like him anyway, and agree with most of what he has to say. Up from the shop floor, with his vision intact.

The speakers have now all done their bit, and Carmen Callil is trying to draw questions from the sparse audience. Ah yes, the audience. Other than the baby Bardot, they all seem to be journalists scribbling notes, or infamous Labour-supporting culture workers: Jeremy Irons, Richard Attenborough, Alan Yentob, David Puttnam.

The meeting is over, the young Bardot lookalike is up and off into the night before anyone can ask her what's the big attraction that drew her to a Fabian Society fringe meeting. Gimpo and I get out before we get waylaid by anybody looking for converts, questions or even polite conversation.

As we make our way back up the hill, away from the sea and towards the station, I become aware of this uncomfortable sensation roaming my brain. It's got something to do with all those fine words I've just heard. The ones that I nodded in agreement to. Even the stuff McGee had to say. The government in power getting in tune with contemporary arts and youth culture – I'm not aware that this has ever happened before in our country,

other than in the most obvious and patronising way. Harold Wilson handing out gongs to The Beatles, etcetera.

Then I remember a friend of mine telling me that when the invites went out from Number 10 to the chosen few in the music business for that soiree, they were seen as the ultimate backstage pass, and hung and framed by everyone that got one. The music business is just play power. All that light, smoke, reverb – just make-believe. As for those movers and shakers, the A&R men, publishers, agents, managers, pluggers, etc – just a bunch of playtime moguls living out some film script fantasy. However unglamorous politics may seem to us, we all know that *that* is real power. The power to start and stop wars. The power to shape and create history. The power to make the world a better place, not just sing about it on a charity record or two.

We are all seduced by power, each and every one of us. Don't let anybody ever try to tell you they are going to corrupt/change/destroy the system from within. They will be the ones who will be corrupted, changed, destroyed, long before the system knows they are even inside it.

Back into present tense proper, and I'm still trying to cope with the seething anger. But now it is becoming somewhat more focused. Yes, I was pleased when the Tories got swept from power – especially the fact that they got totally kicked out of Scotland. And yes, I hope that New Labour can shorten hospital waiting lists, cut down on unemployment, raise standards in our schools, make the streets safer places to walk and all those other things.

But the contemporary arts, be they techno, rock 'n' roll, performance, film, those lot down at the 'Sensation' exhibition or wherever the farthest shore of creative exploration is found, should never have anything to do with the establishment. If the contemporary arts are to fulfil any positive function, other than as some sort of therapy for the artist involved, it is to provide an indefinable cultural Opposition. To keep alive the dreams,

research and development of Utopia. To be involved in any way with the political establishment is to be an unwitting hand-maiden to their PR machine. The only interest governing powers can have in the arts is what the arts can do for them.

That's not some conspiracy theory paranoia. It is in the inter-est of the governing power for London to be the swingingest, grooviest, coolest capital in the world, because that attracts wealth into the country. It's the contemporary arts/youth cul-ture thing which defines that groovy coolness. New Labour know this, far better than their predecessors did. They make no bones about telling us so. They even tell us, in patronising tones, that they think we should be proud of being such a grown-up and important part of the UK economy. Vital to our nation's future prosperity. Bigger than the steel industry. Never forget this fact: bigger than the steel industry. Bigger than the steel industry. Who the fuck ever wanted to explore the dark corners of those farthest shores to be bigger than the steel industry?

Gimpo catches my eye. He looks concerned. He can see the smoke rising from my pencil stub – always a giveaway sign of my unbalanced emotional state. He engages me in a convers-ation about how he thinks he, Z and I should attempt to sail to the moon. My man!

MY MODERN LIFE

5 November 1998

Routine. To get a job done I need routine.

Awake some time before 6 a.m. The Roberts radio has invariably been left on throughout the night. *Farming Today* then *The Today Programme*; John Humphries, James Naughtie and the gang putting the world to rights. Then it's children banging on doors and it's up and dressed and down before seven, feeding dogs and cats, hens and sheep. Radio Three, *On Air*, a pot of tea and a bowl of porridge before the family come down. Out the house 8.02 and it's up the lane and over the stile and a mile across country to catch the 8.23 bus into Aylesbury. It's the workaday walk through the fields that sets me up; fends off my daily quota of self-doubt. Whatever the weather, whatever the season, the hedgerows and clouds always make me feel glad to be part of this living and dying thing. I check the skies for the leaping flight of fieldfares returning from their Arctic summers. Dutch elm disease, that '70s scourge of the landscape, is back. All along the hedgerows young sucker elms have been sprouting forth these past ten years, reclaiming their right to be up there with the oak and the ash, kings of the skyline. But last year I noticed that the leaves on a couple of elms down the lane from my place were turning grey in late July. I hoped it was just the lack of rain during the driest summer since '76, but

come high summer this year, the leaves on more than half the elms had shrivelled up and died, and there had been hardly a dry day. Confirmation came when I noticed that the bark was cracking and falling away, revealing little tram lines. The killer beetles are back from the low country. Holocaust II in the broadleaf world. I hadn't spotted a single mention of this on the *Nine O'clock News* or even the *Guardian*'s 'A Country Diary'.

I notice a straggle of three swallows as they skim over the hedgerows and low across the field, heading for Sahara sun and African insects. I give them the thumbs up and shout, 'Can I come too?'

Panic time. Will this be the one morning in nine that I miss the bus? I start to run the last quarter of a mile to the bus stop. Wordsworth Drummond will have to wait. My legs are heavy, my bag heavier. A run that once could have been done without a care is now counting the toll that forty-five years have taken. The bus shelter is in sight. My panic subsides as I see the three other regulars waiting. The bus shelter, in its completely rural setting, is substantial: brick built with a slated roof, steel window-frames painted black and a dry wooden bench. It doesn't stink of piss and the litter is minimal. There is a plaque:

> This bus shelter was donated by President Benes of
> Czechoslovakia to thank the people of Aston Abbots
> and Wingrave whilst he and his cabinet were in exile
> here during World War II.

Which reminds me; front-page news in this month's parish magazine: 'State visit to Wingrave of His Excellency The President of the Czech Republic VACLAV HAVEL on 20th October 1998.' I still can't get my head round the fact that the long-haired counter-culture hero of the '60s and '70s is now not only president of his country but an international statesman, and I wonder if he ever gets time to write these days, and what on earth he said to my fellow parishioners up at the village

hall. The three other regulars are a skinny, spotty lad in his late teens whom I assume is at the local tech studying for his City and Guilds, a man who wears grey leather shoes whatever the weather and once sold me a bunk bed, and a middle-aged woman who smiles at everyone and looks like an Alan Bennett heroine. Nobody ever says a word except the man with the grey shoes, and that's only 'late again'. The Alan Bennett heroine is the one that is always on look out. I'm always on the bench, my head in my notebook, but out the corner of my eye I can see her bulging bag. When it moves, I know the bus has rounded the bend and will be pulling up in eighteen seconds.

Her bag moves. I spend the eighteen seconds packing my notebook away in my Karrimor Jura 25 haversack, returning my pencil to my leather Finnish hunting-jacket's inside left pocket and digging for change in the front right-hand pocket of my Levi 501 Red Tab button-fly shrink-to-fits. I'm writing this as my Bill Wordsworth tendencies subside for another day, and one of my other great inspirational figures of literature is wanting to vent expression: Patrick Bateman, the narrator and hero of Brett Easton Ellis's *American Psycho*. I love the way that Patrick Bateman feels the need to list and namecheck every passing detail – the designer labels, the menus and the music he hears – impressing us with his eye for minutiae, but getting it all so subtly and tastelessly wrong. It's to be a Patrick Bateman sort of day, but instead of late '80s designer labels and the latest restaurants opening on the Upper East Side, I note the little signs that keep us in check and inform us of what we need to know. They join the dots of my day together. I must have read that plaque about the Czechoslovakian government in exile at least a thousand times, and each time I read it I know I will have to read every other public notice that confronts me on my journey through the day. Not the proper adverts, just the dos and don'ts of modern life. Today I will write each one down as it confronts me. Maybe it will cure me of this nervous tic. Writing about Scotland cured me of my chip-on-the-shoulder

nationalism; writing about The Bunnymen laid at least seven ghosts to rest.

The bus pulls up. A single decker. Blue and yellow, my favourite colour scheme. Not the Swedish blue and yellow, more the Tottenham Hotspur blue-and-yellow away colours (in the seasons when they are not using that disgusting purple). My Patrick Bateman is coming on a treat, but I'm afraid there won't be any chopping up of women and fucking their eye sockets today, I cured myself of all that by writing my half of *Bad Wisdom* (Penguin, 1996). I find a seat near the front with the office workers and mothers. The back of the bus is the domain of the school kids, behaving as they do. I'm sitting next to the black middle-aged nurse who I find myself next to most mornings. She reads the *Daily Mail*. I read my stars over her shoulder. We never talk. I once smiled at her but she looked out the window.

The bus is packed. It's hot and smelly, standing-room only by the time we get to Rowsham. It's a slow, uneventful journey into Aylesbury during rush hour, but I like it. My mind slips its reality moorings and slides down into meandering thoughts and unreliable ideas. There was a plan for the day, to cast my eye over these stories and write an end piece. It'll be tough going now that I've got it in mind to nail down all those public notices.

> Do not stand or leave luggage forward of this point or distract the attention of the driver while the vehicle is moving.

She has put her *Daily Mail* away and pulled her puzzle book out of her big bag. I don't know if she does this to frustrate me reading the Nigel Dempster column over her shoulder, but without fail I'm never sat beside her for more than three minutes before she folds it up and out comes the puzzle book. If that's the way she's going to be . . . I pull out my notebook.

No smoking. Maximum penalty for smoking in the
seats £200.

Through Bierton, past where the Coca-Cola factory used to
be but got knocked down and is now a brand-new housing
estate. All detached, three feet apart. Over the roundabout and
into Aylesbury (population 51,497 at the 1991 census). 'Why
Aylesbury?' I'm often asked. There is no good answer. There is
nothing here to detain the tourist or the culturally inclined. Its
football team languishes but its post-war housing stock is good
and unemployment low. A place to bring up a family, in the safe
knowledge that as yet heroin is not sold in its school yards. For
young people with an eye for horizons, it's a place to leave. For
me it's just a town with few distractions, and as I'm not one for
distraction it will do fine for the time being.

The bus passes the prison gates. A small huddle of Sunday-
best-dressed family members and girlfriends standing by their
menfolk wait for visiting hour. I used to think I could be a vol-
unteer prison visitor, but always excused myself doing anything
about it because there wasn't enough routine in my life. 8.43
a.m. so the timetable tells us, Aylesbury bus station, a concrete
tomb under the Friars Square shopping centre. 'Thanks.' I'm in
the habit of thanking the bus driver on alighting, however surly
s/he may be and however bumpy a ride. A habit I refuse to let
die. I fill my lungs with the diesel fumes and

No parking – vehicles will be clamped. A fee of £30 +
VAT will be charged for its removal. Telephone
01296 483169.

head for the exit and down the steps to the subway under the
inner ring road. Out. Safeway is in sight.

This is a private car park for Safeway Customers.
Ball games and skateboarding are strictly prohibited.

[274]

Persons using the Car Park other than for the
permitted use will be liable for prosecution. By Order
of the Board of Directors of Safeway PLC.

I cross the large, open and almost empty Safeway car park. It
is wet. Reflections of clouds sail across puddles. A pair of pied
wagtails busy themselves in that way they always do in
macadamised car parks and empty school playgrounds.

Breast screening this way.

The architecture of the supermarket is tasteful. Nothing for
Prince Charles to complain about. The Canadian plane trees
planted as striplings five years ago are now over twenty-feet
high. Car park lamp-posts, signposts and railings are painted
the Safeway livery of sea green and dull orange. Subtle, a touch
more middle class than Tesco's stark and no-nonsense red,
blue and white. To the right are the cashpoint machines, Link
and Cash Line. These machines contain all the information
regarding my current financial state of affairs, not including the
loose change in my right front pocket and the fiver in the back
left pocket of my jeans. Last week I lost my Switch card. This
week they sent me a new one. I have forgotten the pin number
of my new Switch card. Thus I do not have access to my current
financial state of affairs.

To the left of two automatic double-doors are the expectant
shopping trolleys. There used to be only one style of shopping
trolley, the one that you would see dumped in the canal. Now
there is a proliferation of designs, none of which I have yet
seen in the canal.

Above the

In – Welcome – Entrance

automatic double-doors is the information

[275]

This store is permitted to be open between 10.00 am
and 4.00 pm on Sundays

and

Safeway Stores PLC licensed to sell game.

Above the

Keep Clear – No Entry – Exit

automatic double-doors is the information

R Meade, R Greenall, licensed to sell by retail
intoxicating liquor of all descriptions for
consumption off the premises.

Between these entrance and exit automatic double-doors is the
paper-towel dispenser.

Please use these to dry your child's seat.

I walk in. To my right is a Postman Pat van for toddlers to have
a bumpy ride in. To the left is a photo booth. The inner auto-
matic double-doors swing open. I walk on into the bright lights
and air-conditioning.

Buy two get one free

above a piled-high display of chocolate digestive-biscuit pack-
ets. I turn right, heading for the coffee shop.

Please ask for help or advice.

I need neither. On my right is the dry-cleaning counter. Next to

the dry-cleaning counter are the customer notices. I try not to read these, but can't help noticing a photo of an attractive bride sitting on the floor in front of a fireplace.

Wedding dress for sale £65 only (ono). Size 14.

The Opportunities noticeboard is the one I always read.

Part time Human Resources Assistant. Full time
Replenishment (nights) and full time Grocery
Produce. Contact Human Resources Manager for
details if you are interested in any of the
opportunities please collect an application form.

In the aisle between the Customer Services desk and the Customer Notice Board is a newspaper stand. Every weekday I stop to read the front covers of all the tabloids before checking out what stories the broadsheets are running with. Today is the day after Tony Blair's big 'Tony's not for turning' speech at the Labour Party Conference. It's a year since Gimpo and I attended the conference down in Brighton and I got mad at something.

Women and children brutally slaughtered in Kosovo
by Serbian police

Paddy Ashdown says something should be done.

Why we have lesbian sex on TV

My daily digestion of world events completed, I move on down and stand in line at the coffee-shop counter. Fresh fried tomatoes, eggs, mushrooms, bacon and black pudding try to seduce me. I resist. When I do succumb, it is only to a rasher of bacon and a fried tomato on toast.

45

> If you are not entirely happy with any item in our
> coffee shop we will refund or replace it.

Three people work in the coffee shop: one young man and two young women. All three wear lightweight white trilby hats and uniforms in the Safeway livery. The young man has sideburns and a regulation black dicky bow. One young woman is very short and wears thick round glasses. The other looks Welsh. All three are very polite. I have no complaints. On average there are thirteen other customers, some happy and some not so. I take my large mug of black coffee to the same table each morning. It's in the No Smoking section, next to the Tiny Tots Play Area. I check the digital clock on the wall above the cutlery and condiments stand. 8.53.

> For the use of Coffee Shop customers. Please feel
> free to help yourself.

I look around to see who is here. There is the man who sits with a straight back, never wears a jacket and only has a glass of milk. There is the man who is old and smells like old men do and mashes his plate of beans with a fork before eating them with a spoon. There are the two fat Asian boys dressed in Kappa gear, sipping Coca-Cola and talking about mobile phones. And there are the rest. Which is good. It's good to be one of the regulars. Nobody speaks to anybody that they don't already know and I don't know anybody and they don't know me. There is no canned music, just the clinking of cutlery and crockery, the bleeps and whizzes of the digital cash registers and the comforting blanket hum of the overhead air-conditioning. This is punctuated every seven and a half minutes by: 'Staff announcement, staff announcement, would . . .' I look up to see who '. . .' might be. It's the woman working on the

> Express lane for customers with nine items or less.

[278]

My Modern Life

My table is next to the fire exit. Above me hangs a sign. It depicts a running man, an arrow pointing down at me and a blank rectangle. It is dark green and pale cream. It is lit with a flickering strip bulb. I like this sign. The two chains that hang this sign from the ceiling are covered in dust, that thick, sticky sort of dust that spring cleaners miss.

> In emergency push bar to open.
> Warning – alarm will sound if bar is pushed.

The early Safeway shoppers push their trolleys up wide empty aisles and don't have to wait in queues. The checkout women chat and look happy. I never buy anything from this supermarket at this time of day, but if I did I would use the express lane for customers with nine items or fewer. I like supermarkets. I regularly use two Tescos, one Sainsbury, a Waitrose and this Safeway. (We don't have an Asda in the Vale of Aylesbury.) I like to watch who's doing what in the super-market war of market share. Who is promising what facility for the young parent. Who has the widest aisles and the biggest selection size-wise of Marmite jars. When Safeway opened in Aylesbury in 1992 the local paper told us it was Safeway's flag-ship store. It was the cleanest and brightest supermarket I had ever been in and the staff were the politest that had ever checked out my shopping. I asked why and they told me they had all been on one-day training courses in customer relations. There were these cute little trolleys for children under five to push and be mummy's/daddy's little helpers. But the trolleys all got put into the back of estate cars and taken away by untrust-worthy customers. 'Cunts', I thought. All those trolleys that children used to look forward to using when they went to the supermarket will now be rusting in back gardens across the vale.

I sip my coffee, reading and correcting what I wrote yester-day. When I finish my coffee I go for a piss. I have to walk up

past the news-stand and Customer Services desk. I make sure I don't look at the customer noticeboard in case I start to read it.

> Toilets. This area is checked hourly. If you are not
> happy with anything just let us know.

I'm happy and I wash my hands. I return to the coffee shop and order another coffee. At 9.29 I pack my bag and go. I walk across the Safeway car park, listen to the sound of trolley wheels on tarmac as people push trolleys to cars. The two pied wagtails are nowhere to be seen. The sky is clearing.

> No trolleys beyond this point. Thank you.
> Car park tariff. Two hours free car parking for
> Safeways customers otherwise £5.00 per hour. This
> car park will close one hour after Safeways closes.

The ticket man is in his cabin. I wonder what he wanted to be when he was a boy. When I was a boy of ten years and six weeks, who went for the messages for my mum at Nicol Logan the grocer's, I had never heard the word supermarket. Then when I was ten years and seven weeks old, Mrs MacCrarry came into our kitchen and asked if I wanted to come to the supermarket with her and her son Mickey. I said, 'Yes.' I thought the Super Market would be selling baby pigs. When we got there I was most disappointed; it was just a big grocer's, but with no Nicol Logan to ask me if I wanted a rich-tea biscuit from his large tin. I now love supermarkets and hate rich-tea biscuits.

A man with a chainsaw cuts back the car park garden's shrubs.

> Safeways. Thank you. Please drive carefully and see
> you again soon.

My Modern Life

Way out.
Exit.

Walk the twenty-seven paces across to the automatically opening door of the Friar Square multi-storey car park.

Friar Square multi storey. Winner of the National
Gold Award for car parks. Important notice –
welcome to Friars Square Shopping. Entry to and use
of this car park within the centre is at your own risk
and is subject to the terms and conditions of Friars
Square (Aylesbury) Management Limited. Copies are
available for inspection on request from the centre
management or at the car park office on level One.
Thank you.

The car park staff are fully trained and will
endeavour to assist you in most situations.

The car park is regularly cleaned and inspected and
graffiti removed at the earliest opportunity.

There are three lifts.

Press button for lift.

Me and my fellow local taxpayers watch the little green lights that indicate which lift will arrive first. The lift nearest to where I'm standing arrives. The doors slide silently open; I stand back to make way for the mother with the pushchair and two children under school age. I step in and avert my gaze from the other lift-goers and my reflection in the smoked-glass surround. The mother presses the button for Level Five.

Closed circuit television in operation.

The lift does not stink of stale piss. The makers of this lift have adopted the American practice of Level One, Level Two, Level Three, as opposed to Ground Floor, First Floor, Second Floor. Is this a trend that will spread? The lift doors open, and we step out.

Level Five – Access to shopping.

Past the Friars Square car park ticket machines

These ticket machines do not hold money overnight.

and on to the enclosed pedestrian bridge. It takes the shopper from the car park over the Aylesbury inner ring road.

Welcome to Friars Square Shopping.

Past Peter's Gent Hairdressers. Past the photo booth which I used once when my passport ran out. Past the two public pay-phones where two mornings out of five I phone people to leave messages on their answer machines, and into Friars Square Shopping proper. I love Friars Square shopping. The contractor who won the contract to build it must have put in the cheapest bid by far to get the deal. I will write more about this place when I have my mid-morning coffee break. All that needs to be noted now is the circular water garden. It's about forty feet in diameter. Its main visual feature is the fibreglass rock forma-tion which sports two waterfalls. The plastic tropical plants are bit by bit being replaced as the real ones take root and spread. The pond contains seaside pebbles and generously thrown coppers.

All money collected from water features in this
centre will be donated to the Children's Amenity
Fund Stoke Mandeville Hospital.

My Modern Life

The water garden is surrounded by benches. Old men sit and smoke and teenage Asians contemplate a life on the dole. There are small hidden speakers throughout Friars Square shopping mall providing us with a soundtrack for our shopping experience. This morning it's *The Best of Mike Oldfield*; yesterday it was The Shadows playing hits of the '80s. I always enjoy whatever has been selected for us to listen to. Poignant or toe-tapping, it is fine by me. Some mornings I stand beneath one of the hidden speakers pretending to be interested in a shop-window display when in reality I'm just listening to 'Incense And Peppermints' and trying to remember which mid-'60s West Coast band recorded it.

> Great news! Sunday shopping has arrived and we are
> open from 11 'til 5. Live music by local bands.
> Exclusive prize draws, just for the 'Sunday Shopper'
> with £1,000s of Friars Square Shopping vouchers on
> offer. Four lucky drivers will win free parking at
> Friars Square for a year. Entertainment for the kids
> and Sunday Artzone Club. Free parking. Don't miss it!

Leave Friars Square Shopping via plate-glass automatic sliding doors.

> In case of emergency push.

Out across the pre-cast concrete flagstone forecourt. Past the fourteen floors of the Bucks County Offices to the County Reference Library. The wind always blows here. County office and library staff stand around smoking in the cold. A fire engine siren can be heard in the distance. The doors to the library are not automatic.

> Pull.
> Registered assistance dogs only.

[283]

Between the outer and inner door to the library are the noticeboards. This morning there are ninety-four notices. I try not to read any of them but after counting them allow myself just the one.

> Don't miss this opportunity to learn the fascinating art of Shotokan karate. The next introductory beginners course will commence 7.30pm Wednesday 16 & 23 September Aylesbury Grammar School. Men, women and children (7 years and over) welcome and no special clothing required. 'Why not take that first step and give it a try?'

One of the inner doors is open. On the other one I read:

> A security system is operating in this library. It is harmless to the general public but may affect heart pacemakers. If you have been fitted with a pacemaker do not enter the library without contacting a member of staff. Please keep door open while the door curtain is on. Push.

The library and the county offices are late-'60s grey-concrete civic architecture to the max. A lot of people don't like this sort of architecture, but I'm not one of them. The library is large and spacious and has most of the books that I like to use for reference.

I walk between the recently installed cyber section and the information desk. I have one thought in mind: 'Has my seat been taken?' It has, by a man in his late thirties with a big blond beard and a red checked shirt. He is filling out a job-application form. I take the seat on the table next to him. Both his (my) table and the one I'm sitting at today face out of the huge perpendicular windows that take up one whole wall of this large library. I dump my haversack on the floor, take off my

jacket, hang it on the back of my chair. The window in front of me looks out at the county offices opposite. I can see people doing proper jobs with pensions and scales of pay and ladders of promotion. The seat I'm sitting on is acceptable because I can just see my pylon. Between the southern corner of the county offices and the western corner of the county library I can see two horse chestnut trees. Between the two horse chestnut trees I can see, in the distance, a pylon. Nothing else, just a distant pylon. Every time I look up from my notebook, I stare at this pylon and wonder where its cables are taking power from and to and I think about all the different things that that power is being used for, then I get on with my writing.

Today is a grey day. I can only make out a vague charcoal outline of the pylon, just enough to know it's still there. Between me and the man with the big blond beard and checked shirt is a pillar. On the pillar are two notices. One has been there for nine years.

No eating or drinking in the library.

The other only went up last winter.

Warning. On several occasions recently, customers
have had valuables stolen from bags and jackets left
on chairs and tables. Please be very careful with all
your belongings – there are thieves about.

I start to read through all the stories I've told in *45*. I want to see if they work together as a whole.

A few years ago, when my father was 78, I asked him: when did he feel he was at the peak of his life? Without hesitation, he told me, '45, son.' I can't remember asking him in what sense he meant his peak was at 45. He had been a sprinter, one of the fastest in Scotland, so as an athlete he must have peaked some time in his twenties, and then there was the war wound that

took its toll. As a preacher? Maybe his sermons at that age were more focused and formed, his faith unshaken. Maybe as a husband and father, but I don't think he ever thought of them as things one could be good or bad at. It is only this morning that I've remembered my father saying '45, son', so obviously my choice of title was nothing to do with the '45 rebellion or the Colt 45 or 45 rpm; it was because I had subconsciously taken on board that the age of 45 is as good as it gets. A point in life where you've gained a certain amount of wisdom, the hormones have settled down, the desperation is easing off, but before the mind starts crumbling and the body starts packing in.

After making some notes I need to go for a piss. I always need to go for a piss after I've been in the library for about twenty minutes. Ever since the warning notice went up on the pillar next to me, I have always left my coat on the back of the chair, the inside pocket showing with just the top of my blue canvas wallet exposed. My haversack on the floor, my notebook open on the table with my last four weeks' worth of notes in it and my pen. To go for a piss takes about ten minutes. I like to think I'm doing my bit to spread trust, but maybe I'm just tempting fate, playing a minor game of chicken with the library thieves.

My bladder is bursting so I get up to leave. Down past the students and the Internet users, past the desk where librarians busy themselves. Through the years of being a regular customer here nothing that could in any way be classed as familiar has passed between me and any of the library staff.

Security alarm. If the alarm sounds as you pass
through the security barrier, please return to the
counter.

Before the security alarm system was fitted I would take reference books out with me so I could carry on my studies during my tea break. But not any longer.

My Modern Life

It was back in '88. My haversack was loaded down with books, all in some way connected with selling one's soul to the devil. As I left, the alarm bells rang and I was detained by the library staff. They asked me to empty my bags. Eleven books in total, all on the same theme – how to beat Satan at poker. They accepted my explanation that I was just taking them out to read while I had my tea break. But since that time over ten years ago, never a good morning nod or a smile of recognition. Whether they had me down as a book nicker or a Satanist has never been clarified. I've only ever stolen one book in my life and that was from an Irish bed and breakfast; a book about the fall of Carthage that had belonged to the son of the landlady, who had died in a car accident while studying for his degree in Dublin.

Below my feet the concrete flagstones and above my head the grey clouds and in between a circling flock of feral pigeons. Back into the Friars Square Shopping.

'I'm the Urban Spaceman Baby' by the Bonzo Dog Doo Dah Band welcomes me in. Instead of retracing my steps into the shopping centre proper I make to turn right, hoping to go up the stairs to the public lavatories – but I'm stopped in my tracks by a yellow and black temporary notice.

Caution – hazardous area.

This is one of my favourite types of public notices. We are not told what the hazard is; it's left to our imagination. Nuclear waste? Escaped crocodiles? Cannibals on the loose? I take my chances. Living dangerously, I sidestep the warning and run up the three flights of slippery stairs.

These stairs are for access. Do not loiter.

With my bladder about to burst, I have no plans to loiter.

Please extinguish your cigarettes now.

[287]

Past the Ladies', the Disabled and the Baby Changing Room.

> These facilities are inspected every thirty minutes.
> Should you find them not up to the standard you
> would expect, then please inform a Cleaner, Security
> Officer or contact Centre Management on Level 4.
> Thank you.

The standard is always high, my only complaint is that the toilet paper can be quite difficult to pull from its dispenser, some-times requiring you to kneel down on the floor of the cubicle so you can get your hand up into the container and make the stuck toilet paper start rolling. This is embarrassing, and you are tempted to call out to fellow shitters that the noises of you rummaging about in your cubicle have got nothing to do with cottaging activities.

> Armitage Shanks.

My bladder relieved and no complaints to report to a cleaner, security officer or centre management, I wash my hands

> Caution! Hot water!

and go.

Back down the hazardous stairs. 'Kites' by Simon Dupree and the Big Sound. Must be a Psychedelic Sounds of the Sixties tape they're playing today.

Back in the library, the man with the blond beard and red checked shirt has gone. My pen, book, jacket and bag have not been stolen. I move my unthieved belongings over on to my rightful table. Sit down, gaze at the pylon. I can see it more clearly now. When I was a teenager in Corby, a pylon towered over our house. If the morning was misty it would hiss and crackle. I used to like living next to a pylon; nobody worried

about catching cancer from it. Back to work. On reading these stories one after the other I'm confronted with the incessant self-mythologising vanity of them all. If they add up to a self-portrait in letters, I've committed the same crime that all mirror-gazing artists have done, and made sure that my disfiguring scar is left hidden in shadow. I've only revealed of myself what I'm content for others to see. There is very little of how I interact with other people or what the other people in my life mean to me. Affairs of the heart are left to gasp for air in their dark and dank waters. In two or three of the stories I've stripped out my fellow travellers from the telling. This has been done either to make the story-telling simpler, or to make me more the romantic loner. Or maybe it's because, like many of us, I only ever feel truly alive when I'm out there on my own. Wandering unnoticed, invisible as can be.

The library is filling. There are the same five retired Pakistani men who come in every day to read the Urdu papers. There are the three mad men who sit and stare and wait all day, until it is time to go wherever it is they go now that the mental hospitals have closed down. There are the students who are gaining degrees or failing 'A' levels, and there is my namesake, Bill. In the eleven years that I have been using this library on an almost daily basis, Bill is the only person I've ever spoken to. We used to take our tea breaks together. I learnt he had been in the Air Force, and not just for his National Service. After that Bill taught engineering at the Tech, but he retired in 1985 and since then he has had a daily regime that includes twenty lengths of the Maxwell swimming pool and studying Greek every morning in the library. He goes to Greece for two weeks each autumn. He will occasionally study manuscripts for piano sonatas. He is tall, slim and straight backed. Sometimes I catch him nodding off. Bill has cut a lonely furrow through life. I wonder who will turn up at his funeral. I would like to attend, but how do you broach the subject in the stillness of the county library? 'Excuse me Bill, you must be almost 80

now and not long for this world, I would like to go to your funeral when the time comes but as I won't know when you die could you let me have the name and number of your next of kin, so I can make contact with them and then they can contact me when you pass on and I can pay my last respects?' After Bill has gone I will be the longest-serving user of this library. The others just seem to come and go. The young ones pass their exams or fail; either way, their lives move on. Even the madmen and the retired Pakistanis leave and get replaced. Its just me and old Bill. The hit singles may come and go, the money gets burned, the journeys are begun, the women change, the children grow, but I'm always back here staring out at the pylon, keeping a record of the days.

Time for a coffee break. Since Friars Square Shopping opened in '93 I've always taken my coffee break in Beatties, a department store. The chain is based in Wolverhampton. I like to think that Beatties was designed to appeal to the aspirational instincts of the better class of lady. There is something so un-London, even un-Home Counties, about Beatties. In fact, if the better-class-of-lady's roots were to be revealed they would show her to be very much of Victorian trade-and-manufacturing stock.

I have been in love with department stores ever since my granny took me to Jarrolds in Norwich at the age of five. There was a time when every city in Britain had its department store. They would bristle with a certain strain of middle-class civic pride in the way that the football team would bristle with working-class civic pride. As is the way, the majority of these department stores are now owned by the likes of John Lewis plc, even if some retain their original name, like Owen & Owen in Liverpool. What I have always loved about these department stores, more than the escalators and make-up-counter girls, is their restaurants. In my imagination, if not in total reality, it is a world where women of a certain age who have never had to do a day's work in their lives can arrange to meet

friends at eleven for coffee, or three for tea. Where matters of
personal importance can be discussed or skirted around,
depending on the company and circumstance, and where the
likes of me can listen in and get all the Alan Bennett lines
before he does. (In fact, that is a lie. I hate overhearing other
people's conversations. If I accidentally do I get locked on to
them and find it very hard to get out and back to my own train
of thought.) Beatties does everything it can to prevent itself
from going down market; it knows it would be ditching its
biggest asset. It is no good me popping into Beatties to get a
cheap biro – they only sell expensive fountain pens or Schaffer-
style ballpoints.

Through the polished hardwood doors of Beatties' second
level.

> Ladies fashion, ladies shoes, underwear and
> nightwear and the Balcony Restaurant

I grab a tray and join the queue. Help myself to a cheese scone.
I could waffle for ten pages or more on what every item of food-
stuff on offer symbolises to me.

> Welcome to our Balcony Restaurant. We hope that
> you are enjoying your visit. My staff and I will do all
> we can to ensure your satisfaction. If there are any
> comments you wish to make please speak to me or a
> member of my team. We look forward to welcoming
> you again soon.
> No smoking.
> If any of our customers suffer from a food allergy we
> will endeavour to prepare something suitable.

'A cup of black coffee please.' The first of three. At the till is
my favourite waitress. She must be in her mid-50s, and she's
looking good. Blonde hair piled high – classy, not Bet Lynch.

And she's always got a smile and a word for the customer. The day is shaping up. Here too I have my favourite table and today it is free. It's by the balcony that looks over the splendour that is the

Friars Square Indoor Shopping Experience.

As for my fellow mid-morning coffee breakers, they are not just the ladies of a certain age but a cross-section of the population of a London-overspill satellite town. This cross-section doesn't stretch as far as racial minorities. I've never seen a sign that says 'No Pakis' but it must be hanging up somewhere. There is the senior barber at Peter's, taking his break from short back and sides. He is all of five foot two and has a small-tough-man's walk. My teenage years were blighted by small cocky cunts who thought they could prove something by trying to pick on my gangling, shambling, six-foot-something self. Over there are the three women who work in the health shop where I buy my midnight-primrose-oil supplies, talking about summer holidays and problems with ageing parents. Shuffling in is the old man with the baggy face permanently drained of colour, watery-blue eyes and saliva encrusted at the corner of his mouth. He has been coming in here every morning for the past five years and every morning looks like it's going to be his last. He's a favourite; everybody seems to know his name except me. He's heading for his regular table by the wall, under the sepia photo of an old horse-drawn Aylesbury that none of us knew.

Diagonally across the pathway from my table is the young mother with the shoulder-length, natural-looking chestnut hair. She has worn the same pair of jeans every day since she first became a Balcony Restaurant regular nineteen months ago. I find stubborn consistency an attractive quality in a woman. At her side is her boy. Four years old I'd guess. He is the apple of her eye. Very much the only child. It will break her

heart the day he leaves home. I sneak a glance at her denimed crotch, try to envisage her dark depths. Not a flicker. I would like to be able to have a minor crush on this woman, it might add a little sparkle to my mornings, but nothing flutters, just a bit of sympathy for another mother struggling through her days. The brutal fact is that in the fifteen years that I have been living around Aylesbury I have not seen one woman whom I'd like to get to know. Dear reader, judge that as a personality defect on my part rather than an objective assessment of the women of the vale. The twisted thing is, I like it this way. It comfortingly confirms I don't belong with the mid-morning Beatties regulars.

I try to continue reading through these stories, but my mind keeps drifting. There was a big piece in last Sunday's *Observer* about the differences in the reading habits between men and women, sweeping generalisations of course, but you know how it is with these sweeping generalisations – they usually contain uncomfortable truths. Blacks are better dancers, Scotsmen make great lovers, that sort of thing. Apparently women prefer novels about relationships, with domestic backdrops: the realities of life. Men's novels are never set within the confines of the home, the *quest* being the underlying theme of all male literature. No stunning revelation in this, but it didn't half make me feel better reading it in a proper paper. *So*, my leaving out almost all the domestic stuff in my life and the frictions and bonds within my working partnerships is not just because I'm a coward unwilling to confront my dysfunctional personality – it's down to my *maleness*.

And yet, and yet. My friend and colleague Z is of the opinion that the prime motivation of the artist is to create masks with which to hide his true self. From these masks, in all their hues, subtleties and burnished glory, we can judge an artist's true genius. It is also how Z views religion. For me, the many religions of mankind are the paths we have tried to hack through the jungle to get to the one inner truth of our existence. For Z,

the religions of the world can be judged not by how clearly the paths have been hacked but by the wondrous stories and fabulous pantheons they have on offer. For him the many deities evolved by the Hindu people and the glorious and bloody lives of martyred saints depicted in brightly painted alabaster and stained-glass windows are as good as religion gets. Even to attempt the journey to inner truth is futile, when at best all there is waiting for us is a rather bleak Zen riddle. Religions are the masks that mankind makes to hide the nihilist core that we all know lurks at the centre of our existence. Let us celebrate the masks and sod the emptiness that lies behind them. I know that Z would have it that the masks he has created in his careers as a rock 'n' roll sex god, maker of pictures and wordsmith are so obviously masks that nobody would ever confuse what might lie behind with what is on display. One could never question his motivation; he is not asking us to believe that his masks are anything but glorious artefact. But I lay out my stuff with some grimy and sordid detail, as if to say, 'Judge what is here as me, the real me, the true me. The racism, the sexism, the fear and loathing.' When in fact it is just another mask, which I'm trying to convince you is the true me, the artist stripped bare. In so doing, my mask making, the weaving of my own myth, is so much more fraudulent. Friend and photographer Marc Atkins, who has worked with numerous writers, told me recently that he had come to the conclusion that 'all writers are liars'.

I suck the dregs and chew the granules to get that last hit of caffeine then it's up for my second cup. My coffee addiction has evolved only over the past couple of years. I once loathed the whole decadent notion of coffee: its Europeanness, its café societyishness, its association with people talking late into the night about art and revolution. But sadly, I'm now at the point where I can't lift a pen without first feeling the caffeine shaking down my arms and banging in my head like some cheap teenage powders. 'Black coffee please.' It's the Filipina bride at

the cash desk. She's my second favourite. Other than the Pakistanis, Aylesbury has very few visible ethnic minorities – a smattering of West Indians, two Chinese takeaways, an Italian bakers and that's about it – so a Filipina-looking woman in late youth stands out, and I can't help but make the assumption she was a bride for sale. Mind you, she does not seem trod upon or repressed at all. She is in fact very vivacious, and the life and soul of the behind-the-counter banter.

'What's your name?' she asks the sixtysomething man in front of me in the queue.

'Pardon?'

'Your name. What's your name?'

'Fallow.'

'Is that with a P-H or an F?'

'F.'

'Shirley, Lee, Jane and Fallow. That can't be your first name. What's your first name?'

He hesitates. 'What's going on? Why on earth is this racial minority asking me, a retired professional man, my first name? Fallow, Mr Fallow is good enough for you; only my wife and close friends can call me by my first name,' he thinks.

'Why do you want to know my first name?' he asks.

'We serve the same people every day; we smile, we wish them well. But we never know who they are or even what they are called. So today I decided to start finding out and trying to remember.'

'My name is George.' And George takes his change and is gone to find a table in the far corner.

I'm next in line and I'm panicking.

'Eighty-five pence, and what's your name?' She has a lovely smile, she means no harm, her motives are innocent, but I should lie. I want to say Bob or Dave or Jim but I don't.

'Bill.'

'Shirley, Lee, Jane, George and Bill. That's easy to remember, my husband's name is Bill.' Oh my God, I'm thinking, I knew I

should have said Tony. There are that many Tonys in Aylesbury, she would never have remembered. Back at my table I manfully push aside the fact that all writers are liars and lose myself in the rising and falling hubbub of the Balcony Restaurant. I close my eyes to feel it better. It envelops me, makes me feel warm, soothes the caffeine storming around my nervous system. There are laughs, the odd snatched word, a distant Vivaldi's *Four Seasons* and the sound of the water tumbling over the fibreglass rocks below. I suppose it's total back in the womb stuff.

I've had vague ideas about giving some of these stories a life away from the confines of a pair of book covers. I like the idea of printing the Echo and The Bunnymen story on a series of sixty-inch by forty-inch posters and pasting them up around Liverpool. Give it a shelf life as short as any other pop poster. Push the tale back where it belongs, in the ephemeral world and short-haul hype of the four-week promotional campaign. There is a twisted part of me that would like all these stories disseminated in that way. The trouble is, I would want to be congratulated for doing it, get a thumbs up from the likes of you, which in turn would annul the whole thing and reduce it to a publicity stunt.

The coffee drained, time for my third and final cup. 'Eighty-five pence, Bill.' On returning to my table I drink this last coffee as fast as I can, pack my bag, put my jacket on and leave, just stopping long enough to note:

Craft Evening Tuesday 6th October 1998
7.00pm – 9.00pm
Come and enjoy an evening of craft, demonstrations
featuring decoupage, stencilling, Christmas
decorations, glass painting, dried flower arranging,
fabric painting, knitting, aromatherapy, art
needlework, ribbon crafts paper shapes and scissor
art and latch hook. An event not to be missed!

Admittance by ticket only. Ticket £2. Complimentary refreshments. £1 redeemable against any craft purchased on evening. Enter our prize draw.

I make my escape through the ladies' fashions, shoes, under-wear and nightwear, heading for the escalator. This will be the last time. I can never come back here again. I thought I was invisible, I thought I sat at my table and nobody saw this dishevelled man scribbling in his notebook. But now I have a name. Bill. The same name that retired and lonely airmen who fall asleep in the library have. The same name as men who fly to the Philippines to buy themselves a wife have. The same name as presidents who fall from grace have. Step on the escalator. Down escalators are one of the greatest inven-tions ever. The way the perspectives change is like being in a computer game. Heady aromas welcome me into the per-fumery department and islands, each manned by visions of painted femininity. I avoid all eye contact as I scuttle past. 'There he is, his name is Bill.' Out into Friars Square Shopping. On a normal day I would check the latest displays in Waterstones for new titles and bin bargains. But not now, not today, not now they know my name. 'He's called Bill you know.' 'What, the shambling, gangling one?' 'Yes, the one that scribbles and scribbles day after day.' 'The one with stains down the front of his trousers.' In my flight I just about hear the sound of Al Green's voice being squeezed through the hidden speakers. 'I'm Still In Love With You.' I have an urge to run to the payphones, pump in a coin, bang out a well-remembered telephone number, hold the phone to the air and let the answerphone at the other end record this lost '70s lament for a damaged love.

Escape, escape, down the concrete stairs to the bunker below all that is the Friars Square Shopping Experience. Down, down, into the diesel fumes and stale cigarette smoke of the bus station. Bay ten, the 12.45 to Leighton Buzzard.

For your safety and comfort, please remain in the seating area until departure time.

I run.

Smile, you are on CCTV.

I get on the bus and I'm gone.

ART TERRORIST INCIDENT AT LUTON AIRPORT

8 November 1998

Breakfast at Bewley's was always worth the £6.95 day-return ticket from Liverpool to Dublin. The ferry would leave Pier Head at midnight and be snug in the Liffy by around 6 a.m. A bus ride into Dublin city centre and Bewley's was opening. A full Irish breakfast, a large pot of Bewley's tea (leaves not bags) and round after round of toast and marmalade. Bewley's (est. 1840) is a large and rambling warren of tea rooms. With its wood-panelled walls (pre-war, at least in vibe) it is neither a workman's café nor particularly snobbish, and it doesn't appear knowingly to set out to woo tourists. It always seemed to be used by a whole cross-section of Dublin society; office workers, shop girls, stressed mothers laden with prams and bags, farmers up from the county and bohemian layabouts. It felt like a place where adventures began and doomed romances came to an end. But this was all back in the late '70s/early '80s. Nostalgia has had time to corrode the critical faculties of my memory banks, and my natural inclination to the romantic is prone to take its toll. There is a Bewley's tea caddie in my kitchen – black, gold and green. For the past twenty years it's gone with me, from house to home to hide-out to where I brewed my first pot this morning. The Bewley's caddie has

become part of my daily ritual, even if what's inside it is PG Tips and not Bewley's own brand of Finest Irish Breakfast.

These days, Belfast has replaced Dublin as my Irish city of choice. Today, as in right now, I'm on an Easyjet flight from Luton Airport to Belfast. Not that I'm heading for Belfast just for a breakfast. There's business of sorts to be done. When I arrived at Luton Airport, I had thirty-five minutes to go before check in; time for a pot of tea. So I looked around for a café or restaurant to fulfil my needs. To my delight and surprise I saw that familiar and comforting logo, Bewley's. But on entering this place, twenty years of regarding Bewley's as an icon of unchanging excellence was destroyed in less time than it takes to say 'A pot of tea for one and a toasted teacake, please'. Every morning for twenty years I've been picking up that tea caddie to make the first pot of the day, and subconsciously I've been thinking that whatever else is going on in the world, there is still Bewley's, where adventures are beginning and doomed romances are ending. But no, all along in a boardroom some-where, evil plans were being hatched to maximise the potential, to widen the good name, to export the atmosphere, to franchise the legend. The Celtic tiger economy in action. Some design company won the contract to 're-create the ambience of Bewley's' in any corner of the globe where some creep was willing to put up the money for a franchise; thought they could fool Bill Drummond into thinking this was the place to start writing the great novel, disappear without trace, or even start again. I couldn't even bring myself to pour a cup of much-needed tea. The place was empty except for me and a confused elderly couple off to sunny Spain for an out-of-season.

I love the modern world. I love all the crap it churns out and throws up and blows about. I love the way it repackages the past and regurgitates it for us to consume as heritage culture. Well at least I do in theory. So in *theory* I should love this fake bit of Dublin in the corner of Luton Airport. So what was the problem? The problem was that somebody was trying to pull

my security blanket away from me and I didn't like it. I mean, go and look at the place: no pretty Dublin office girls to have a fleeting crush over, no young priests taking their proud mothers out for afternoon tea, no lovers clutching each other's hands across the table, knowing it's all too late. And no me attempting to harness a creative urge that will leave its mark on civilisation.

Then I became aware of two boys in their late teens ordering a pot of tea. There was something strange about them, as if they didn't belong. But we all belong in airports. Airports are the one place in the world where we are not surprised at seeing an African chief with his ten wives, Manchester United football team, a Turkish guestworker, a gaggle of schoolgirls on an exchange trip. All classes, colours, creeds pass through airports and nobody points and stares and thinks, 'but they shouldn't be allowed'. So what was it with these two young men? One of them had got a shock of dyed-blond hair, but that's not unusual. The other was wearing an old baggy cardigan and a pair of slippers. So he wanted to express some eccentric affectation, plenty of us did at his age. There was nothing particularly outlandish or outrageous about them beyond the slight bohemian slackness. Then I got it. They didn't have any bags with them. That is what unites everybody this side of check-in. Whether we are South American rainforest people, diplomats from China or my mum and dad, we all have luggage of some sort. OK, I know that people meeting other people off flights and airport workers don't have bags, but these two lads weren't meeting nobody. Without luggage, you don't belong.

I ate my toasted teacake and left my now stewed pot unpoured. Time to check in. While crossing the main concourse looking for the Easyjet check-in desk, I noticed something untoward. One of the above-mentioned lads was running across the concourse towards his mate, who was kneeling on the floor on one knee, his arms outstretched, clutching a handgun that he was aiming at his friend. From

the other side of the concourse, two security guards were running towards the gun-toting teenager. I didn't panic. It all made perfect sense; I knew exactly what was going on. Some moments later, as my small black haversack was going through the X-ray security-check machine, the two lads were led past in handcuffs by a couple of airport cops. No heads held high in defiance, just a look of sheepishness that said, 'How do I explain this to Mum?'

Should I have intervened, explained to the cops, 'They meant no harm – I was once like them. Mere art students. Just a little attention is all they seek'? But I was too excited; I had my own agenda. I couldn't wait to get on the Easyjet, settle down in my seat, open up my notebook and write, something about Bewley's, tea caddies, the modern world and security blankets being ripped away, only to discover in the end that Bewley's – even if it's only a crappy, franchised, corner-of-Luton-Airport version of it – is still a place where ludicrous and foolhardy adventures can begin. In the years to come, those two lads will be able proudly to recall the day their performance art caused a bit of a stir at Luton Airport. Maybe they won't even realise that having refreshments at Bewley's played an important part in their adventure – that's unless they ever discover this short story, and all is revealed.

MY P45

2 December 1998

Last night I was on the phone to friend and poet Paul Simpson.
He was telling me what he'd been up to: fatherhood, words and
dreaming – the usual things. And I had been telling him what
I'd been up to: fatherhood, words and nightmares – the usual
things.

'So why are you using 45 as a title, Bill?'

I explained all about handguns, 1745, seven-inch records and
my dad.

'Oh, I thought it might be because you were frightened that
somebody was going to tell you to collect your P45.'

It made me think.

GREAT EXPECTATIONS

4 December 1998

The 68 bus starts its route at Euston Station and ends at Norwood Garage, in the depths of south London. A north–south slice through the capital. I have never grown out of the urge to sit on the front seat of the top deck and watch the world from that advantaged position.

When I first started using this particular route in early 1977 I was living in Liverpool, but my working week was spent in London building a stage set for the National Theatre. On Monday mornings I would get the 6.20 a.m. down from Liverpool Lime Street, arrive at Euston at 9.05, take the 68 as far as the National Theatre on the South Bank, and get on with my work. Monday, Tuesday, Wednesday and Thursday nights were spent on a friend's couch. This friend, Kit Edwards, was studying for his master's degree in fine art at the Royal College of Art. He lived in Herne Hill, further along the 68 route to Norwood Garage. The 68 was my London bus; it was the only one I used. On Friday nights I would take the train back to Lime Street.

Last week I was in Liverpool, sorting out a contribution I was making to a show at the Bluecoat Gallery. I had a look around the then current exhibition. It was by Tom Wood. He

had spent the last twenty years riding the buses around Liverpool and taking photos of what he saw out the window. The exhibition was the fruit of his labours. It was a brilliant show, as was its title, *All Zones Off Peak*. He captured something and nailed it down. A something I've written about before, sort of, but which I've never seen staring back at me from the walls of a gallery or picture book. There were at least three pictures that I wanted to buy, snap up, own, have at home, belonging to me not you. And there, my friend, is the heart of the problem, and the reason why I'm sitting on the front seat of the top deck of the number 68 as it pulls out of the bus park in front of Euston station this late November morn. The urge to own art.

Ever since I first had a bit of surplus cash it's not been down to the bookies or around to the drug dealer, or even sending off cheques to a charity of my choice. I've gone out and bought art. It's not that I've got empty wall space that needs filling, or have an interest in art as high-risk investment. No, it's something far more shameful, something I'm sure has been dissected and written about thoroughly by those that make it their business to know these things. I've even written about it myself, in 'A Smell Of Money Under Ground', but this morning I'm not interested in the psychology of wanting to own art, or even the sociology of the art-owning classes; I just want to put a stop to this futile urge. The fact that I have no surplus cash at the moment and am not likely to have in the foreseeable future is irrelevant – I know the urge is still there, lurking around in the hope of a for-gotten royalty cheque turning up from South America or somewhere.

In 1996 cultural worker Stewart Home staged an exhibition entitled *Vermeer II* in a small gallery in the East End of London. *Vermeer II* paralleled a larger exhibition of the Dutch master's work at the Hague in Holland. I like Vermeer. I also like what Stewart Home does. *Vermeer II* was an exhibition of twenty-two bad photocopies of those serene Dutch interiors. Home had also written a short essay, 'To Transvalue Value', for the gallery

visitors to browse through while admiring the twenty-two cheaply framed pictures:

> Since art objects gain their appearance of ideological autonomy from their commodification (1), marketing is obviously a crucial component in the production of a successful work of art. Naturally, unique works command higher prices than multiples. Thus while cheap copy technology enabled me to produce the work for Vermeer II in the course of approximately twenty minutes, it was necessary to introduce an element that makes the pieces on display appear unique. By adding paint to manipulated xeroxes of Vermeer's output, I am able to inflate the price of my work. Since a relentless interrogation of the notion of ideological autonomy constitutes an important element of the work, the pricing of the pieces reflects the deconstructive intent of the exhibition. The price for one picture is £25, the price for two £100, the price for three £400, and so on. With each additional piece purchased, the price is multiplied fourfold. Thus, the cost of all twenty-two pieces is a prohibitive £10,865,359,993,600.

The truth is, if I had the surplus sum of ten trillion, eight hundred and sixty-five billion, three hundred and fifty-nine million, nine hundred and ninety-three thousand and six hundred pounds stuffed in the mattress, I'd have bought the lot. As it was, I bought two. When the young person asked me which two I wanted, I casually replied, 'The nearest will do'. And when she wrote out an invoice for £50 I said, 'No! No! You don't understand, two costs £100. Look, read the essay: one, £25; two, £100.'

'But I think that's only meant as a joke. You don't actually pay that much.'

'But I want to.'

'OK. If you insist.'

'I do.'

In the next paragraph in his essay, Home gets into his theory stride:

> Few who understand the issues involved can doubt
> that any radical criticism of art must at the same
> time be a critique of a broader ideological system
> that uses the notion of taste to buttress social
> stratification. If the bourgeois subject constructs
> 'himself' as a 'man' of taste, then it follows that those
> who wish to escape the constraints placed upon them
> by this society, must necessarily transgress all
> notions of good taste . . .

Of course Home's self-conscious use of the language of Marxist dialectic is a joke but – and this is what I like most – he means it (I hope). Back in the Home Counties, I took the 'To Transvalue Value' essay and the invoice that read 'Stewart Home – Vermeer II – 2 pictures, £100.00' to my local picturer-framer. And now they, plus the two badly framed, pink-splurged photocopies of Vermeer prints, hang proudly in my work room. Not only does this bourgeois art buyer construct himself as a man of taste, he sees right through it and celebrates the fact that he can't do anything about it. Except today. Today I am going to do something about it.

I'm up here on the front seat of the top deck of a number 68 doing something about it. In my back pocket are five crisp ten-pound notes, fresh out of the machine. I left Euston about ten minutes ago. The bus has just passed St Martin's College of Art and Design, as featured in the Pulp classic 'Common People'. Down Kingsway to Bush House, home to my nocturnal companion, the BBC World Service. Over Waterloo Bridge, where you can see – just as Turner did – the morning sunlight dance on the murky waters of the Thames; it's too early in the day for

Ray's sunset. And there to the right is the National Theatre, where I'm proud to say you can still just about work out the faint remains of Jimmy's and my first great attempt at public proclamation: '1987', which we daubed on its north-facing grey concrete exterior in twenty-foot numerals. Below in four-foot letters was added the question, 'What the fuck's going on'. We forgot the question mark. It was done in the early hours on the polling day of Thatcher's third great electoral success, May '87. It was viewed by those very few who knew who the authors were as a publicity stunt for our new album of the same name.

Round the roundabout, under the iron rail bridge and past Waterloo Station. One of the highlights of this journey for me always used to be passing Waterloo Station and staring down at the beaming and happy-looking Buster Edwards as he manned his flower stall. Buster Edwards. A London legend, one of the infamous Great Train Robbers. Unlike his more famous comrade Ronnie Biggs, Buster Edwards had done his time, reformed his character and turned an honest shilling by selling flowers. Up here on the top deck it always seemed he was doing a brisk business, always a queue of eager commuters willing to buy their bunches of peace offerings from a real-life ex-member of London's notorious gangland. Jimmy and I were considering asking him to be witness to our money-burning exploit. They even made that film, *Buster*, starring Phil Collins. Then he topped himself. And that's not an attempt at a sick joke about the current cultural status of Phil Collins. So Buster Edwards is no longer there, nor his flower stand.

Kit Edwards and I got to know each other when we were both doing foundation at Northampton School of Art. Kit was by far the best painter of us all. He knew what he wanted to paint and had the skill to do it. He was born to hold a brush in his hand and stand in front of an easel. Kit had a twin brother who had a proper job, the kind that people respect and which requires no self-doubt. He was a fireman. In 1975 Kit's brother hanged himself.

Along this 68 route there is plenty to interest those who find the secret history of London enthralling – medieval pubs, place names unchanged since the plague, Shakespeare's barber, that sort of thing. I'm sure if I were to compare notes that I made on this same bus route twenty years ago to this morning's ride, a whole thesis could be built up about the evolution of the culture of the Afro-Caribbean community in south London. But today, for me at least, these things are irrelevant. Down London Road, around Elephant and Castle, on to Walworth Road. The bus bullies and shoves its way through the dense traffic, and as Walworth Road becomes Camberwell Road there is one shop-front I'm looking out for. It's a bicycle shop. It's on the east-side after the Albany Road turning, set back off the main thorough-fare. More an emporium than a mere shop. It's called Edwardes (note the additional E). After Kit Edwards's brother hanged himself, Kit went there and bought a racing bike and commit-ted himself to cycling. He hero-worshipped the greats of the Tour de France, had their pictures on his wall. According to Kit, Edwardes bicycle shop had been there forever, or at least since the war, when the original premises (up the road) got bombed and they had to move. There is a bus stop outside Edwardes, but I have never got off and gone in. I just sit up here on the top deck and stare at the racks of bikes and they mean nothing to me. For Kit, though, it was an outpost of a far-off land, a land where mythical frames lived in union with newly developed braking systems. Kit also knew that his urge to own a certain mythical frame could never be sated by its mere acquisition. By early 1977, when I was a regular passenger on the 68, Kit Edwards was in his final year at the Royal College of Art. The capital's most hardcore cyclist, he had long given up painting. He considered it an immature phase. He was now doing text pieces. I didn't understand it; the Art and Language movement left me cold. I just thought, 'but Kit, you could have been as good as Turner' (my favourite).

Camberwell Green, and I'm getting near my destination. But

first, a diversion. John Ruskin, one of England's great aesthetes, the man who celebrated the fact that you didn't have to know what you were talking about to write big fat books about it, had a park named after him in Camberwell. It seems he had bequeathed a portion of his family fortune to set up a local school for the poor. Maybe it was this local history that inspired me to read Ruskin's first book on art criticism, *Modern Painters* (1843) on my daily run from Herne Hill to the National Theatre and back again. Ruskin's fallibility suited me fine.

In my teens, when I first started to squeeze burnt sienna from the tube, Turner was my man, and I've carried a torch for him ever since. All that violence, those tempests, raging seas, alpine heights and tragedy were very seductive to an adolescent boy. By the time I was 19 I had shoved myself into the tightest 'pseudo-intellectual' (remember them) corner a brush-wielding art student could. I've been trying to get out of that corner ever since. I quote my notebook of May 1973:

> Until science and technology have developed a way
> of reproducing the works of the great masters and
> their progeny to such a level that even top experts
> cannot discern the difference between the original
> and the copy, and these copies can be reproduced at
> a cost so low that every council house in the land can
> have a 'Haywain' or a Rothko hanging above the
> mantelpiece, we must leave the oils to dry on our
> palettes, and turn our easels into ploughshares. It is
> to the world of pop music we must look for
> leadership where the work of the 'fabbest' to the
> work of the least is available to all for less than 50
> pence on a piece of seven-inch black plastic.

It all made dreadful sense. If not a worker's free state, then at least some sort of artistic democracy. How sweetly innocent it seems from these far shores on which I now find myself

standing. Of course, my 1973 notes on why pop music was good and the art business bad were all written a number of years before I gave the pop industry a helping hand by borrowing marketing strategies directly from the art business: the numbered limited edition, the whole notion of exclusivity to create desirability, etc. (The 'four legs good, two legs bad' is no longer such a clear vision in my head. It's easier to stagger from 'the wonder of it all!' to 'it's all shit' and back again than to hold any clearly defined artistic ideal.)

Underlying all this was the fact that I realised I was never going to cut it as a painter. Instead of facing the futility of my efforts, it was easier to come up with a polemic as to why the palette must be burnt, the brushes snapped and the linseed oil poured down the sink. This may explain why in 1977 I couldn't understand how Kit Edwards, who undeniably had the raw talent to move paint around bits of stretched and primed canvas, could walk away from the easel on the grounds of mere principle. And why, while I should have been writing my three-chord punk anthems, I was sloping off to galleries to gaze at old oil paint, and furtively reading about the masters on the top deck of buses. In one ear I had Ruskin proselytising Turner's epic and romantic sweeps, and in the other I had Kit Edwards giving it the Art and Language movement. What may have unified these disparate arms of the thing we call art is a vague dream of the Socialist Workers' State. Art history, of course, now ridicules Ruskin, that towering buffoon: I mean, he couldn't even get it up for his wife on their wedding night, and he had the Tate destroy those Turner pictures of women with their kit off.

The bus pulls up at the first stop on Denmark Hill. All this note-making this morning, all this arguing the toss about the urge to own, is done to keep my fear at bay. The fear is that some other bugger may have spotted the most desirable 'ready-made' in London and snapped it up in the past fourteen days since I last saw it. I alight, and as I do I make a note of the

advert, '*You can earn up to £300 a week driving our buses. Interested? 0181 684 6740*'. I've always fancied being a bus driver. Mind you, it would have to be in one of the old sort, where I'd be in my little cab and there would be a conductor taking the fares; I couldn't be dealing with all that giving change and interfacing with members of the public. Dreaming of being a bus driver – yet another diversion. Reality time. My right hand is beginning to shake, as it does when I get nervous. I want to run, but I control myself. Walk calmly and casually through Camberwell's Monday morning shoppers up towards the Maudsley Hospital. My eyes are straining to see if it's still there. I'm running. Oh my God, it's gone! No, no, it's still there. It's not been bought, stolen or burnt. It's just tied to the lamp-post as it was when I first saw it twenty-one years ago.

What *it* is, is a hardboard placard about eighteen inches wide, standing five feet tall, held in a flimsy metal frame. The hardboard was painted black in some earlier age. On the weathered black has been daubed in white letters, using the style favoured by greengrocers and fishmongers, today's bargains:

IN STOCK £7.99
KLEE
DUFY
MACKE
KLIMT
MATISSE
MONET
VAN GOGH
RENOIR
PICASSO
DEGAS

Fuck Duchamp's pisspot, this is the greatest ready-made the twentieth century has thrown up, and all that stands between it spending another miserable day out here in the elements being

pissed on by the Maker and splashed on by every passing rainy day 68, and being snug in the warmth of my work room, is a small deal with a shopkeeper. If it is true that we all have our price, I only hope the shopkeeper has one that is less than fifty quid. There are three other similar sign boards tied up, each braving the elements, each advertising different services and wares that are available inside the adjacent shop. The shop is called Great Expectations. Did Pip pass this way on his journey up to London? I've never been inside. Never even walked past. Only ever viewed it from the top deck of the 68. Since I saw it again two weeks ago when I was on an expedition to discover the source of the 68 bus, I've been filled with a great notion: that if I were to own this humble and falling-to-bits bit of advertising, I would lose my urge to own art completely. Of course, the notion didn't arrive complete all in one go. I had to build it up, construct a thesis, even decide that by writing this whole piece on the urge to own as I rode the top deck heading south to where I'm standing now I could rid myself of that silly little tic of mine, that need to spend whatever loose zeroes I've got jangling around the bank balance on art. I seem to have got my Scottish nationalism under control since writing about my day trip to Paris, so why not rid myself of this disfiguring self-inflicted birthmark, cut it off at the pass by turning the urge into a few pages of self-effacing prose?

Some time in 1990 Kit Edwards was riding his bike. A bus ran him over. His head got squashed. He didn't die, but he was well and truly fucked-up for months. And when he got better he was a different person. Not in a bad way or a sad way, but in a way that allowed him to begin painting again. Not angry young man painting, not painting to change the course of art history. But painting, done because he had the talent to do it.

I push the door of Great Expectations open and step inside. The walls are covered with picture frames of all shapes and sizes, waiting to be filled with art. The floor space is stuffed with racks of prints. I wait in line to be served.

'Can I help?' A young woman with a French accent. Obviously not the person I should be cutting a deal with.

'It's a rather strange request this one; I'm interested in one of the sign boards outside.'

'Excuse me?' As in 'Pardon', as in, 'I don't understand'.

'I'm interested in talking to someone about buying one of the sign boards that are tied up on the lamp-post on the pavement outside.'

'I think you should speak to Mrs Penney.' Mrs Penney is serving someone else. She is a shortish woman in her later working life, the type that made England a nation of shopkeepers before the Asians turned up and showed them how it should be done. A clock on the wall hammers out the passing seconds. My paranoia keeps me company, whispering, 'Even if the old biddy doesn't know, that French bint will.' 'Know what?' I reply. 'That Duchamp has long since replaced Picasso as the most influential artist of the twentieth century. A young Frenchwoman who turns up working in a south London picture framers and print shop must have an agenda, and part of her agenda will be to understand that sort of thing. So she knows that sign board out there in the cold is the most desirable piece of art in London up for grabs.' The seconds are still being hammered slower and slower as my heart gets banging faster. Finally:

'Mrs Penney, this gentleman is interested in buying one of your signs outside.'

Mrs Penney turns and stares me in the eye. 'A lot of people are interested in my signs. And which particular one are you interested in?'

'The "In Stock £7.99" one.'

'Of course.' Her wry smile gives away her intuitive knowledge of what is what when it comes to sucking on an art-sucker's desires. I have planned on offering thirty quid for the worthless piece of rubbish/priceless art treasure. The other twenty is just there in reserve, in case I get squeezed or rival bidders start to force the price.

'And, sir, how do you think I could explain to my husband if his handiwork was sold to a stranger for a few bob?'

Desperation flows through my veins. 'I will offer you fifty pounds,' I blurt out.

'Do you want to take it now or collect it later?'

'Now!' The crisp notes are pulled from my back pocket. Money changes hands. A receipt is written, 'Paid in full' stamped across it in the shopkeeper's scrawl. No Value Added Tax shown. Should I lose the receipt in one of my bulging envelopes marked 'tax return' and stuffed with a year's supply of old train tickets, supermarket receipts and tea-shop tabs, or should I save it as documentation, a prized piece of art history in the making? The receipt gets carefully placed between some virgin pages of my ever-ready notebook. Art history is the winner; the taxman can wait.

Outside it's beginning to rain. As I try to undo the cords that bind the sign to the lamp-post, the ends of my fingers are tingling the way they do the very first time you try to undo the buttons on a young woman's blouse. The French assistant looks bemused as I put my snip-at-a-thousand-times-the-price-under my arm.

'You English men are so crazy.' She smiles.

'Scottish. I'm Scottish.'

'Oh, sorry.'

'It's OK.'

Back when Kit Edwards was at the Royal College the students had a sit-in, as students were wont to do in those days. Kit was a ring leader. They broke into the principal's office, ransacked his cupboards and liberated a stack of MA degree certificates. Kit Edwards gave me one. I forged the principal's signature and gave myself a 2:1. (I thought a first would be a bit showy.) I thought that it might come in handy one day if I were looking for a job as a bus driver.

I'm now standing at the other side of the road, waiting for the 68 to come down the hill and take me all the way back up to

Euston. It's only now, as the rain decides to rain properly, that I begin to wonder what it is about this piece of worthless rubbish that I wanted so badly. It's got to be something to do with those notes I quoted from my notebook in 1973. A private joke that's so private I don't even get it myself. A bus comes lumbering down the hill, shuddering to a stop. The automatic doors fold open. As I step on board I turn the sign board vertical again, to make it easier to get past exiting passengers. While doing this, I notice that Degas is not the last of the artists whose work is for sale at £7.99 a shot. After years of getting sodden and soft in these soaking times the hardboard has sunk and curled up on itself. The top of six letters can be seen. TURNER.

Lightning flashes around my senses. If I were the sort of bloke to cum in his pants, I'd have a sticky stain right now. Those parts of my brain still able to function coherently try to make sense of the mere objective facts, and force meaning into a random existence. Fuck the four shortlisted losers in the Tate. Chris Offili may pick up the cheque for his 'black man in Britain' paintings supported by tabloid-friendly lumps of elephant dung. But I, me, Bill Drummond, Scotsman with a chip, am the outright winner of any prize with the name Turner on it, today or any other day. All that violence, tempest, raging seas, alpine heights and tragedy didn't let me down.

I step on the bus. Cured. The urge to own? Who needs it. Burn the lot.

ACKNOWLEDGE

I would like to acknowledge that I have been corrected, composed, connected, contained, confused, curtailed, continued, confronted, collided, combined, confined, concealed and conceived by the following three women, in order of appearance: Julia Drummond, Sunie Fletcher and Sallie Fellowes.

I would also like to acknowledge that if it were not for my collaborators in creation Balfey, Jimmy and Z, I would be something different.

To Cally for the way these things look.

And lastly to Mick for being there for over twenty years.

THRASHED

Friday 13 June 1997

11.34 a.m., Studio One, Worldwide International, Mute Towers, Harrow Road, north-west London. England thrashed Australia in the first Test five days ago. The summer is here and I'm feeling crap.

'It sounds shite.' Dull, boring, irrelevant, not of the moment. Definitely not timeless, just old and tired. I'm crouched up on the floor of the studio, and I wish I wasn't here. Jimmy is bent over the mixing desk. His shoulders droop, his body sags; his hair is not grey beyond his years, but way too grey for someone trying to make disco records. I mean, who the fuck do we think we are fooling? How come we ended up here, five years after making our glorious exit? 'Ladies and gentlemen, The KLF have now left the music business.' So why are we doing this? We don't need the cash. We're both already committed to other projects, plans that excite us and take up all our time. We've got the rock 'n' roll legend intact, even if somewhat faded. We have somehow been able to side-step an embarrassing decline into irrelevance and remainder bins.

The history of rock 'n' roll has been littered with pathetic comebacks, in which the heroes of our teenage years are paraded before us to taste and try again. And we see them for what they are, and what they probably always were: puffed-up

and pampered egos indulging any will o' the wisp whim that might float by. And we'd feted them as geniuses. In our youth, we saw their posturing and arrogance as something to aspire to. We saw their infantile hedonistic excess as the struggle of heroic freedom fighters against the repressive morals of our parents' generation.

No comeback has ever worked. The motivation behind the comeback has never and will never be the same as when the group or artist first crawled out of their sub-cult. If there were ideals, they have been replaced by mortgage-repayment demands and school fees for the kids. If there was fresh, original talent, it is now tired and tested, only capable of flicking the nostalgia switch. The Sex Pistols and The Velvet Underground, two cornerstones of rock's many-roomed mansion, have made that sorry journey around the world's festivals over the last couple of years, and whatever twist they put on it, however well they handled barbed questions at the press conference, we knew it was all a bag of shite. Now Echo and the Bunnymen are about to relaunch themselves, in the hope that somebody will buy the legend that they were the Godfathers of Indie. On a personal level I hope so, for their sakes, but it still stinks.

Graham, the assistant engineer, brings in a fresh pot of tea. He tries to give me the red-and-white mug, the one with a cannon and the word 'Gunners' on it. It's a joke. A bad one. Although Graham is a northerner and has no interest in all things Highbury, everybody else that works in this studio (and seemingly the whole Mute empire) is a Gooner. I have to run a gauntlet of posters of Ian Wright, Donkey Adams, David Seaman and the rest. Mute Records? You'd think it would be all eastern-European avant-garde techno talk, and if they have to be into football, why not the Polish first division? You can imagine a Mute worker wearing a Czech Republic shirt, but not the dreaded Arsenal away top. I think it's all pathetic, and whatever respect I had for the fiercely independent Mute Records ethos

has evaporated. The fact that I have to keep my White Hart Lane membership well hidden, or the lads here would have it up on the dartboard for practice, may explain my distaste. But this is the light banter . . . the reality is that Jimmy is rolling another rollie, I'm still crouched up in the corner scribbling notes and we are jointly coming to terms with the fact that we've lost it, haven't got a clue, and should be back on our respective farms bringing in the hay. A pair of fortysomethings who are even past our mid-life crises, we are both seriously regretting ever offering to get involved with Jeremy Deller's Acid Brass project.

Last year, when we first met Jeremy up in Liverpool and he explained his idea – acid house anthems from the late '80s played by a brass band – and all his theories about northern working-class amateur-music-making traditions, we were seduced. Sheffield bedroom techno-boys being the same as a colliery brass band makes sense. Open-air raves being the same as a band on a park bandstand on a Sunday afternoon – of course. But maybe it was just our egos being stroked; maybe we were just into the idea of hearing a brass band having a go at our three-note warhorse of a signature tune, 'What Time Is Love' (with or without question mark). After Jimmy and I attended Jeremy Deller's sell-out Acid Brass concert at the Queen Elizabeth Hall with the Williams Fairey Brass band (current national champions), we were up for the challenge. Sod whatever else we were doing at the time, and how retro the idea was of us two getting back into the studio to do this tune. I think we thought it wasn't going to take up more than a couple of days, and would only involve getting the Williams Fairey Band into the studio, the engineer slinging up a couple of overhead mikes, the band banging down the track and us making sure the right delays and reverbs were used, and the whole thing would sound fabulous.

On 17 May we went into Parr Street Studio in Liverpool with the band. From the word go, we knew it was a disaster. Not

only was there a thirty-piece brass band in the studio, but there was also the house engineer, his assistant, a specialist brass band engineer who had been responsible for all the top brass band recordings of our time, the arranger of the track, the conductor of the band, whose job it was to interpret and realise the arranger's arrangement, the band's manager, the bloke from the record company . . . and the FA Cup Final going on in the TV lounge. Jimmy and I tried to keep a low profile, but knew the whole thing was a waste of time, seeing as there was no way the band, however many championships they had won, could play in time. To be fair to them, their type of music isn't about playing in strict machine time; it's about ebb and flow, rise and fall. But if we were going to have any chance of doing anything with the track, other than let it be what it wanted to be, we needed all their parts nailed to a click track.

It didn't happen.

Back down in London Kevin and Graham, the engineers, spent five days sampling all the individual brass parts and flying them back in, moving them about a millisecond back, a millimillisecond forward. I mean, this is techno; you don't want any of that natural-feel stuff that musicians go on about. But it doesn't seem to matter how precise Kevin and Graham have got the brass parts; as soon as we put anything else on top, it sounds like a pile of stodge. It sounds like an idea that is screaming at us not to happen. Usually by now Jimmy and I would be going 'sod that, dump the idea, cancel the studio' and be off.

It takes about an hour and a half for me to drive into London from my place. Every morning I stop at the service station and pick one of those club compilation cassettes: *Ministry of Sound Vol III, Ibiza Classics*, you know the ones. I shove it on the cassette player and drive. I hope to hear something that inspires me, makes me feel good, makes me think something's going on out there in disco land. But it all sounds limp, crap, shit and

lame. No ideas, no risks, just a bit of shallow packaging and an ad campaign. And they all come on like they are on some sort of a mission, like this well-past-its-sell-by-date handbag techno has got some sort of moral high ground going for it.

Back in the studio, things get worse.

This week *Fat of the Land* came out. Everybody acknowledges that 'Breathe' and 'Firestarter' are the only two modern pop records to come out in the last twelve months. The Chemical Brothers are always mentioned in the same breath as The Prodigy, the current music-business thinking being 'forget Britpop, it's bands like the Prods and the Chemicals that are going to break America'. I bought *Fat* . . . and the latest Chemicals album on the way in, and right now, as I sip my seventh mug of tea of the morning and Jimmy rolls his eleventh rollie, we are listening to The Prodigy and we're thinking, How do they do it? How do they get that sound? That right-between-the-eyes, dry, cut-back but full-bollocks hardest noise in the world, that still sounds like they did it all in the inside of a biscuit tin? We know it's time to quit. That fence where the sheep get out needs mending.

We stick on the Chemicals. We are hoping to hear something that we both understand and are capable of ripping off. Track one is 'Block Rocking Beats', and it rocks. These modern groups are all banging away at about 134 bpm – we're still stuck at 120. I mean, we still think it's hip to pretend to be into jungle and threaten to make records at 170 bpm. We had no idea 134 was where it was at. Track two: I don't know what it's called. It sounds like they use a live drummer, you can hear the tom-tom fills go slightly out of time. Very clever. The funky drummer has got even funkier. I love the clattering sound they get. Then we find it, a two-bar drum-fill without too much other noise on top. Graham's already got it sampled; Jimmy loops it. We varispeed it and bang it down on to our track. It sounds brilliant! But all it does is show up how crap the brass band idea is.

Two Chinese takeaways, seventeen mugs of tea and thirty-

Thrashed

two roll-ups later. It is now almost 11.30 p.m., we're both knackered. We've spent all day trying to get this Chemical Brothers drum loop to work in with the Williams Fairey Brass Band. We give up. Outside in the car park, Jimmy and I climb into our respective rusting family saloons, each littered with debris left by young children. Young children who don't give a shit what their dads do, as long as they are at home to play with.

WHEELCHAIRS

Monday 30 June 1997

11.37 a.m., Studio One, Worldwide International, Mute Towers, and I'm feeling good like James Brown.

Driving in this morning, banging my palm on the steering wheel in time to whatever crap was coming out of the one speaker that still works on my C reg. Volvo estate, two statements were crashing around my head. It was only when I started to get looks from fellow drivers waiting at the lights that I realised the statements were not only in my head, but I was screaming them as loud as I could.

In the studio, Kevin and Graham seem to have got the Chemical Brothers loop, somehow, to sit in the track and make the whole thing rock. Jimmy's got a bass line. At times like these, Jimmy having a bass line is the most important thing in the world. The fact that it is the same bass line we have always used doesn't matter. It is a process of having to go through every conceivable bass line in the world before discovering the only one we have ever used as if we have never used it before. Nick, the keyboard player and programmer, has a new piece of cheap studio hardware called a Sherman. He got it from a tower-block flat in south London. It makes everything sound as tough as The Prodigy – it's obviously the secret of their sound.

[324]

Wheelchairs

This time next month everyone will have a Sherman, and the month after, it will be last month's studio gimmick.

Jimmy is rummaging through his trunk of disks, which contains every sample we have ever used. 'It must be here somewhere.' He is looking for a disk that contains the searing synth sound that we used on the original 1988 Pure Trance version of 'What Time Is Love'. He can't find it. We are not surprised. A bike is sent in search of a copy of the record so we can sample it from there. As the track's playing back at full volume on the speakers and the brass parts are sounding big and shiny and right and true, the two statements come surging back into my brain. Somehow they seem even more right, more meant to be, more handed down by God, and needing to be proclaimed to the nation. But what will Jimmy think? I'm sure the last thing he'll reckon the track needs is a load of shouting from me on it.

'Give it a go,' he says. I do. It takes a few goes before you get down to that bit in you where your primeval howl lies in its lair. Jimmy decides which two we should keep, by which time the bike is back with a copy of 'What Time Is Love (Pure Trance Version)'. Kev rigs up a deck and we stick it on. The fact is, what took us only an afternoon to do nine years ago on some basic home-recording gear sounds more now, relevant, hard and happening than what we have spent the last three weeks working on. But fuck all that, 'cause Jimmy is now randomly jamming the two chosen samples of my primal scream along with the Pure Trance Version still playing on the deck.

'FUCK! FUCK! FUCK THE MILLENNIUM!
WE WANT IT
WE WANT IT
WE WANT IT NOW!
FUCK THE MILLENNIUM! WE WANT IT NOW!
FUCK THE MILLENNIUM! WE WANT IT NOW!
FUCK THE MILLENNIUM! WE WANT IT NOW!

[325]

This is rock 'n' roll, this is every Hendrix solo, every Johnny Rotten sneer, every Keith Moon smashed drum kit. At least, that's what me and Jimmy are thinking. Fuck knows what Kevin and Graham are thinking, as they watch us acting like kids messing about with a sampler for the very first time, like small-town punks in a local eight-track studio, thinking their three-chord racket is the future of rock 'n' roll. What this has got to do with brass bands and art concepts, or even hit singles, I haven't a clue, but we're off. More tea (and not in an Arsenal mug). Gimpo turns up, with his new shaved head, sideburns and sticky-out ears look. He tells us sticky-out ears are 'in'. We shove him in the recording booth and tell him to bellow, 'It's 1997, what the fuck's going on?' He does. Then we get him to try 'Fuck the millennium' and 'We want it now'. It sounds good. Finally, we ask him to scream 'Bill!' and 'Jimmy!', like the two of us are lost and he's trying to find us. What we want this for I don't know, but it might help if we ever try to find our way back. Gimpo disappears off up the Harrow Road on his push-bike. Things are moving. More tea, more roll-ups. Graham orders the Chinese takeaway and talks about when he was in the RAF.

When things in the studio start getting a life of their own, they also start to grow as a visual thing in your imagination, so for Jimmy and me, things are getting pretty visual by now. For some reason, we are to be in wheelchairs. My leg in plaster, Jimmy on a drip, both of us being pushed by these two dollybird nurses with white uniforms so tight across their ample busts that you can catch glimpses of their red (or black) push-up bras between the buttons. Almost Benny Hill. A slight concept shift, and Jimmy reckons he wants Hattie Jacques as his nurse, which I suppose means that I get Barbara Windsor. (The fact that Hattie is at least ten years dead is irrelevant.) Now we have our image sorted out, things are becoming clearer.

Z turns up with his bible. He proudly shows us how he has just spent the morning cutting up his genuine snakeskin boots

and using the scaly hide to cover the book. He then goes into one about how he has had it with the Old Testament and all that jealous, angry God stuff. He quotes us from the Acts of the Apostles – chapter 19, verse 19 – and insists on writing the words down in my notebook: 'Many of them which also used curious arts brought their books together and burned them before all men, and they counted the price of them and found it fifty thousand pieces of silver.' He thinks it's relevant to me and Jimmy. He may be right. He wants us to use the quote on the track. No way. Jimmy and I have our own ideas. We've got our hymn books. I want 'I Vow to Thee, My Country' and Jimmy wants 'For Those In Peril On the Sea'. Poor Kevin and Graham. They haven't got a clue what's going on by now. They kinda looked up to us as a pair of geezers who'd had a bunch of hits, been there, done that, in the early rave wars. Kevin even told me that hearing the original version of 'What Time Is Love' at an acid-house party at Westworld Studios back in late '88 was a defining moment of his life. And here we are, a couple of farmers with cow shit on our wellies, arguing about what hymn we want to sing.

Z gets in the vocal booth, but we are not too sure whether his performance should be in the style of a boxing promoter or a southern evangelist. Of course, the southern evangelist wins out, and the Reverend Bitumen Hoarfrost is born. Then Z is off, back into the night. Jimmy and I are on the settee in the studio kitchen, MTV on but the sound turned down. The coffee table is covered with the remains of our Chinese takeaway, and we're plotting full-page ads in national newspapers. We are getting totally into the institution of The Comeback, drawing on the sad, pathetic nature of the whole thing, the desperation of all concerned to exploit whatever they can from the myth, while trying to convince themselves (if nobody else) that the band is still relevant. We want to pick that scab, squeeze that pus, mix it up. We want to play at going ungracefully, we want to see the tawdry show with the battered props.

The week that we were Number One as The Timelords, the thing we revelled in more than anything else was the prospect of one day having to tour faded seaside resorts as part of some second-division nostalgia package – Hazel Dean, S'Express and us – like you still get Merseybeaters doing, and all sorts of variants of the original '70s glam bands doing. It was only right and proper that all that had to happen. And once again, we are finding it an interesting subject. No, not interesting. Totally irresistible. Maybe we should do a one-off show as these two old geezers, almost a pastiche of Harry Enfield and Paul Whitehouse characters, and make out that this record we're doing is a live recording of that event – they're back, but for one show only.

So these are the words we've already got down on the bag the prawn crackers came in . . . 'THEY'RE BACK' in bold letters. Underneath in smaller letters: 'from the accountants', followed by some as-yet undecided description of how ground-breaking we were, followed by the line 'The greatest rave band in the world. Ever!' (Who in these late '90s would want to describe themselves as a rave band? Not even 808 State. The word 'rave' is at that stage where it's no longer used as something to be aligned with, but has yet officially to be deemed naff. Often that's when words are at their most potent.) Then in huge letters, 'THE KLF', followed by, 'For one life only'. This done with all the usual graphics we used in the past, same typeface, white out of black, but strapped across the lot will be a white flash with the words 'Cancelled due to severe senility'. Mute Records have been desperate to involve the letters K, L and F in this project. We have been resisting. They've come up with the idea of stickering the record with 'This is not The KLF'.

We're back to thinking about us in the wheelchairs. These two old, decrepit geezers, dribbling, stinking of piss, desperately trying to convince the nursing-home nurses that we used to be hip pop stars. Jimmy is scribbling one of his cartoons of the scene. We've got the rhino horns on our heads, the ones we

used to wear under our cowls in the latter KLF period. They now hang in my work room at home. The number of people who are so disappointed to find they are made of some sort of polystyrene, shoved into empty cat-food tins that have then been Gaffa-taped to the innards of building-site hard hats.

Back in the studio, it's hymn-singing time. We drag in as many people as are left in Mute Towers at this late hour, and tell them to sing like men.

> O Holy Spirit, who didst brood
> Upon the waters dark and rude,
> And bid their angry tumult cease,
> And give, for wild confusion, peace,
> O hear us when we cry to thee
> For those in peril on the sea.

Those are words to drown for. We love it. We do take after take, building the vocal tracks up into a mighty congregation. Jimmy is able to get the octave underneath, Nick does the descants and I just about keep in tune. Hymn-singing, music for real men, none of that poofy disco. We can see it now: *Hymns Justified and Ancient*, a long-playing record by the Justified Ancients of Mu Mu. Somebody has just phoned me and wants to know what Jimmy and I are up to. When I tell him, he says by doing a comeback, even if it is just for twenty-three minutes, don't we think we will disappoint all those people who hold us in such high regard? 'Yeah, that's the whole point,' I tell him. He doesn't believe; I don't know if I believe myself. But none of that matters, because we are now born-again hymn-singers. Lifeboatmen. How we are going to make all the disparate elements work in one record we have no idea. We can work that out another day.

Jimmy and I decide to knock it on the head. It's past midnight. Outside there is a clear sky and a full moon. The two of us set off in different directions. It is only then that I remember

that I've forgotten to tell him about the answerphone message I got last night from Stuart Home, about the Rollright Stones coming up for sale.

It can wait.

NOW THAT'S WHAT I CALL DISILLUSIONMENT, 1

4 January 1999

To a select few, The Residents were the greatest band in the history of rock 'n' roll. To me they may not have been *the* greatest, but they certainly were one of them. Not that I have ever owned a Residents record, or come to that listened to one from beginning to end. Actually listening to the music was not necessary to judge their greatness; in fact it might have put you off, since much of their recorded output was unlistenable. Hearing it unannounced and out of context, you could understandably mistake it for badly recorded, naïve, avant-garde crap. Context was almost everything. They gave the best context going. To three or four of us living in Liverpool in the late '70s, the idea of The Residents was the pinnacle of rock 'n' roll as concept. The fact that this was an era where concept was the most derided of notions somehow added to the potency. If you know nothing of The Residents, and why should you, I will try to give you a brief description of their attraction. That said, I know it is within the context of those times that their greatness shone, and maybe in these latter days it will seem a tad dull, in a lo-fi way.

The Residents came from San Francisco. There were four of them. We never got to know their individual names or what they looked like, and of course they never gave interviews.

There were photographs of them, in which they wore tuxedos and masks shaped like giant eyeballs. There was a later photo of the four of them wearing different, dark masks. In these you could see the whites of their eyes. In their photos they were invariably towering above such American landmarks as the Golden Gate Bridge or Mount Rushmore. The sky was always dark. With these two or three photo images, The Residents were able to haunt the imaginations of young men looking for something more than the posturing inadequacies of Iggy Pop and Lou Reed. They existed in a perfect world where they never grew old and never got chucked by their girlfriends. Even better, your girlfriend didn't like them. The band were represented by an even more mysterious organisation called the Cryptic Corporation and their records were released by a company called Ralph Records. Album releases would be announced in the rock press. Full-page adverts would appear. Then, for never-explained reasons, the records would be shelved. Nothing. Just three or four of us standing in Button Street, Liverpool, going, 'Wow! Brilliant!' and, 'They didn't even have to release the record.' Of course, albums did get released, the first of which was called *Meet The Residents* – this title and the sleeve artwork informed at least my imagination that they were in fact The Beatles from a parallel universe. (Maybe it was a notion that Julian Cope also had, inspiring him to create his own parallel universe, where The Teardrop Explodes existed as Whopper.) Other albums followed – *Third Reich & Roll*; *Duck Stab*; *Eskimo*. Each of their sleeves would be pored over in search of clues and signs, and caused much debate in the Armadillo Tea Rooms in Mathew Street.

Then in the early '80s the *Mole Show Trilogy* was announced. Over the next few years they planned to release three albums that were to reveal the epic story of the Moles' struggle against the Chebs. While me and my contemporaries in Liverpool were having meagre little careers, fretting over whether it was selling out or not to appear on *Top of the Pops*, then worrying about

subsequent chart positions and radio play, The Residents were striding out across landscapes where none of these piddling things mattered. The only other band that could come close to The Residents in our imaginations was Kraftwerk, but that's another well-documented story. The Residents seemed to be perfect in every way. We were never troubled by what their motivations might be. And the last thing we thought about was who the living, breathing, pissing and farting men were behind the masks. The Residents were as real to me as Rupert Bear had once been. *Real* real.

Then in 1983, or was it 4, it was announced that The Residents were going to do a world tour performing the Mole Show, their epic opera. As Will Sergeant and I sent off for our tickets for The Residents show at the Birmingham Town Hall, I didn't stop to think, 'The Residents can't perform live, they don't exist in this mortal universe – and even if they could get here, they would tower over everything, crushing all underfoot . . . and what kind of tour bus could ever fit them in?' Will and I had to reschedule the recording commitments of Echo and the Bunnymen's fourth album to fly back to the UK in time for the show. For us, The Rolling Stones were a mere pub-rock band, U2 a sixth-form covers band, compared to the massive stature of The Residents. If they had been playing Wembley Stadium I wouldn't have been at all surprised, but Birmingham Town Hall?

Will and I duly turned up, clutching our tickets. They weren't good ones. We were in the balcony. Our fellow seekers were a strange cross-section of early '80s youth culture. There were long-haired heavy-metallers, past-their-sell-by-date small-town punks, sharp mods, dirty hippies, but the majority of the audience seemed to be made up of introverted loners. Will and I blended in. In a previous career I had been a designer and builder of stage sets. I knew the tricks of the trade and understood how to create the backdrops and props for that other world beyond the proscenium arch. In Birmingham Town Hall

there was no proscenium arch for us to peer through at this other world. On stage were only a few shoddy and shaky bits of scenery, some dodgy-looking musical hardware and a very unimpressive PA system.

Show time. The lights went down. Then four individuals shuffled on stage. They looked like they were going to a student fancy-dress disco, got up in moth-eaten second-hand tuxedos and four belisha beacon shades they had nicked and then painted, in an attempt to look like The Residents. Most of what followed has been eradicated from my memory banks. I don't know what Will Sergeant thought, or where we headed to after the show. The only thing I can truly recall with certainty is that the individual who was pretending to be the lead singer had that nasally voice that featured on The Residents records down to a T, but his onstage body language was that of a rather small middle-aged man with a bit of a stoop and no idea how to move about a stage with any confidence. Contrary to how it might sound, I did know that the four individuals dressed up in Residents costumes were, in real reality, the four Residents. It's just that I hadn't prepared myself for the fact that this glorious and epic band that stalked my imagination would simply be four blokes from America who had an appetite for the weird and avant-garde. Four blokes who had the wherewithal, drive and imagination. Four blokes who got pissed off with each other, got pissed off with the fact they didn't sell more records, got pissed off with the fact they couldn't pull birds after the show, got pissed off that their genius was not recognised the world over.

In *Bad Wisdom* I go on about the first time that I saw Elvis Presley up on the screen of my local cinema, when I was 10 years old, and how that was my first great pop moment. Well, since watching The Residents at Birmingham Town Hall I have a freeze-frame memory of the middle-aged and slightly stooped figure of The Residents' lead singer, his bits of curly black hair sticking out the back of his eyeball mask. In a rational sense, it

should be a memory of catastrophic disillusionment, up there with being confronted by your big sister on Christmas Eve with the knowledge that Santa isn't real. That's what gives it its potency. It is why that freeze-framed memory is a pop moment just as great as seeing and hearing Elvis for the first time.

NOW THAT'S WHAT I CALL
DISILLUSIONMENT, 2

5 January 1999

Yesterday, when I got back home from writing about The Residents in Aylesbury library, I phoned up Will Sergeant. I hoped he could remember in which year we had paid our visit to Birmingham Town Hall. He couldn't, but what he could remember was that our seats were not in the balcony, but towards the back of the stalls on the right-hand side and that the next morning he had to fly off to the States to join the rest of The Bunnymen, who were about to start an American tour. He also reminded me of the time the two of us were in San Francisco and we went looking for Ralph Records. Will had the address. We found the place, a non-descript boarded-up office front. It was closed. Will went back later. The door was open and Will wandered in. The place was empty. On a work bench was one of the eyeball masks. Will picked it up and was trying it on for size when somebody walked in and started yelling at him. Will made his excuses and left.

The last time I saw Will was backstage at the Barbican concert hall in London in 1997. It was after Jimmy and I had done our 'Fuck the Millennium' performance. That performance, the unfocused emotions and uncertainties that it generated within me, have pushed me towards wanting to write this story about The Residents and some of the stuff that our performance that

[336]

night churned up in me. It's been a notion of mine to write this thing for over twelve months, but as I wanted it to be one of the last stories I wrote for *45* I kept on putting it off. After phoning Will, I re-read 'Thrashed' and 'Wheelchairs' to refresh my memory of what state of mind I must have been in and to make sure I didn't repeat myself. After the record had been finished and Jimmy and I were almost satisfied with all its lumbering parts, we were encouraged by those at Blast First/Mute Records to think about making a promotional video clip for it. Not only was the record to be called 'Fuck the Millennium', but it had me liberally using the F-word all over it, thus making it a piece of product unbroadcastable in all media. When Jimmy and I had done things in the past, it was always at our own expense, in every sense of the phrase. This time someone else was paying the pipers. Our initial idea was to make the video clip on a steep and blustery beach up north somewhere near Whitby, with an angry sea threatening from behind and a dark and troubled sky glowering from above. The whole cast would be there: the brass band; the hymn singing lifeboatmen; Jeremy Deller; the Rev Bitumen Hoarfrost giving full-submersion baptisms; Gimpo running about and of course me and Jimmy in our wheelchairs, attended by Hattie Jacques and Barbara Windsor. Reality pointed out to the pair of us that however great the idea might be, angry seas and troubled skies are not readily available in the middle of the summer. Instead, we thought of creating and presenting a grand tableau in a theatre in front of an audience of paying guests. Not a rock 'n' roll show, but something that would only last as long as the track. A tableau that would include all the above mentioned characters minus Hattie Jacques and Barbara Windsor, sadly. A little research revealed that real lifeboatmen didn't look like the ones in our imagination, so the Viking Society that we worked with on our 'America: What Time Is Love' video clip were contacted. They were more than willing to dress up as turn-of-the-century lifeboatmen. They had the beards. They were committed beard growers.

Paul Smith – not the tailor nor the New Neurotic Realist, but the boss of Blast First – was responsible for promoting the whole event. He also had his own ideas, good ones. He said we should invite the striking Liverpool dockers to take part in the event. Although Jimmy was originally from Merseyside and I spent many years living there, neither Jimmy nor I was up to speed with these particular malcontents' complaints about the system. But we understood them to be a fashionable (in an unfashionable way) *cause célèbre*. It was thought that their involvement would bring a reality factor to our end-of-the-career-show. Paul Smith booked the Barbican, Jimmy and I dreamt up ad copy and worked on layout in our standard style, for two full-page ads in the same issue of *Time Out* (London's leading listings magazine). The first ad read: 'They're back, the creators of Trance, the lords of Ambient, the kings of Stadium House, the godfathers of Techno Metal – the greatest Rave band in the world, ever. The KLF, for one life only'. Nothing else, just our usual typeface, black out of white. A few pages later the second advert read: 'Jeremy Deller presents "1997 – WHAT THE FUCK'S GOING ON?" Jimmy Cauty and Bill Drummond invite you to a 23-minute performance during which the next 840 days of our lives will be discussed. Barbican main hall Tues. 2 September. Millennium crisis line: 0800 900 2000.'

Media interest was aroused. Tickets sold. Then Diana got killed, so the show got put back in respect of a nation in mourning and the fact that our little tableau would earn no media coverage compared to what the dead princess would get. Ken Campbell and Colin Watkeys directed the cast. Show time. 23 minutes later, job done, and Jimmy and I were happy men. Still in our aging make-up and piss-stained pyjamas, we willingly posed for photos and jabbered with gay abandon into any microphone that was put in front of us. We waved goodbye to the supporting cast and bit-part players and were off into the night, with some Scam-Mongering Publicity Stunts to be

done. We scaled the walls of the National Theatre with pots of emulsion, long-range paint rollers and a journalist from *Time Out* in tow. Ten years earlier we had followed the same route to daub the beckoning acres of virgin grey-concrete wall with our opening salvo, '1987: WHAT THE FUCK'S GOING ON?' This time, '1997: WHAT THE FUCK'S GOING ON?' Some things change, some things don't. And 2007 is not that far away.

> Yes we shall not grow up
> As you that are left grow fat
> Age shall not bring us wisdom
> Nor the years learn us
> At the going down of the sun
> And in the morning
> We will still be up for celebrating
> Our own Futility

Job done, we scarpered. Stood on Waterloo Bridge watching the security guards swarm. But over the following days and weeks the printed media, those few that were interested, ran their reports and reviews of what us pair of aging pranksters had been up to. And I despaired and was wounded. And I quote (at length):

> It's five years since The KLF left the music business. And yet it seems like they've never been away. Maybe that's because they haven't. OK, so they haven't released a record in those five years, but they've done just about everything else they could to stay in the public eye.
> Since they pretended to machine gun the audience at the Brits in 1992, and threw a dead sheep across the foyer of the hotel where the aftershow bash was held, they've been up to all manner of mischief. How

we laughed when they offered a £40,000 prize to the worst artist at the Turner Prize in 1993, and then nailed it to a board as an artistic statement of their own! How we frowned in conclusion, then thought, 'You're a bunch of tossers actually, aren't you?' as they burnt a million quid on a remote island, filmed it, and talked about going off to Rwanda to show it to poor people, but showed it to their music biz and media mates instead! How we thought, 'Can we go home now please?' as they ferried loads of journalists to Devon to hear Jimmy playing with his tank-cum-soundgun toy, and kill animals with it! And how it stimulated minor dinner-party debates among the chattering classes! . . .

Aren't they playing all these pranks not to highlight the bullshit the world is wallowing in, like say Chris Morris, but to be clever, and to tickle their own art-wanker egos? Aren't they running out of ideas somewhat, rehashing an old hit with their new single, and calling it 'F - - - The Millennium' for no other reason than an unimaginative attempt to surf the Zeitgeist? Have they actually done anything of any consequence or meaning as a creative partnership except make four hit records? Weren't they brilliant when they were populists (stadium rave, The Timelords) and aren't they f - - - ing tedious now they're elitists (endless pranks for the benefit of no-one but themselves and a mildly uninterested media)? And perhaps most importantly – does anyone give a f - - - what is going on any more?

Aha! But we're debating it even now! We're still fascinated by them! We still give them triple-page spreads! We don't know how to react! We're questioning our most basic values, sort of thing! So

they've won! Ha ha! Congratulations. But we are kind
of in the hope that some shadow of their former
genius for spectacular pop music might re-emerge.
We'd really rather have some entertainment than an
art-school debate.

Prospects for the spectacle part of the equation look
promising as we arrive at rehearsals to the sight of
30 Liverpool dockers standing on a stage with
placards, in front of a full brass band in uniform,
with a male voice choir of lifeboat men, recruited (I
kid you not) from the Viking Appreciation Society Of
Great Britain. To our right, a funk band is jamming
in the corner of the stage. Meanwhile, a vicar in a
gold sequinned suit stomps around, followed by a
strange man in a white coat and a Salvation Army
officer. And at centre stage is a large white sheet
covering something we can't quite make out.

The dockers are herded offstage for the moment,
and then, without warning, a loud noise, like a CB
radio, crackles into life. '1997 – What the f - - - is
going OOOOOOOOOOON? F - - - THE
MILLENNIUM!' The vicar tries to mime the words,
despite the fact they're obviously on backing track –
all part of the postmodern statement, no doubt. The
white sheet is pulled off the large object and hark! it
reveals our heroes, made up as grumpy old men (all
be it [sic] with the trademark horns on their heads)
in pyjamas and motorised wheelchairs. They proceed
to whizz around the stage for a bit, as the funk band
soldier on in their flat caps and the brass band mime
for all they're worth.

The discerning observer will notice, however, that
the actual tune being played is 'What Time Is Love?',

The KLF's 1991 hit. Oh well, suppose writing anything new was far too prosaic and orthodox an approach for Drummond and Cauty's mischievous sensibilities.

Johnny Cigarettes, *NME*, 27 Sept 1997

An evening to remember, said the people who collected their Fuck The Millennium shopping bags and went home. But there was no press furore the next morning – merely the anticlimactic aftertaste left by 40-year-old men miming to a seven-year-old song . . . 2K was unquestionably a failure. The single got no radio play, the event attracted precious little non-music attention, and it achieved even less than Drummond and Cauty's last stunt – their burning of £1 million on the island of Jura, filmed and shown to the requisite gasps before the whole thing fizzled out and they could no longer be arsed.

Select, December 1997

I wanted to stamp my feet and scream, 'But you don't understand, the whole show was about the crapness of the comeback, of blowing one's own myth. You are supposed to see that and applaud the fact that we have an incredible understanding and postmodern take on all things pop, at the same time as delivering the goods.' And then I did understand. Everything was OK. The show was a success, the record stiffing at number twenty-eight in the charts was just what the doctor ordered. We had not only blown it, we had destroyed whatever remnants of credibility, bankability and myth we had left. We had been exposed for what we had become. It wasn't just the money that got burnt; it was also the bridge that we could have trotted over any time we felt like it for a fiscal graze in the green pastures of

success. With my finger no longer on the Zeitgeist, I could pick up this pencil, downgrade my horizon and get on with the rest of my life without being weighed down by that sack of credibility, myth expectations. That sounds like a cute riding-off-into-the-sunset ending to this particular fable but there is more. Or at least there are a few loose ends to tie.

The journalist from *Time Out* who came with us as we scaled the walls of the National Theatre had been one of our most hardcore fans. In 1988, at the age of twelve, he had bought our 'Doctorin' The Tardis'. He got on board. Then through his teenage years he had faithfully followed our every move. We were the idealised big brothers he never had. On our official retirement from the music business in 1992 he even wrote a book recounting our exploits. Then that night in 1997, after we daubed our message on the grey concrete and were about to speed off looking for some after-hours action, I shook our former teenage Number One Fan's hand and wished him well. In that moment, as our hands shook, I detected something in the glint of his eye: disillusionment, as real and pure as disillusionment can get. Almost as powerful and strong as when I saw that bit of dark curly hair sticking out the back of that Resident's eyeball mask. In our (Jimmy's and my) short journey through pop, that moment of disillusionment was maybe our greatest creation. Without that final state of disillusion, the power and glory of pop is nothing. And when it happens (and if it has not already happened for you, it surely will), savour it, because it very quickly slithers into disinterest and gets forgotten as life marches on.

WHERE'S BILL?

12 January 1999

There was a story that I was going to write for this book. A
story that I never got round to writing, one I wanted to be the
penultimate story in this book. The unwritten story involved a
Mr Best Left Unnamed v W. E. Drummond and Others legal
case. It is a case that has hung over the writing of all these sto-
ries, from first to last. Whatever the final outcome, it will only
be of any consequence to those directly involved with the suit,
and personally I found the constant threat of a case being found
against me inspirational. I originally thought that 'My Modern
Life' was to be the closing story but, while waiting for the case
to be closed, all these other stories kept forcing themselves out
of my pencil, demanding to be written down and included in
this volume. It kind of destroyed the bleak purity of me getting
on the Leighton Buzzard bus and being gone, never to return
and all that – after a week or so, I was back at my table in the
library, and back in Beatties for my three cups of coffee. I've got
over the waitresses knowing my name. They even gave me a
Christmas card. There are a couple of things that have changed
at Friars Square Shopping. The lift in the multi-storey car park
now has a computer-controlled pre-recorded voice informing
lift-travellers 'Doors closing, doors closing, going up. Level
Five. Doors opening, doors opening.' Some days I hang around

on Level Five as the three lifts arrive at random; their doors open, their doors close and then they return to Level One and the process starts again. Before the lift arrives at Level Five, you can hear the muffled pre-recorded voices informing the as yet unseen lift-travellers that they are approaching Level Five. On their arrival, but before the doors open, you hear the less muffled 'Doors opening', and as the doors actually open, you hear in all its clarity 'Doors opening'. Then the first of the 'Doors closing' starts.

So there I loiter, listening to the rumblings and crankings of this trio of lifts as they come and go, the rise and fall and the pre-recorded voices calling out and responding to each other. A lost-and-found tone poem dedicated to life in a modern satellite town. Years ago I would have wanted to record this and use it in a record. Jimmy and I used the 'Mind the gap' voice from the London Underground on our first LP together back in '87. But these days, every last sound that the world has on offer has been sampled up and used on a record somewhere. If you're interested in hearing what I'm talking about and feel like a bit of hanging about listening to a triptych of lifts chattering their lonely lines to each other, you know where to go. Or better still, find your own song out there that soothes the suburbs of your soul.

As for Bill, my fellow long-service, medal-wearing user of Aylesbury Reference Library, he's no longer there. I put off asking one of the librarians if they had seen him come in lately. Today I plucked up the courage, but although I was able to furnish them with an extensive description they were afraid they didn't know who I was talking about. Every year he made it to the Cenotaph for Armistice Sunday. I never did get to know his surname.

Just another Bill
In another library
Reading the papers and falling asleep
Ah well
Another boat across the morning harbour.

W. E. Drummond, 12 Jan 1999

FORWARDS TO THE FOREWORD

Nobody reads forewords, or at least that's what Sallie told me. She then qualified her statement by saying she may read a foreword after she's read the book, if she liked it.

Do you read forewords?

When the paperback edition of *45* was first mooted, my editor at the publishers suggested I might consider writing a foreword for it. I considered it, then told her I didn't want to. But then an idea struck. I had recently found a small art book called *The Collected Works of George Orwell & Other Paintings* by Simon Morley. There was an introduction to this book by a Neal Brown. The opening paragraph went like this:

> A catalogue essay, such as this one, is usually a eulogy. Simon Morley is a suavely able, intelligent artist, whose works are paradigms of painterly sophistication. I myself am clever and erudite. The Percy Miller Gallery is an exceptionally advanced centre of artistic excellence. And you, the reader, are not bad looking yourself. Were anyone to dispute these truths, they might reasonably be assumed to be either a grunting cretin, or one of the commonly embittered persons of the art world – jealous and

vengeful – whose opinions may be safely
disregarded.

I liked this.

The closing two paragraphs went like this:

> It is difficult to read a catalogue essay about the
> contemporary fine arts which does not gain stature by
> invoking the name of a – usually French – philosopher.
> I do so here for readers who prefer this: Bataille,
> Baudrillard, Deleuze, Derrida, Foucault, Lyotard. I
> would also mention the psychoanalysis of Lacan and,
> as it is prudent to do so, the German philosophers
> Hegel, Heidegger, Kant, and, probably, Nietzsche.
>
> *
>
> The following list is offered in the context of Simon
> Morley's work; neither oppositionally, nor as an
> alternative to those names above, but simply as some
> kind of a furtherance of possible understanding:
> William James, Brahms, Iggy Pop, St Augustine, St
> Thomas Aquinas, The Flaming Groovies, Meister
> Eckhart, Elisabeth Kübler-Ross, U-Roy, Zen Buddhism,
> Jesus of Nazareth, the anonymous author of 'The
> Cloud of Unknowing', Lao Tzu, Subway Sect, Nelson
> Mandela, John Coltrane, Plato, and Joy Division.

This was even better, not that I have ever read a French
philosopher but because 'Shake Some Action' by the Flaming
Groovies is one of the most uplifting 45s ever cut and for a few
months in 1978 The Subway Sect were the greatest pop group
in the world.

Now if I was to have a foreword I would like one that was to
read like the above. Neal Brown had had no previous involve-
ment with my work, which I also liked.

Forwards To The Foreword

My editor was keen, in principle, on the idea of a foreword by this Neal Brown. So I sent him a copy of *45* with an invitation to write a foreword. A fortnight later he sent me his copy. I read it. And now you can read it.

INTRODUCTION

by Neal Brown

I

Contained within Bill Drummond's creative vocation are certain advocacies of wholesome and pure moral betterment, the fires and brimstones of their obliquely expounded righteousness qualifying him as a kind of missionary – like his father (a Scottish Presbyterian minister) and great uncle were before him; both once missionaries to Africa and New Guinea respectively. *45* collects the essayed testimonies of Drummond's beliefs, testimonies I sincerely commend to the reader, and about which I will – using the Bible as my infallible guide to eternal truth – seek to correct misrepresentations made against the author by the slimy-tongued Satans of abominable commentary.

II

In *45* we learn of 'a rare golden day' when 'sunlight danced on the river'. A day when, with two companions, the young boy Drummond – in the spotless lambhood of his youth – preferred to seek the mortal danger of an unexploded bomb from the Second World War, believed impacted in a local hillside, rather

than dally with the dappled trout found in a stream, or other innocent pleasures.

Drummond, by the many digressions of his reminiscence, somewhat understates the compelling attraction of this bomb – a bomb which was never found, its actual and metaphorical power hidden by the actual and metaphorical plant growth obscuring its resting place. For our purposes, however, Drummond's search for something inherently unstable and explosive serves as representative of his creative themes, such as (orphic) mystery, innocence, odyssey, and the duties and justices of actual or symbolic power – what might, in terms of a moral psychology, be seen as a sacrificial willingness to a great or wrathful providence. Crudely systemised, these themes may be described as 1) uncertainty of objective, 2) expedition, and 3) a (hem, hem) reckless grandeur, so effecting a magico-religious atonement or merit – the author heralding with the pure tones of his prophetic musical trumpet the . . . KA-BOOM.

III

To the Shores of Lake Placid was the title of a book Drummond began, but which he never completed. 'I wrote and wrote,' Drummond says. 'It was rubbish.' In *45* this book is salvaged, abridged, and retitled *From the Shores of Lake Placid*. It is no longer rubbish. An Ovidian meta-story, Drummond's relationship with the demigod 80s bands he describes – whether they are known to the reader is not the point – is a compelling mythology, with a theme of transformation. This is clearly represented in the title's slight change. '*To*' becomes '*From*', so offering a clue to the nature of Drummond's creative task in *45* – a task in which everything that was previously a going 'towards' now becomes, upon meditative reflection, a returning 'from'. In this way, Drummond's life's travel – his often absurdist expeditions, journeys and explorations – is transformed through the act of writing, so that an epic chaos becomes an ordered universe.

IV

Bollocks.

V

As well as an exceptional travel book, *45* is a description of a spiritual journey, a history, and a wry self deprecation. A work of comic – sometimes tragicomic – transformations, *45* invokes Ovidian digression, Montaigne, Patrick Keiller, Ian Sinclair, Boswell and Johnson, Terry Southern's *Magic Christian*, James Hogg, Ecclesiastes, Diogenes and Sergeant Bilko. In terms of Drummond's relationship with art, though, he seems to have more in common with Quang Duo, the Buddhist monk who immolated himself as a protest during the Vietnam war.

VI

Much of *45* is a description of the making of art, or aspects of its appreciation or presentation, art being a subject to which Drummond is in an ambiguous relationship – he values it highly, but also defines himself oppositionally in his relationship with it. Although having an intelligent appreciation and under-standing of art, Drummond's contrary idealism prevents his having proper comprehension of the wickednesses and devilments occurring in art's translation into the world, passing as it does through the unholy dogmas of its conspiring priest-hoods. Of course, to say this of Drummond is only a compliment.

The late-Duchampian, neo-conceptualism that characterises much art practice of the last ten years is less a meritocracy than almost any other area of human endeavour (even primogeniture requiring an honest sperm race), unlike that of popular music or writing, areas in which Drummond has unarguably excelled. Let us then tap Drummond on his shoulder, and gently draw his attention to the sad fact that in

spite of (or maybe because of) these successes, the artworld has disallowed him a dispensation to practice art, and that he is denied access to the coded strategies and secret handshake plottings that determine artistic status.

At the time of writing, reviews are appearing for a show by the artist Michael Landy, who systematically destroyed his material possessions, in public, in the name of art. For his statement about ownership and wealth, Landy is receiving considered attention. A deserved attention, as he is a good and sincere artist, but received in a way that Drummond and Cauty's K Foundation, when they redistributed their wealth by burning a million pounds, were not privileged with.

Such art world benediction is not only withheld from the miscreant Drummond but, even worse – like Ovid's banishment from Rome – the artworld is somewhere from which he has been permanently exiled, for an offence which remains unspecified.[1]

VII

All through history, in the periodical conflicts of Puritanism with the don't-care temper, we see the antagonism of the strenuous and genial moods, and the contrast between the ethics of infinite and mysterious obligation from on high, and those of prudence and the satisfaction of merely finite need.

William James (1842-1910). 'The Moral Philosopher and Moral Life'. *Selected Writings*, Dent 1995

VIII

1 Actually, Drummond's offence is not unspecified, and holding up the Turner Prize to a fiscal ridicule in 1993 didn't help, either. And maybe Ovid deserved his banishment. But I prefer not to make pronouncement on these matters, as they are extremely difficult and complicated, and have many disputations.

... when Drummond dies, a thousand wicked demons from art-world hell will seek him, falsely claiming him as their own all along, the wild-eyed fiends salivating at his corpse, prancing their cloven-hooved dance around him, and seeking to drag his soul into the many circles of their foul suppurations ...

IX

I am forty-six years old. Therefore, I've been there – been forty-five for exactly a year. Not as forty-five as Drummond was, but still not bad. I've also been Scottish, certainly prior to my parents removing me elsewhere, without my permission, in 1960. And I am the co-author of a truly terrible novelty record that got as far as number 22 in the UK charts. It is my considerable authority in these matters that qualifies me the privilege of writing this introduction. I am a proud man to do so *[clears throat, adjusts bow tie]*, proud to be able to introduce you, ladies and gentlemen, to this clever, funny and brave book, by the clever, funny and brave Mr Bill Drummond.

BACKWARDS FROM THE
FOREWORD

Do you think it's any good as a foreword? I do. I think it's great. Compared to (bar one) even the most favourable of reviews that *45* received, when it was first published, this was the only bit of writing about the book that made any attempt to engage with what I do at any level other than the most facile. Yes he hypes me up, makes claims for my 'creative vocation' that I do not dare to claim for myself. I do not even dare to claim to understand the basis of the claims he makes.

I sent it to the editor. Things started getting difficult. She didn't like it. Why? She thought it gave the wrong impression of what the book was like. She thought it *prescriptive*, *portentous* and somewhat *pretentious*. I had to look up the word portentous. She thought it would put off potential readers. I was crestfallen. In the past I have greatly valued her input and judgement. What to do?

I gave it to Sallie to read. As well as her previously remarked upon thoughts on forewords, she tended to agree with the editor. In particular, she felt that it would only antagonise readers to have my name mentioned alongside the greats of classical and English literature and even the inclusion of Sergeant Bilko did little to debunk the pretentions.

She also wanted it made public that I wasn't clever, funny or brave. She lives with me, she ought to know.

I now hope to strike a deal with the publishers. They can keep the downmarket cover that the sales force like; they can keep the cheap use of edited review quotes that may entice the casual bookshop browser but cause me acute embarrassment in exchange for using the – adjectives of your choice – foreword by Neal Brown.

Bill Drummond, June 2001

Postscript: I have just spoken to the much-mentioned editor. A deal has been struck. Crap cover stays as do the review quotes in exchange for the Neal Brown foreword appearing. At the back of the book along with the 'Forwards to the Foreword' and this 'Backwards from the Foreword' by me.